SOFA
CHICAGO
SCULPTURE OBJECTS
& FUNCTIONAL ART

The Tenth Annual International Exposition of Sculpture Objects & Functional Art

October 17-19
Navy Pier

A project of Expressions of Culture, Inc.

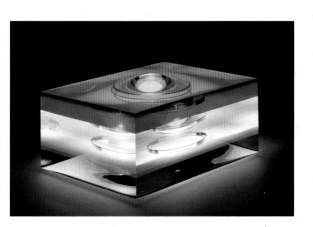

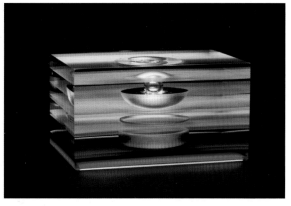

front cover:
Tom Patti
Compacted Red Echo
with Green, 1992-93;
fused, hand-shaped,
ground and polished glass
3 x 7 x 4.5

back cover:
Tom Patti
Red Lumina with
Solarized Ring, 1990-91;
fused, hand-shaped,
ground and polished glass
3.25 x 6 x 4.25

All dimensions in the catalog
are in inches (h x w x d)
unless otherwise noted

Library of Congress Cataloging – in Publication Data

SOFA CHICAGO 2003
The Tenth Annual International
Exposition of Sculpture
Objects & Functional Art

ISBN 0-9713714-1-5 (hardcover & paperback)
2003111301

Published in 2003 by Expressions of Culture, Inc., Chicago, Illinois

Graphic Design by Design-360° Incorporated, Chicago, Illinois
Printed by Pressroom Printer & Designer, Hong Kong

SOFA
CHICAGO
SCULPTURE OBJECTS
& FUNCTIONAL ART

Expressions of Culture, Inc.
325 West Huron, #500
Chicago, IL 60610
voice 312.654.0870
fax 312.654.0872
info@sofaexpo.com
www.sofaexpo.com

Mark Lyman, president
Anne Meszko
Julie Oimoen
Kate Jordan
Jennifer Haybach
Greg Worthington
Barbara Smythe-Jones
Therese Donnelly

Conte

SOFA

CHICAGO

SCULPTURE OBJECTS & FUNCTIONAL ART

Welcome to SOFA CHICAGO 2003!

Synergy is a word often used today when speaking about cooperative efforts, about people and ideas working jointly together to achieve an effect of which each is individually incapable. SOFA CHICAGO, now celebrating its Tenth Anniversary, is a perfect example of a synergistic effort that started when a group of visionary galleries, artists, museum curators and collectors came together, dedicated to bridging the fine and decorative arts.

New expressions and rich artisan traditions came together at SOFA expositions, and a dialogue enriching both took place. New insights were produced that neither wholly contained before. Each had more to say than it had said. There was a sense of discovery and earnestness to the dialogue—for after all, the reason artworks are made, the reason we speak, is to say more than what has been said.

Synergy began to happen organically at a second level. People began to organize, forming new galleries, museums and collector groups. A vibrant international community and marketplace was born. SOFA CHICAGO and its sister show, SOFA NEW YORK, are the lucky beneficiaries of this remarkable synergy.

SOFA CHICAGO 2003 is another wonderful example of cooperative and creative efforts by individuals and groups to enhance the field. Of special mention is an exhibit at SOFA organized by the Association of Israel's Decorative Arts (AIDA), in cooperation with Eretz Israel Museum, a new project initiated by collectors Doug and Dale Anderson, and Charles and Andy Bronfman. The admirable goal of the project is to personalize and humanize the current situation in the Middle East,

by bringing working artists from Israel to meet the American arts community, and to build a bridge between Israel's decorative arts community and American dealers and buyers. Many thanks to Dale Anderson for curating the exhibit, and also to advisors Jane Adlin, Assistant Curator, Metropolitan Museum of Art; Aviva Ben-Sira, Eretz Israel Museum; Rivka Saker, Sotheby's of Israel; and Davira Taragin, Curator of Exhibitions and Programs, Racine Art Museum. And special thanks to Charles Bronfman, Chairman of The Andrea and Charles Bronfman Philanthropies, for his accompanying essay in our catalog.

We are pleased that the American Craft Council will hold its Gold Medal Awards Ceremony at SOFA CHICAGO and present a special exhibit of artwork by ACC award winners. We welcome the participation of the field's top collector groups and academic institutions, some presenting special exhibits at the show, lecture series presentations and catalog essays including The National Council for Education in Ceramic Arts (NCECA), and Rhode Island School of Design (RISD). We are delighted to partner again with The Corning Museum of Glass Hot Glass Roadshow, the world's premier mobile glassblowing unit, to present hot glassblowing at the show. Many thanks to Steve Gibbs, Events Marketing Manager, Corning Museum of Glass, Corning, NY; and to the many participating glass artists represented by SOFA CHICAGO 2003 galleries.

Perhaps synergy is nowhere more apparent than in the SOFA Lecture Series, which is also celebrating its Tenth Anniversary! Since 1993, over 300 renowned and emerging artists, curators, and collectors have generously shared their passions, inspirations and aesthetics. We thank the individuals and organizations who present lectures for their many contributions; and are excited that this year's Lecture Series will feature a record 37 presentations.

The SOFA community continues to grow in scope. Five new galleries from Denmark will exhibit for the first time in SOFA CHICAGO 2003. Over 90 U.S. and world galleries will exhibit in the exposition representing the U.S., Australia, Canada, Czech Republic, Denmark, England, France, Italy, Scotland, South Korea, Sweden and Wales.

At the local level, we are delighted to present the special exhibit Artists on the Map, in celebration of the 8th annual Chicago Artists Month, organized by the Chicago Department of Cultural Affairs.

Artists on the Map features the artwork of nationally and internationally renowned artists affiliated in some way with Chicago, including Ruth Duckworth, Ed Paschke, Julia Fish, Richard Hunt, Michiko Itatani, Vera Klement, and Martyl. We are grateful to Thea Burger and Kim Coventry for curating Artists on the Map, and are pleased to join in the celebration of Chicago's rich visual art community.

Building on the 40% increase in attendance at last year's SOFA CHICAGO's Opening Night Benefit, which raised almost $100,000 for the Arts Program of Northwestern Memorial Hospital, Northwestern Memorial Foundation has planned an elegant Tenth Anniversary SOFA CHICAGO 2003 Opening Night Benefit. Proceeds will again benefit the Arts Program of Northwestern Memorial Hospital, which supports a 2000-piece collection that enhances the recovery and spirit of its patients and their families. We are again indebted to the energetic Benefit Committee, especially Co-Chairs Joan Himmel Epstein, Charles R. Gardner and Dr. Lawrence Michaelis. Thanks also to Holly Gibout and Ann Torp of Northwestern Memorial Foundation for their excellent support; and to the SOFA CHICAGO 2003 galleries and dealers participating in the Friends of the Arts Program, donating a portion of their Opening Night sales to benefit the Arts Program.

Looking forward, continued synergy will carry the artworks at SOFA to new heights of artistic expression, technical sophistication, and market value. The challenge of the next decade for the field will be to develop a relevant critical discourse; for while beauty always exceeds its frame, it will always be framed by discourse.*

Thank you all, individually and collectively, for making SOFA expositions a dynamic confluence of people, artworks and ideas, where dialogues enriching all take place.

Here's to continued synergy and the certain excellence of the next decade!

Mark Lyman
president and founder

Anne Meszko
director of educational programming

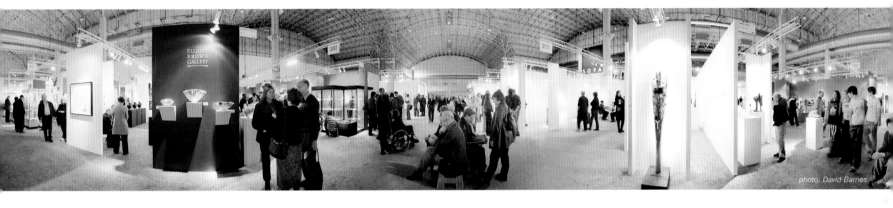

photo: David Barnes

Expressions of Culture, Inc. would like to thank the following individuals and organizations:

Participating galleries, artists, speakers and organizations
American Airlines
American Craft Council
Aaron Anderson
Dale Anderson
Doug Anderson
Arpin Logistics
Art Alliance for Contemporary Glass
Art Jewelry Forum
David Barnes
Joan Baxt
Maria C. Bechily-Hodes
Barbara Berlin
Sandra Berlin
Kathy Berner
Jennifer Blum
Lou Bradaric
Carmine Branagan
British Crafts Council
Andrea Bronfman
Charles Bronfman
Gail M. Brown
John Brumgart
Desiree Bucks
Thea Burger
Sheryll Catto
Aurore Chabot
Chicago Art Dealers Association

Chicago Cultural Center
Chicago Tribune
Julian Chu
Claridge Hotel
The Clay Studio
Jim Cohen
Kelly Colgan
Collectors of Wood Art
Camille Cook
Keith Couser
Kim Coventry
John Cowden
Design-360°
Dietl International
Floyd Dillman
Gillian Davies
Hugh Donlan
Miguel Dowgopoluk
Anne Dowhie
Lenny Dowhie
Jeff Drabant
Joan Himmel Epstein
D. Scott Evans
Fine Art Risk Management
Focus One
Friends of Contemporary Ceramics
Friends of Fiber Art International
Charles R. Gardner
Steve Gibbs

Holly Gibout
Judith Gorman-Prawdzik
Gretchen Goss
Jeff Guido
Lauren Hartman
Evan Haughey
Matthew Haughey
Adam & Paula Haybach
Scott Hodes
Holiday Inn City Centre
Holly Hotchner
Jill Hurwitz
J & J Exhibitor Service
Scott Jacobson
James Renwick Alliance
Kevin Jankowski
Mike Jentel
Kathy Jolley
Howard Jones
Ulla Munck Jørgensen
John Keene
Gregory Knight
Janet Koplos
Jane Kozlow
Lakeshore Audio Visual
Edward Lebow
Ruth Lopez
Ellie & Nate Lyman
Jeanne Malkin
Arthur Mason

Jane Mason
David Revere McFadden
Metropolitan Pier & Exposition Authority
Jo Mett
Gretchen Meyer
Lawrence L. Michaelis, M.D.
Mint Museums of Craft + Design Founders' Circle
Brenda Moore
Lois Moran
Louis Mueller
Bill Murphy
Cathy Murphy
Nancy Murphy
Susan Murphy
Kathleen G. Murray
Museum of Arts & Design
Museum of Contemporary Art
Ann Nathan
National Council for Education in the Ceramic Arts
Penland School of Craft
Maria Philips
Rob Poleretzky
Pressroom Printer & Designer

Cynthia Quick
Rhode Island School of Design
Bruce Robbins
Christina Root-Worthington
Michael Roth
Al Sanchez
Savannah College of Art & Design
Lisa Schaller
Linda Schlenger
Patrick Seda
Sheraton Chicago Hotel & Towers
Dana Singer
Gary J. Smith
Society of North American Goldsmiths
Ben Spinelli
Dr. Louise Taylor
Skeffington Thomas
Ann Scott Torp
Kenneth Trapp
Karen Turner
VU Case Rentals
Natalie van Straaten
Israel Vines
Larry Vodak
The W Hotel
Danny Warner
Don Zanone

*Jeremy Gilbert-Rolfe, **Beauty and the Contemporary Sublime** in *Uncontrollable Beauty: Towards a New Aesthetic, Edited by Bill Beckley and David Shapiro, p. 41 (Allworth Press, New York NY, 1998).*

A.

The Arts Program of
Northwestern Memorial Hospital

Art and the environment can have a profound impact on an individual's sense of well-being. Simple things like color, texture, natural light and natural materials can create a more relaxing, healing environment. Research shows that representational art depicting natural landscapes and positive human interaction can relieve anxiety, lower blood pressure, improve post-surgical recovery, reduce the need for pain medication and shorten the hospital stay.

The Arts Program of Northwestern Memorial Hospital captures this philosophy. Driven by a commitment to create a welcoming and supportive atmosphere for patients and their families, visitors and staff, the hospital collaborated with leading authorities on healing environments to develop specific guidelines for art selection. Special attention was given to select pieces that not only promote healing, but also reflect the cultural diversity of the hospital's community and celebrate the city of Chicago and the Midwest.

The collection encompasses more than 2,000 pieces of original oil paintings, acrylics, pastels, pencil drawings, watercolors, lithographs, serigraphs, collages and photographs. A unique aspect of this collection is the *Looking Up* series of backlit nature photography mounted on the ceilings of several examination rooms. This series enables patients to relax before, during and/or after certain diagnostic or therapeutic procedures by allowing them to "look up" at calming nature scenes as opposed to the glare of customary white lights. The program also provides lush plants and decorative floral arrangements throughout public areas of the facility, creating relaxing seating areas that simulate indoor gardens.

The Arts Program of Northwestern Memorial Hospital is made possible through the generosity of many friends and supporters. If desired, contributions may be given in memory or in honor of a friend, loved one or caregiver. For more information on the program or to take a tour, please call the Office of the Vice President of Northwestern Memorial Foundation at 312-926-7066.

A.
Acanthus Leaves, *carved stone panel, circa 1928, artist unknown Northwestern Memorial Hospital's Passavant Pavilion*

Carved from Indiana Limestone, the leaf, flower and vine motifs traditionally represent abundant life and immortality. This and other works of art from the facades of Northwestern Memorial Hospital's predecessor hospitals have been salvaged and will be incorporated into the hospital's Feinberg and Galter pavilions to preserve its heritage and perpetuate its 137-year tradition of healing.

NM Northwestern Memorial® Foundation

October 16, 2003

Dear Friends:

Welcome to SOFA CHICAGO's Opening Night Benefit!

We are delighted you could join SOFA CHICAGO and Northwestern Memorial for a spectacular evening. Tonight's event promises to bring you the most innovative and impressive collection of art from galleries around the world, and a wonderful opportunity to celebrate the Arts Program at Northwestern Memorial which depicts *"the strength of the human spirit and the beauty of the world."*

It is a privilege for Northwestern Memorial to be involved in SOFA CHICAGO for the 4th consecutive year. This event provides essential charitable support to the Arts Program at Northwestern Memorial Hospital. The Arts Program exemplifies the Hospital's commitment to build and maintain a healing environment for patients, family members, visitors and staff. We are proud to have art throughout the Hospital which supports healing and reflects the communities we serve.

In addition to continuing to build the arts collection at our Feinberg and Galter Pavilions, Northwestern Memorial is in the initial stages of building a new woman's hospital—a state of the art facility that will change the way we deliver healthcare to women and their families. We envision a premier facility filled with sculpture, light, color, texture and soothing images that will create the most comfortable and healing environment for women's health care. Your contributions will allow the Arts Program to continue as a vital part of our overall mission.

Thank you for your generous support of Northwestern Memorial Hospital and SOFA CHICAGO.

[signature: Kathleen G. Murray]

Kathleen G. Murray
President and Chief Executive Officer
Northwestern Memorial Foundation

OFFICE OF THE MAYOR

CITY OF CHICAGO

RICHARD M. DALEY
MAYOR

October 17, 2003

Greetings

As Mayor and on behalf of the City of Chicago, it is my pleasure to extend warmest greetings to everyone attending the Tenth Annual International Exposition of Sculpture Objects and Functional Art: SOFA CHICAGO 2003.

Bridging the gap between the contemporary, decorative and fine arts, SOFA CHICAGO 2003 presents the work of nearly 800 artists from ten countries at Navy Pier. Having blossomed into a vibrant international art community, SOFA celebrates its success with an Opening Night Benefit promoting the Arts Program at Northwestern Memorial Hospital. I commend the organizers and participants of this exposition for their support of artists and charitable work.

While you are here, I hope you will take time to discover all that makes Chicago a great place to live and visit. I know you will like what you find. From our great architecture and beautiful Lake Michigan shoreline to our fine restaurants and world-renowned cultural institutions, Chicago offers something for everyone.

Best wishes for an enjoyable and memorable event.

Sincerely,

Mayor

CHICAGO ART DEALERS ASSOCIATION

730 North Franklin
Suite 308
Chicago, Illinois
60610

Phone
31.649.0065

Fax
312.649.0255

October 17, 2003

Mark Lyman
Executive Director
Expressions of Culture/SOFA
Chicago, IL 60610

Dear Mark:

Congratulations on your 10th anniversary of SOFA CHICAGO. It marks a decade of success as we look forward
to another outstanding exhibition at Navy Pier, bringing the very best work bridging decorative and fine arts in an
amazingly wide range of media. In addition to the exhibits presented by over 90 participating galleries, the special
exhibits and lectures you offer during SOFA also will add so much to the weekend and our city.

Oh behalf of the members of The Chicago Art Dealers Association, we wish each of your exhibitors a successful and
fun-filled visit to Chicago. The best of luck to you, your staff and everyone involved in this wonderful annual event.

Sincerely yours.

Thomas McCormick
President, Chicago Art Dealers Association

10TH ANNIVERSARY! RONALD ABRAMSON JANE ADAM RENIE BRESKIN ADAMS HANK MURTA ADAMS GLENN ADAMS(
CAROLYN MORRIS BACH CLAYTON BAILEY PHILIP BALDWIN SAMUEL BARKAI SUE BARRY DR. JUDITH A. BARTER LYNN BA
DAWN BENNETT JAMIE BENNETT HARRIETE ESTEL BERMAN MARY BERO ANITA BESSON MARIAN BIJLENGA LIV BLAVARP
STEPHEN BOWERS STUART BRAUNSTEIN VERNON BREJCHA JOHN BREKKE CAROLINE BROADHEAD CHARISSA BROCK JO
BRYCHTOVA MARIO BUATTA RICHARD BURKETT MARK BURNS LARRY BUSH HARLAN BUTT MAUREEN CAHILL DOROTHY CA
CASTLE PIERRE CAVALAN NICK CAVE JOHN CEDERQUIST JOSE CHARDIET DAVID CHATT DALE CHIHULY SHARON CHUR
LIA COOK EDWARD COOKE, JR BARBARA COOPER DIANE COOPER MICHAEL COOPER JEAN S. COOPER GIOVANNI CO
DAN DAILEY WILLIAM DALEY ARTHUR DANTO MICHAEL DAVIS VIRGINIA DAVIS MICHAEL DAVIS GILLIAN DAVIES DOUGI
BETTINA DITTLMANN STEVE DIXON STEPHEN DIXON LAURA DONEFER SHERRY DONGHIA MARY DOSSBEN MARY DOUGLA
JOHN DUNNIGAN JACK EARL DAVID EBNER CAROLE ECKERT SUSAN EDGERLEY STEPHEN DEE EDWARDS GEOFFREY ED
WHARTON ESHERICK SUSAN ETCOFF FRAERMAN JAY FAHN JONATHAN FAIRBANKS SALLY FAWKES CHRISTINE FEDERIGHI
LEOPOLD L. FOULEM MAXINE FRANKEL WHITTAKER FREEGARD MICHELE FRICKE JOHN GARRETT KATYA GARROW THOM
JEFF GOODMAN NEIL GOODMAN GRETCHEN GOSS MARC GRAINER LISA GRALNICK LINDA GREEN SUZANNE GREENA\
GUGGENHIM MONICA GUGGISBERG ANNA RIITTA HAAVISTO DENISE HAGSTROMER ODED HALAHMY PATRICK HALL BO
HAYES TUCKER BARBARA HEINRICH MICHAEL HELLER DOUGLAS HELLER MICHAEL HELTZER LLOYD HERMAN WAYNE HIC
MICHELLE HOLDEN SUSAN HOLLAND MICHELLE & DAVID HOLZAPFEL JAN HOPKINS HOLLY HOTCHNER MARY LEE HU WAYN
ILSE-NEUMAN SERGEI ISUPOV KIYOMII IWATA RITZI JACOBI SCOTT JACOBSON MICHAEL JAMES DOUG JECK SUSAN
JUSTICE GARY JUSTIS MARGE BROWN KALODNER GLORIA & SONNY KAMM PAT KANE DONNA KAPLAN SUSAN KAVIC
CANDACE KLING VLADIMIRA KLUMBAR GARRY KNOX BENNETT KAREN KOBLITZ NANCY KOENIGSBERG LISA KOENIGSBERG
LAKY MARIANNE LAMONACA KAREN LAMONTE REBEKAH LASKIN JO LAURIA MARK LEACH PATTI LECHMAN ALBERT L
KEITH LEWIS FRANK LEWIS JACQUELINE LILLIE MARK LINDQUIST DAVID LING MARVIN LIPOFSKY DONALD LIPSKI MAR
FLORA MACE DAN MACK DAWN MACNUTT PATRICIA MALARCHER KATE MALONE SAM MALOOF THOMAS MANN PT
CATHERINE MARTIN LOY MARTIN PHILL MASON JOHN MASON SIGNE MAYFIELD WALTER MCCONNELL MIA MCELDOWNEY
MARI MESZAROS BRUCE METCALF JULIE MIHALISIN ELERI MILLS CRAIG MITCHELL KLAUS MOJE MICHAEL MONROE BEN
PHILIP MYERS MILO M. NAEVE SHIGEKAZU NAGAE RON NAGLE GEORGE NAKASHIMA JILL NORDFORS CLARK CRAIG N
OLDRICH PALATA ALBERT PALEY ZORA PALOVA CHRIS PANTANO MARILYN PAPPAS TOD PARDON FRANKLIN PARRASCH
PETERSON MARC PETROVIC ROBERT L. PFANNEBECKER MARIA PHILLIPS BINH PHO MARIA PORGES MARIBEL PORTELA
RAMSHAW SUSAN RANKIN JOANNE RAPP TINA RATH KRISTIE REA R. DUANE REED DAVID REEKIE DON REIT SUZA
ERIC ROCHAT MARY ROEHM MICHAEL ROGERS KIMERLY RORSCHACH TACEY ROSOLOWSI KATHERINE ROSS MICHAEL RO
JANE SAUER MARJORIE SCHICK DONNA SCHNEIER JAMES SCHRIBER AMY SCHWARTZ JUDITH SCHWARTZ LOUIS SCLAFAN
SHERRILL ESTHER SHIMAZU MARY-BETH SHINE CAROL SHINN HELEN SHIRK RANDY SHULL LINDA SIKORA ALLIN SILBER
SMALL BARBARA LEE SMITH CHRISTINA Y. SMITH PAUL J. SMITH PAUL SOLDNER JEFF SPENCER BARBARA SPRING JULIA
SUSAN SZENASY LINO TAGLIAPIETRA JAMES TANNER DAVIRA TARAGIN MARCUS TATTON ELLEN NAPIURA TAUMAN YO
CAPPY THOMPSON LINDA THREADGILL JOHN TORREANO KENNETH TRAPP KEN TRAPP PAMINA TRAYLOR MARCUS TREMO
GERLOF PETER VOULKOS LAURIE WAGMAN WENDY WAHL JANUSZ WALENTYNOWICZ JAMIE WALKER PHILIP WALLING RI
WILLIAMSON ANNE WILSON PAULA WINOKUR ANDREA WIPPERMAN MICKY WOLFSON BRUCE WOLMER JOE WOOD
YOOD BRENT KEE YOUNG MICHAEL ZOBEL LILLIAN ZONARS TOOTS ZYNSKY

BERT AIBEL SUSAN AIELLO PETER ALDRIDGE KATE ANDERSON GLENDA ARENTZEN ADRIAN ARLEO JACQUELINE ATKINS
CHARD BASCH JAMES BASSLER BENNETT BEAN CLARE BECK LINDA BEHAR HOWARD BEN TRE REVITAL BEN-ASHER PERETZ
BLEEM ILSE BOLLE KATE BONANSINGA JONATHAN BONNER IRVIN BOROWSKY CHRISTINA BOTHWELL AGNES BOURNE
KS DR. CHARLOTTE BROWN KATHLEEN BROWNE NEIL BROWNSWORD JOHN BRUNETTI STANISLAV LIBENSKY & JAROSLAVA
FRED CAMPER DANIELLE CARIGNAN DAVID CARLIN WILLIAM CARLSON DR. MARGARET CARNEY CHRIS CARTER WENDELL
CTOR CICANSKY GARTH CLARK DANIEL CLAYMAN JASON CLEVERLY ROBERT COFFLAND CAROL COHEN CAMILLE COOK
CYNTHIA COUSENS KEKE CRIBBS DANIEL CRICHTON BOB CROOKS SUSAN CUMMINS CLARE CURNEEN ANNE CURRIER
SON LAURA DE SANTILLANA EDMUND DE WAAL ELLEN ROTH DEUTSCH RICHARD DE VORE GABI DEWALD ULYSSES DIETZ
DRESANG JOHN DRISCOLL HELEN W. DRUTT ENGLISH DENNIS DUBOIS EMILY DUBOIS ALAN DUBOUIS RUTH DUCKWORTH
PHILIP EGLIN JOHN ELDER DAVID ELLSWORTH DAVID ELLSWORTH RAYMON ELOZUA LISA ENGLANDER KJELL ENGMAN
HY FEIBLEMAN BOB FERGUSON LESLIE FERRIN LINDA FIFIELD BONITA FIKE ARLINE FISCH PAT FLYNN DONALD FORTESCUE
TILLE MARY GILES MARY GILES JOHN GILL ANDREA GILL DOROTHY GILL-BARNES MARTHA GLOWACKI AMY GOGARTY
AN GREENBERG GARY GRIFFIN CANDICE GROOT DEBORAH GROOVER DAVID GROTH SANDY & LOU GROTTA DR. HANS
NSSON TIM HARDING JENNIFER HARRIS TANYA HARROD PEGGIE HARTWELL MARGARET HAWKINS PETER HAYES PAUL
ARION HILDEBRANDT ERIC HILTON BRIAN HIRST KATHRYN HIXSON RON HO CAROLE HOCHMAN STEVE HOHENBOKEN
DSON LISSA HUNTER MARIANNE HUNTER WILLIAM HUNTER SIDNEY HUTTER ANDREA HYLANDS TOSHIO IEZUMI URSULA
S DANIEL JOCZ INDIRA JOHNSON TWIG JOHNSON RICHARD JOLLEY ARTHUR JONES NANCY JONES WETMORE GARY
EIKO KAWASHIMA MARGARET KENNEDY STUART KESTENBAUM RUTH KING ANNA KING JOEY KIRKPATRICK DAN KLEIN
KOHLER JANET KOPLOS LINDA KRAMER GREGORY KUHARIC YIH-WEN KUO STEVE KURSH NANNETTE LAITMAN GYONGY
SARAH TOMERLIN LEE JIM LEEDY JOHN LEIGHTON JACK LENOR LARSEN ANTOINE LEPERLIER DAVID LEVI MARGE LEVY
BRETT LITTMAN JOAN LIVINGSTONE KEVIN LOCKAU THOMAS LOESER MARIA LUGOSSY MARK LYMAN MARTHA LYNN
MANN JANET MANSFIELD IVAN MARES MARTINA MARGETTS DANTE MARIONI RICHARD MARQUIS TATJANA MARSDEN
D MCFADDEN LANI MCGREGOR CAROL MCNICOLL JOHN MCQUEEN REBECCA MEDEL RICHARD MEITNER MYRON MELNICK
MOORE NANCY MOORE BESS LOIS MORAN DARREL MORRIS WILLIAM MORRIS PHILIP MOULTHROP LOUIS MUELLER JOEL
EPHANIE ODEGARD DOUGLAS OHM ANGELA O'KELLY TINA OLDKNOW JUDY ONOFRIO MARGARET O'RORKE TANJA PAK
PARRIOTT TOM PITTI MICHAEL PAVLIK BRUCE PEPICH DANNY PERKINS JOHN PERREAULT CORINNE PETERSEN GEORGE
RTER MELISSA G. POST STEPHEN POWELL PIKE POWERS DOROTHEA PRÜHL ROBIN QUIGLEY SUSAN RAMLJAK WENDY
CHRISTOPHER RIES CHRIS RIFKIN JON ERIC RIIS MEZA RIJSDIJK DAVID ROACH SARA ROBERTSON AVIVA ROBINSON
NY RUFFNER JASON RUSSELL KARI RUSSELL-POOL DAVID SAMPLONIUS AMY SARNER WILLIAMS HIROKO SATO-PIJANOWSKI
CE SCOTT WARREN SEELIG CARRIE REID PAUL REIDE BARBARA SEIDENATH MARY SHAFFER SONDRA SHERMAN MICHAEL
FRANKLIN SILVERSTONE TOMMY SIMPSON PRESTON SINGLETARY ANNA SKIBSKA KIFF SLEMMONS ROSE SLIVKA ELAINE
CHRIS STALEY JAY STANGER PAUL STANKARD SUSAN STEINHAUSER MISSY STEVENS JAIME SUAREZ JUSTIN SUNWARD
AYLOR SUTTON TAYLOR LOUISE TAYLOR SUSAN THAYER BILLIE JEAN THEDE RACHELLE THIEWES SKEFFINGTON THOMAS
MURPHY ROGDON POLLY ULLRICH BERTIL VALLIEN JOHAN VAN SWEGEN PETER VANDENBERGE ANDRES VON ZADORA-
WARHOLIC WILLIAM WARMUS CAROL WARNER JACK WAX KURT WEISER LYNN WHITFORD ARTHUR J. WILLIAMS ROBERTA
L WOODMAN JOHN WOODWARD NANCY WORDEN RON WOLNICK SIGRID WORTMANN WELTGE JAN YAGER JAMES

ectures

Lecture Series

sponsored by SOFA CHICAGO 2003

Friday
October 17

Admission to the 10th Annual SOFA CHICAGO Lecture Series is included with purchase of SOFA ticket.

9:00–10:00 AM
Arbor Mundi
Artist Lori Talcott discusses her jewelry, travel and research. *Presented by Art Jewelry Forum*

9:00–10:00 AM
Fanfare for Fiber I
Illustrated presentations by artists Dorothy Gill Barnes, Reina Mia Brill, Michael Davis, Polly Adams Sutton, and Jiro Yonezawa. *Presented by Friends of Fiber Art International*

9:00–10:00 AM
NCECA Emerging Artists 1996-2000: New Art
An overview of the National Conference on Education for the Ceramic Arts and the impact of its Emerging Artist Program on the field of contemporary ceramics. Michael Conroy, NCECA exhibitions director and Skeffington Thomas, NCECA director-at-large. *Presented by NCECA*

10:00–11:00 AM
Enameling: a current perspective
A discussion of the 2003 Exhibition in Print, on view at SOFA, by curators Gretchen Goss, associate professor and department head of enameling at the Cleveland Institute of Art, and Maria Phillips, adjunct professor at the University of Washington, Seattle. *Presented by SNAG*

10:30 AM – 12:30 PM
Fanfare for Fiber II
Illustrated presentations by artists Joyce Crain, Mary Giles, Jan Hopkins, Nancy Koenigsberg and Anne McKenzie Nickolson. *Presented by Friends of Fiber Art International*

11:00 AM – 12:00 PM
Tom Patti: INSIDE OUT
Tom Patti discusses his work and the links between his glass sculptural objects, viewed from the outside in, and the more recent architectural scale projects, which are viewed from the inside out.

12:00–1:00 PM
The Clay Studio
This internationally recognized ceramic art learning center, soon to be 30 years old, evolved from an artists' collective. Amy Sarner Williams, executive director, The Clay Studio, Philadelphia

12:00–1:00 PM
Surface Design in Textiles: An Evolving Edge
New developments in surface design for textiles—processes, advancements and industrial/digital adaptations. Patricia Malarcher, editor, Surface Design Journal. *Presented by Surface Design Journal*

12:00–1:00 PM
Judy Onofrio Tells All
Self-taught artist Judy Onofrio talks about her artistic interests, ranging from the formal to the naïve to the outrageous.

1:00–2:00 PM
Early Woodturning Masters: The Origins of a Legitimate Art Form
The master woodturners laid the foundations of image and style, created new standards for design and craftsmanship, and inspired many. David Ellsworth, *presented by Collectors of Wood Art*

1:00–2:00 PM
Kate Malone: Ceramic Artist in London and Provence
Kate Malone illustrates her works of art—cups to fountains—their extraordinary glazes and influences, including historicism and worldwide travels.

1:00–2:00 PM
California College of the Arts: Craft's Intersection with Art, Architecture and Design
Why CCAC changed its name to California College of the Arts at a time when craft is ever more important to its curriculum and its artists. Michael S. Roth, president, California College of the Arts

2:00–3:00 PM
Richard DeVore: 67 Years (More Than You Wanted to Know?)
Richard DeVore, best known for his work in the pottery format, presents a chronological selection of works in various media, addressing his motivation in each media.

2:00–3:00 PM
British Fiber Artists in Conversation
British fiber artists Eleri Mills, Linda Green and Michelle Holden discuss their work and current trends in the British Fiber sector. Introduction by Dr. Louise Taylor, director of the British Crafts Council

2:00–3:00 PM
Harlan Butt: Earth Beneath My Feet
Often influenced by flora and fauna, enamellist Harlan Butt takes what he sees, what he thinks and makes it tangible. *Presented by SNAG*

3:00–4:00 PM
Preston Singletary: The Shaman That Went Into the Fire
Preston Singletary discusses his work, the integration of Alaskan Native designs with glass, and his collaborations with other Native artists.

3:00–4:30 PM
Aileen Osborn Webb Awards Presentation
American Craft Council's Aileen Osborn Webb Awards presentation ceremony, followed by a reception with award winners.

4:00–5:00 PM
Glass as a New Expression of Contemporary and Modern Czech Art
Glass is the best-known area of Czech contemporary art, yet the complicated journey from applied art to fine art has almost been forgotten. Oldrich Palata, chief curator, North Bohemian Museum, Liberec, Czech Republic

4:00–5:00 PM
Patrick Hall: Silent Recordings and Strange acts of obsession
The Australian artist speaks about his recent work and how the idiosyncratic is expressed through the one-off object.

5:00–6:00 PM
Tradition in Transition: A Survey of Education at Rhode Island School of Design's Jewelry and Metalsmithing Department
An educational survey of RISD's Jewelry and Metalsmithing Department over the last two decades.

5:00–6:00 PM
My Work: The Visible and the Invisible
An in-depth look by Italian glass Maestro Lino Tagliapietra into the ideas and thoughts behind his blown glass sculpture.

6:00–7:30 PM
Chicago Artists in Conversation
A panel discussion moderated by James Yood, art critic and lecturer at Northwestern University, Chicago

Special Exhibits

Saturday
October 18

9:00–10:30 AM
Hammer, Anvil and Plasma Torch: Contemporary Expression in Iron
An overview of the renaissance of blacksmithing, followed by a survey of current trends in the field. Gary Griffin, head of metalsmithing, Cranbrook Academy of Art, Tom Joyce, blacksmith, Christina Shmigel, associate professor, Webster University, St. Louis, moderated by collector Laura Taft Paulsen, Siasconset, MA. *Presented by Penland School of Craft, NC*

10:30–11:30 AM
How Long Did It Take To Make?
How do aspiring artists acquire the necessary skills to become bamboo masters? Robert T. Coffland, director, TAI Gallery, traces their development.

10:30–11:30 AM
The Parade of Objects: Installation and Ceramics in the 20th Century
The history and contemporary practice of the dramatic use of 20th century ceramics to 'think' about architecture or politics. Artist Edmund de Waal, London

11:30 AM – 12:30 PM
Gestures in Process: objects, cultural exchange and the human experience
An examination of modern craft in the context of the fluid cultural, material and information exchange in today's world. Gillian Davies, professor, Savannah College of Art and Design, GA

11:30 AM – 12:30 PM
Teapots, Teapots and more Teapots! — Building a Special Collection
Gloria and Sonny Kamm share their collecting adventures and experiences during the evolution of their collection into a preeminent and kick-ass collection of artist made, antique and production teapots.

12:30–1:30 PM
Craftsmanship in the 21st Century
An examination of contemporary art, craft and design, creative engagement with materials and techniques, and innovation in the field. David Revere McFadden, chief curator, Museum of Arts & Design, NY

12:30–1:30 PM
Johan van Aswegen: Ornament/Monument
The work of Namibian-born enamellist and jeweler Johan van Aswegen, student of Herman Junger, encapsulates an age-old tradition in jewelry — that of a personal marker or monument.

1:30–2:30 PM
David Reekie: Ten Years Hard Labour
British artist David Reekie examines the social and artistic influences on his work and how it has developed in the last decade.

1:30–3:00 PM
Innovation and Influence: Two Views
Conceptual and technical aspects of work by two Israeli artists: Revital Ben-Asher Peretz, independent artist and curator, and Samuel Barkai, silversmith and designer. *Presented by the Association for Israel's Decorative Arts*

2:30–4:00 PM
The Role of the Gallery in the New Millennium
What is the role of today's gallery — connoisseur, curator, educator, market maker, trendspotter, patron — or all of the above? A discussion with Leslie Ferrin, Ferrin Gallery, MA, Douglas Heller, Heller Gallery, NY, Scott Jacobson, Leo Kaplan Modern, NY and R. Duane Reed, R. Duane Reed Gallery, St. Louis, moderated by Mark Leach, deputy director, Mint Museums, Charlotte, NC. *Presented by the Founders' Circle, Mint Museum of Craft + Design*

3:00–4:00 PM
2 Faced Art
Might art be more than 'making trouble and selling doubt'? Artists Richard Meitner and Michael Rogers offer SOMETHING DIFFERENT, using each other's work to illustrate what is essential in art.

4:00–5:00 PM
Richard Jolley: Transformations
Jolley discusses his use of glass as a nontraditional material for making sculpture, and his exploration of the figure over the last twenty-five years.

4:00–5:00 PM
Suzan Rezac: Journey Around My Bench
My personal development as a goldsmith: a tour of a jeweler's world of travel, history, botany, cultures and the decorative arts. *Presented by SNAG*

5:00–6:00 PM
William Daley: Thoughts on Excellence for Makers
A talk with 'hero' slides. *Presented by the American Craft Council*

5:00–6:00 PM
Keeper of the Flame: A Curator of Craft Looks Back
Kenneth Trapp, curator in charge, the Renwick Gallery, discusses his 37 years in the museum curating world and looks at the value of work and work of value, as embodied in the art of craft. *Art Alliance for Contemporary Glass' annual award to a program or institution than has significantly furthered the studio-glass movement*

Innovation and Influence
Work in a variety of media by ten artists currently living and working in Israel. *Presented by the Association for Israel's Decorative Arts*

American Craft Council's 2003 Aileen Osborn Webb Awards
Work by award recipients William Daley, Ana Lisa Hedstrom, Tom Joyce, Norma Minkowitz, James Tanner and Kurt Weiser. *Presented by ACC*

Exhibition in Print/ SOFA CHICAGO 2003
Metalsmith magazine's 2003 Exhibition in Print — *Enameling: a current perspective. Presented by the Society of North American Goldsmiths*

RISD on the Road: Jewelry & Light Metals
The Rhode Island School of Design presents work by their alumni

NCECA Emerging Artists 1996-2000: New Ceramic Art
Current work by 30 artists designated as 'emerging' by the National Council on Education for the Ceramic Arts between 1996-2000. *Presented by NCECA*

A MAD VISION: The Museum of Arts & Design at Columbus Circle
A model of the museum's new and expanded facility, scheduled to open in 2006, and a foretaste of the new programs and resources. *Presented by MAD, NYC*

The Clay Studio: Thirty Years
Work by current and past resident artists of The Clay Studio in Philadelphia. *Presented by The Clay Studio*

Artists on the Map
A curated exhibit of work by renowned artists affiliated in some way with the City of Chicago, presented in conjunction with Chicago's month-long celebration of the arts.

Making Our Mark: Work from the Savannah College of Art and Design
Works exploring the cultural relevance of objects and materials, created by students, faculty and alumni of SCAD. *Presented by SCAD*

SOFA 2003

Essays

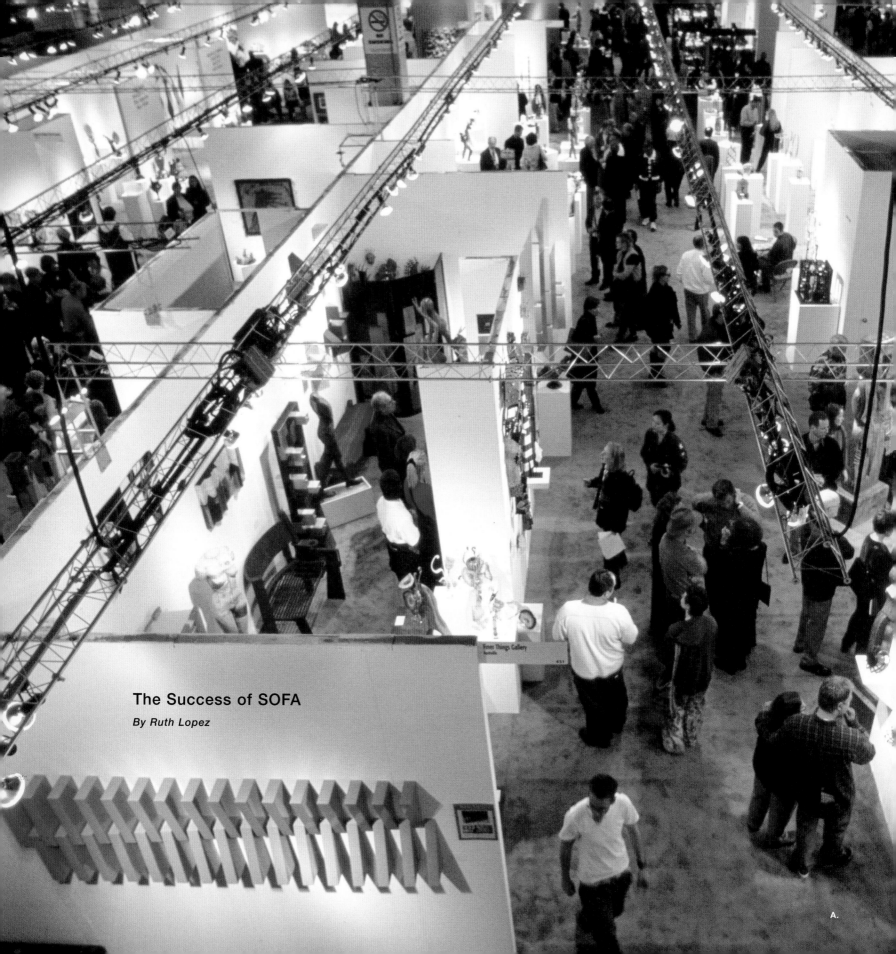

The Success of SOFA

By Ruth Lopez

A.

"SOFA does provide a unique international showplace and there is simply nothing else in the United States where one could go to and see such a panorama of work in one location."

– Paul Smith, director emeritus of the American Craft Museum (now called the Museum of Arts & Design)

In the course of ten years, SOFA has become more than an art exposition, it has become a family reunion.

For the SOFA community of gallery owners, artists, collectors, curators, museum professionals, arts educators and media specific organizations, SOFA CHICAGO, and its sister show, SOFA NEW YORK are meeting places, times of intense social interaction where ideas are incubated and deals are made.

Everyone comes to see new work. One can learn by simply looking, but a varied educational program of lectures and artist presentations has developed over the years. SOFA continually aims to broaden the scope and define the content of the exposition but the direction was clear from the beginning— create a marketplace for sculpture, objects and functional art.

We can look at obvious numbers such as square footage—from 30,000 to 170,000— to know how much SOFA has grown in its first decade. The average size of the galleries continues to expand and the number of galleries participating also grows. There is an increasingly strong international presence. But the story of SOFA, and its effect on the field, comes from the community it serves.

"Perhaps one of the primary reasons SOFA was created was to present work that had been overlooked as not having intellectual content," said Mark Lyman, who founded SOFA with his wife, Anne Meszko. "We wanted to create a venue for artworks that appealed to both the senses and the mind."

SOFA's mission was to present works that bridged the decorative and fine arts. A positive outcome was that in providing a key venue for this crossover work, the number of galleries professionally involved in the field increased.

"A great deal of refinement has taken place over the years," said Paul Smith, director emeritus of the American Craft Museum (now called the Museum of Arts & Design) in New York, who began his curatorial work in 1957. "If you look back to the early days of the field in the 70s, it is amazing what has happened— there were only a handful of collectors, and only a few galleries that showed work."

"Today, SOFA provides a unique international showplace and there is simply nothing else in the United States where one could go to and see such a panorama of work in one location," said Smith.

B.

A.
*SOFA CHICAGO
photo: David R. Barnes*

B.
*Fujinuma Noburo,
represented by Tai
Gallery/Textile Arts,
demonstrates the art of
bamboo basket making
at SOFA CHICAGO 2001
photo: David R. Barnes*

C.
*Synderman-Works
Galleries Installation at
SOFA CHICAGO
photo: David R. Barnes*

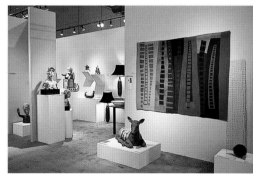

C.

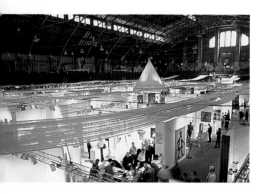

D.
SOFA NEW YORK
photo: David R. Barnes

Scott Jacobson of Leo Kaplan Modern Gallery in New York has also noticed an increase in the market since the emergence of SOFA. "It has played a major part in terms of making the market larger and exposing it to a larger number of people, and it has created larger demand for the work," he said. SOFA has become so important as a networking event. "It has become a focal point for the whole movement," Jacobson said. "It sets the stage for the next six months of our work."

Franklin Silverstone has worked as a curator for Charles Bronfman and is the creator of Collectify, software programs for managing collections. He is presently the curator for the Claridge Collection of Canadian Arts & Crafts. "One of the things about decorative arts, it wasn't as popular as the fine arts—whatever that is—and SOFA has certainly almost single-handedly built a level of interest that the auction rooms haven't been able to do—except perhaps in the fields of Art Nouveau and Art Deco," said Silverstone. "There is very little doubt that SOFA has put the word fine in arts, the word arts that we understand."

SOFA has also introduced a broad public to international arts that transcend cultures as well as traditional aesthetic boundaries. Doug Dawson's gallery in Chicago specializing in tribal art has been participating in SOFA since its inception. "We save lots of artwork for SOFA; when we buy it, we target it for SOFA, things that transcend the boundary between tribal art and contemporary art. When people see the same aesthetic originating in two completely different worlds, finding common denominators, it is affirming, and this contradiction appeals to people."

"As a participant, the show has gotten better and better as a self-editing entity, and I like the way that it has transformed," Dawson said. For him, it bespeaks "an increase in aesthetic sophistication and connoisseurship of people who are friends of SOFA."

Robert T. Coffland, co-owner of Tai Gallery/ Textile Arts in Santa Fe, New Mexico has been exhibiting contemporary Japanese baskets at SOFA for six years. "I think one of the outcomes of our being at SOFA is that we have introduced bamboo to a greater Western audience. It has stimulated the interest of basketry within the Western world and definitely challenges basket makers to further their skills," said Coffland.

At SOFA 2001, Coffland sponsored a bamboo artist from Japan for an artist presentation that was wildly popular. So, this year there will be two young artists—Kawano Shoko and Honma Hideaki. They are emerging artists in a sense. "Just learning the material handling can take three years and building your technical base can take up to a decade," said Coffland.

As the only dealer of Japanese bamboo art in the United States, Coffland has found SOFA to be a wonderful opportunity to meet collectors. "That is the wonderful serendipity of art fairs, you never know who is going to walk into your stand," he said.

Karen Turner, Director of Business Development Department, British Crafts Council, which has provided financial and organizational support to the galleries exhibiting from the United Kingdom in SOFA CHICAGO since 2000, said, "The British galleries have appreciated the opportunity SOFA has provided for them to meet and develop long-term relationships with the influential collectors who attend the show, to introduce British work to these collectors, to establish a profile for their artists, and maintain an international reputation for their gallery exhibition programs."

In recent years, SOFA has added a further dimension—galleries that present mid-century modern as well as contemporary artworks. Bob Aibel, owner of Moderne Gallery in Philadelphia has led the way, specializing in work from the American craft and studio furniture movements. At SOFA NEW YORK 2003, Aibel coordinated a museum-quality presentation of works by the master craftsman Wharton Esherick (1887-1970), which included built-in units originally installed in private homes, furniture, lighting, objects and wood-cuts.

"SOFA is the only show that I felt was at the level that would made me feel comfortable exhibiting important craftwork," he said. "The concept was that the work was clearly art."

The response to the Esherick special exhibit was overwhelming. "And it hasn't stopped. I have continued to get calls from magazines, news-papers and collectors all as a result of having heard about what we did there," said Aibel.

Bruce W. Pepich, executive director and curator of collections at Racine Art Museum said that while many media specific events exists, what SOFA offers is a "forum of diverse but connected interests." It is also an opportunity to create comparisons between artists and media. "I can see an American metalsmith's work and com-pare it with metalsmiths from Europe, or see European vessels in ceramic alongside vessels in glass," said Pepich.

Then there is that ability to find wonderful objects. "We don't collect with an acquisitions fund but with gifts from collectors," said Pepich. "SOFA makes it possible for collectors, artists and dealers to meet—it has been a wonderful forum," he said.

"As a museum director, I am very attuned to the importance of the role of the collector: how they support the creation of new work by buying work of contemporary artists, and in turn create more public understanding by contributing this work to museums, which put them on display," Pepich said.

For the past two years, The Racine Art Museum has operated a booth in SOFA's Resource Center, an informational section of the exposition dedicated to not-for-profit organizations and publications relevant to the field. Pepich said he has seen an attendance bounce at the museum as a result "with people who come a day early to SOFA CHICAGO to visit us in Racine."

"SOFA is really all about building bridges and helping make connections—visual, intellectual—and making connections between institutions and between individuals who have limited time and limited budgets," Pepich said.

Sonny and Gloria Kamm attended first as dealers, now as collectors. Some of the California couples' treasures will be on exhibit at the Chicago Cultural Center. "The Artful Teapot" will run from October 18 through January 4, 2004. "I think for us the thing that has enhanced our collection, particularly teapots, is the ability to be at SOFA several days and, after the initial flurry of running around, spend some quality time with artists and dealers," said Sonny Kamm, General Counsel, Secretary and Senior Vice-President of The Capital Group Companies, Inc.

Kamm said that at least a-half dozen commissions for their collection came out of SOFA expositions in 2002. SOFA is an important event, to be sure, yet Kamm says that as a collector it would be a mistake to just wait for the shows. "But it is the contacts we make at SOFA that set up the year," Kamm said.

For Ulysses Dietz, curator of Decorative Arts at the Newark Museum in New Jersey, SOFA is an opportunity to study contemporary work. "I see things that are totally outside my realm... to see this broad thing we call the craft world and how it ranges and how my collecting goals fit into that," he said. "Like most curators, I don't get out of my office as often as I should. It is an unprecedented opportunity to see a range of work in one place," Dietz said. "It is very valuable for a curator, even if I am only window shopping."

"SOFA plays an incredibly important role in representing the field of, shall we say, sculpture, objects and functional art," said Holly Hotchner, director of the Museum of Arts & Design in New York. The museum is the beneficiary of opening night at SOFA NEW YORK.

"New York is the center of the art world and I think SOFA has had an extremely important role in introducing collectors to art they were not aware of...SOFA has certainly created a lot more interest in the field," she said.

"I do think the field has changed enormously, the boundaries that separate fine art are a lot more blurry," said Hotchner.

Mark Leach, the deputy director of the Mint Museum in Charlotte, North Carolina has been coming to SOFA from the very beginning. "It occurs to me that over the last decade there seems to be heightened awareness on the part of cultural institutions around the country about the power of craft," he said, referring to past shows of ceramics at the Metropolitan Museum of Art and contemporary glass at the Museum of Fine Arts in Boston. "SOFA expositions truly have become international events that help professionals like me look at the evolution of craft heritage from unique vantage points," he said. "A lot of important cultural business gets done there."

Leach adds, "And there are few places other than SOFA where people interested in the field can drink [visually] of the artwork until they've had their fill."

Tina Oldknow, curator of modern glass at the Corning Museum of Glass in Corning, New York came late to the SOFA scene. "But as soon as I saw what was going on, I knew that I would want to go every time it happened. There is no better way to see so much at once," she said.

It's an important time to see friends in the glass community and to see work. "I get to know dealers and see artists they represent and how they present them," she said. "The glass community is already a very strong community and SOFA just helps that along," said Oldknow.

Last year, Oldknow purchased "Black Octopus," a chandelier from Italian dealer Caterina Tognon for the Corning collection. "I would have never seen this piece otherwise," she said.

Bill Warmus, a writer and independent curator from New York State started a curator's group in 2001. The former Corning Museum of Glass curator was inspired by Doug and Dale Anderson, who started a collector's seminar at Pilchuck Glass School in Washington and invited curators to attend. The group is now up to 50 members and meets every Saturday morning at SOFA CHICAGO for a round table discussion. "Anne Meszko and Mark Lyman are always willing to lend support, give us a room with coffee and snacks and make us feel at home," said Warmus. "It has been useful to organize as a group and it is something that couldn't have been done without SOFA."

Camille Cook, the founder of Friends of Fiber Art International, has been attending from the very beginning and considers SOFA a stimulus to collecting. "Because of the informal nature of our organization, the best gift we can give a fiber artist is a fiber collector."

The Friends meet annually at SOFA and have developed programming around the events that include talks and tours to private collections in the area. "I like the fact that topnotch galleries pre-select the art because when collectors come, we know we are going to see the best."

Space and time only allowed for discussions with a fragment of the SOFA family, but there were many echoes—it has gotten bigger, it has gotten better, and to be fair, there were many pleas for more clay. But perhaps SOFA's greatest achievement is in bringing visibility to, as one interviewee put it, the real brilliance of things made by hand.

Ruth Lopez writes about the arts and lives in Chicago.

Published in celebration of the 10th Anniversary of SOFA CHICAGO.

Richard DeVore:
Bodylandscapes

By Janet Koplos

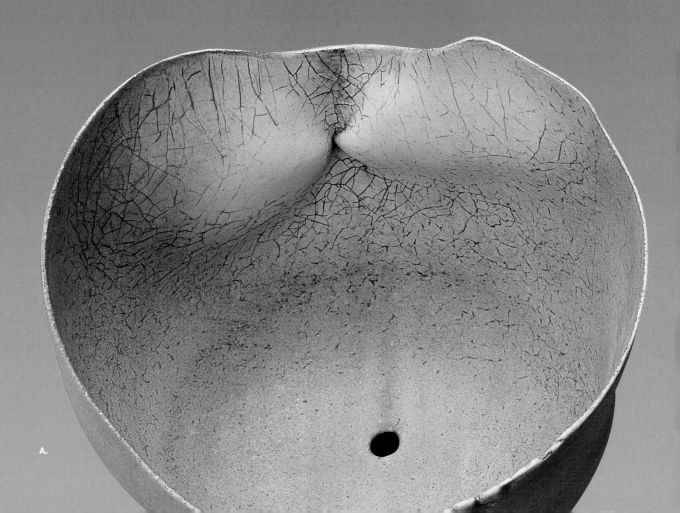

A.

In Colorado State University's art department, where Richard DeVore has taught since 1978, students of a philosophical bent gravitate toward his classes. That may seem a little odd for a ceramics course. Clay, a material rich in history and meaning, has been variously associated with such diverse contexts as traditions, alternative lifestyles, design and popular culture, to name just a few, but rarely with philosophical rumination. This attraction begins to suggest DeVore's distinctiveness as an artist.

His long-term exploration of a chosen form and surface is also striking. Clearly, he doesn't embrace the art-world pursuit of the new, in which some radical change must be trotted out every few years. His mature work, since the early '70s, has engaged vessel form and vessel scale. It could be asserted that he, like a potter, has developed a style and stuck with it, yet he seeks metaphor rather than function. He focuses on two of the age-old references of clay as a material: earth and flesh. Since environmentalism and the body were two of the great themes of late 20th-century art, DeVore now seems to have been astonishingly prescient—as if, when he took up these ideas, he had his finger on the pulse of his time.

To address these themes, he has neither produced jeremiads nor used text or images to tell a story. Instead, he has relied on the allusions that can be carried by highly abstracted forms and surfaces. The human capacity to understand through intuition, through feeling as much as thinking in response to formalist qualities, allows these intimations to be understood. This process is surely the essence of visual art as opposed to language, which is so often employed in art today (sometimes as an enrichment, sometimes as a crutch.) DeVore has staked his career on viewers' ability to extract an unspoken message of sensation from line, plane, contour, color, texture, máss and volume.

Within the boundaries he has set for himself, his work is much more varied than common wisdom has it—and that's true even without considering his first 15 years of works, which would not be recognized by anyone as "a DeVore." He went to graduate school at Cranbrook in 1956 as a painter of abstractions with subtle color relationships. Under the influence of Maija Grotell, a minor in pottery eventually became a concentration on clay. When he began teaching in the early '60s, his work ranged from conventional tight weed pots to partial figures, life-size and very funky, with occasional two-dimensional works leavening the mix (then and now). By 1971, however, he had found the forms and themes that have held his attention to this day.

His signature form is a vessel with an undulating rim, a flat or rounded base, and sometimes with a doubled or trebled interior floor into which one can peer through amoeba-shaped excisions. These features describe an archetype but still leave DeVore with a vast range of choices within the traditional vessel scale of modest, holdable objects. His works can be compared to a crowd of people, recognizable as a species but amazing in their variety. DeVore has made his population of ceramic forms tall and squat, wide and narrow, sloped and straight, ragged and smooth, deep and shallow. They range from tall vases to low bowls and include flaring conical shapes. But all conform to the limits of an austere purity of profile with subtle distortions such as pinched crevices, pushed bulges and slits. His color shows the same richness within restrictions. His preferred hues may be characterized as earth tones, but they have in fact ranged from black to white, encompassing all the warm shades in between.

DeVore's works are perfectly poised between suggesting body and suggesting landscape. They are so persuasive in both those directions that it's impossible to conclude that he means one or the other. Rim or wall or interior may seem to describe topography, particularly wind-eroded stone and parched clay. But just as much,

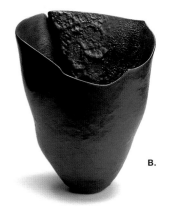

A.
#1056, *2002*
stoneware
12.25 x 13

B.
#959, *2001*
stoneware
16.75 x 13.5

these features evoke the irregular contours of real bodies, with sags and creases and dimples as well as more erotically suggestive clefts, holes and swells, generally more female than male but not exclusively so. His surfaces are usually dry, often crackled, like the Western landscape with its evaporated lakes and scarred hills (remember, he lives in the high desert). But still the body is simultaneously present: calluses and scars and weathered skin have a similar appearance when examined close-up, and coming close fits the intimacy of his forms. Color usually has the same doubleness as the substance: earth tones are by and large also skin tones.

So what is the point of this devotion to land and body? DeVore doesn't specify through titles or statements, and he has the reputation (in New York, at least) of evading public contact when he can—although he can also be strikingly open about himself, even voluble. At any rate, he chooses not to speak for the work. It rests in its dual identity, allowing times and events to suggest implications.

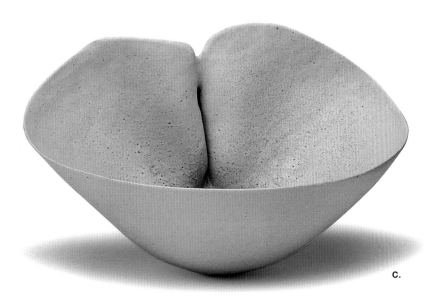

c.

Let's say that the worries of recent years have been drought, development, overgrazing and pollution on the environmental side of his equation, and sexual aggressiveness, disease, racial identity and abuse on the human side. These negative or at least troublesome associations are relevant, for DeVore approaches his work with serious intent and high expectations: he is not making decoration or entertainment. The positive experiences linked with both body and landscape include beauty, comfort, nurturing and pleasure. The positives are just as relevant, because DeVore is not a cynic. He captures both sides of existence in his beautiful forms with their less-than-beautiful associations.

Flesh and earth are our internal and external natural environments and are so crucial to life that mere reference to them makes a statement of basic issues, basic values. By making this choice, DeVore declares his concrete concerns, withholding only the specific interpretations.

His conflation of these essentials makes a point about the inseparability of humanity and the natural world. That belief, which goes against Western civilization's idea that mankind has dominion over nature, is more in tune with the Asian notion of seamless continuity. What we do affects nature, and what nature does affects us. We are not hermetically sealed off.

That's the general picture. In the specifics, DeVore's works are as powerful as his theme. Let's consider a few of them individually.

The low, wide bowl numbered 363 (1982) is of a color somewhere between gray, pink, tan and white. It is slightly darker around its subtly irregular horizontal rim, which has a single tiny notch cut into it. Attention is concentrated on the inside of the bowl, which is open for display and available for study. Toward the center depths, the bowl darkens along lines that could be patterns of rivers if this were a national map. A single opening in the bottom has two squared corners, with the remainder raggedly oval. Below it, a darker mottled surface can be seen. The piece evokes a desiccated landscape in which someone has dug into a vanished water hole to find some residual dampness.

A deeper bowl, 10 by 17 inches, numbered 742 (1994) is so intimately human it is almost embarrassing to look at. The exterior of the bowl is a creamy white, while the inside blushes pink along a deep, buttocks-like contour, slightly freckled and darkening toward the bottom of the bowl, where there is a light streak and a dark "stain" that partly rings a single round hole. One thinks "rectum," although the physical relationships are mixed: if this is a rectum, we are on the inside of the body looking down through its volume to the opening, but the contour of the buttocks would in that case be inside out (we seem to see them from the back side, although they're within the bowl). In other words, this "feels" more than actually looks like that particular part of human anatomy.

A tall vessel numbered 959 (2001) is familiar in contour, a lumpy and irregular conical form. The emphasis here is on the satiny exterior, which darkens to almost black near the top. As usual, one's vision is pulled inside the vessel, where a lava-like crust pouring down one side is both beautiful and horrible in its implications. It might not be lava but rather something destroyed by burning. (The unsettling implication becomes ironic with knowledge that DeVore was one of the unfortunate travelers stranded in New York City by the 9/11 terrorism; the irony is that this work, which was motivated by private experiences, was on view in his gallery show in those painful days, like some kind of premonition.)

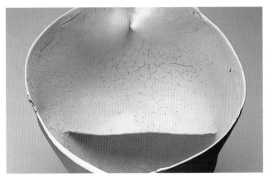

D.

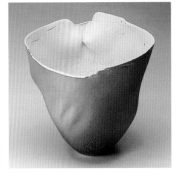

E.

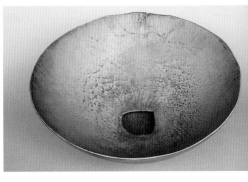

F.

Number 1052 (2002) is a vase form of a modest 13-inch height, its verticality given a boost by its taper to a narrow, rounded foot. The outside is a warm, earthy tan, verging on ocher. The inside, however, is much lighter, a creamy white. It has a small pinch high on the wall that recalls body folds in general but is too abbreviated to suggest anything as specific as breasts, buttocks or rolls of fat flesh. Deeper within the near-luminous interior, a membrane seamlessly integrated into the wall stretches most of the way across the opening, ending in a straight edge that contrasts with the continuing curve of the outside wall. It throws the bottom interior of the pot into a gentle shadow.

The slightly shallower vessel numbered 1056 (also 2002) has a fuller profile—a more rounded hip—and a pinker coloration, especially toward the interior bottom. There one finds a single tiny hole, bellybutton-like, that matches in finesse the single small pinch high on the interior wall. The outside surface seems relatively impersonal, recalling sand dunes. The interior sends two messages: a dark crackle in the pale ground looks almost hairy, almost coarse, while the deep interior conveys a kind of tenderness.

All these works fall within the "typical" character of a DeVore vessel, but they differ formally and in emotional nuance, eliciting a range of feelings from deprivation to near arousal to incipient horror to euphoria. And this is not to mention some of DeVore's greater deviations. Surely one of his most elegant exceptions is *Requiem* (1980), a dark green vessel set in the center of a matching cloth that was created at Philadelphia's Fabric Workshop. The rim is smooth and even, and a white line makes a border less than a quarter of the way down from the top; the square fabric also has a border defined by a white line. Both materials show crackle patterns, which suggest fragility and the potential for change— perhaps birth, perhaps ruin. Yet the figure and ground in this composition are both soothing. A square is stable rather than dynamic, and the regularity of this vessel plus its perfect centering on the cloth make it seem to settle into some state of deeply inward concentration and quiet.

These works reveal DeVore as a master of intensity and control in concatenations of intelligence and sensuality. His vessels employ hand-made reductiveness, like Agnes Martin's paintings; they communicate bodily sensations, like Kiki Smith's sculptures; they define a range of forms and works it obsessively, as Giorgio Morandi did. There's nothing spontaneous about DeVore's works. That contrasts with the instinctive processes that have propelled abstract ceramics by artists as different as Peter Voulkos and Robert Turner. On the other hand, the powerful emotions compressed in these works are quite unlike the plotted, plodding diagrams of artists (too often teachers) who work out of their heads rather than their hearts. DeVore's works are distinguished by their very human blend of passion and self-consciousness.

Janet Koplos, a senior editor at *Art in America* magazine, has been writing about ceramics and other arts since the mid '70s.

Richard DeVore is represented at SOFA CHICAGO 2003 by Bellas Artes/Thea Burger and is a speaker in this year's lecture series.

All images courtesy of Bellas Artes/Thea Burger

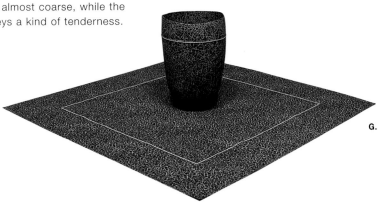

G.

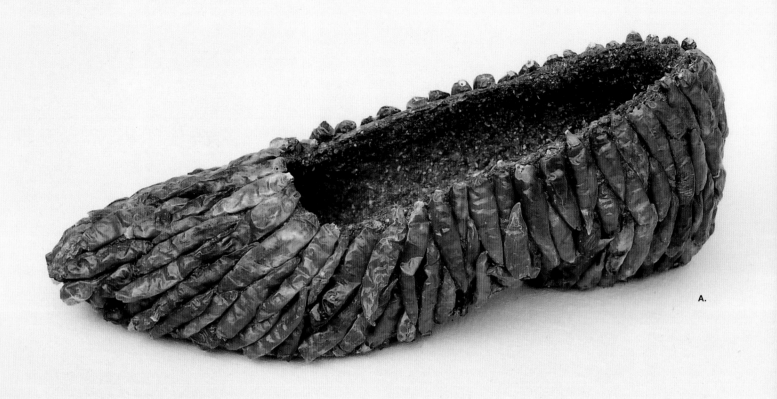

A.

Innovation and Influences
AIDA - Association of Israel's Decorative Arts

By Charles Bronfman, on behalf of the AIDA committee

Fine ideas have many beginnings. Some evolve, some are accidental, some are thought of long and hard, and some are the result of circumstances. AIDA is in the latter category. Its story follows.

Dale and Doug Anderson have been friends of ours for the last decade. They have taught us much about a world we've come to love—the world of studio glass. Through them, we've met many collectors and many artists and have enjoyed ourselves to the full.

At dinner one evening, Andy (my wife) was discussing our impending visit to Israel. It was to be in December 2001, a few months after the intifada had started. For us to journey to Israel under those circumstances was not an issue. We spend three months at our home in Jerusalem each summer. The winter trip is a short one, having to do with a fantastic program in which we're engaged—*birthrightisrael*— a project whose aim is to entice every Jewish young adult between 18 and 26 to visit Israel on an educational journey for ten days as a gift from one generation to another.

A voice, literally from left field said, "We're coming with you". It was Dale. She had never evinced any interest in visiting the Holy Land. "But why" we asked, astonished. "Because with what's happening, it won't be so crowded," she replied.

Reservations were made, a guide was engaged and in December, we four flew to Jerusalem. Andy and I mostly did our thing, while Dale and Doug toured. It wasn't the normal tour! Every time the guide would suggest some biblical site, the question of what ceramics, glass, fiber or jewelry could be found at that locale was asked! Dale and Doug fell in love with the quality and variety of craftsmanship that they discovered in this small country. The variety stems from the fact that there are citizens in Israel from over 100 countries throughout the world. Many artists are from such disparate environments as Ethiopia, Yemen, Morocco, Algeria, Buchara, Russia, Iran, Iraq, Syria, North America, Argentina, Uruguay, South Africa, Australia, and, of course, Europe, both East and West. There are artists who are members of families which have lived in these environs for generations and who bring their perspective to their work.

The two D's found great merit in the diversity of these artists and what they brought to the whole. They envisaged an enterprise that would engage many collectors who they would introduce to this as yet unknown artistic world. A trip was planned but, as the intifada intensified, new thinking about the introductions became necessary.

Andy knew two remarkable Israeli women. Aviva Ben Sira runs the best craft shop in Israel, interestingly enough at the Eretz Israel Museum in Tel Aviv. Andy sought her advice. Then she contacted Rivka Saker, the Director of Sotheby's in Israel. They, plus the two D's and Andy, formed a committee to pursue the idea of how to bring this world-class work to the attention of American collectors, dealers, and museum curators.

Enter SOFA. It has a well-earned reputation for supporting and expanding knowledge of international art. Mark Lyman and Anne Meszko have enthusiastically gone beyond the shores of North America in order to broaden our

A.
Lili Poran
Red Peppers Shoe
2002, red peppers
4 x 10.5 x 2

B. and C.
Dafna Kaffeman
I never imagined
this to be my wolf
(front and back)
2002, flame-worked
glass, clay, silicon
8 x 3.5 x 3

B.

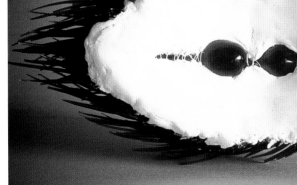

C.

D. E.

F.

appreciation of the talented artists of other nations. Doug arranged for them to meet Andy and me for a drink one evening last fall. We soon found that we were of like minds. Doug and Mark pursued the discussions. A complimentary special exhibit was organized and AIDA was on its way!!

Things were now becoming serious. The project was expanded to include a manager, a friend to all, Jo Mett. Jane Adlin, Assistant Curator, Department of Modern Art at the Metropolitan Museum in New York and Davira Taragin, Curator of Exhibitions at the new and excellent Racine Art Museum were recruited as advisers. Well known Seattle architect, Norman Sandler and his interior designer wife, Elisabeth Beers Sandler agreed to take on all design challenges.

All that remained now was to choose the artists. Word of the venture spread throughout Israel. Artists were quick to send portfolios. While no formal Request-for-Proposal was needed, standards were established from which there would be no deviation.

Early on it was thought that ceramics and glass would be the mainstays of the exhibit. Rivka and Aviva culled through hundreds of submissions and sent fifty to Dale, Jane and Davira. Their conclusion was that there was great strength in ceramics and also world-class abilities in fiber and jewelry. Glass has been slower to take hold, yet several examples captured the attention of these superb judges.

Portfolios were shipped across the Atlantic. Meetings were held and decisions taken. Ten artists have been asked to participate in SOFA CHICAGO. The title of AIDA's exhibition

is *Innovation and Influences.* Obviously, the art of the nations from which the artists or their families originate, plus the influence of the history, ancient and modern, of the Middle East, combine to offer both a unique perspective and a new tradition of art and artifact. The time has arrived when Israeli craftsmanship in these disciplines can compete with the best in the world.

AIDA invites all participants to SOFA CHICAGO 2003 to visit our special exhibit, meet the ten jury-selected artists and consider their work. We hope you will be as excited as we.

Charles R. Bronfman is Chairman of The Andrea and Charles Bronfman Philanthropies, a family of charitable foundations operating in Israel, the USA and Canada. A Canadian citizen, Mr. Bronfman has been awarded his country's highest civilian honors. Together with his wife, he is an avid collector of decorative arts.

Published in conjunction with the special exhibit *Innovation and Influences* presented at SOFA CHICAGO 2003 by the Association for Israel's Decorative Arts.

G.

H. I.

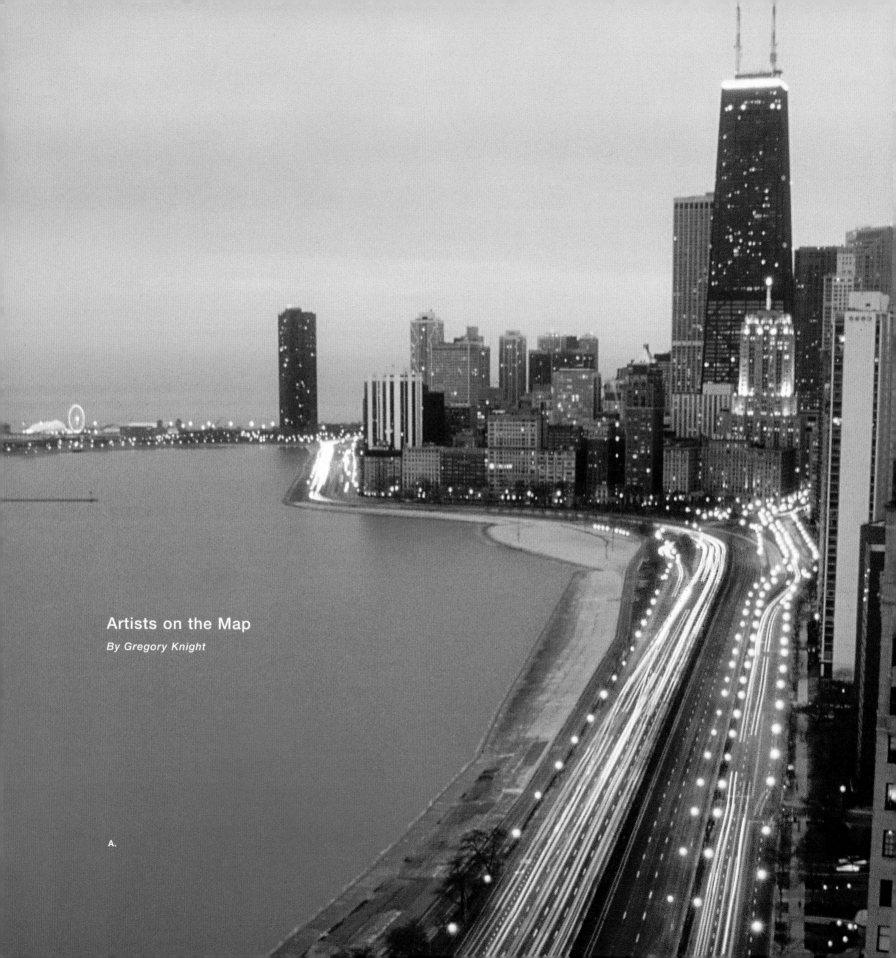

Artists on the Map

By Gregory Knight

A.

B.

C.

What does it mean for an artist to be "on the map"? Is this a status of having "arrived" at a certain level of achievement or recognition, or is it more about being a "player" in the greater art community worldwide, and less about having arrived? Artists chosen for *Artists on the Map* at SOFA CHICAGO each hold a key place in both this city as well as beyond it. Conceived to augment and coincide with Chicago Artists' Month, celebrated annually in October, this project raises the critical issue of place in today's global art world.

This selective exhibition presents fourteen prominent artists who hail from, once lived in, or have made lasting contributions to Chicago —a city having one of the most dynamic art scenes in the United States. There is both history and fashion intertwined here, and art produced in Chicago is arguably on an equal level with that being made in any of dozens of other art centers in Europe, Asia, and Latin America. Boasting great museums, universities and art schools, galleries, and community arts centers, Chicagoans only bemoan the lack of a concomitant quantity and quality of art criticism to better reflect this vibrant scene.

In the increasingly globalized world that we now inhabit, being defined by a predominant stylistic school or a particular geographic locale is generally considered undesirable by artists themselves. Being pigeonholed as a Chicago artist is far less advantageous for many practitioners than being considered a Chicago-based artist—or, ideally, just an artist. Period. In this scenario, the map that we may speak of becomes more conceptual than geographic. As was so evident from labels at this year's Venice Biennale, an increasingly high number of artists now claim at least two places of residence/work, be that Glasgow and Berlin, New York and Tokyo, or Los Angeles and Verona. The international dialogue that now fully connects the continents and the great cultural centers of the world has completely helped to redefine the visual arts as a global phenomenon.

Earlier in the last century, a Chicago–Paris or Chicago–Rome axis existed, but this primarily meant study or short-term residencies abroad, bringing culture back home in the end. It also extended to Mexico, California and the American Southwest, and Maine as alternative and less urban environments in which to work. Today, an artist based in Chicago—perhaps for teaching or personal choice—may not have gallery representation here at all, instead showing regularly in New York, Los Angeles and Europe while still enjoying success at home. In this

regard, I could cite Dan Peterman and Inigo Manglano-Ovalle, among several other current examples, who enjoy international success from this home base.

Artists also choose to move around for numerous reasons. What still is commonplace is movement between Chicago and New York or L.A. Yet, this migration works both ways as Chicago has become home to such rising stars as Kerry James Marshall and Dawoud Bey. Indeed, Chicago does not let go easily of Leon Golub, an artist who left this city in the mid-1950s, because of both historical and stylistic affinities in his work. While Martin Puryear worked and taught at The University of Illinois at Chicago for twelve years, he is still associated with this city long after leaving—through civic pride in his lasting contributions to public art, as well as through his gallery here and the many collections that contain his works. Both older and now quite young artists grapple with their commitment to work in Chicago, while still wishing to place themselves in the larger visual arts context around the world.

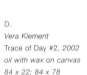

D.

In the case of both older and younger generations, the majority of these artists in *Artists on the Map* have come here from some other place—even from abroad—to ultimately stay and make Chicago central to their practice. Ruth Duckworth and Vera Klement both are immigrants from Europe, each arriving in Chicago after first establishing careers there or elsewhere. Others, such as Ed Paschke, Richard Hunt and James Valerio hail from Chicago and yet have reputations that extend far and wide. The Zhou Brothers, Michiko Itatani and Alejandro Romero, are all examples of success stories from other countries of birth, now based in Chicago, yet equally successful abroad and in their native counties.

This year marks thirty years for many arts organizations and support mechanisms that were born in that fertile era of the early 1970s. 1973 has become one of several benchmarks of expansion and maturation of Chicago's art community and one, I believe, that deserves further research and discussion as a pivotal time to all that followed. So much has developed since then in the way of expanded gallery districts, multiple art schools, and world-class institutions, that we can easily lose sight of the deep roots of our arts community, and curtail our efforts to put all things today in their proper historical perspective. The final show this past August of Artemisia Gallery—just short of its thirtieth anniversary—struck a sad note in the community. It also marked the turning of another page in Chicago's evolution, now that all of the original "alternative" spaces, but for the non-profit collective Artists, Residents of Chicago (ARC), have joined the ranks of history. Several of the artists included in this exhibition, in fact, were instrumental in the early stages of Chicago's alternative culture, c.1973, yet they continue to contribute mightily today.

Of these fourteen well-established artists, only five are Chicago natives. Nine others, like myself, are part of a large number of transplanted players from other regions of the U.S. or from abroad. The vast majority, however, are associated through their own education or current teaching with The School of the Art Institute of Chicago, which has been pivotal to the arts in this city for well over a century. The University of Illinois at Chicago is also strongly represented by faculty now associated with a smaller, yet top-notch art school. Likewise, both the University of Chicago and Northwestern University are well represented by current or retired faculty of great distinction.

What really is impossible to do here, happily, is to divide this rich selection of Chicago-based painters and sculptors into figurative and abstract camps, as several of these artists have moved back and forth between these seemingly opposed styles over the course of their long careers. That said, there is a strong polarity between the absolute realism of James Valerio, and the abstraction that dominates Ruth Duckworth's overall career, with innumerable variations represented between the two, especially artists focusing our attention on the human figure in vivid forms of wacky variation and identity. Photography and its great historical tradition at the Illinois Institute of Technology stands aside from this group and could easily be a topic for another exhibition or essay in its own right.

E.

Although pride of place backs up such efforts as this exhibition and artists' promotion by the Chicago Department of Cultural Affairs, SOFA, and the Union League Club of Chicago, there are many justifiable reasons to celebrate the strength of the visual arts in our city. This is done constantly through mid-career and retrospective exhibitions of Chicago-based artists in our local institutions, and by the inclusion of our more celebrated artists at international biennials—such is the case with Helen Mirra and Kerry James Marshall, whose works are presently on view in Venice. Indeed, in 1973, Don Baum—artist, curator and educator for over five decades—laid solid groundwork for Chicago's current generation of curators working internationally by his introduction of the Chicago Imagists at the XII Bienal de São Paulo, in Brazil. Now, somewhat routinely, Chicago-based visual artists pop up in many important foreign galleries and biennials, not to mention their regular exposure in the U.S. from coast to coast. So, *Artists on the Map* does seem to be an apt theme and cause for celebration at this year's 10th anniversary of SOFA CHICAGO, which brings the world of art and collectors together in Chicago.

The co-curators, Thea Burger and Kim Coventry, and I wish to thank these artists for their enthusiastic participation: Phyllis Bramson, Ruth Duckworth, Julia Fish, Richard Hunt, Michiko Itatani, Vera Klement, Ellen Lanyon, Robert Lostutter, Martyl, Ed Paschke, Richard Rezac, Alejandro Romero, James Valerio, and Ray Yoshida.

Gregory G. Knight is the Director of Visual Arts Chicago Department of Cultural Affairs

Published in conjunction with the special exhibit *Artists on the Map* presented at SOFA CHICAGO 2003 by the City of Chicago Department of Cultural Affairs.

F.

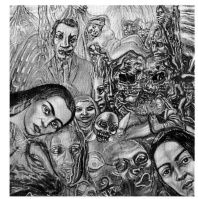

G. H.

I. J.

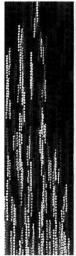

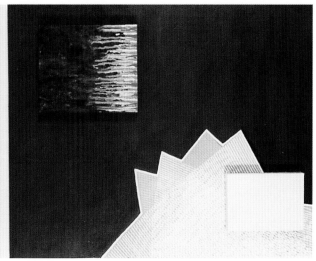

K.

William Daley: Staying in Motion

By Edward Lebow

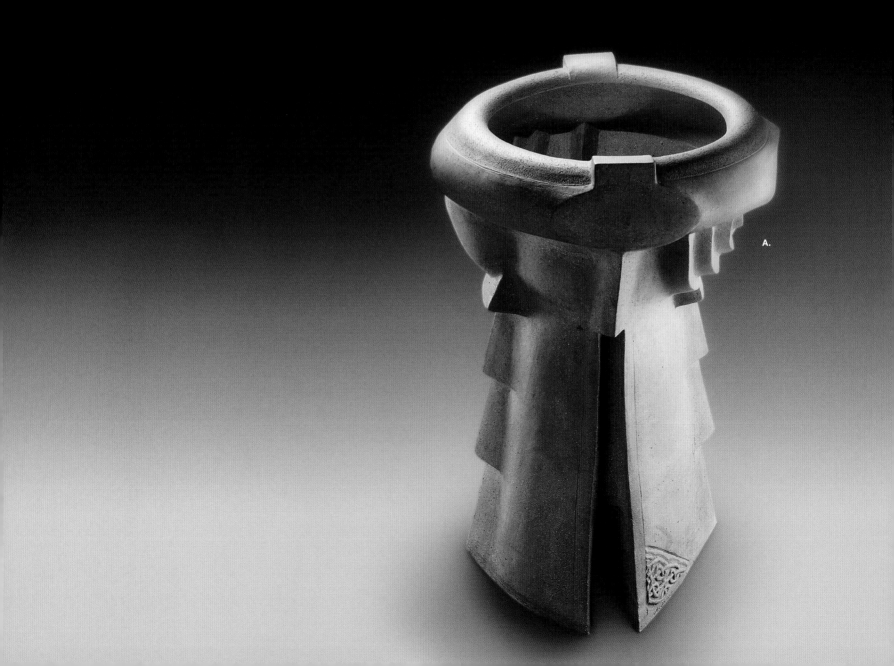

A.

A.
Haystack Vesica, 2003
cone 8 stoneware, 34h
photo: James Quaile

B.
Petras's Passing Place, 2001
cone 7 stoneware
20 x 23
photo: James Quaile

C.
Study for Petras's
Passing Place, 2001
ink on paper
14 x 17

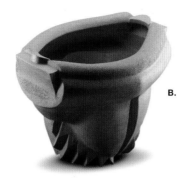
B.

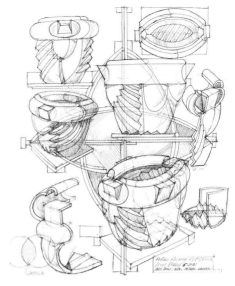
C.

The escape artist in William Daley is always leaving himself a way out. His exit is rarely big or flashy. It's usually nothing more than a detail in his elaborate ceramic forms—perhaps a squared-off end to the donut rim of a broad bowl, or a D-shaped protuberance that reads as softness at the center of a hardened intersection. Such breaches in visual logic are just enough to trip the eye and slow the mind to wonder whether there might be some other way to see, feel and think about the pot at hand. His invitation to take a second opinion is one of the great hesitation moves in modern ceramics. Subtle and easy to miss, it nevertheless reveals the probity of an artist who, for more than 50 years, has drawn comfort from making himself and his forms just slightly less than perfectly clear.

"There's nothing wrong with clarity," he says, "but over time it can be pretty boring." Afflicted by a spiritual and an intellectual greed to feel and know more, Daley has avoided tedium by staying in motion, filling himself with the search for new twists on the forms and ideas that obsess him. The result has been a wide path of achievement as both an artist and a teacher.

Daley would be the first to tell you that he hasn't traveled alone. Family, teachers, friends and colleagues have continually nudged him along, feeding his mind and generous heart. The sculptor William Parry, the painter Jules Olitski and the plaster master Petras Vaskys are just a few of them. And then there is the world of objects and art. Daley's eyes dance when he talks about the intoxicating forms of Gaudí and Brancusi, the aesthetic ideals of sacred architecture, Fibonacci, the golden mean and, yes, even hubcaps. "I'm transfixed by hubcaps," he confides. "They're fantastic exercises in form."

One could easily mistake such a list for an eclectic mix. But that suggests a miscellaneous slant. And there is nothing haphazard about what draws Daley to people, ideas and objects. He gravitates toward the authentic—toward images and objects whose originality gives them an indispensable authority. His heroes among forms range from European cathedrals to Silla dynasty pottery stands from Korea. In addition to chimney pots by Gaudí and abstracted torsos by Brancusi, he swoons over the classical facades that the ancient builders of Petra, in Jordan, carved directly into stone. Peter Voulkos had the touch, too. "I'm in a totally other universe from him," Daley says of

Voulkos's pots, "but they have a necessity and an authenticity that's irrefutable—a signature that's absolute. I put great stock in that. That's what every artist's quest is to do."

Daley's own quest began with his family. He was born in 1925 in Hastings-on-Hudson, a short distance upriver from New York City. His father was a house painter who loved to recite poetry and improve the world with his hands. His mother stayed at home and raised Bill and his brother and sister. He began drawing when he was young, inspired by his father, who had taken a course in lettering and would practice the numbers and letters from the family's address on the white enamel surface of the kitchen table every night after the children were in bed. It was ephemeral work. Daley's mother would wipe away the penciled skeins of calligraphy every morning before breakfast.

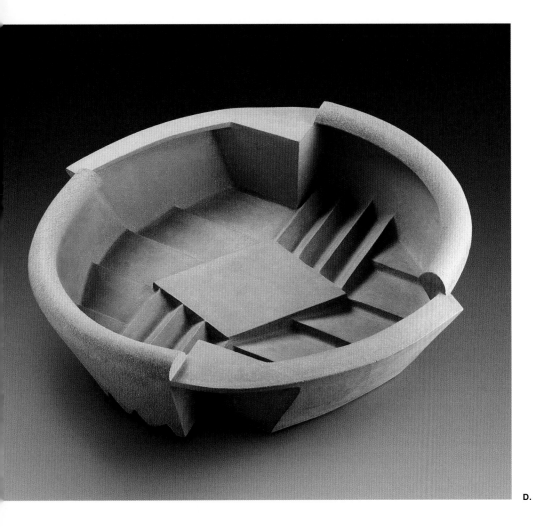

E.

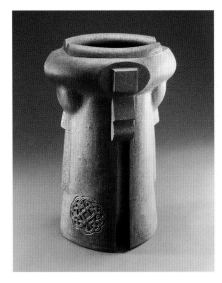

D.

F.

His father taught him, Daley once wrote, "how to get ready, how to stay in the work, how to use tools and the hands in my head." His father also conveyed how to find meaning in work. The secret of his father's success, he wrote, was that "he was always working to please himself." It was rich training for an artist and craftsman. But possibly poor preparation for scholastic obedience. The budding artist fled the tedium of schoolwork, Matthew Drutt points out in his smart 1993 catalog essay about Daley's work and career, by drawing a parallel universe of pictures, filling his tests and tablets not with the needed answers, but with daydreams of calligraphic letters and

aerial battles.[1] Even when the real war snared him in 1943, he didn't stop drawing. Forced to bail out on his first aerial mission as a turret gunner in a bomber, he spent the final 10 months of World War II as a prisoner of war. In the German prison camp, he bartered drawings for cigarettes. The images, he says, weren't much more than cartoons. Yet they were small measures of the constant desire to escape: "Guys would ask me to draw pictures of things they thought about or longed for."

D.
Mandarin Inn, *1990*
cone 6 stoneware
9 x 36
photo: James Quaile

E.
Ovaled Oval, *2001*
cone 6 stoneware
14 x 22.5
photo: James Quaile

F.
Celtic Vesica, *2002*
cone 7 stoneware, 32h
photo: James Quaile

Daley set out to be a painter after the war, but swerved into ceramics thanks to the influence of Charles Abbott, his teacher at the Massachusetts College of Art. He learned the basics of wheel-thrown forms, but the utilitarian ethic didn't stick. For one thing, he wasn't particularly good at making useful pots, he says. For another, he had no interest in following utilitarian canons. He preferred to make his own rules—ones that would facilitate his quest for distinct forms.

From the outset, his visual god was geometry. Like so many other potters of the day, he was drawn to the organic sensual geometry of human, animal and plant life—female torsos, birds, seedpods, among other things. He melded these with the abstract simplicity of Scandinavian design and Chinese ritual bronzes. Drutt points out that the bronzes, in their union of symbolic, ritual and religious meaning, got under Daley's skin to a degree that other objects hadn't.[2] Daley mimicked their patinated surfaces by eliminating the hand-worked textures of his pots, and coating them with a rich green glaze. Like all of the other influences he has absorbed in his career, the bronzes confirmed his evolving biases toward his own work. They legitimized interest in forms whose linked physical and visual efficiency enabled them to do the most with the least.

That has been the singular ambition of Daley's work, to concentrate all of his desires, intellect and responses into the walled efficiency of a pot. It is reflected in his aesthetic canons. The common link between his *Reptilian Chiclet* of the late 1960s, his *Shang Form* of the 1970s, and the more recent *Vesica* pots is that they begin with the assumption, he says, "that the form will contain something." One could say the same of architecture. However, pottery's smaller size allows it to be "totally comprehensible," says Daley. "You can be both outside and inside." That isn't to say the experience of the two is the same. Over the years, Daley has zeroed in on the discrepancy between inside and outside, using the natural disparity as an aesthetic spark gap to draw a decisive emotional charge.

Most of his generation of potters used this inside/outside dichotomy to play up the expressive volumes of forms, breathing life into their implicit—and hidden—spaces. Daley instead chose to make everything about a pot visible. Exploring the membraned nature of his vessels, he has sought to make sense of the way in which their clay walls translate inside dents into outside bumps, or troughs into ridges. This transaction between physical causes and visual effects is fairly easy to grasp. But its subtle shift from fact to feeling is not. That's the great mystery of his vessels. It's just vexing enough to keep Daley in the hunt for new turns of visual phrases and forms. "I'm always trying to stretch my skull," he says. "I don't know that I'll ever understand that. But it's just so damned satisfying that it's become a kind of habit."

[1] Matthew Drutt, "Inside/Outside," in *William Daley: Ceramic Works and Drawings*, Levy Gallery for the Arts in Philadelphia, Moore College of Art and Design, 1993, 5.

[2] Ibid., 6-7.

Beginning in 1970, the American Craft Council has formally honored those whose artistry and leadership have enriched and advanced the craft field in the United States. Now named for the Council's founder in acknowledgment of her vision and generosity, the Aileen Osborn Webb Awards represent the highest levels of artistry, leadership and service. The Council's 2003 Awards will be presented October 17 at SOFA CHICAGO.

William Daley, whose deep involvement with ceramics is the subject of this essay, will receive the Council's highest honor, the Gold Medal, signifying consummate craftsmanship. In recognition of their accomplished artistic careers, Ana Lisa Hedstrom, Tom Joyce, Norma Minkowitz, James Tanner and Kurt Weiser will be named American Craft Council Fellows, joining 229 other artists who have previously received this honor. Albert LeCoff, executive director of The Wood Turning Center, will be named an Honorary Fellow. Awards of Distinction will be given to The University of the Arts, Philadelphia, and Rhode Island School of Design, Providence, for their contributions to the craft field.

Edward Lebow has written frequently on ceramics and other media, and is a staff writer with the *Daily Press*, Newport News, Virginia.

Published in conjunction with the special exhibit *American Craft Council Aileen Osborn Webb Awards* presented at SOFA CHICAGO 2003 by the American Craft Council.

Facing Reality: An Outline
of Contemporary Danish Crafts

By Louise Mazanti

A.

C.

D.

C.
Steffen Dam
Night (detail), 2003
glass, 22d
photo: Ole Akhøj
represented by
Galleri Grønlund

A.
Torben Hardenberg
Plate for Raw Seal's Liver
(detail)
silver 925, spoon
3.25 x 6 x 5
photo: Torsten Graae
represented by Galerie Tactus

D.
Gitte Bjørn
Disquieting Pocket
Charms (detail), 2002
silver, 2d
photo: Jesper Hyllemose
represented by
Galerie Metal

B.
Martin Bodilsen Kaldahl
Continuation I and II, 2002
stoneware, 12 x 17.5
photo: Søren Nielsen
represented by Galleri Nørby

Acting as a global catalyst, SOFA has created a unique opportunity to look at what is happening on the international scene. Galleries from all over the world are represented and the concepts of "sculptural objects" and "functional art" therefore encompass a wide range of cultural expressions, different perceptions of art, and a varied choice of materials.

SOFA CHICAGO offers a chance to view contemporary Danish crafts from a global perspective. It is precisely through the interaction with other forms of expression that a Danish uniqueness becomes apparent, with characteristics so ingrained in our approach that we barely notice them.

Since the 1950s, the concepts of Danish or Scandinavian design have become familiar to most people, a particularly Nordic look recognized all over the world. It offers a unique kind of functionalism, characterized by refined simplicity, respect for the material, good craftsmanship and, above all, an almost dogmatic insistence on the usability of objects.

What about today?

Contemporary Danish design now looks much more varied at first sight. Rather than confirming the sense of national identity, the strands of functionalism, post-modernism and the avant-garde now exist side by side. The chains of tradition have been severed, giving way to a more international pluralism.

As an example, consider the glass artist Steffen Dam's deep blue dish *Night*, with holes drilled like stars producing light and shadow effects that discreetly reinterpret a classical concept of beauty. Another example is Gitte Bjørn's *Disquieting Pocket Charms*, where the concept of time is relative and becomes the personal secret of the owner.

B.

No matter what the aesthetic ideal—the beautiful versus the disquieting, humor versus seriousness, form versus concept—there is one characteristic that permeates all Danish design and which differentiates it from international trends: a sense of moderation—the human scale. It reflects the democratic instincts of Danish designers who rarely venture into creating art for art's sake. They don't usually allow themselves to be seduced into creating sensuous ornaments or objects without any function!

This is evident in ceramist Martin Bodilsen Kaldahl's vessels *Continuation I + II*, which are restrained, with a simple sense of form. Even the striped ornamentation of the horizontal bands keeps all superfluous elements at bay. This almost minimalist clarity appears to assign these vessels to the pure sphere of the fine arts, remote from physicality, everyday life and functionality. But then you discover an opening via the attached tubes, which breaks the symmetry, arouses your curiosity and impels you to move around the vessels in order to maintain your perception of the object. In this way, the viewer is drawn into the physical space of the piece.

At the same time, these are exactly the qualities that characterize Danish crafts. By retaining the form of the "vessel", the "dish" and the "pocket watch" as in the previous examples, there is a connection to the universal; to the familiar and usable objects that Danish designers never completely relinquish.

Even Michael Geertsen's ceramic *Wall Object*—a piece without functional use, as the title suggests—conforms to the formal universe of kitchenware: the cut forms are based on the cup, the plate, and the bowl. Even in this decorative interplay of the free forms of pop art and humor, there is a reference to the sphere of everyday life, which is so characteristic of Danish crafts.

The Geertsen piece also revels in an industrial aesthetic. With its perfectly smooth surfaces, bright colors and clean forms, the object is no longer imbued with the characteristics of the handmade, but rather suggests the design of a mass-produced object.

This reference to the concept of design is essential to the understanding of Danish crafts. Going back to the early industrialization of the 1800s, there is a traditionally close relationship between industrial production and artistic creativity. The seed of the continuous reference to functionality and familiarity that still characterizes Danish crafts today is to be found in this particular historical background.

You might say that Danish crafts still haven't dealt with their industrial origins and broken free to become an independent art form, one of the fine arts. But that close relationship is precisely why Danish crafts are so distinctive and occupy such a central position in contemporary culture. When crafts become an art form that maintains a continuous dialogue with the realities of everyday life and still retain a human scale, then it creates a whole new field of possibilities.

Through the clarity of abstraction, modern art was given a utopian vision of a better world. The fine arts then became an autonomous pocket of true values. In contemporary pictorial art, this art concept has almost been replaced by a more political, socially committed idealism.

E.

E.
Michael Geertsen
Wall Object, *2003*
earthenware
12.5 x 7
photo: Søren Nielsen
represented by
Galleri Nørby

F.
Kirsten Nissen
Inside the Envelope, *1999*
ramie, hand-woven safety
patterns in color and weave
63 x 83
photo: Ole Akhøj
represented by
Gallery deCraftig

G.
Sten Bülow Bredsted
Nomad Sculpture, *2003*
silver, plastic, 71 x 16
photo: Jesper Hyllemose
represented by Galerie Metal

H.
Torben Hardenberg
Plate for Raw Seal's Liver
silver 925, spoon
3.25 x 6 x 5
photo: Torsten Graae
represented by Galerie Tactus

I.
Ane Lykke
Zen, *1999*
Japanese paper, ramie
47.5 x 79
represented by
Gallery deCraftig

F.

G.

To insist on a modernist concept of crafts as an autonomous art form is therefore to actually diminish the possibilities inherent in practice. By maintaining a connection to the reality of everyday life, if only through symbolic references, Danish crafts transcend the merely decorative. Danish crafts suggest structures and actions that may be almost invisible due to their familiarity, but which are imbued with significance through the artistic treatment.

Just think of Gitte Bjørn's watches; hidden away in your pocket, but when touched, reminding you of the relativistic concept of time. Think of the woven rug *Inside the Envelope* by textile designer Kirsten Nissen, which on closer inspection turns out to be an accurate description of the present age: the safety envelope that represents the last remnant of our concept of privacy in a world where all kinds of information are freely available.

Jewelry designer Sten Bülow Bredsted's *Nomad Sculpture* is poised exactly in this position between art and reality. A brand new function is suddenly apparent; a kind of stick or scepter for today's nomad, where the interplay between the object and the owner is central. The work's functionality keeps it firmly anchored in reality, but at a conceptual level, Sten Bülow Bredsted has created a cultural icon about human rootlessness and the loss of social belonging.

Goldsmith Torben Hardenberg's *Dish for Seal's Liver* in silver and quartz is another work loaded with double layers of meaning, although his starting point is quite different. Overwhelmed by the simple beauty of the work, at first glance it is hard to see how these precious materials in any way allude to a deeper layer of significance. In Greenland, raw seal liver is a delicacy eaten immediately after the seal has been caught and it is easy to imagine the blood red color spreading in the icy translucency of the rock crystal.

But by creating such a dignified and respectful image of Inuit culture, Torben Hardenberg counters the post-colonial prejudice prevalent in Denmark that the Inuit are socially and culturally inferior.

The dish is then both an aesthetically pleasing object, which joins simple materials with excellent craftsmanship, and an attack on social convention, which proves yet again that Danish crafts have 'scores to settle' with the world.

A similar feel for the sensuous qualities of the material is explicit in textile designer Ane Lykke's *Zen*, a rug made of paper yarn. Through the material, you experience the sounds and feelings generated when walking across the rug. A meditative space is created involving both the intellect and the senses.

It is precisely this mix of functionality, aesthetics and sensuous qualities that is characteristic of the way in which Danish crafts interact with the real world, no matter what the starting point.

In contemporary culture, this middle position between the pure sphere of the fine arts and the functional reality of crafts is proving very interesting because it takes on a form of practice that not only rests on classic aesthetic qualities, but is as committed to real life as are the newer art forms. By combining the avant-garde with the aesthetic, Danish crafts occupy a position that is extremely relevant to contemporary culture.

Louise Mazanti, MA in Art History
Studying for a PhD at Danmarks Designskole

Published in conjunction with Danish Crafts, the Danish Trade Council, and participating Danish galleries: Galerie Metal, Galerie Tactus, Galleri Grønlund, Galleri Nørby and Gallery deCraftig.

H.

I.

California College of the Arts

Craft's Intersection with Art, Architecture, and Design

By Michael S. Roth

A.

In the summer of 2003, California College of Arts and Crafts, better known in recent years as CCAC, announced that it had changed its name to California College of the Arts. It was, in some ways, a change long expected, as the misperceptions about a college of "arts and crafts" had been an issue for many years. The confusion had grown even more pronounced with the recent addition of the college's San Francisco campus, the home of its design, architecture, and graduate programs. In other respects the change was a surprise; never had there been a stronger lineup of faculty in the craft disciplines, and never had the role of craft been stronger in the curriculum.

As a historian with deep respect and affection for the Arts and Crafts movement, I cherished the interrelationships between disciplines at CCAC—textile art and fashion design, glass and architecture, painting and ceramics. I have also been committed to the Arts and Crafts movement's belief that art thrives when it maintains a vital connection to society, and that society is impoverished without a vital connection to the arts. However, as president of the college, I also realized that the college was less effective than it should be in communicating its seriousness of purpose and the breadth of its programs. This was partly due to always having to explain what "arts and crafts" did not mean at CCAC. We needed to dispel the summer camp connotations of working with Popsicle sticks and lanyard. After considerable reflection and consultation, I recommended to the board of trustees that we adopt the name California College of the Arts, and they unanimously embraced this new appellation.

But, after nearly a century with the arts and crafts moniker, was dropping "crafts" from our name the right decision?

First, a little history. The college was founded in 1907 by Arts and Crafts movement partisan Frederick Meyer. Originating in Europe in the nineteenth century, the movement was a reaction to the industrial revolution and advocated an integrated approach to art, design, and craft. A cabinetmaker in his native Germany, Meyer immigrated to San Francisco at the turn of the twentieth century. There, he established a cabinet shop and taught at the Mark Hopkins Institute of Art. The 1906 earthquake and fire destroyed both his shop and the institute. At a meeting of the Arts and Crafts Society shortly after the disaster, Meyer expressed his dream of a school that would integrate both theory and practice in the arts. A year later he founded the School of the California Guild of Arts and Crafts across the bay in Berkeley with $45 in cash, forty-three students, three classrooms, and three teachers. In 1908 the school moved and was renamed the California School of Arts and Crafts.

The school quickly outgrew its early homes. In 1922 Meyer bought the four-acre James Treadwell estate in Oakland. Students, faculty, alumni, and the Meyer family all pitched in to transform the dilapidated buildings and grounds into a college campus. In 1936 the school was renamed California College of Arts and Crafts, with Meyer as its first president, a position he held until his retirement in 1944. Post–World War II population growth and the educational support of the GI Bill led to dramatically increased enrollment, prompting the addition of several academic programs and the expansion of campus facilities. The reputation of the college spread far and wide as graduates from the 1940s, '50s, and '60s, such as Nathan Oliveira, Viola Frey, David Ireland, Raymond Saunders, Louis Siegriest, and Peter Voulkos, gained prominence in the art world.

B.

A.
Clifford Rainey
Gaia, 2000
glass, 20 x 9 x 7
photo: courtesy of the artist

B.
Marilyn da Silva
Recipes for Blackbird Pie
2001, sterling silver, brass,
wood, gesso, colored pencil,
paint, 17 x 10 x 9
photo: courtesy of the artist
and Mobilia Gallery

D.

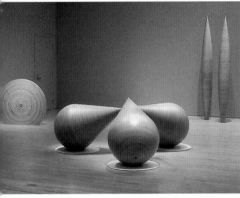

C.

C.
Donald Fortescue
Pip, Plumb, Pike
Installation at SFMOMA
laminated Finnish plywood
various sizes
photo: courtesy of the artist

D.
Lia Cook
Traces: Big Beach Baby
2001, cotton/jacquard
160 x 56
photo: courtesy of the artist

The 1980s ushered in a new period of growth. The college established an architecture program in 1985. In 1989 the Oliver Art Center opened on the Oakland campus, housing a professional gallery that has exhibited everything from woven baskets by Julia Parker to a bull's head and dead butterflies in works by Damien Hirst. Ten years later the college completed a new permanent San Francisco campus to house the growing architecture and design programs, individual graduate studios, and a first-class exhibition space, the Logan Galleries. New graduate programs in design, visual criticism, and writing were established in the last three years, and today the campus is a beehive of creative activity.

One of the most important legacies of the Arts and Crafts movement at California College of the Arts has been our dedication to playing a role in the wider civic culture. In recent years the college's Wattis Institute for Contemporary Arts has mounted one of the most exciting contemporary arts exhibition programs in the country, initially under the leadership of Larry Rinder, and for the last three years with Ralph Rugoff at the helm. The Logan Galleries in San Francisco and the Oliver Art Center in Oakland have been destinations for those seeking a fresh perspective on current artistic practice. In the last three years, we have also developed the Center for Art and Public Life, which has worked closely with partners around the Bay Area to develop service learning in the arts, and to use art practice to make a positive difference in the lives of diverse populations of our region. Our commitment to the Wattis and the Center reflects the best of the Arts and Crafts movement in a contemporary American context.

Of course, the people who have been associated with the institution over the last ninety-six years constitute our most enduring legacy. CCA faculty and graduates have influenced, and in many cases led, almost every mid- and late-twentieth-century art movement. The prominent Bay Area

figurative and expressionist work of Manuel Neri and Nathan Oliveira has inspired generations of artists and collectors. The photorealist movement of the 1970s is represented by current faculty member Jack Mendenhall and alumni Robert Bechtle and Richard McLean. Alumni have also been prominent in conceptual art (Dennis Oppenheim), minimalist sculpture (John McCracken), painting (Raymond Saunders, Squeak Carnwath), and film (Wayne Wang). As leaders of the California design movement, faculty members and alumni Michael Vanderbyl and Lucille Tenazas have had a major impact on contemporary American graphic arts.

California College of the Arts has been an especially fertile ground for artists working in the craft media. In the 1960s, alumni Robert Arneson, Peter Voulkos, and Viola Frey helped instigate the ceramics revolution, firmly establishing the medium as art. The path they forged has been explored with humor and bravado by Arthur Gonzalez, current chair of the Ceramics Program. For many years, Marilyn da Silva, metals artist and chair of the Jewelry/Metal Arts Program, has astonished viewers with her ability to combine delicacy and strength in her work while revealing extraordinary refinement and playfulness (B). Clifford Rainey, chair of the Glass Program, has used figurative sculpture to make powerful political art that is both grounded in specificity and capable of speaking to problems of violence that have become all too familiar universally (A). The Wood/Furniture Program has been led in recent years by Donald Fortescue, an Australian artist whose abstract forms teeter on the brink of fragility and solidity (C). Lia Cook, chair of our Textiles Program, has a boundless capacity to make her textile work respond to the world around her. Lia has taught at California College of the Arts for more than twenty-five years, and she continues to inspire students to weave their most contemporary concerns—be they with technology, history, or childhood trauma—into their artwork (D). All these artists have found innovative ways of mining craft traditions to create work that is richly conceptual yet grounded in the specificity of their materials.

This brief list of artists illustrates the centrality of contemporary craft at California College of the Arts. However, no list of all-star craft artists will convey how the media of ceramics, wood, textiles, and metal inspire creative work across the many disciplines at the school. Industrial designers learn about working with materials of all sorts when they solve problems in the glass studio. Architects have their concepts of space reconfigured when they confront the patterning of textiles as boundaries, mirrors, and screens. Designers working with metals and illustrators critiquing figurative representation in ceramics—all are drawing on the deep well of the crafts, even as they feel surprise and delight at how contemporary craft can transform their work.

Then why did our board of trustees decide to drop the last "C" in CCAC? California College of the Arts has not dropped the "C" word; it has integrated that word and what it represents into a broad and inclusive concept of the arts. One of my first insights into the importance of doing this happened after the opening of SOFA CHICAGO in 2000. Having only recently started as president of the college, I was getting to know a group of prominent collectors and patrons of SOFA. In the course of a late-night dinner after the opening evening's festivities, I asked the distinguished group (which included CCA trustees Ronald Wornick and George Saxe) whether we should consider changing the name of the school. Much to my surprise, the answer was a resounding yes. We collect *art*, they added. This was the beginning of the process that resulted in our name change.

Craftsmanship and an understanding of cultural context have always been key to the education offered at California College of the Arts. These are values we have embraced in the past and will continue to embody. In today's world, craft *is* art; the artificial boundaries between art, design, and craft that were so important to the nineteenth-century academies no longer exist. Our commitment to the unity of the arts, our curriculum's reinforcement of craftsmanship, and our continued support of community-based arts programming are substantial evidence that the college will continue to embrace the ideals of the Arts and Crafts movement. In the past one hundred years, the understanding of the words "arts and crafts" has clearly changed. Moreover, contemporary craft is now firmly part of the most progressive work in art, design, and architecture. And the visual, performing, and literary arts are now intersecting in the most productive and powerful ways. By placing our students and faculty at the heart of these intersections, we will continue to provide them with the very best of what an education in the arts, and an education *through* the arts, can offer.

Michael S. Roth is president of California College of the Arts (CCA), and a speaker in this year's lecture series. An intellectual historian and curator, he is the author or editor of several books in cultural history and visual studies.

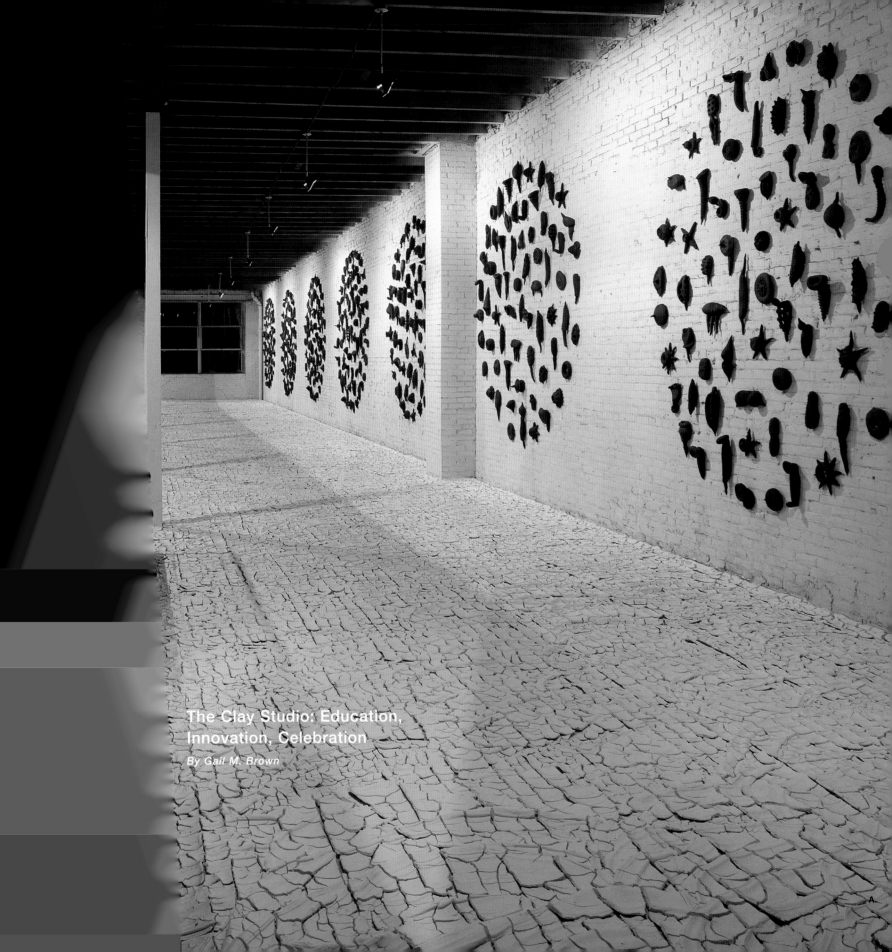

The Clay Studio: Education,
Innovation, Celebration

By Gail M. Brown

A

At 139 North Second Street in Philadelphia, a wall-to-wall picture window reveals a spacious gallery with a singular, enticing focus: clay. This is The Clay Studio, (TCS), a nearly thirty year old bastion of visual and tactile celebration of the ceramic arts. A busy street in Old City, the affectionately referential name of an eclectic neighborhood of historic sights, restaurant suppliers, galleries and theatres abutting the Delaware River, is home to the internationally known ceramic arts center.

For some, a first visit is a focused destination to the place they know from print and reputation. For others, it is a chance connection, just around the corner from the oldest residential street in the city still boasting cobblestones and tiny, colonial era houses. The audience for clay includes both the knowledgeable and a growing community of beginners who all quickly sense the welcome: the creative spirit and vibrant energy here echoes the inherent nature of the material itself.

Is the innate comfort due to a nonverbal memory of our own hands in this primal material, while simultaneously seeing it celebrated by the accomplished works in the Galleries? Clay "remembers." It catches and keeps the unique imprint of each individual touch. It inspires and implements a remarkable breadth of human expression. Its nature and connection to the earth afford seemingly limitless possibilities. Clay also encompasses immediate material contradictions: being both soft and hard, appearing both fragile and strong, appropriate for exquisite miniaturization and surprisingly monumental scale, intrinsically rooted to the past, yet possible always to become something new, wearing a perfect, accomplished skin or reflecting the emotional and physical finger marks of each maker. Its variables allow and honor the panoply of human expression.

We can become part of the community of makers and appreciators almost intuitively. Clay beckons the maker. It invites experience, it binds the hand and the heart in a spiritual connection embracing history and inspiring innovation, rooted in the functional and the expressive. This medium and its realizations beckon the viewer, too; the objects, be they utilitarian or sculptural, seduce insistently and invite a shared encounter.

TCS was founded in1974 when local artists—Ken Vavrek, Jill Bonovitz, Janice Merendino, Betty Parisano and Kathie Regan—sought a collective studio space, first at a former spool factory on Orianna Street. Five resident artists quickly grew to fourteen through a jury selection. Classes were given to cover the rent, equipment and maintenance. As interest in working in clay drew others, the need for more space became a marker of its success and emergence as a community. In 1980, shortly after TCS moved to a larger space on Arch Street, an electrical fire destroyed the building. Undaunted, tenacious and clearly a dedicated group, TCS reopened six months later in modest quarters at 49 North Second Street.

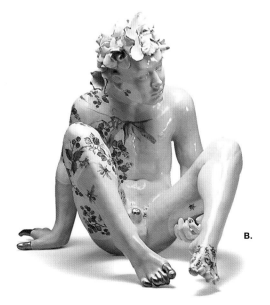

B.

A.
Sadashi Inuzuka
River, 1999

B.
Christyl Boger, Evelyn
Shapiro Foundation Fellow
2000-01
Untitled, 2001
ceramic with decals
and luster
30 x 26 x 26

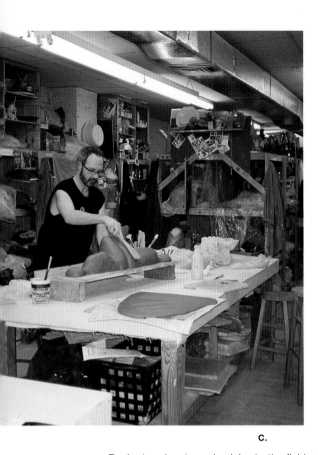

C.

D.

E.

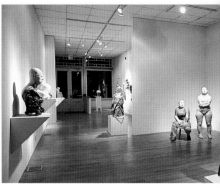

F.

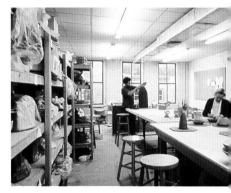

G.

Desire to educate and celebrate the field outside the studio walls grew. Interest in sharing work and ideas through shows inspired the *American Clay Artists Exhibitions* in 1983, 1986 and 1989, mounted in multiple venues in the city; participation was by invitation to nationally known artists, by juried acceptance to Delaware Valley makers, and to celebrate TCS Residents. A Lecture and Workshop Series was instituted in 1986, inviting nationally known ceramic artists for information and dialogue. Simultaneously, Philadelphia was becoming a haven for artists working in craft materials. Degree granting programs in craft disciplines at the city's art schools brought artist/teachers and students to the area. The emergence of galleries celebrating craft were exhibiting local and nationally based makers, and pivotal annual exhibitions, symposia and craft shows were conceived to entice and educate a growing audience for all forms of craft art. Philadelphia's reputation as a center for contemporary craft and clay, in particular, was thriving.

Jimmy Clark, a ceramic maker who had studied in Germany, became Director in 1986, bringing a wealth of personal contacts and broad knowledge of European artists working in clay. His strong interest in extending the outreach of the Studio focused particularly on international exchanges of people, ideas and objects. This widened access and opportunities for more artists and a growing, responsive audience. In 1990, TCS inaugurated a multistoried facility as the Second Street Art Building (at #139), renting spaces to other collectives. Studio, workshop, exhibition space and vision expanded. The intensity and sincerity of the mission and its implementation continued to attract and inspire a broadening community.

In 1992, with the Philadelphia Ceramic Consortium and generous support from the Pew Charitable Trusts, TCS hosted NCECA, the National Council on Education for the Ceramic Arts' annual conference. Thirty venues in the city and environs mounted shows celebrating the art of clay. The focal point was *Contemporary East European Ceramics*, a survey exhibition at TCS curated by Clark, introducing the diverse creativity of

that politically closeted world. It was comprehensive and eclectic, by invitation to artists whose differing techniques and aesthetic viewpoints could provoke and enlighten American audiences. It subsequently traveled to other venues, heightening interest in the power of clay as a vehicle of layered information.

Community support for TCS programs further blossomed. A generous grant program was transformed into a *Residency Fellowship* funded by the Evelyn Shapiro Foundation in 1991. The Foundation awards a designated studio space, monthly stipend, materials and a solo exhibition to an exceptional, emerging artist who demonstrates unique potential. Those thus far honored have continued to make cutting edge work and many have garnered national recognition. Some of those individuals choose to remain at the Studio in the *Resident Artist Program* after their Fellowship year.

H.

I.

C.
Associate Artist Studio, 2002

D.
*Brad Johnson, resident artist
1998-2003
Collected View, 2002
porcelain*

E.
*Linda Cordell
Squirrel, 2001
porcelain, plastic
13 x 8 x 17*

F.
*Installation View,
Contemporary East European
Ceramics, 1992*

G.
*Community Classroom, The
Clay Studio, 2003*

H.
*Heeseung Lee, resident artist
1997-2002
Teapot, 2002
earthenware
7 x 5 x 8*

I.
*Jin Won Chung, Visiting Artist
Program 2002 (Korea)
Trace, 2003
porcelain
4 x 3 x 6*

The *Resident Artist Program*, begun by the founders, is an ongoing community of twelve, many from out of state, whose goals are professional development in the ceramic arts. They have individual studios on the fourth floor and may work for up to five years within this nurturing community—a slice of time and place which can fill an interim need, after or between formal education, before setting up a more permanent studio. TCS's reputation as a world class arts center has made this program extremely competitive. The Residents are a diverse group of younger makers who explore their personal vocabularies, interact and reciprocate by teaching at TCS School or in its *Claymobile Programs*. They exhibit in solo and group shows in and out of the Studio. They have, individually, received prestigious grants, university teaching opportunities and major gallery representation. These placements are juried from a national body of applicants who often choose to make Philadelphia a permanent home thereafter, further enhancing the vibrant, local ceramic population.

The *Associate Artist Program* is a collective studio on the third floor providing twenty five spaces to local artists, many of whom are serious Clay Studio students and others who are professionals in need of workspace. They, too, are individually and collectively committed to supporting TCS's efforts and programs. During the annual November Auction weekend and at other requested times, the third and fourth floors are open for view to acquaint the public with these highly energized environments.

Jimmy Clark, who served for sixteen years as Executive Director, worked effectively to expand visibility and outreach for TSC. The *International Guest Artist In Residence Program* has brought national and international artists from thirty countries to-date for one to two month stays, a time to create a special body of work. This affords TCS artists, students and audience the chance to witness the guests' artistic processes, while offering the visitors an opportunity to work with Americans in a communal setting. Integrating visitors into the Studio's educational programs by slide lectures and demonstrations, is mutually enriching. Clay is truly an international language! Each summer, an exhibition, *Made at The Clay Studio*, shares work of the guest artists of the past year. Each visitor leaves one piece for the permanent collection, an exceptional visual record of this program.

The Gallery Program, offering two major shows each month, has over the years exhibited outstanding work at all levels of experience and intentions. There are juried solo opportunities introducing emerging artists, specific thematic shows, installations of aesthetic, social and political focus, sculptural works and functional objects, showing traditions referenced, innovations explored, unexpected mixed media with clay, and mastery by the already well known and the upcoming generation. Some have introduced international artists; some have traveled. All serve to teach about the nature of clay and its seemingly limitless possibilities. TCS Shop focuses on functional objects of fine design that beckon hands and invite use, celebrating our ongoing connection to pre-industrial, utilitarian work.

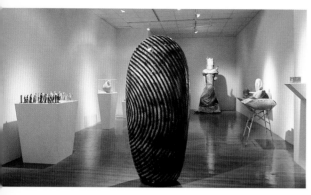

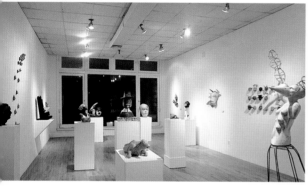

K.

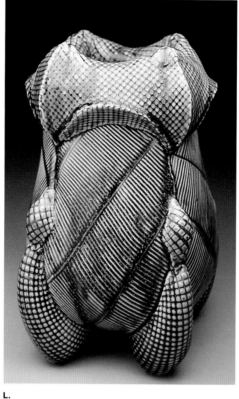

J.

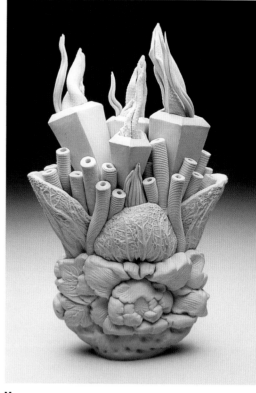

L. **M.**

In June 1999, visiting artist, Sadashi Inuzuka, created *River*, a monumental installation in a suitable, adjacent space. The artist's interest in the fragility of the natural environment inspired this site-specific work referencing the Delaware River in its post-industrial state. Sadashi created individual, altered biomorphic forms, mounted as patterned wall tableaux, accompanied by a deeply crazed, clay riverbed of dramatic proportion which filled the elongated room. This unique, timely document, conceived when the area was experiencing a drought and made possible by very generous support from a local foundation, garnered major visual arts interest beyond the ceramic community.

TCS School offers classes at all levels, with concentrations in particular, technical and aesthetic issues and workshops taught by Residents and visiting artists. It has educated and inspired hundreds of those who put their hands in "the mud" and appreciate thereafter its pleasures, potential and challenges. It nurtures skills and serves best to create an informed, instinctive audience who understand from experience how arduous it can be to make the final work look effortless.

The Lecture Series and individual symposia have thrived, energized by replenished lists of provocative speakers, which include an art historian or curator each year, and the presence of new audiences. The Series brings individual perspective and personal interaction with accompanying workshop opportunities that further engage the sense of a clay brother/sisterhood.

N.

O.

P.

Another major outreach focuses on the youngest population. Many educational programs were begun to collaborate and share clay experience with diverse communities; it became clear quickly that transportation issues were a solvable roadblock to reach the most culturally needy. *The Claymobile*, a mobile ceramic education program for underserved populations, established in 1994, expanded the ability to provide arts education and "hands on" clay, off-site, to children and adults by traveling to host locations at inner city cultural centers, after school programs, homeless shelters, programs for the aged and recreation department camps and schools. The van brings a teacher and all of the equipment and materials necessary for a class and is outfitted to transport the work back to the Studio for firing.

Kathryn Narrow, TCS Managing Director, a Resident Artist herself in 1978, who oversees all aspects of the building and the School's educational programs, had originated the *Claymobile* idea and continues to choreograph its calendar. She understands the potential of the ceramic arts experience as an inspirational, healing tool. The annual exhibition of the *Claymobile* participants brings us full circle: the works resonate with the unselfconscious energy and creativity we bring as children to the creative process —joyous, non-judgmental, intuitive exploration of our hearts along with the materials. This Exhibition draws on our personal memory banks of the seductive pleasures of working with a tactile material and following a process to an anticipated, yet always new, resolve.

Each program joins individuals with the larger clay community of artists and audience. Amy Sarner Williams, a resident artist in 1975, became TCS Executive Director in 2002; she envisions, as The Clay Studio nears its 30th anniversary, its continued commitment to expanding education and support for the ceramic arts though passionate leadership in the field. Jeff Guido, named Artistic Director in 2002, visualizes expanding opportunities to nurture and direct young artists and to build an appreciative audience of their peers. TCS is dedicated to promoting and developing the ceramic arts and elevating the stature and visibility for clay within the broader visual arts community. TCS is a reflection of the ceramic art it was created to serve. Clay promises a vital, individual experience for each participant. It offers a direct bond, sharing the voice within the work. We can revel in the individual connection and the collective community of which we become a part. The possibilities are still endless.

Gail M. Brown is an Independent Curator of Contemporary Craft. She has curated a number of ceramic exhibitions, including *Political Clay* at the Clay Studio in July 2000.

Published in conjunction with the special exhibit *The Clay Studio: Thirty Years* presented at SOFA CHICAGO 2003 by The Clay Studio.

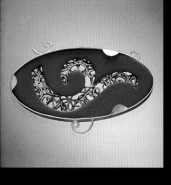

A. B. C. D.

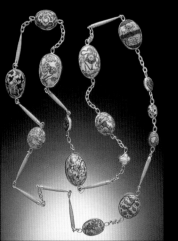
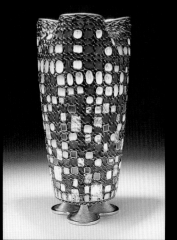

Enamel: A Current
Perspective

By Gretchen Goss and Marie Phillips

Enameling, like other mediums in the vast world of art, has seen ebbs and tides of production, enthusiasm, and admiration. We proposed this technique as the focus of the 2003 *Exhibition in Print* on the premise that enamel has experienced renewed interest and growth since the mid-1990s. When considering current cultural conditions affecting art, economy, and technology, it is surprising, even to us devotees, that a strong interest in enameling persists. Enamel has survived, and at times thrived, since it's ancient beginnings, despite the meager support it has received through the formal avenues of education, museums, and the marketplace. Enamelists' devotion to their craft has no doubt contributed to the endurance of the medium through history.

This *Exhibition in Print* examines an array of current works in enamel, assembled from a broad call for entries and through our personal knowledge of work seen in exhibitions, publications, educational venues, and the craft and art marketplace. We have selected works in which enamel is an integral element that reinterprets or exceeds traditional enameling approaches. We have discovered a number of new artists with similar concerns, who are generating challenging and stimulating work.

After the mid-twentieth-century surge of interest in enameling, three departments devoted to the medium emerged in higher education: Kent State University (KSU), San Diego State University (SDSU) and The Cleveland Institute of Art (CIA). State and government cuts to education in the mid-1980s struck a great blow to the field, with significant reductions to the programs at KSU and SDSU; the already small number of artists able to focus on enamel within a broader formal art education was reduced to the bare minimum. CIA remains the only department with an entire curriculum, facility, and faculty devoted to the study of enameling. There are, however, many notable artists teaching enameling in jewelry and metals programs in the U.S. and abroad, many of whom are included in this exhibition. Unfortunately, the depth and breadth of investigation into enamel is limited in comparison to the ever-increasing techniques of the jewelry and metals disciplines.

This void in higher education affects the ability of the field to grow within the broader scope of the art world. It also accounts for the high percentage of practitioners who have excellent technical skills, but make work that seems to exist outside of any visible concern for art theory and practice in the last half century. At the same time, we found a strong base of activity in enamel, with definite influences and trends paralleling contemporary art and craft issues. We also witnessed highly skilled enamelists who hold true to traditional process and values, while continuing to make new and pertinent pieces.

Through this search we found specific trends, centers of activity, and various techniques in use. Jewelry comprised close to half of the work submitted for consideration and more than half of our selections. All other formats, including wall pieces, sculpture, and vessels, composed the other half of the entries, with the majority in wall-based pieces. CIA, KSU, and SDSU continue to have an influence, considering the number of enamelists from those regions or holding degrees from the programs. Seattle and the Northwest region, and the New York/New Jersey region, also support a great amount of activity. Out of several hundred artists, we only received 38 international submissions. Unfortunately, we did not reach many of the international artists who practice throughout Europe and Asia; notably absent were Japanese enamelists. Of the international work reviewed, that from England, Germany and Israel appears to be the most consistent and advanced.

Insofar as techniques being practiced, cloisonné still reigns in the traditional category, and is found predominantly in the jewelry format. We were, however, disappointed to find that many of the forms, images, and patterns we viewed were rather antiquated. Despite these observations, leaders in the field are producing work that is arguably outstanding in its traditional mastery and technical feats. While Marilyn Druin's work remains loyal to its lineage, her pieces transcend any time frame due to an exceptional comprehension of the medium. Her combination of cloisonné and basse-taille produces an intrinsic depth through intricately layered and embellished surfaces. Harlan Butt demonstrates virtuosity over his materials by fusing metalsmithing and enameling techniques into a coherent language. Through the vessel form, Butt captures and contains moments of our daily existence. Valeri Timofeev suspends enamel and consistently astounds the viewer through his command of the plique-a-jour process.

A.
Jan Baum
Red Floral, *2001*
sterling silver, enamel,
steel, 3 x 1.5 x .25
photo: Norman Watkins

B.
Hye-young Suh
ng*3 (necklace), *2002*
enamel on electroformed
copper, sterling silver
2 x 6.5 x 6.5
photo: Hye-young Suh

C.
Michal Bar-on
Black Wreath #4, *2002*
silver, gold leaf, enamel
3.5d
photo: Leonid Padrul

D.
Helen Elliot
Marked Moments 2, *2002*
porcelain enamel on steel
6 x 6 x .75
photo: Greg Staley

E.
Jamie Bennett
Florilegium Necklace, *2002*
enamel, 18k gold, copper
41 long
photo: Dean Powell

F.
Valeri Timofeev
Vase, *2000*
plique-a-jour enamel,
gilded silver, 8 x 4 x 4
photo: Bob Barrett

G.

With its origins in fifteenth-century Limoges, France, and having quickly spread throughout Europe, the process of painted enamel continues to intrigue artists whose work traverses different historical, cultural, and technical strategies. JoAnn Tanzer, an important and influential artist in the San Diego area and the first American to be included in The Limoges Museum of Art, pushes the medium through large, abstract, painterly pieces, which incorporate contemporary applications of industrial enamel products and sgraffito on steel panels. Enlisting similar materials and techniques, Helen Elliot's fluid color fields defy opacity, producing layers that are simultaneously absorbent and reflective, reminiscent of Mark Rothko's and Joan Mitchell's paintings. In contrast, Keith Lewis's images are more closely related to historical miniature portraits executed in the Limoges technique. In the style of ancient frescoes, the enameled images reside as gemstones in elaborate filigree and pearl-encrusted settings. Blatantly seductive, the pieces draw the viewer in to be confronted and humored by their sexual references.

In eighteenth-century England, the industrial application of "transfer printing" was developed as a means of commercializing and expediting traditional enameling procedures. This process has evolved to the current technology of ceramic decals. Elizabeth Turrell has revived the decal process through research at the University of the West of England at Bristol. She curated the exhibition "Print on Enamel," and has conducted numerous workshops that introduce ceramists, printmakers, metalsmiths, and enamelists to the exploration of decals. Embracing this process, Kathleen Browne appropriates historical portraiture while introducing humorous, if not ill-starred, images from the 1950s. By elevating this commercial-industrial output to the status of a "jewel," Browne is in effect commenting and challenging current constructs of value and preciousness. For printmakers Kate Ward Terry and Margaret Kimura, the technology to produce the decals is closely aligned to their own processes, and has allowed them to explore imagemaking, color, and surface texture in an entirely new medium. The work of Morgan Brig, Browne, and Turrell reveal the minimal influence of digital technology on the medium.

Imagery from nature has been an enduring of art, serving as a source of inspiration and engagement. The unique beauty belonging to the natural world enchanted Fabergé, Lalique, Bates, Winter, Drerup, and Miller. Creating work that was either representational or abstract, each artist managed to explore nature's innumerable characteristics. This appreciation and interpretation continues to be visible in the work of many of our selected artists. Employing the process of champleve, Michal Bar-on's grave wreaths expose the contradiction of beauty and pain associated with death; beneath a fabricated arrangement of flowers resides a cluster of thorn-like forms destined to mar and imprint the ground below. Proving to be both compelling and moving, Bar-on's wreaths serve as a platform to address current social and cultural concerns. Linda Darty draws inspiration from foliage in her immediate surroundings, as well as her intuitive response to the natural occurances yielded in the firing process. Marjorie Simon's botanicals convert realistic forms into unique interpretations through the processes of origami and kirigami. Repetition, a dominant characteristic of nature, proves to be an engaging stratagem for many practitioners. Jacqueline Ryan reinterprets natural configurations through the repetition of geometric shapes. Generating seductive surfaces and forms, her jewelry solicits interaction from both the wearer and viewer. Indirectly referencing nature, Sarah Turner's blossom composition introduces a unique presentation of the wearable object. Exploiting form, pattern, and repetition, Turner probes the essence of identity within a mass. As the individual pieces are removed from the whole, do they obtain a level of individuality or does the collective structure begin to disintegrate?

Trained as a painter, Jamie Bennett has returned to more direct painterly applications of enamel, evident in his neckpiece, *Florilegium*. Rather than striving for the botanically correct, Bennett is "more interested in the liberty I have to concoct and unravel whatever I work from, for the sake of maximizing a willfully emblematic object." While Bennett strives to make nature resonate through the transcendent capability of ornament, David Freda mimics inhabitants of the natural realm, occasionally

H.
Sarah Turner
All for One... (brooches
and buckles), 2002
copper, enamel, sterling
silver, steel buckles
3 x 2 x 1; 75d overall
photo: Courtney Frisse

G.
Ester Knoble
My Grandmother Is Knitting Too
Series (knitted brooches), 2000
copper, enamel
2d each
photo: Uri Gershuni

I.
Jessica Calderwood
The Good Girls Are Home
with Their Mommas, 2002
enamel, copper
7 x 6 x 4
photo: Jeffrey A. Scovil

J.
Kathleen Browne
Kiss, 2002
enamel, fine silver, sterling silver
9.5 x 7.25 x 5
photo: Kathleen Browne

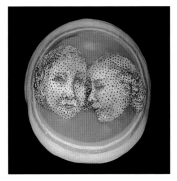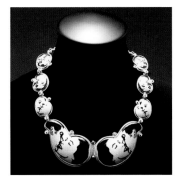

H. I. J.

altering their inherent physical traits, producing jewelry pieces that are at once beautiful and disturbing. His technical accomplishment of *en ronde* bosse on cast surfaces is commendable.

Many artists addressed the inherent fragility of enamel. Within a collection of delicate objects, Bettina Dittlmann references both the wearable and the natural. Encrusted with a sugar coating of enamel, the objects are enticing, yet seem precarious as wearables. Dittlmann's interest resides in breaking and pushing the laws of the enamel, even if it proves to be a futile pursuit. Meanwhile, her densely enameled wire and garnet brooches appear sound and impervious to the process endured for their completion. By recreating paper-thin floral elements, Lydia Gerbig-Fast achieves a sensual and temporal semblance of the ancient Mediterranean artfacts she references. Hye-young Suh simulates the forms and colors of sea life and allows the enamel to separate and crack, exposing copper and achieving a physical layer of depth and time in her surfaces. In contrast to this pursuit of fragility, John Iversen relies on the physical strength of the glass as the sole structure of his pieces. His bold and saturated works invite and disclose the adroit accomplishment of its maker, achieving a backless and solid plane of enamel that is simultaneously astonishing and deceptive.

"Simply sifting" might be the process of the age, the new millennium. There is a recognized trend towards enamel as pure color, not unlike patina. Due to the overwhelming presence of this simple and direct application, we have included several artists who employ enamel in a manner that advances it beyond the traditional and functional items of the past. The resulting work is extremely diverse and provocative. Sarah Krisher's brooches overlap pierced planes in congruous color fields; upon closer inspection her alternating surface textures complement and fascinate. Jan Baum elicits a sense of place and time by lightly dusting and under-firing her enameled brooches. Echoing one another, decorative exterior forms function as containers, protecting the delicate steel filigree that inhabits the interior. Through varied surface applications, Ester Knobel's work communicates a sense of pathos. Sparse and over-fired enamel bears witness to the state of decline in her neckpiece *Garland*, while the densely layered enamel appears burdensome in her series of knitted brooches. Devices such as these that subvert, embrace, and exaggerate enamel's inherent qualities allow the field to move beyond the traditional interpretations and assumptions about the medium

Surprisingly few artists applied enamels to three-dimensional forms, most likely a result of the skill required. Jessica Calderwood's forms feign anatomical structures, whose integrated imagery alludes to visceral and emotive inquiry. June Schwarcz's vessels are an endless source of inspiration, consistently inventive and contemporary. Johan Van Aswegen's cast cocktail ring of skulls humorously exaggerates the notion of the gemstone, whereas his tube-twig forms are somber and graceful. Veleta

Vancza assumes a much larger pursuit and exploration of enameling as an art form through the format of installation. A collection of amorphous forms saturated with brilliant colors, it investigates an interesting combination of relief, color interaction, and the spatial relationship of installation.

After viewing thousands of pieces by several hundred artists, we have confirmed our initial premise: there is a renewed and rejuvenated interest in enamel. We are enthusiastic about our selections and observations of the different approaches being pursued. As enamelists, we sought to uncover artists who challenge and expose new and alternative applications of the medium. Furthermore, there is evidence of a real knowledge of current art and craft concerns. It is obvious that the field of enamel resides in two intersecting arenas: that of decoration and function and that of fine art. There is strength in both directions and an auspicious future for this ancient enduring medium.

Gretchen Goss and Maria Philips, co-curators, *2003 Exhibition in Print: Enameling a current perspective*

Gretchen Goss is associate professor and department head of enameling at the Cleveland Institute of Art, where she has taught enameling for fourteen years. Her work has been exhibited nationally and internationally, and she has taught workshops throughout the country and in the U.K.

Maria Phillips is a visiting faculty member at the University of Washington, Seattle, and has conducted workshops at several other universities. She is the recipient of a Warhol Foundation Visiting Artist Grant at the Penland School of Crafts, and was an Artist in Residence at the John Michael Kohler Arts Center.

This essay was first published in *Metalsmith* magazine's *Exhibition in Print* issue. Reprinted in conjunction with the special exhibit *Exhibition in Print 2003: Enameling: a current perspective* presented at SOFA CHICAGO 2003 by Society of North American Goldsmiths.

NCECA Emerging Artists
1996-2000 Exhibition

By Aurore Chabot

A.

A.
Keisuko Mizuno
Untitled
porcelain
8 x 15 x 10

B.
Suze Lindsay
Three Stacked Candlesticks
salt-fired stoneware
15.5 x 1 x 6

B.

The National Council on Education for the Ceramic Arts (NCECA) is dedicated to improving and promoting the ceramic arts through education, research and creative practice. In pursuit of this mission, NCECA sponsors several proactive programs including the Emerging Artists series, which showcases the work of early career artists each year at NCECA's national conference. Mentors or peers from the field at large nominate artists, who do not need to be NCECA members, to give slide presentations of their work to 4,000 plus attendees of the conference. The artists submit slides, career documentation and letters of nomination and recommendation to NCECA. Two NCECA Board members review the nominees' submissions and select six artists based primarily on the quality of their work. The Emerging Artist program has been an integral component of NCECA's annual conference and journal since 1982, showcasing arguably the best and most dynamic new ceramic art, and launching numerous careers.

NCECA Emerging Artists 1996-2000 at SOFA CHICAGO 2003 highlights the history and mission of NCECA while spotlighting new directions in ceramic art for the collectors, critics, museum and gallery curators, artists, patrons and ceramic aficionados of all kinds who attend SOFA and read this catalogue. While NCECA has sponsored countless high quality and critically acclaimed exhibitions

over the years, this is the first NCECA exhibition at SOFA to assemble a group of dynamic new work created entirely by Emerging Artists who, a few years after winning the honor to present slides of their work to NCECA members, are still active, producing artists. This is an important opportunity for NCECA to serve not only its membership, but the entire field of ceramics and the larger world of fine arts.

Individuals who were Emerging Artists in 1996 through 2000 were invited to submit five slides each to co-curators Michel Conroy and Skeffington Thomas, who chose twenty-four works, one from each artist, to include in the exhibition. Artists who agreed to participate include Tori Arpad, Margaret Bohls, Judith Condon, Cameron Crawford, Dana Groemminger, Kevin W. Hughes, Kathy King, Phyllis Kloda, Marc Leuthold, Suze Lindsay, Ray Liao, Matt Long, Keisuke Mizuno, Cara Moczygemba, Justin Novak, Yves Paquette, David Pier, Liz Quackenbush, Jo Schneider, Nick Sevigney, Deborah Sigel, Martin Tagseth, Hirotsune Tashima and James Tisdale. The full range of diverse art expression is represented by these works of sculpture, ceramic and mixed media, and vessels, functional and conceptual—all vibrant, original, personal, traditional and unconventional— the polyglot, post-modern world of art today.

As a NCECA Director-at-large (1999-2001), I had the privilege of mentoring Emerging Artists twice. Co-jurying the Emerging Artist nominees with NCECA Conference Liaisons Jim Connell for the 2000 conference and Cary Esser for the 2001 conference, was a difficult, albeit enlightening process due to the high quality of work submitted. Because of the incredible strength of the field, it was not easy to choose just six Emerging Artists for each conference. It is no surprise that many Emerging Artists have pursued highly successful and prominent careers in exhibitions and/or academia and can be regularly found listed on prominent workshop/lecture circuit rosters. Since "emerging," the artists represented here have been very busy. Many have won honors such as the Virginia A. Groot Award, National Endowment for the Arts Individual Fellowship Grants, Fulbright grants, state and regional fellowship grants, artist-in-residency awards, and academic research and travel grants. Their works of art are in the collections of the Brooklyn Museum; the Everson Museum; the Renwick Gallery, the Smithsonian Museum of Art; the Museum of Fine Arts, Boston; the Los Angeles County Museum of Art; the Museum of Contemporary Ceramic Art, Shigaraki, Japan; and many other notable private and public collections.

Several Emerging Artists have also distinguished themselves as educators at academic venues such as Florida International University, Miami; the University of Florida, Gainesville; California State University, Chico; Pennsylvania State University, University Park; St. Cloud State University, St. Cloud, Minnesota; Princeton University; the State University of New York, Potsdam; Kansas City Art Institute; Herron School of Art, Indianapolis, Indiana; Millersville University, Millersville, Pennsylvania; Georgia State University, Atlanta; the School of the Museum of Fine Arts, Boston, Massachusetts; the University of Oregon, Eugene; the State University of New York, New Paltz; and Pima

C.
Liz Quackenbush
Two Chickens, *2002*
earthenware, life-size

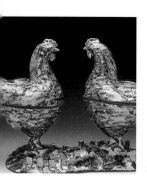

C.

D.
Yves Paquette
Lugustrum, *2003*
ceramic
8 x 12.5 x 24

E.
Kathy King
Biological Clock, *2002*
porcelain, 10 x 13 x 5

F.
Jo Schneider
ceramic, copper

G.
Nick Sevigney
Fictionware, Spouted Vessel,
2002, wood and soda-fired
stoneware, 10 x 9

H.
Judith Condon
Plants IV, *1999*
ceramic
24.5 x 18 x 13

I.
Cara Moczygemba
Still Life with Virgin, *2001*
ceramic, 15 x 10 x 7

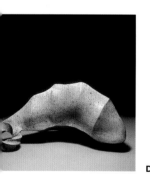

D.

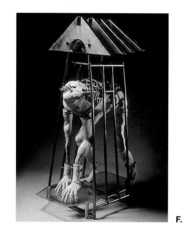

F.

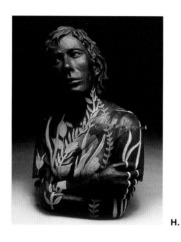

H.

E.

G.

I.

Community College, Tucson, Arizona. Their work has been included in every conceivable important ceramic and art exhibition world-wide, such as the NCECA Clay National Exhibition; Ceramic National exhibitions at the Everson Museum; the San Angelo National Ceramic Competitions; the Museum of Arts & Design exhibitions, New York City; the Craft Alliance, St. Louis, Missouri; Santa Fe Clay, New Mexico; Contemporary Arts Center, New Orleans; Baltimore Clay Works, Maryland; the Schein-Joseph Museum at Alfred University, Alfred, New York; SOFA NEW YORK and CHICAGO; Nancy Hoffman Gallery, New York City; Aukland Museum, New Zealand; Musée de Vallauris, France; David Zapf Gallery, San Diego; Frank Lloyd Gallery, Santa Monica, California; the Works Gallery, Philadelphia; gallerymateria, Scottsdale, Arizona; the Contemporary Crafts Gallery, Portland, Oregon; and various university and college galleries and museums. The Emerging Artists' art has graced the covers and pages of these influential periodicals: *Ceramics Monthly, American Ceramics, Ceramics Art and Perception, American Craft, Sculpture Magazine, Art In America.* Examples of their work are illustrated and their ceramic techniques and creative visions are explicated in author-itative books on ceramic art too numerous to name here.

If SOFA's bustling atmosphere and rich displays are any indication, it is crystal clear that ceramic art in its many guises continues to garner a tenacious hold on the art exhibition world and marketplace. This exhibition puts into action NCECA's mission to make available to as broad a discerning audience as possible the new forms, surfaces, techniques, styles and ideas generated by the ever-evolving field of ceramics. NCECA is honored to have this special opportunity at SOFA to promote ceramic art and the careers of these now emerged artists, thus inspiring the present and future generations of art-makers, art-viewers, art-buyers and art-lovers the world over. NCECA thanks SOFA for supporting this extra-ordinary exhibition of top-quality ceramic art.

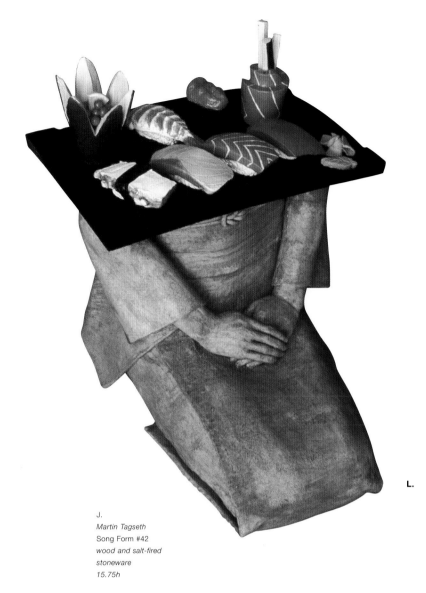

L.

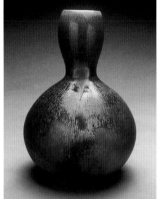

J.

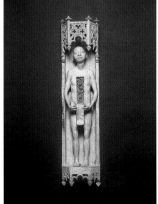

K.

J.
Martin Tagseth
Song Form #42
wood and salt-fired
stoneware
15.75h

K.
Justin Novak
Canopied Figure #7,
2001, raku-fired ceramic
24 x 5 x 6

L.
Hirotsune Tashima
Would You Like Sushi?
stoneware
27 x 26 x 22

Aurore Chabot is NCECA Publications Director until the 2004 NCECA Annual National Conference in Indianapolis and is Professor of Art and Ceramics at the School of Art, The University of Arizona, Tucson, where she has taught since 1988.

Published in conjunction with the special exhibit *NCECA Emerging Artists 1996-2000: New Ceramic Art* presented at SOFA CHICAGO 2003 by NCECA, co-curated by Michel Conroy, NCECA Exhibitions Director and Skeffington Thomas, NCECA Director-at-large.

A.

B.

The Savannah College of Art and Design is pleased to debut
Making Our Mark at SOFA CHICAGO 2003. This exhibition
explores the dynamic creativity of the renowned international
arts community at the College by showcasing the work of
multi-faceted students, faculty, and alumni. This October,
when SOFA CHICAGO is marking its tenth anniversary, the
Savannah College of Art and Design will likewise be celebrating
an important milestone—twenty-five years of successfully
preparing students for careers in the visual and performing
arts, design, the building arts, and the history of art and
architecture. I would like to express my heartfelt appreciation
to SOFA CHICAGO, and also sincerely thank Bonnie Kubasta,
Dean of the School of Design, our esteemed faculty and
Professor Sandra Blain of the University Of Tennessee School
of Art who curated Making Our Mark.

Paula S. Wallace, President
Savannah College of Art and Design

Making Our Mark

By Gillian Davies

Making Our Mark demonstrates a mastery of technique, craft, patience, originality, and resolved virtuosity. Gold, glass, acrylic, exotic and domestic veneers, aluminum, stainless steel, polished rebar, sterling silver, cotton, plastic, nylon fabric, and found objects such as watch parts, tin litho, and snow globes are the raw materials from which these works are constructed. Brought into being through welding, rolling, lamination, embellishment, dyeing, soldering, thermoforming, joining, bleaching, polishing, brushing, and burnishing, the significance of handwork is heightened in the context of our increasingly digital reality. Design strategies and methodologies employ or are enhanced by the ability to program, model, visualize, and animate through electronic design applications.

For 25 years the Savannah College of Art and Design has provided students with the opportunities to engage in meaningful dynamic dialogues with their faculty, visiting artists and, maybe most importantly, with other talented student artists/designers from around the world. At times, college guests have remarked on their delight in the array of creativity represented in the studios and classrooms across campus. "SCAD is a wonderful example that I use many times as an affirmant environment. There is so much happening here on so many levels at all times," said Tal Danai, president and founder of Artlink@Sotheby's. "There is such a level of dedication here by faculty and staff and students, but it starts with the faculty: that is welcomed and rare." The character of this unique institution to embrace innovation is enhanced by a diversity of talent, sensitivity to material and process, and respect for history and tradition. There is a willingness to pursue advanced integrated technologies while at the same time maintaining the integrity and importance of the hand in process.

SOFA expositions have recognized and given validity to the critical conversation between materiality, physicality, and issues of functionality in each of its past 10 years. This dialogue is enriched by the range of disciplines practiced at SCAD. Such reexamination of object-use resists tradition and brings inherited definitions and differences to the surface. The function of these objects arises from distinct personal priorities and inclinations: a wall cabinet, coffee table, rings, candy dish, multifunctional furniture, eyeglasses, even an ossuary. Objects such as these appearing in the SCAD exhibition at SOFA CHICAGO, are important communicators of the changing location and meaning of design. The reflexivity of identity that lies within the biographical meaning of any object is formed through culturally perceived relationships.

The work in this exhibition embodies potent responses from across cultural boundaries. The creators find aesthetic value in relation to specific cultural experiences. The metal work of Pei-Jung Chen (MFA Metals and Jewelry 2002), heavily influenced by the ideologies of Buddhism, explores intangible feelings and reflected desires. Chen says of her work, "Our society can be peaceful if people continue to cultivate themselves and think about others. My work acts as a bridge to communicate with people and as a reminder for people to respect themselves. The mind alone creates everything. Decision-making, for better or worse is in our hands." This process maintains the vitality of the object through the achievement of a global meaning that is found simultaneously within the specificity of the object's use.

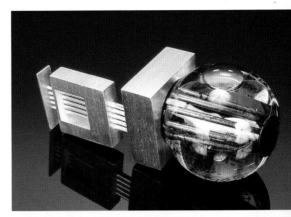

C.

D.

E.

A.
Lori Corbus
Untitled, *2001*
dyed silk

B.
Amanda Leibee
Untitled, *2001*
paper, wire, thread

C.
Kristi Sword
Untitled #3, *2003*
silver, glass, plastic

D.
Kathy Waite
Candy Dish, *1999*
sterling silver

E.
Pei-Jung Chen
Greedy, *2001*
sterling, gold, glass, acrylic

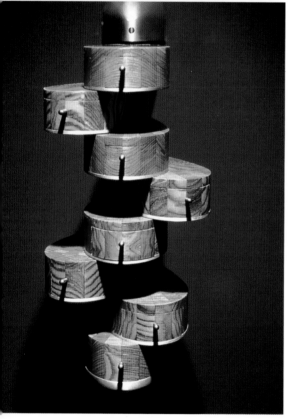

F.

G.

Intuitive recognitions and individual cognitive responses are empowered through transmission to others. Professor Jay Song (MFA Metals and Jewelry, 1999) says, "My work is based on personal relationships that I have experienced. The pieces express my beliefs that everything exists for a reason and that those reasons are often related or interconnected." Each artist contributes a unique history and aesthetic to the discussion and process of making art.

With knowledge and experience of different cultures, the artist gains a deeper insight to re-interpret vernacular forms and ideologies with a widened perspective. "The transformation from food to designed object involves the process of abstraction while striving to remind the viewer of its source," says Nopmanee Supspoontornkul (MFA Furniture Design candidate), demonstrating respect for concepts mirroring human experience. This diversity also helps to unlock the familiar errors of cultural experience that can be associated with objects and their use.

A positive embrace of the possibilities of innovation characterizes the spirit of inquiry. The availability of fused deposition modeling and computer numeric controlled machinery provides expanded possibilities of design without replacing the satisfaction of hand fabrication. A cabinet by Kern Maass (MFA Furniture Design 2003) demonstrates this by blending traditional forms, in the use of dovetail joinery, with current technology of CAD modeling and the application of CNC machinery to realize this piece. The artist comments, "Art to me is the process of creating. Therefore making what I design is just as important, if not more so, than the idea itself." He tests his command of technical means through use of new materials, manipulation of established materials in new ways, or adaptation of a fabrication method.

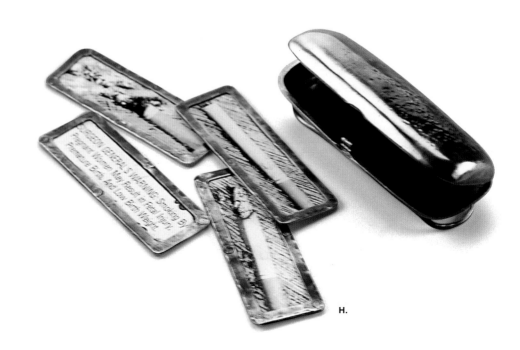

H.

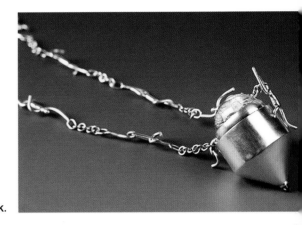

K.

J.

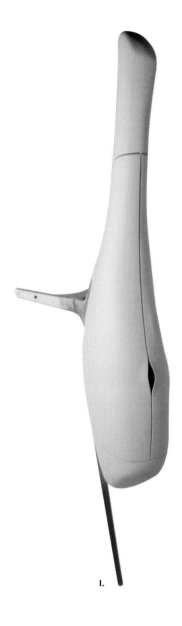

I.

F.
Hyun Jong Song
Untitled ring series, 2002
sterling silver, 14k gold

G.
Kern Maass
Untitled, 2001
aluminum, cocobolo

H.
Liaung-Chen Yen
Reminder, 2001
sterling, photographs

I. and J.
David Borgerding
Ma (open and closed)
2000, fiberglass,
aluminum

K.
Hui-Mei Pan
Self-Portrait, 2001
hair crystal, silver

Knowledge of traditional material and technique is combined with new technology to show evidence of preceding generations and acknowledge history through process. Savannah College of Art and Design Fibers Chair Pamela Wiley explores the importance of craft and suggests that its source holds the origins of family and community. Wiley's intention of preserving craft is based in her belief that its legacy can easily be lost in the overwhelming deluge of available options. The transference of these skills carries with it the personal narrative and investment in the continuation of an on-going history. "Information is Not Knowledge" references historic form as a yoyo quilt. It emphasizes the concept of frugality, while presenting an irony of fabrication by employing computer digitized text.

In a world of increasingly non-material and conceptual work, materially produced objects that were traditionally found within the domestic spaces of human experience can be profound signifiers of a cultural and aesthetic language which increase our ability and desire to perceive the physical ways of learning and comprehension. Objects expand our humanity and counterbalance the ephemeral realms of spirit and digital domain.

Gillian Davies is Professor of Interior Design at Savannah College of Art and Design.

Published in conjunction with the special exhibit *Making Our Mark: Work from the Savannah College of Art and Design* presented at SOFA CHICAGO 2003 by SCAD.

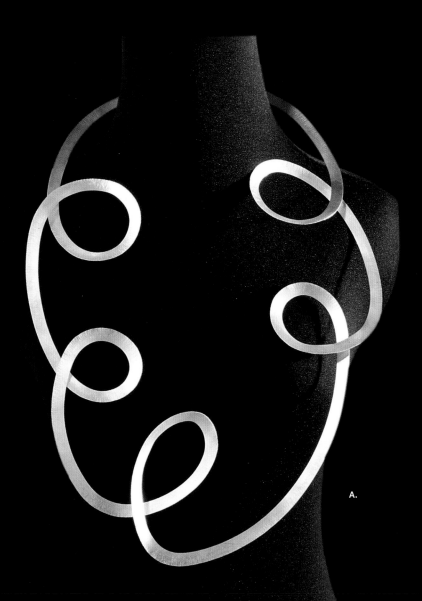

RISD on the Road Jewelry and Light Metals Exhibition

A Curatorial Overview by Kevin Jankowski
A Departmental Perspective by Louis Mueller

A.

A Curatorial Overview

Swirling geometric gestures captured in sterling silver, wave-polished stones set in a beach-comber's dream ring, freshwater pearls poised as parasitic wasp eggs on a tomato hornworm brooch carved from fossilized bone—these are a few of the striking pieces shown in the *RISD on the Road Jewelry and Light Metals Exhibition*. This collection celebrates the creative excellence of 25 alumni of Rhode Island School of Design and highlights the prominence of RISD's Jewelry + Metalsmithing Department.

David McFadden, chief curator of the Museum of Arts & Design in New York, and Sienna Patti, owner of the Sienna Gallery in Lenox, MA, served as jurors for the show. The jewelry they selected demonstrates fine craftsmanship, strong conceptual clarity and exquisite quality through a broad range of techniques, materials and processes. Professional jewelers with extensive exhibition records share gallery space with up-and-coming graduates in a show that will have traveled from coast to coast between April 2002 and December 2003. Venues include The Works Gallery in Philadelphia, Sienna Gallery in Massachusetts, Shaw Contemporary Jewelry in Maine, Woods-Gerry Gallery in Providence, Widney Moore Gallery in Portland, Velvet Da Vinci Gallery in San Francisco, Yaw Gallery in Michigan, Katy Beh Contemporary Jewelry in New Orleans, SOFA CHICAGO and the Houston Center for Contemporary Craft.

The *RISD on the Road* exhibition program began eight years ago and has grown into an exceptional event that showcases the diverse accomplishments of RISD alumni. So far the program has partnered with RISD's departments of Illustration, Textile Design, Photography, Printmaking, and Jewelry + Metalsmithing to sponsor exhibitions highlighting work in these areas. Jurors for each show have included prominent artists, designers and curators such as Jack Lenor Larsen of Larsen Designs; Sherri Donghia of Donghia Textiles; Ruth Fine, chief curator of Modern Prints and Drawings at the National Gallery; and Philip Brookman, curator of Photography and Media Arts at the Corcoran Gallery.

Since 1877 Rhode Island School of Design has educated artists and designers who have influenced creative disciplines throughout the world. The college's remarkable reputation has made it one of the most recognizable names among art institutions, yet rarely are the works of its students and alumni shown together off campus. As the title suggest, the *RISD on the Road* exhibition program brings the creative excellence for which RISD is known to galleries, museums and art centers throughout the United States. Alumni have been eager to participate in this program as a means of reaffirming the value of their education and acknowledging RISD's influence on their lives as artists and designers.

Unified by their educational background, the jewelers in the current *RISD on the Road* exhibition build upon the skills, processes and methods of thinking acquired at RISD to create pieces that ultimately reflect their personalities, histories and environments. Their education informs their artistic decisions, having left them with strong problem-solving skills and a full understanding of the creative process. They take chances; they question and experiment, creating work that surprises and informs. Whether it's one-of-a-kind or a production piece, their jewelry is seductive because of its concept, materials, color, texture and craftsmanship.

As curator of the show, I have come to know the 25 jewelers represented, but mostly through their jewelry, which I have packed and unpacked on numerous occasions. I have tracked the inanimate lives of the pieces like old friends and carefully observed the effects of shipping and handling, along with the reactions from gallery owners, collectors and the general public. I marvel at this work each time I evaluate it and become absorbed in its power to entice and entrance, much like the most enduring jewelry has done throughout history and cultures. Each piece is like performance art, commanding its diminutive space and drawing attention to itself on a finger, neck, ear or wrist. Some of these pieces show structural complexity and an amazingly deft hand while others deceptively mask their technical finesse behind simplicity and elegance. But in all instances, this jewelry elicits a sense of intimacy and value beyond the materials that compose it.

B.

A.
Boosoon Bea
Large & Light I Necklace
silver, 18k gold

B.
Sam Shaw
Stand Up Rings
beach stone, sterling silver

Viewers of the *RISD on the Road Jewelry and Light Metals Exhibition* will surely discover pieces that delight and amaze, challenging the way we look at the world. This is a show that celebrates creative excellence and the vital role of RISD's Jewelry + Metalsmithing Department in educating artists. It's a show that hints of still more promising work from these and other RISD graduates well into the future.

Kevin Jankowski
Curator, *RISD on the Road Jewelry and Light Metals Exhibition*

c.

A Departmental Perspective

My first introduction to RISD and its light metals program came in 1968 when I drove to Rehoboth, MA, to meet John Prip, a well-known metalsmith, professor in RISD's Industrial Design Department and the father of one of my Rochester Institute of Technology classmates. I was totally awed by the elder Prip and the way he approached his life and his work. He took me to RISD to visit his modest two-room basement facility, and we discussed the possibility of initiating a graduate program; he suggested I apply to the school's Industrial Design Department and write a letter expressing my interest in graduate study with him. By the fall of 1969 I had become one of the first three graduate students to begin thesis studies with Jack Prip. In the summer of 1970 the program expanded to a new home on the second floor of the building, and that fall an undergraduate degree program in jewelry and light metals got off the ground. Our department now occupied three rooms, with windows, daylight and a great deal more visibility at RISD.

It's impossible to put into words the magical, mystifying atmosphere in the department and the school during that period. There was an inspiring level of creativity that has left its mark on me to this day. The interaction between the departments that shared space in that building proved to be an important part of my educational foundation. My memories of discussions with faculty and students from glass, ceramics and painting were important in my growth and maturity as an artist.

When I received my MFA in 1971, I moved to the West Coast to begin teaching in San Francisco, but I couldn't stop telling my students about my experiences at RISD and the creative magic I found there. Somehow for me, RISD provided the perfect climate—fertile ground in which my technical and conceptual skills blossomed. When Jack Prip invited me to teach a Wintersession class in 1977, I found that the students and the atmosphere were all that I had remembered.

The following year I returned to Providence to teach at RISD. The department had moved from being a subsidiary of Industrial Design to the Division of Fine Arts and two more rooms had been added to accommodate increased enrollment. Jack and I taught together until he retired in 1981 and I became head of the department. During the three years we were together, we designed and implemented a cohesive curriculum. Our goal was to develop problems that were technically challenging while being creatively stimulating, maintaining a harmonious balance between creativity and craft. At the time the field was going through a period of transition; instead of graduating into positions working in industry, students were discovering a new phenomenon—the embrace of the art world, with galleries offering shows and sales, and colleges and universities adding new programs and teaching positions.

Robin Quigley, a graduate of our program, joined in 1981 as the second full-time faculty member, and we have been working together effectively and creatively ever since. During our time at RISD, many changes have taken place at the college as well as in our own curriculum. When I met Claus Bury, a German goldsmith turned sculptor in 1979, it marked an important turning point in the direction the department would eventually take. Through Claus, I was introduced to Hermann Jünger who was then in charge of the jewelry department at the Academy of Art in Munich. This association enabled me to meet many of the European artists whom I have since invited to RISD as visiting lecturers and faculty members because of their distinctive approach to jewelry and metalsmithing education, and their high level of craft, in conjunction with design and problem-solving skills. We now try to bring at least one European artist a year to teach one or more classes in the department. In addition, we have established exchange programs with a number of academies in Europe. This is a wonderful opportunity for students who are able to study abroad and for visitors who add new dimension to our studios. As a result, RISD is one of the few American schools whose Department of Jewelry + Metalsmithing is highly regarded in Europe and Asia.

At RISD our goal is to seek a balance between the execution and the idea—to maintain important contacts with tradition while also promoting progressive thinking in the content and concepts our students investigate. Following a year of Foundation Studies, undergraduates in the department spend three years working towards a Bachelor of Fine Arts degree, while graduate candidates for the Master of Fine Arts degree are enrolled in a two- or three-year program. Requirements include one year each of design and rendering courses, with most other courses directly related to bench working skills.

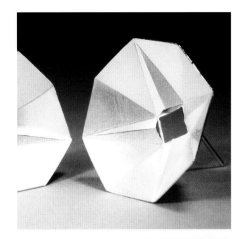
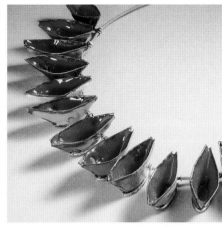

D. E.

We believe it's important to give students a good foundation in technical skills while helping them to develop their curiosity, sense of observation and critical vocabulary. The wonderful thing about teaching is that you can give someone an alphabet and watch them create words; from words come sentences and eventually, stories. In essence you provide the raw materials, then observe as students work through the process, starting with very rudimentary exercises, and building to an ability to create totally new objects of their own invention. Some do it much more comfortably than others, but this is the wonderfully satisfying part of passing on knowledge: you're able to see how differently people interpret the same rudiments.

Artistic success is dependent on a sense of fearlessness and the ability to listen to an intuitive inner voice. What is important in any educational experience is not to give students your voice, but to let them struggle to find their own. If you give them fundamental skills and if they have the drive, the determination and the reckless abandon, they can begin to invent their own songs, their own stories and their own images. And if they are able to continue the process, that voice should grow stronger, more confident and more beautiful as time goes on. The work presented in *RISD on the Road* offers a close look at the beauty and quality—both conceptual and technical— that have earned our department its reputation. Of course, it suggests just how that reputation translates into satisfying and successful careers for our graduates.

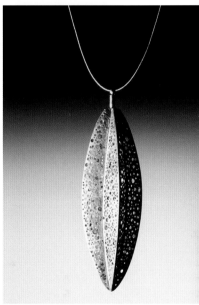

F. G.

Louis Mueller
Former Department Head, Jewelry + Metalsmithing
Rhode Island School of Design

Published in conjunction with the special exhibit *RISD on the Road: Jewelry and Light Metals* presented at SOFA CHICAGO 2003 by Rhode Island School of Design.

C.
Mielle Harvey
Tomato Hornworm with
Wasp Eggs, *2002*
bone, dye, sapphires, gold

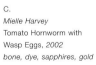

D.
Sook-Hyun Lee
Pleasure of Lightness
Earrings, *2001*
sterling silver

E.
Tamar Kern
Voyage Necklace, *2000*
enamel, copper, cord, silver

F.
Kiwon Wang
Aeonic Time *necklace, 2000*
sterling silver, rice paper, pearl,
nylon, ink lacquer

G.
Sandra Enterline
Star Fruit Pendant, *2002*
pierced sterling, heat patina,
steel, 18k yellow gold,
14k yellow gold

Contemporary
Crafts in Britain

By Dr. Louise Taylor

A.

There has never been a more exciting time to be involved in the world of contemporary crafts in Britain. There is a wider engagement with craft and applied arts as a whole, there are more artists emerging and more galleries dedicated to showing their work. In addition, galleries who traditionally specialized in fine art or antiques are now introducing their clients to the work of contemporary artists and showing this work within their galleries and at art fairs. This year for the first time, a major name from the applied arts, Grayson Perry, has been nominated for the prestigious Turner Prize for fine art.

The British Crafts Council has recently celebrated its 30th anniversary. The Council's key role as the lead body for the crafts in Britain was recognized by a Royal Charter in 1982 which sets out our mission 'to advance and encourage the creation…of works of fine craftsmanship and to foster, promote and increase the interest of the public in the works of craftspeople and the accessibility of those works to the public.' The Royal Charter document was presented to the Council by the Queen and is a valued object in our National Collection of Crafts.

In my first year as Director of the British Crafts Council, I have been working with my colleagues to refocus and reposition the organization in order to ensure that we continue to serve the needs of our sector and, thereby, continue to fulfill our mission. Our first task has been to develop a new strategic plan, which will help us to raise the profile of the sector and to position craft in the public consciousness as a dynamic art form that demonstrates British creativity on the world stage.

Now we are poised to extend our range of influence in furthering the development of the sector within national and international arenas. We are only too aware of the need to foster international partnerships and value the continued support of our friends across the continents.

B.

C.
Lucie Rie
Bottle Vase with Flared
Lip, *c.1980-81*
porcelain, mangnese
bronze pigment with
sgraffito lines through slip
9.5 x 5.25
representated by
Joanna Bird Pottery

D.
Gordon Baldwin
Vessel to Light a Dark Place
2002, ceramic
14h
represented by
Barrett Marsden Gallery

E.
Hiroshi Suzuki
Aqua Posey, *VII*
fine silver
represented by
Clare Beck
at Adrian Sassoon

F.
Sally Fawkes
Eternally Here III
2003, glass; cast,
cut and polished
19 x 13.5 x 5.25
represented by
Contemporary
Applied Arts

G.
Jim Partridge
Oak Vessel
wood
represented by
The Scottish Gallery

H.
Audrey Walker
Observed Incident, *2002*
hand-stitching on cloth
52 x 55
represented by The Gallery
at Ruthin Craft Centre

I.
Hans Coper
White Composite Form
c. 1972
stoneware, 7h
represented by
Galerie Besson

Having helped to build the current surge of public interest, we will be maximizing support from our Government, which recognises the part craft can play in economic and social regeneration programmes.

Ensuring the development of the best new work through the support of individual makers remains one of our top priorities. We will continue the substantial work we have been doing to nurture new artists through schemes such as the Crafts Council Development Award (formerly known as the Setting Up Scheme) and Next Move, a new graduate residency programme run in conjunction with a network of regional agencies, universities and colleges across the UK.

It is, however, also important for us to celebrate the pioneers of the studio craft movement as we know it today. To this end we have been involved in a remarkable new project—*Show5*—which brings together five regional English galleries and five major names from the world of the applied arts into one exhibition series, opening this autumn. The artists featured will be well known to international collectors and have been selected to represent a cross section of the amazing work being created by British craftspeople today. The exhibitions will be 70 per cent retrospective and 30 per cent newly-created works, with a series of five commemorative books to be published by Lund Humphries.

C.

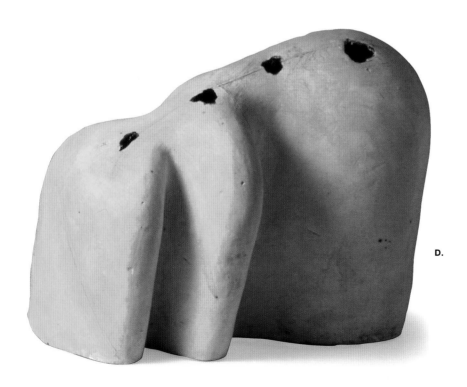

D.

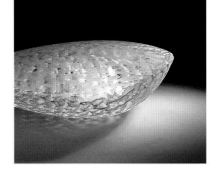

F.

The five shows are:

Carol McNicoll's *Contemporary ceramics—domestic treasures*, which will be launched at the City Gallery, Manchester from 6 September – 1 November 2003.

Jim Partridge's *Woodwork—a view from the bridge*, which will be launched at Manchester Art Gallery from 6 September – 12 October 2003.

Michael Rowe's *Meticulous metalwork*, which will be launched at Birmingham Museum & Art Gallery from 18 October 2003 – 18 January 2004.

Richard Slee's *Tempting ceramics*, which will be launched at The Potteries Museum & Art Gallery in Stoke on Trent from 13 September – 2 November 2003.

Anne Sutton's *Weaving, wit and logic* which will be launched at The British Crafts Council Gallery in London from 23 October 2003 – 18 January 2004.

Following the launch shows, all five will go on to tour within the UK and internationally. Information about these and all of the other key British artists can be obtained from the Council's Photostore® pictorial database, which will be accessible on the Internet from early 2004, and on our web site at www.craftscouncil.org.uk.

The British Crafts Council's ultimate aim is to support the growth and strengthening of the crafts sector, and we have a leading role to play in coordinating the efforts of all of the artists, galleries, curators, educators, academics and so forth, who are all working towards this common goal. Our involvement in SOFA CHICAGO has made us aware of the importance of focusing public attention and providing a meeting place for those within the sector.

The British Crafts Council will once again be presenting an important group of British galleries at SOFA CHICAGO 2003. Between them, they will be showing some of the finest work from new and established artists.

SOFA CHICAGO has been extremely important to us as it has given us the opportunity to introduce the work of contemporary British artists to the international collectors market. I would like to take this opportunity on behalf of the British Crafts Council and the British crafts sector to congratulate SOFA CHICAGO on this its 10th Anniversary. I know I speak for my colleagues, as well as myself, when I say that I am looking forward to renewing old acquaintances and making new friends.

Dr. Louise Taylor
Director, British Crafts Council

Published in conjunction with the British Crafts Council and participating galleries from the UK: Clare Beck at Adrian Sassoon, Barrett Marsden Gallery, British Crafts Council Gallery, Contemporary Applied Arts, Galerie Besson, The Gallery at Ruthin Craft Centre, Joanna Bird Pottery and The Scottish Gallery.

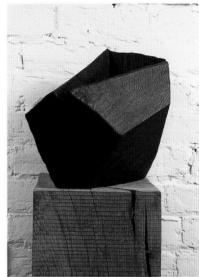

G.

H.

E.

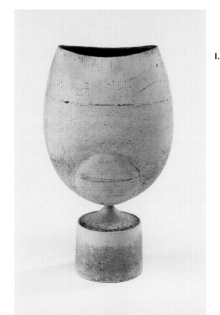

I.

hibitors

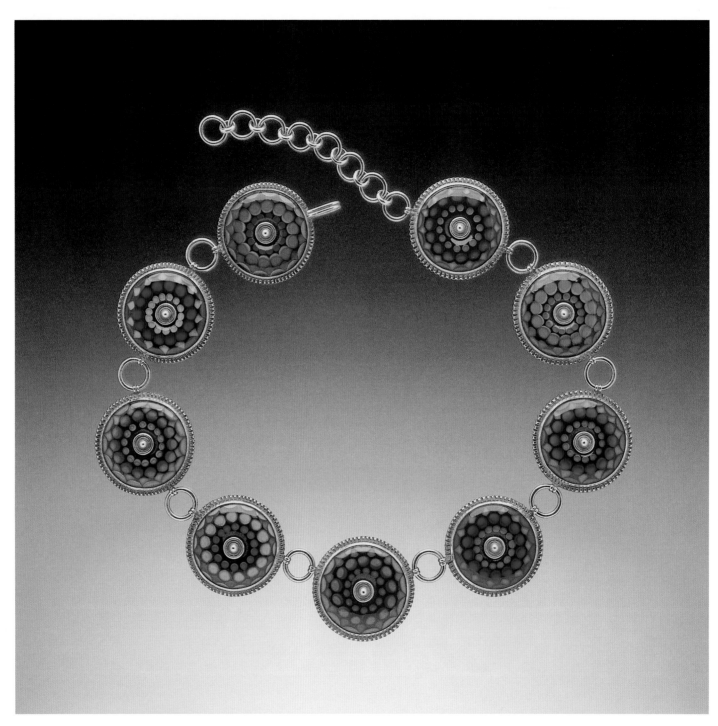

Kristina Logan, **Turquoise Constellation** necklace, *2003*
sterling silver, lamp-worked glass disks
22 long

Aaron Faber Gallery

100 Years: Design in Jewelry
Staff: Edward Faber; Patricia Kiley Faber; Felice Salmon; Erika Rosenbaum;
M.P. Carey; Jerri Wellisch; Jackie Wax; Sabrina Nameri; Roxanne Awang

666 Fifth Avenue
New York, NY 10103
voice 212.586.8411
fax 212.582.0205
info@aaronfaber.com
aaronfaber.com

Representing:
Glenda Arentzen
Margaret Barnaby
Marco Borghesi
Chavent
Namu Cho
Joseph English
Michael Good
Christine Hafermalz-
 Wheeler
Marianne Hunter
Kristina Logan
Bernd Munsteiner
Jutta Munsteiner
Tom Munsteiner
Tod Pardon
Linda Kindler Priest
Sydney Scheer
Susan Kasson Sloan
Jeff Wise
Susan Wise
Michael Zobel

Michael Zobel, **Bracelet***, 2003*
sterling silver, 22k and 24k gold, coral, diamonds
photo: Fred Thomas

Marilyn Druin, **Brooch/Pendant,** *2003*
cloissonné, guilloche, basse taille enamels

Aaron Faber Gallery

Special SOFA CHICAGO presentation: *Focus on Enamels*

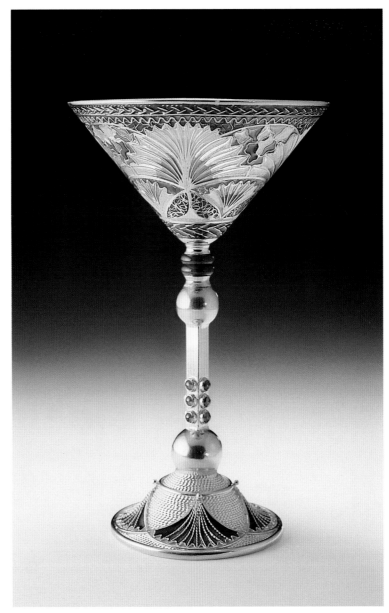

Representing:
Marilyn Druin
Karen Erhardt
Melissa Huff
Larissa Podgoretz
Karen Pohl
Judy Stone
Valeri Timofeev
Ginny Whitney

Valeri Timofeev, **Martini Glass,** *2003*
gilded silver, plique-a-jour enamel, 5.5 x 3.5 x 3.5

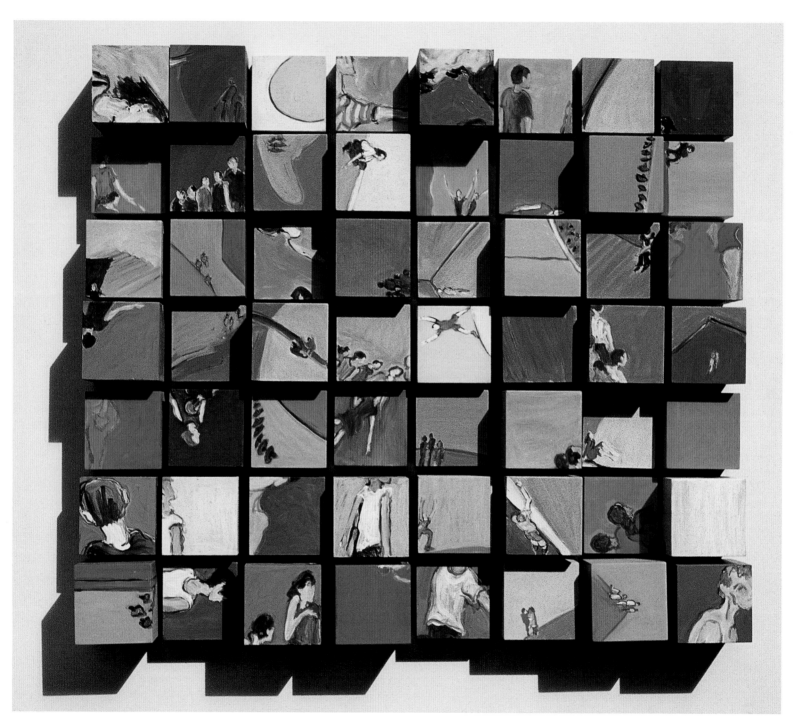

Gretchen Minnhaar, **Urban Rhythms I,** *2003*
oil on wood, 42 x 47 x 5

Adamar Fine Arts

Contemporary fine art by internationally recognized American, European, and Latin American artists
Staff: Tamar Erdberg, owner/director; Adam Erdberg, owner; Douglas Jencks, gallery director

177 NE 39th Street
Miami, FL 33137
voice 305.576.1355
fax 305.576.0551
adamargal@aol.com
adamargallery.com

Marlene Rose, **Body Maker,** *2003*
glass, copper, 35 x 15 x 8
photo: David Monroe

Representing:
Sally Bennett
Clemens Briels
Brad Howe
Gretchen Minnhaar
Niso
Rene Rietmeyer
Marlene Rose
Tolla

Jim Rose, **Cupboard and Case of Drawers**
rusted matched steel, 80 x 65 x 18

Ann Nathan Gallery

Artist-made furniture, sculpture and paintings by prominent and emerging artists
Staff: Ann Nathan, director; Victor Armendariz, assistant director

212 West Superior Street
Chicago, IL 60610
voice 312.664.6622
fax 312.664.9392
nathangall@aol.com
annnathangallery.com

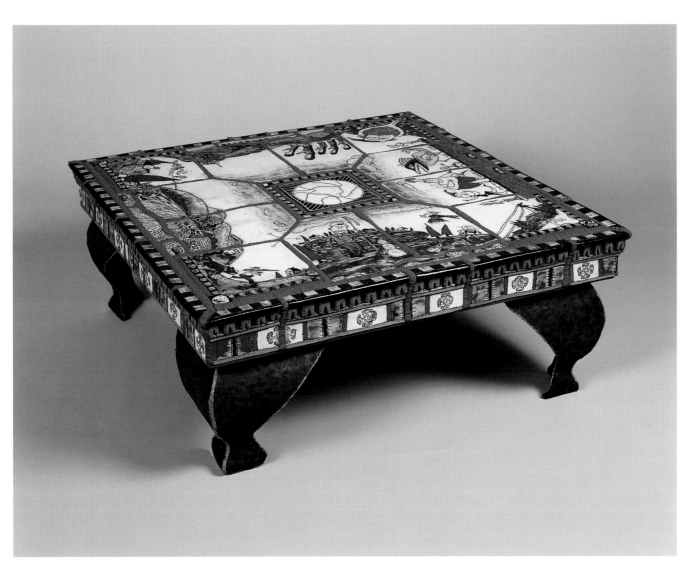

Representing:
Pavel Amromin
Mary Bero
Gordon Chandler
Krista Greco
Michael Gross
Chris Hill
Jesus Curia Perez
Jim Rose
Tibor Timar

Michael Gross, **Ruby** *table*
ceramic, steel legs, 17 x 44 x 44

Gordon Chandler, **Kimonos**
steel, enamel finish, 60 x 35 x 6

Chris Hill, Sculpture
steel, acrylic paint, 62 x 48 x 12

Lawson Oyekan, **Analogous Fabric,** *1999*
ceramic, 24.5 x 34.5 x 5
photo: Philip Sayer

Barrett Marsden Gallery

Staff: Juliana Barrett; Tatjana Marsden

17-18 Great Sutton Street
London EC1V 0DN
England
voice 44.207.336.6396
fax 44.207.336.6391
info@bmgallery.co.uk

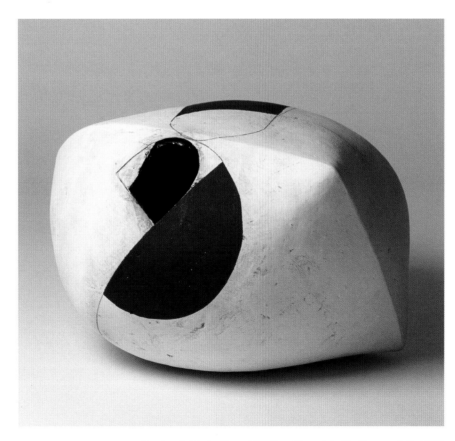

Representing:
Gordon Baldwin
Alison Britton
Caroline Broadhead
Tessa Clegg
Ken Eastman
Philip Eglin
Chun Liao
Robert Marsden
Steven Newell
Lawson Oyekan
Sara Radstone
Nicholas Rena
Michael Rowe
Richard Slee
Martin Smith
Maria van Kesteren
Emma Woffenden

Gordon Baldwin, **Vessel for Your Thoughts Mr. Brancusi III**, *2003*
earthenware, 14 x 18 x 13.5
photo: Philip Sayer

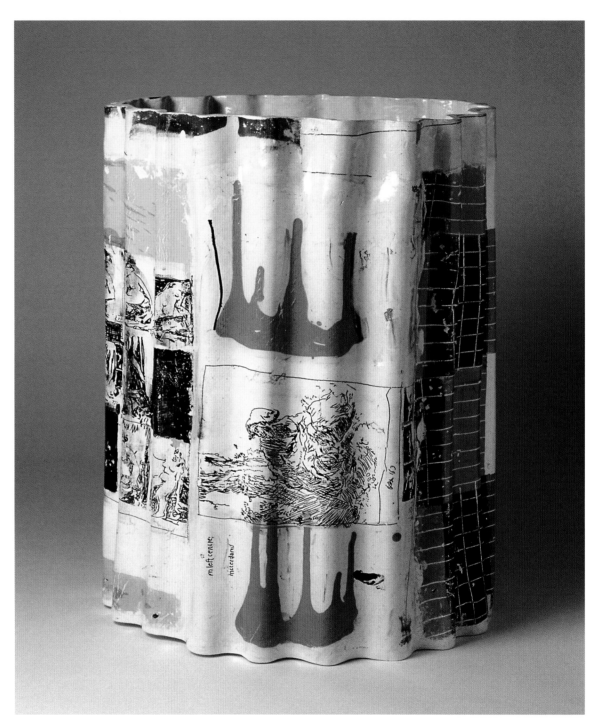

Philip Eglin, **Corrugated Christ Bucket,** *2003*
earthenware, 23 x 20.5 x 18
photo: Philip Sayre

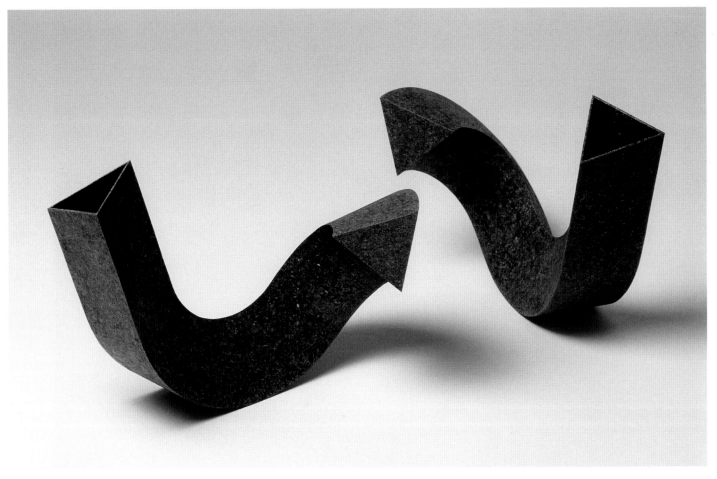

Robert Marsden, **Serpentine Spouts (1985),** *2003*
patinated brass, 8 x 18 x 12
photo: Philip Sayer

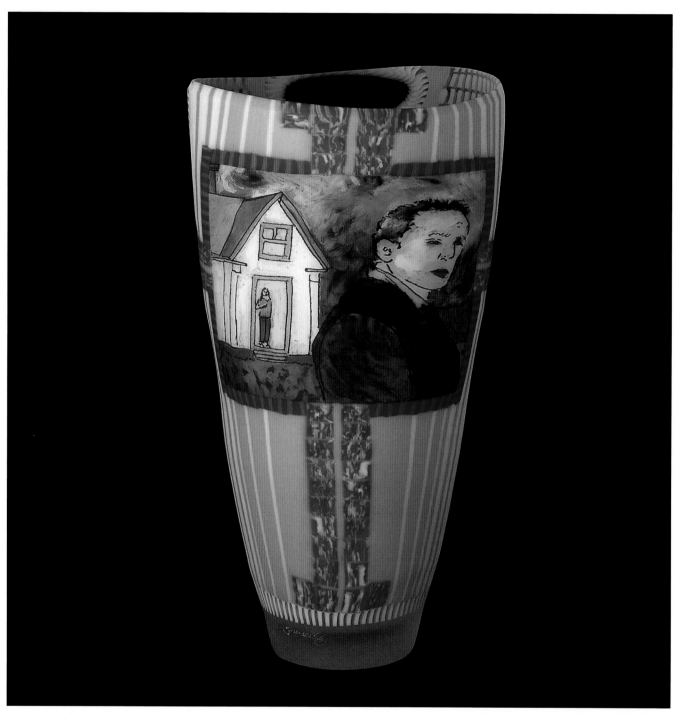

Scott Chaseling, **Half empty - Half full,** *2003*
fused, blown and wheel-cut glass with painted and murrine panels, 19 x 9.5 x 9.5

Beaver Galleries

Contemporary Australian fine art and craft
Staff: Martin Beaver, director

81 Denison Street, Deakin
Canberra, ACT 2600
Australia
voice 61.26.282.5294
fax 61.26.281.1315
mail@beavergalleries.com.au

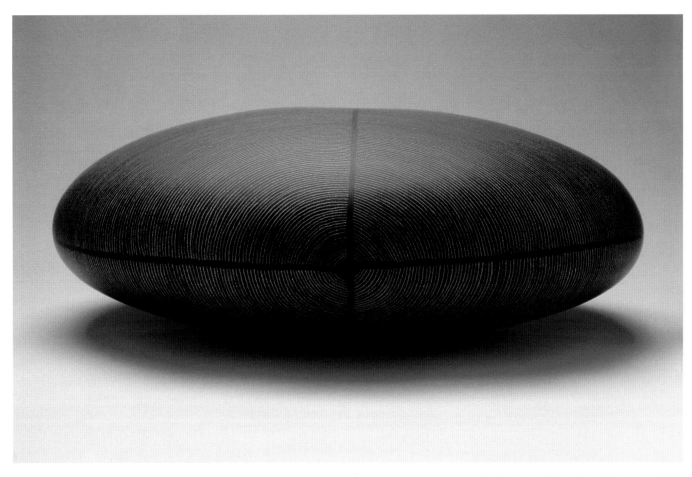

Representing:
Scott Chaseling
Mel Douglas
Kirstie Rea

Mel Douglas, **Where Four Ways Meet,** *2003*
blown, cold-worked and engraved glass

Olga de Amaral

Richard DeVore

Ruth Duckworth

Shihoko Fukumoto

Robert Kushner

Norma Minkowitz

Bellas Artes/Thea Burger

Staff: Thea Burger; Charlotte Kornstein

653 Canyon Road
Santa Fe, NM 87501
voice 505.983.2745
fax 505.983.1271
bc@bellasartesgallery.com
bellasartesgallery.com

39 Fifth Avenue, Suite 3B
New York, NY 10003
voice 802.234.6663
fax 802.234.6903
burgerthea@aol.com

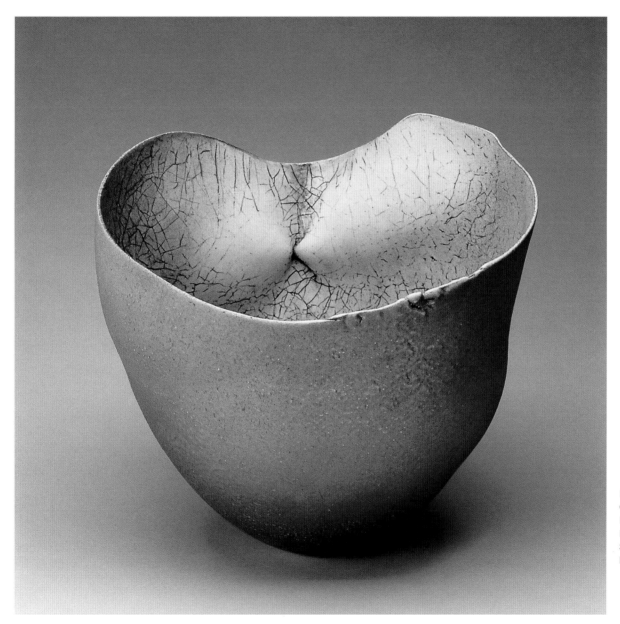

Representing:
Olga de Amaral
Richard DeVore
Ruth Duckworth
Shoichi Ida
Norma Minkowitz

Richard DeVore, **Untitled No. 1056***, 2002*
stoneware, 12.5 x 13 x 12

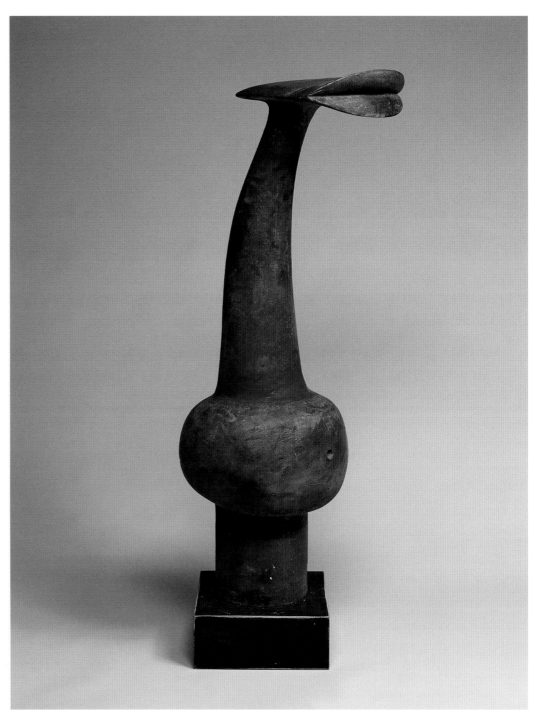

Ruth Duckworth, **Untitled No. 692900,** *2000*
stoneware, 47 x 16 x 15
photo: Jim Prinz

Olga de Amaral, **Imagen Perdida 30**, *2002*
linen, gold and silver leaf, acrylic, 40 x 40

Ursula Huber, **Ego,** *2003*
glass, 12.5 x 9.5 x 5
photo: D. Lazzarini

Berengo Fine Arts

Contemporary art in glass
Staff: Adriano Berengo; Marco Berengo

Fondamenta Vetrai 109
Murano, Venice 30141
Italy
voice 39.041.527.6364
fax 39.041.527.6588
adberen@berengo.com
berengo.com

Representing:
Roberto Aguerre
Luigi Benzoni
Dusciana Bravura
Pino Castagna
James Coignard
Ursula Huber
Marya Kazoun
Kiki Kogelnik
Alexandra Nechita
Juan Ripollés
Sandro Sergi
Giuseppina Toscano
Silvio Vigliaturo
Tsuchida Yasuito

James Coignard, **La Main Blanche**
glass, 19.75 x 14.75 x 3
photo: D. Lazzarini

Malcolm Martin & Gaynor Dowling, **Great Turn**, *2002*
wood, 60h
photo: Martin & Dowling

British Crafts Council

Promoting excellence and innovation in craft
Staff: Kathleen Slater; Catherine Williams

44a Pentonville Road
London N1 9BY
England
voice 44.207.806.2557
fax 44.207.837.6891
trading@craftscouncil.org.uk
craftscouncil.org.uk

Representing:
Robert Cooper
Jill Crowley
Edmund de Waal
Gaynor Dowling
Dawn Emms
Nora Fok
Anna Gordon
Michelle Holden
Angela Jarman
Malcolm Martin
Anna Osmer-Andersen
Naoko Sato

Edmund de Waal, **Untitled,** *2003*
white stoneware, 5.5 x 9
photo: Sara Morris

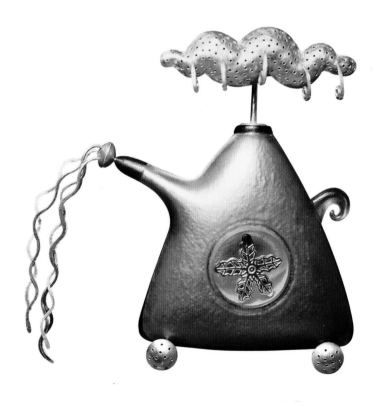

Dawn Emms, **Dream Brewers Infusion Pot** brooch, *2000*
cellulose, acetate, silver, 4.75 x 3.75 x 1.75
photo: Dawn Emms

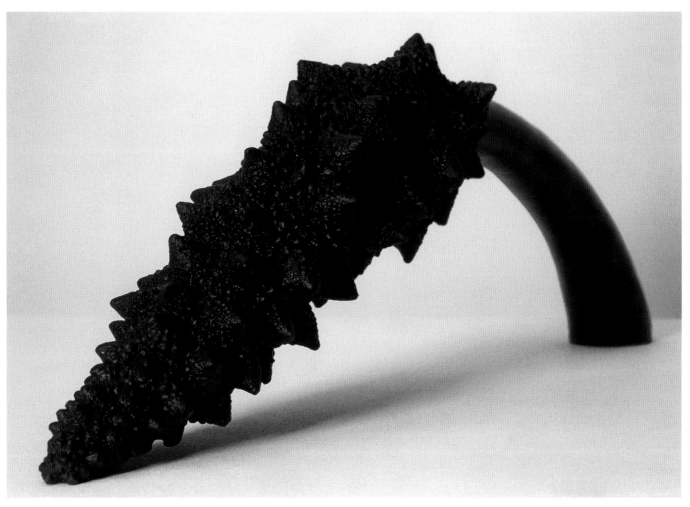

Angela Jarman, **Flora***, 2003*
glass, 7.5 x 4 x 16.5
photo: Graham Murrell

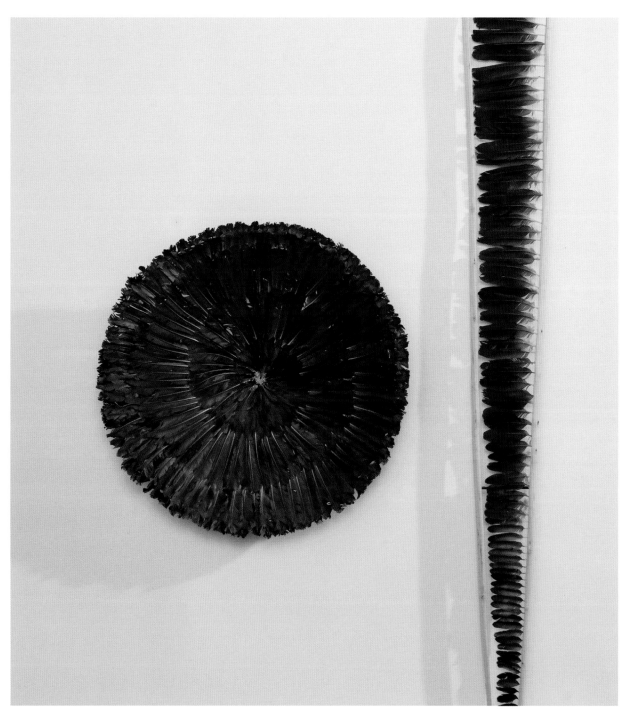

Chris Drury, Basket for the Crows, 1986
crow feathers, willow, hazel, 118 x 12 x 1.5; 29 x 29 x 5.75
photo: Tom Grotta

browngrotta arts

Focusing fiber art for 16 years
Staff: Tom Grotta and Rhonda Brown, co-curators; Roberta Condos, associate

Wilton, CT
voice 203.834.0623
voice 800.666.0623
fax 203.762.5981
art@browngrotta.com
browngrotta.com

Representing:

Adela Akers	Gyöngy Laky
Dona Anderson	Inge Lindqvist
Jeannine Anderson	Åse Ljones
Marijke Arp	Kari Lønning
Jane Balsgaard	Astrid Løvaas
Jo Barker	Dawn MacNutt
Dorothy Gill Barnes	Ruth Malinowski
Caroline Bartlett	Rebecca Medel
Dail Behennah	Mary Merkel-Hess
Nancy Moore Bess	Judy Mulford
Birgit Birkkjær	Leon Niehues
Rebecca Bluestone	Keiji Nio
Sara Brennan	Greg Parsons
Jan Buckman	Simone Pheulpin
Pat Campbell	Valerie Pragnell
Chunghi Choo	Ed Rossbach
Chris Drury	Scott Rothstein
Lizzie Farey	Mariette Rousseau-
Mary Giles	Vermette
Linda Green	Debra Sachs
Françoise Grossen	Toshio Sekiji
Norie Hatekayama	Hisako Sekijima
Ane Henriksen	Kay Sekimachi
Maggie Henton	Carol Shaw-Sutton
Helena Hernmarck	Hiroyuki Shindo
Sheila Hicks	Karyl Sisson
Marion Hildebrandt	Britt Smelvær
Agneta Hobin	Grethe Sørenson
Kazue Honma	Kari StiansenNoriko
Kate Hunt	Takamiya
Kristín Jónsdóttir	Chiyoko Tanaka
Christine Joy	Hideho Tanaka
Glen Kaufman	Tsuroko Tanikawa
Ruth Kaufmann	Blair Tate
Tamiko Kawata	Lenore Tawney
Linda Kelly	Jun Tomita
Anda Klančič	Deborah Valoma
Lewis Knauss	Claude Vermette
Mazakazu Kobayashi	Ulla-Maija Vikman
Naomi Kobayashi	Kristen Wagle
Nancy Koenigsberg	Wendy Wahl
Yasuhisa Kohyama	Katherine Westphal
Markku Kosonen	Jiro Yonezawa
Kyoko Kumai	Masako Yoshida

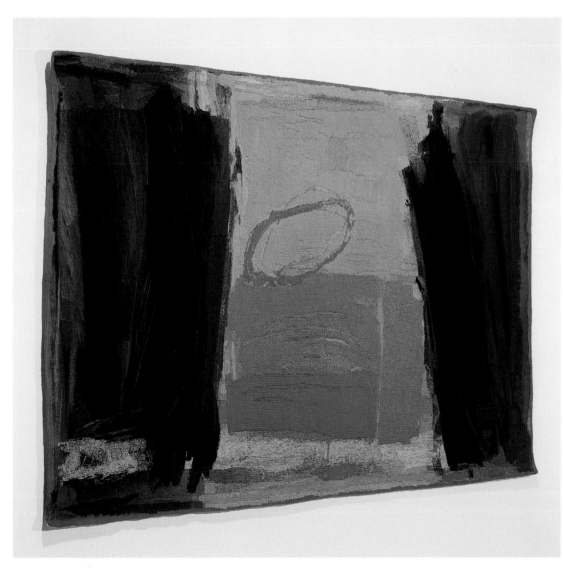

Jo Barker, **Ellipse***, 1994*
wool, cotton, linen, chenille, metallic, embroidery thread, 63 x 84
photo: Tom Grotta

Agneta Hobin, **Claire de Lune**, *2003*
mica, steel, 56.25 x 56 x 3
photo: Tom Grotta

Gyöngy Laky, **Slowly,** *2002*
apricot and eucalyptus prunings, screws, 38 x 41 x 32
photo: Tom Grotta

Giles Bettison, **Grid #4**, *2003*
glass and steel block, 15 x 11 x 2.5
photo: John Healey

The Bullseye Connection Gallery

Contemporary works in Bullseye glass by established and emerging artists
Staff: Lani McGregor, executive director; Holly Clemmons, office manager;
Rebecca Rockom, sales associate; Stephen Rue, art handler

300 NW Thirteenth
Portland, OR 97209
voice 503.227.0222
fax 503.227.0008
gallery@bullseye-glass.com
bullseyeconnectiongallery.com

Representing:
Galia Amsel
Bennett Battaile
Giles Bettison
Judi Elliott
Anja Isphording
Steve Klein
Alicia Lomné
Jessica Loughlin

Bennett Battaile, Déjà Vu, *2003*
glass, 13 x 12 x 10
photo: Bill Bachhuber

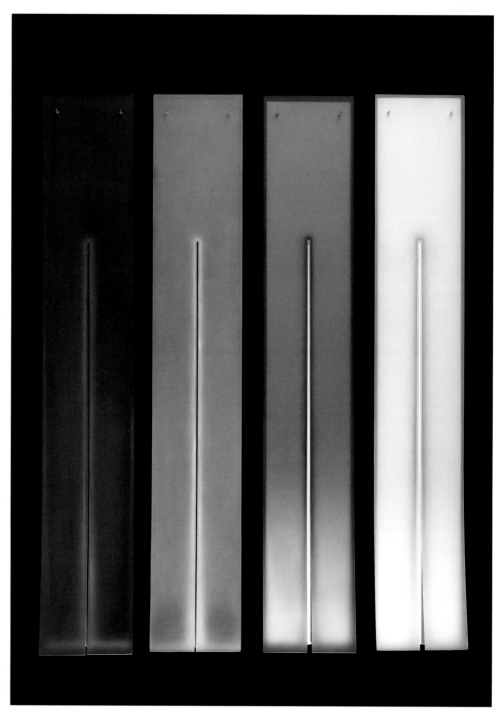

Jessica Loughlin, **Vertical Lines 5,** *2002*
kiln-formed glass, 47 x 7 x 3
photo: Grant Hancock

Steve Klein, **Exploration XXVII**, *2003*
fused and blown glass, 7 x 18.5 x 18.5
photo: Jason Van Fleet

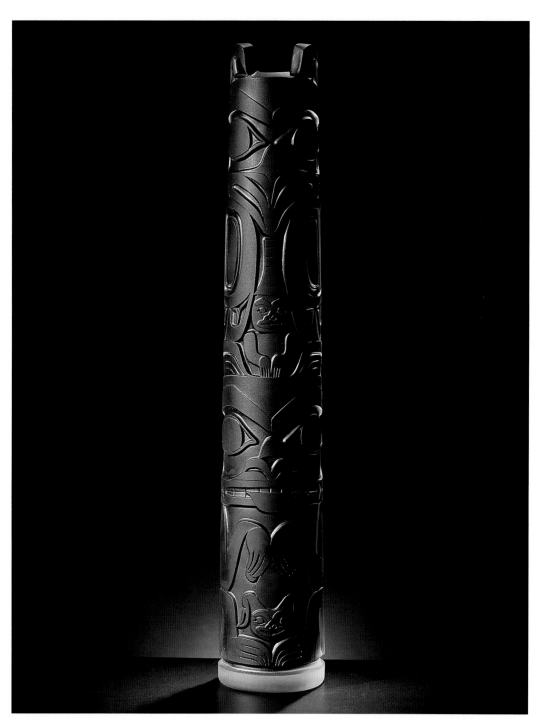

Preston Singletary, **Eagle Bear Totem**
blown and sand-carved glass, 23.5 x 4

Chappell Gallery

Contemporary glass sculpture
Staff: Alice M. Chappell; Vivienne A. Bell; Sara B. Zurit

526 West 26th Street, #317
New York, NY 10001
voice 212.414.2673
fax 212.414.2678

14 Newbury Street
Boston, MA 02116
voice 617.236.2255
fax 617.236.5522
amchappell@aol.com
chappellgallery.com

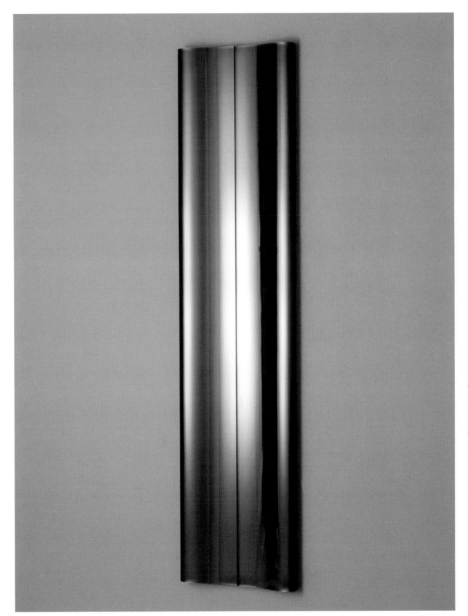

Representing:
Mary Ann Babula
Alex Gabriel Bernstein
Lyndsay Caleo
Stopher Christensen
Kathleen Holmes
Toshio Iezumi
Yoko Kuramoto
Kait Rhoads
Joyce Roessler
Youko Sano
Takeshi Sano
Gale Scott
Ben Sewell
Naomi Shioya
Preston Singletary

Toshio Iezumi, **P. 011202**
laminated sheet glass, carved and polished, 72 x 16 x 2.5

109

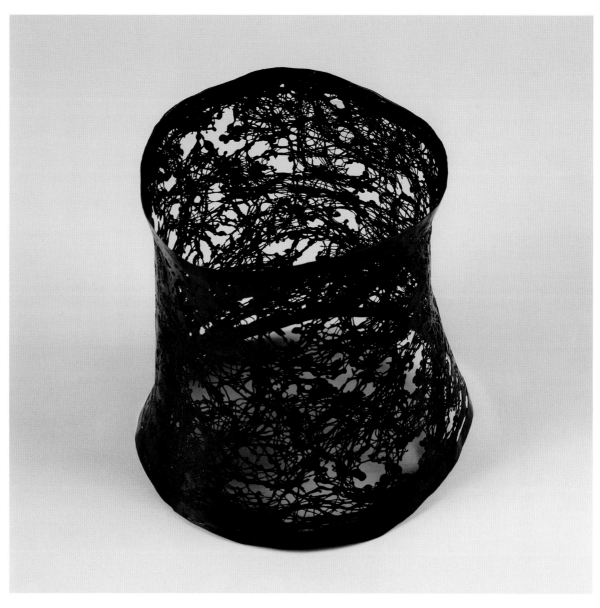

Henriette & Martin Tomasi, **Bracelet,** *2003*
silver thread, fine silver; oxidized
photo: Karen Bell

Charon Kransen Arts

Contemporary innovative jewelry from around the world
Staff: Adam Brown; Lisa Granovsky; Charon Kransen

By Appointment Only
357 West 19th Street
New York, NY 10011
voice 212.627.5073
fax 212.633.9026
chakran@earthlink.net
charonkransenarts.com

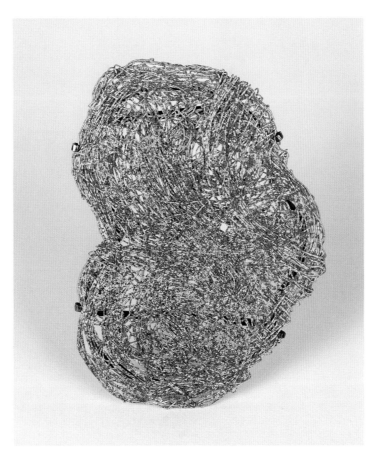

Ike Juenger, **Brooch,** *2003*
silver, enamel
photo: Karen Bell

Representing:

Efharis Alepedis	Stefano Marchetti
Ralph Bakker	Floor Max
Michael Becker	Bruce Metcalf
Harriete Estel Berman	Miguel
Brigitte Bezold	Barbara Paganin
Liv Blavarp	Annelies Planteydt
Petra Class	Jackie Ryan
Giovanni Corvaja	Lucy Sarneel
Simon Cottrell	Sylvia Schlatter
Claudia Cucchi	Renate Schmid
Caroline Friedl	Biba Schutz
Ursula Gnaedinger	Verena Sieber Fuchs
Sophie Hanagarth	Vera Siemund
Anna Heindl	Marjorie Simon
Yasuki Hiramatsu	Charlotte Sinding
Meiri Ishida	Claudia Stebler
Reiko Ishiyama	Dorothee Striffler
Hilde Janich	Barbara Stutman
Karin Johansson	Hye-Young Suh
Ike Juenger	Janna Syvanoja
Traudl Kammermeier	Salima Thakker
Yeonmi Kang	Henriette Tomasi
Martin Kaufmann	Martin Tomasi
Ulla Kaufmann	Tomasi
Yoon Kim	Silke Trekel
Yael Krakowski	Felieke van der Leest
Deborah Krupenia	Andrea Wagner
Dongchun Lee	Jin-Soon Woo
Nel Linssen	Annamaria Zanella
Eva Maisch	

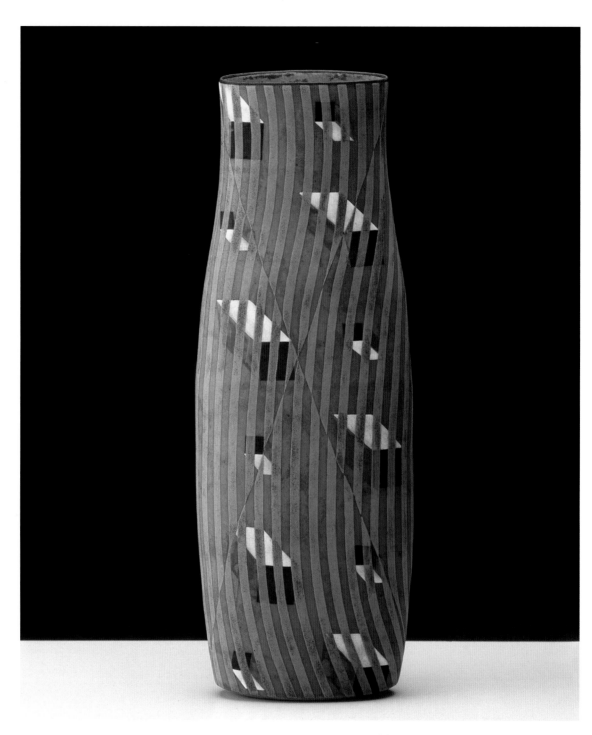

Elizabeth Fritsch, **Counterpoint Vase***, 2003*
hand-built stoneware painted with colored slips, 17 x 6 x 2.5
photo: Alexander Bratell

Clare Beck at Adrian Sassoon

Contemporary British studio ceramics, glass and metalwork
Staff: Clare Beck; Adrian Sassoon

By Appointment
14 Rutland Gate
London SW7 1BB
England
voice 44.207.581.9888
fax 44.207.823.8473
email@adriansassoon.com
adriansassoon.com

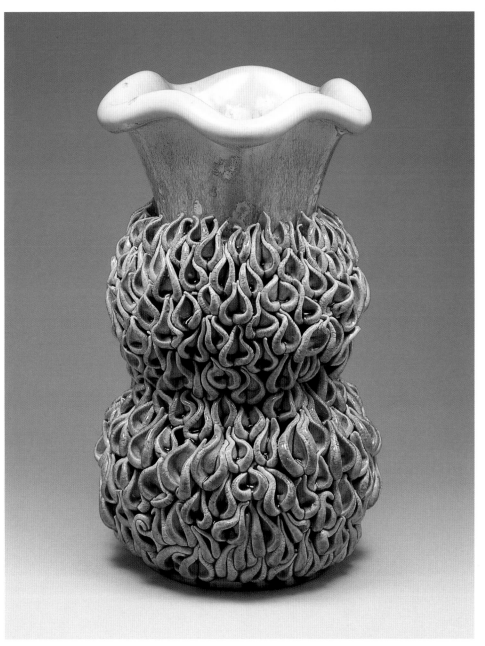

Representing:
Christie Brown
Steve Follen
Elizabeth Fritsch
Kate Malone
Carol McNicoll
Junko Mori
Bruno Romanelli
Hiroshi Suzuki
Neil Wilkin
Rachael Woodman

Kate Malone, **Cotignac Seed Head Baby Bumper Car Pitcher,** *2003*
crystalline-glazed stoneware, 7 x 10.5 x 7
photo: Stephen Brayne

113

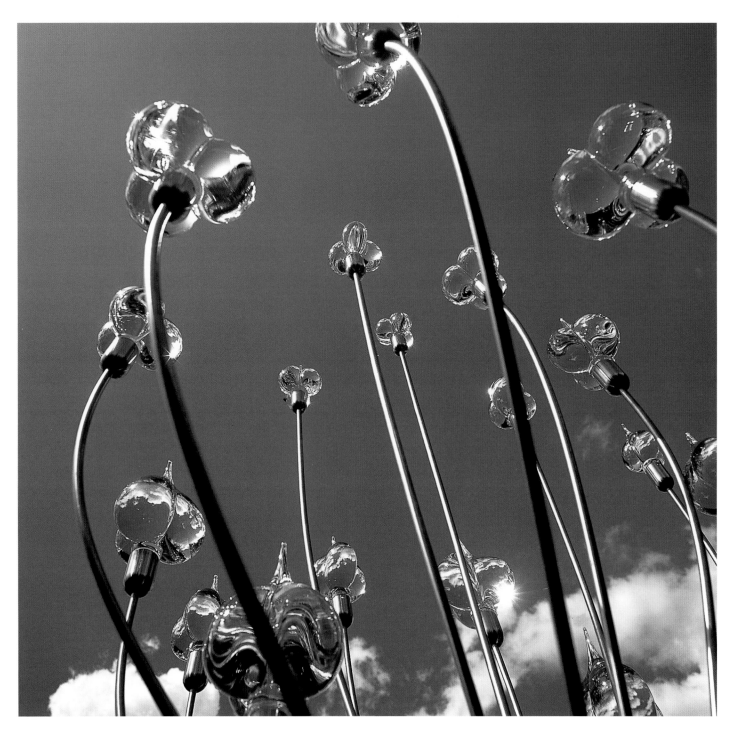

Neil Wilkin, **Tridrop Bush,** *2003*
glass, stainless steel, 48 x 35 x 30
photo: Neil Wilkin

Rachael Woodman, **Vertical 18**
glass, slate, 32 x 23.5 x 5.75
photo: Mandy Reynolds

Jane Blackman, **Intake Lane,** *2003*
ceramic, 16 x 17.75 x 12.5

Contemporary Applied Arts

Promoting the best of British craft since 1948
Staff: Mary LaTrobe-Bateman; Michelle Aitken

2 Percy Street
London W1T 1DD
England
voice 44.207.436.2344
fax 44.207.436.2446
caa.org.uk

Representing:
Julie Arkell
Louise Baldwin
Heather Belcher
Jane Blackman
Bob Crooks
Claire Curneen
Stephen Dixon
Sally Fawkes
Ptolemy Mann
Craig Mitchell
Rupert Spira
Carole Waller
Koichiro Yamamoto

Sally Fawkes, **Eternally Here III,** *2003*
cast, cut and polished glass, 19 x 13.5 x 5.25

Heather Belcher, **Overcoat**, *2003*
felted wool, 63 x 43

Julie Arkell, **Shelf Life**, *2003*
papier maché, wool, fabric, wire, 11.5 x 21 x 4.25

James Nowak, **Sea Pedestal,** *2003*
glass, 56 x 14 x 14

Glass, wood and photography by the best contemporary artists
Staff: Richard Coplan, director; Janna Oxman; Zachary Oxman; James Nowak

10667 Stonebridge Boulevard
Boca Raton, FL 33498
voice 561.451.3928
coplan@bellsouth.net

Representing:
George Green
James Nowak
Zachary Oxman

James Nowak, **Sea Fan**
glass, 12h

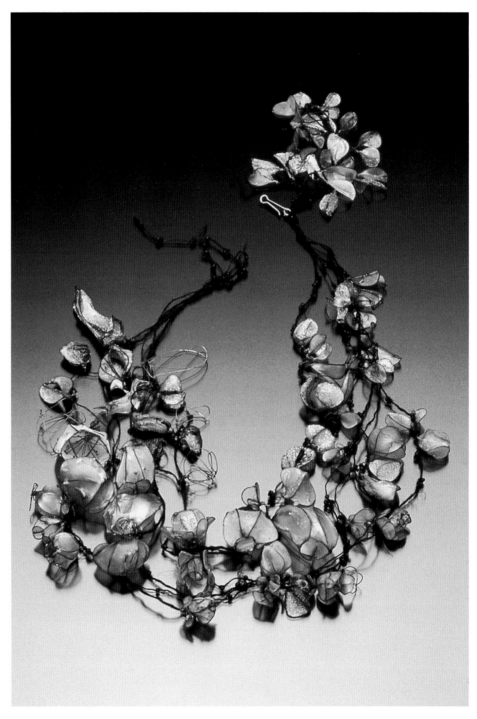

Maria Phillips, **Moment** *neckpiece, 2001*
gut, steel, thread, seed beads
photo: Doug Yapple

The David Collection

International fine arts with a specialty in contemporary studio jewelry
Staff: Jennifer David

44 Black Spring Road
Pound Ridge, NY 10576
voice 914.764.4674
fax 914.764.5274
jkdavid@optonline.net
thedavidcollection.com

Representing:
Mikiko Aoki
Tomomi Arata
Beate Brinkeman
Barbara Christie
Carol de Both
Matina Dempf
Valentine Dubois
Nina Ehmck
Kyoko Fukuchi
Gill Galloway-
 Whitehead
Ursula Gnaedinger
Taru Harmaala
Masako Hayashibe
Lydia Hirte
Tracy Dara
 Kamenstein
Kyung Shin Kim
Heide Kindelmann
Ingrid Larssen
Wilheim Tasso Mattar
Kathie Murphy
Suzanne Otwell Negre
Helge Ott
Inni Pärnänen
Maria Phillips
Alexandra de Serpa
 Pimental
Yvonne Raab
Sabine Reichert
Kayo Saito
Aki Salminen
Berthold Schwaiger
Larry Seegers
Kyoko Urino
Silvia Waltz

Kyung Shin Kim, **Brooches**
handmade Korean paper, pure gold, 24k gold plate
photo: Rudiger Floter

123

Michael Davis, **Flower Series: Ardently Artichoked,** *2003*
reed, acrylic and enamel paint, tin, Plexiglas base, 55.5 x 21 x 21
photo: Deloye Burrell

del Mano Gallery

Contemporary art objects in wood, fiber and clay
Staff: Ray Leier; Jan Peters; Kirsten Muenster; Priscilla Helen

11981 San Vicente Boulevard
Los Angeles, CA 90049
voice 310.476.8508
fax 310.471.0897
gallery@delmano.com
delmano.com

William Hunter, **Free Vessel**
cocobolo, 15 x 15 x 24, photo: Alan Shaffer

Representing:

Dona Anderson	Bud Latven
Gianfranco Angelino	Ron Layport
Trent Bosch	Mike Lee
Joan Brink	Simon Levy
Christian Burchard	Alain Mailland
Marilyn Campbell	Sam Maloof
Jean-Christophe	Bert Marsh
Couradin	Michael Mode
Robert Cutler	William Moore
Leah Danberg	Philip Moulthrop
Michael Davis	Debora Muhl
Rob Dobson	Judy Mulford
Virginia Dotson	Dennis Nahabetian
David Ellsworth	David Nittmann
Wendy Ellsworth	Michael Peterson
Clay Foster	Binh Pho
Donald E. Frith	Norm Sartorius
Giles Gilson	Merryll Saylan
Stephen Gleasner	Betty Scarpino
Louise Hibbert	Peter Schlech
Matthew Hill	David Sengel
Robyn Horn	Michael Shuler
Todd Hoyer	Alfred Sils
William Hunter	Steve Sinner
Arthur Jones	Jack Slentz
John Jordan	Hayley Smith
Donna Kaplan	Gary Stevens
Ron Kent	Jacques Vesery
Leon Lacoursiere	Hans Weissflog
Stoney Lamar	Andi Wolfe
Merete Larsen	Cindy Wrobel

Despard Gallery

Contemporary Tasmanian artists—contemporary and decorative art
Staff: Steven W. Joyce, director

15 Castray Esplanade
Hobart, Tasmania 7000
Australia
voice 61.36.223.8266
fax 61.36.223.6496
steven@despard-gallery.com.au
despard-gallery.com.au

Representing:
Patrick Collins
Bern Emmerichs
Gerhard Emmerichs
Patrick Hall
Ross Straker
Roger Webb

Patrick Collins, **Curtain Call,** *2003
ceramic, majolica, 46.5 x 33.5 x 6.5*

Stanislav Libenský & Jaroslava Brychtová, **Space II**
cast glass, 12 x 12

Donna Schneier Fine Arts

Modern masters in ceramics, glass, fiber, metal and wood
Staff: Donna Schneier; Leonard Goldberg; Jessie Sadia

By Appointment Only
New York, NY
voice 212.472.9175
fax 212.472.6939

Representing:
Jaroslava Brychtová
Wendell Castle
Dale Chihuly
Stanislav Libenský
Harvey Littleton
Michael Lucero
William Morris
Ken Price
Mary Shaffer
Bertil Vallien
František Vízner
Peter Voulkos

Ken Price, Celtic, *1986*
ceramic

Rag Textile (boro), 19th century Japan
indigo dyed cotton, 62 x 76
photo: Paul LeCat

Douglas Dawson

Ancient and antique tribal arts and textiles from Africa, Asia, Oceania and the Americas
Staff: Douglas Dawson, director; Nancy Bender, manager; Armando España, assistant; Roman Bilik

222 West Huron Street
Chicago, IL 60610
voice 312.751.1961
fax 312.751.1962
info@douglasdawson.com
douglasdawson.com

Vessel, Tlatilco Culture, Mexico, 1200-900 B.C.
earthenware, 15 x 6.5
photo: Paul LeCat

Susan York, **The Color of Porcelain No. 2**, *2003*
porcelain, beechwood, 5 x 5 x 7.5

Dubhe Carreño Gallery

Contemporary ceramic art by international artists
Staff: Dubhe Carreño, director; Scott Cedro

5415 West Grace Street
Chicago, IL 60641
voice 773.931.6584
fax 773.442.0279
info@dubhecarrenogallery.com
dubhecarrenogallery.com

Representing:
Tanya Batura
Sadashi Inuzuka
Jae Won Lee
Noemí Márquez
Eric Mirabito
Mariana Monteagudo
Sydia Reyes
Patricia Rieger
Ben Ryterband
Xavier Toubes
Susan York

Noemí Márquez, **Casas del Silencio #5,** *2003*
stoneware, 20.5 x 20 x 12.25

Warren Langley/David Hancock, **Drift #2, Simpson's Gap, Central Australia,** *2003*
remote source lighting installation, digitally recorded image printed on canvas, 45 x 30
photo: David Hancock

Elliott Brown Gallery

Fine, applied and decorative arts in all media; photography, installations
Staff: Kate Elliott, director; Charlotte Webb; Jill Davis

Seattle, WA
voice 206.660.0923
fax 425.831.3709
kate@elliottbrowngallery.com
elliottbrowngallery.com

Representing:
Dale Chihuly
Laura de Santillana
David Hancock
Charles Krafft
Warren Langley
Richard Marquis
John McQueen
Louis Mueller
Pike Powers
Toots Zynsky

Louis Mueller, **Come Again,** *2003*
fabricated bronze, oil paint, 13 x 9 x 4

Sergei Isupov, **Fourteen Pleasures,** *2003*
vitreous china, 43 x 72 x 3
photo: courtesy of John Michael Kohler Arts Center

Ferrin Gallery

Contemporary ceramic art and narrative sculpture; featuring a selection of contemporary teapots and individual artist presentations
Staff: Leslie Ferrin; Donald Clark; Michael McCarthy; Todd Clark

Postal address:
163 Teatown Road
Croton on Hudson, NY 10520
voice 914.271.9362
fax 914.271.0047

56 Housatonic Street
Lenox, MA 01240
voice 413.637.4414
info@ferringallery.com
ferringallery.com

Representing:
Adrian Arleo
Russell Biles
Linda Cordell
Paul Dresang
Michelle Erickson
Julia Galloway
David Gignac
Rain Harris
Mark Hewitt
Sergei Isupov
Randy Johnston
Michael Kline
Robin Kranitzky
Kathryn McBride
Jan McKeachie-
 Johnston
Matthew Metz
Ron Meyers
Kim Overstreet
Karen Portaleo
Mark Shapiro
Jane Shellenbarger
Michael Sherrill
Linda Sikora
Michael Simon
Chris Staley
Mara Superior
Joan Takayama-
 Ogawa
Susan Thayer
Christine Viennet
Jason Walker
Patti Warashina
Red Weldon-Sandlin
Irina Zaytceva

*Michael Sherrill, **Undressed (Mountain Magnolia)**, 2003
porcelain, forged steel, 16 x 22 x 10
photo: Tim Barnwell*

Rusty Wolfe, **Enchanted,** *2003*
lacquer, MDF, wood, 76 x 60 x 4

Finer Things Gallery

Wall constructions and sculpture
Staff: Kim Brooks, director

1898 Nolensville Road
Nashville, TN 37210
voice 615.244.3003
fax 615.254.1833
kkbrooks@bellsouth.net
finerthingsgallery.com

Representing:
Sylvia Hyman
Brad Sells
Kathleen Stephenson
Joël Urruty
Delos Van Earl
Scott Wise
Rusty Wolfe

Sylvia Hyman, **Sonatina Album**
stoneware, porcelain, 12 x 11.5 x 9

Beverly Mayeri, **Braid,** *2003*
low-fire clay, acrylic, 19 x 12 x 8
photo: Lee Fatherree

Franklin Parrasch Gallery, Inc.

Contemporary art

Staff: Franklin Parrasch; Ian Pedigo; Kate Simon

20 West 57th Street
New York, NY 10019
voice 212.246.5360
fax 212.246.5391
info@franklinparrasch.com
franklinparrasch.com

John Cederquist, **Untitled Cabinet**, *2003*
various woods, inks, 69 x 54 x 19

Representing:
Robert Arneson
Lynda Benglis
Kate Blacklock
John Cederquist
Stephen DeStaebler
Beverly Mayeri
Ken Price
Betty Woodman

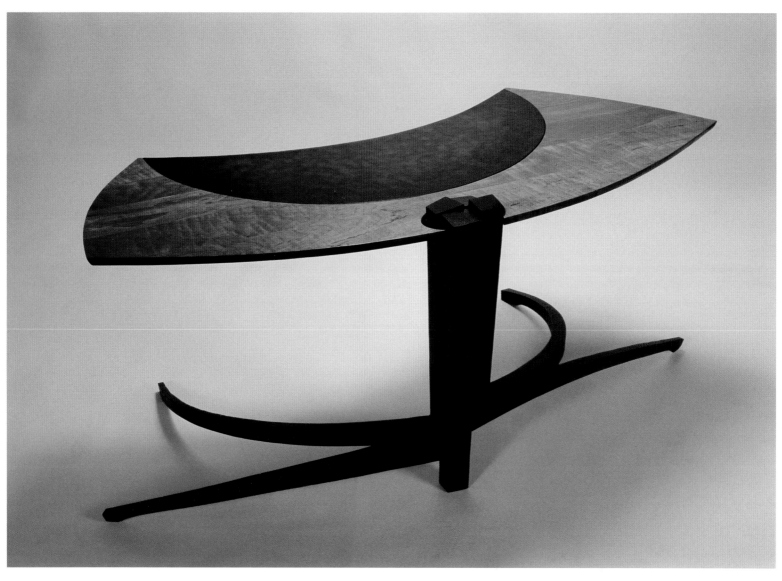

Christopher J. Martin, **Writing Desk,** *2000*
cherry, steel, leather, 30 x 74 x 32

Function + Art

Fine contemporary craft specializing in glass and studio furniture
Staff: D. Scott Patria, director; Amy Hajdas and J. Thomas, assistants

1046 West Fulton Market
Chicago, IL 60607
voice 312.243.2780
director@functionart.com
functionart.com

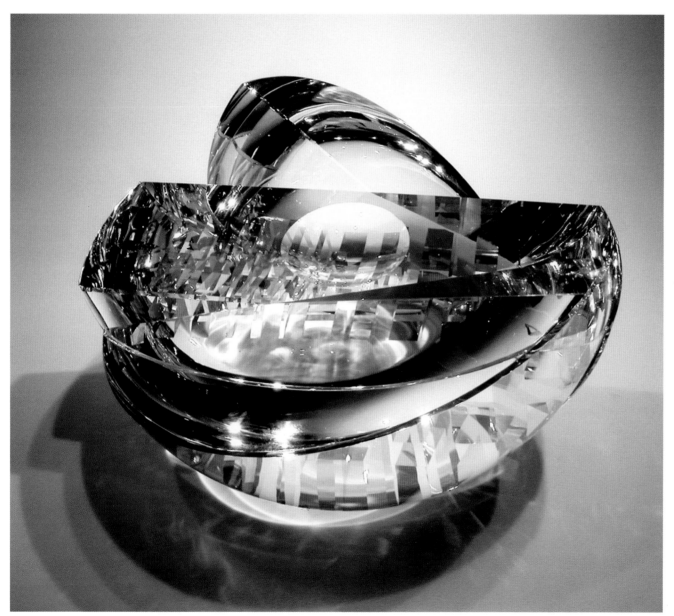

Representing:
Christopher J. Martin
Ed Pennebaker
Toland Sand

Toland Sand, **Hemisphere Redux,** *2003*
laminated optical and dichroic glass, 10 x 10 x 7

Stanislav Libenský & Jaroslava Brychtová, **Rise***, 1986*
moulded glass, 32 x 47
photo: Jiří Švachula

Galerie Aspekt

Fine contemporary art—painting, glass, sculpture
Staff: Jiří Švachula, owner; Katerina Nemcova

Udolni 13
Brno 60200
Czech Republic
voice 420.60.316.7181
fax 420.54.123.6494
galerie@galerieaspekt.com
galerieaspekt.com

Representing:
Jaroslava Brychtová
Bohumil Eliáš
Vladimír Kopecký
Stanislav Libenský
Jan Mares

Vladimír Kopecký, **Peace,** *2001*
glass, steel, 39 x 13 x 6
photo: Gabriel Urbánek

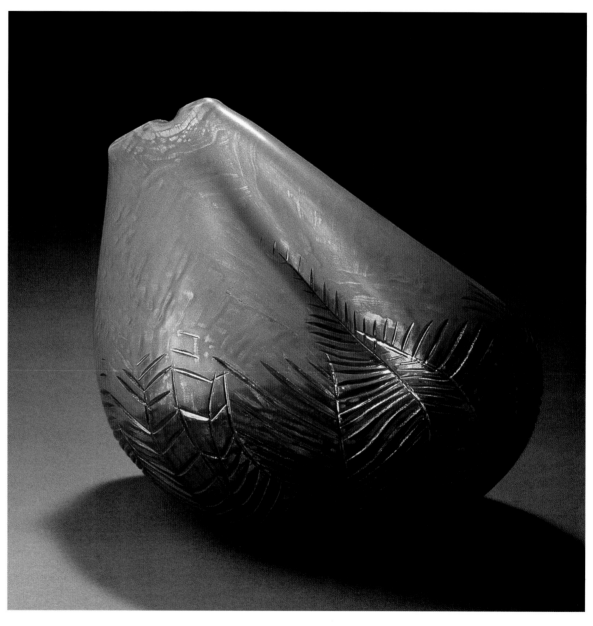

Gérald Vatrin, **Leaves,** *2003*
glass, 10 x 12 x 11

Galerie Ateliers d'Art de France

Work by contemporary French artists in a variety of media
Staff: Marie-Armelle de Bouteiller; Anne-Laure Roussille

22 Avenue Niel
Paris 75017
France
voice 33.14.888.0658
fax 33.14.440.2368
galerie@ateliersdart.com
createdinfrance.com/artwork

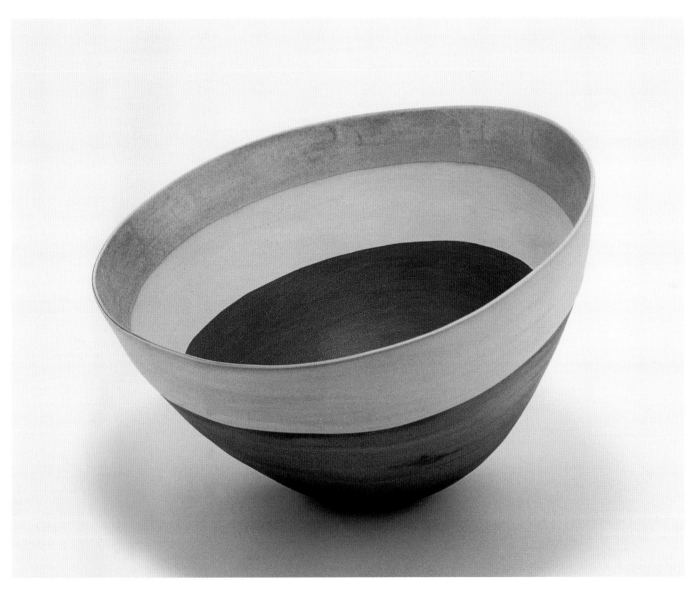

Representing:
François Belliard
Martine Damas
Roland Daraspe
Gérald Vatrin

Martine Damas, **Hommage à la Sphère**, *2003*
colored clay, 14 x 11

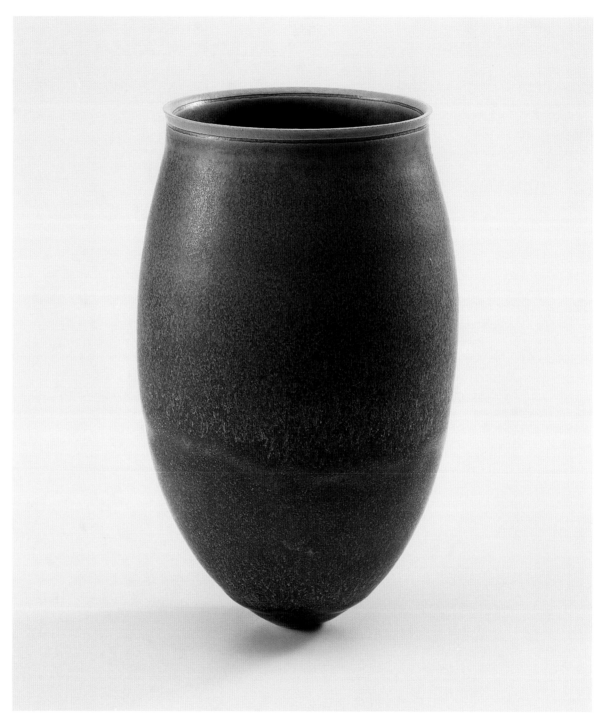

Alev Ebüzziya Siesbye, **Mediterranean Blue Vessel,** *2003*
stoneware, 11 x 5.75

Galerie Besson

International contemporary ceramics
Staff: Anita Besson, owner; Matthew Hall, manager

15 Royal Arcade
28 Old Bond Street
London W1S 4SP
England
voice 44.207.491.1706
fax 44.207.495.3203
enquiries@galeriebesson.co.uk
galeriebesson.co.uk

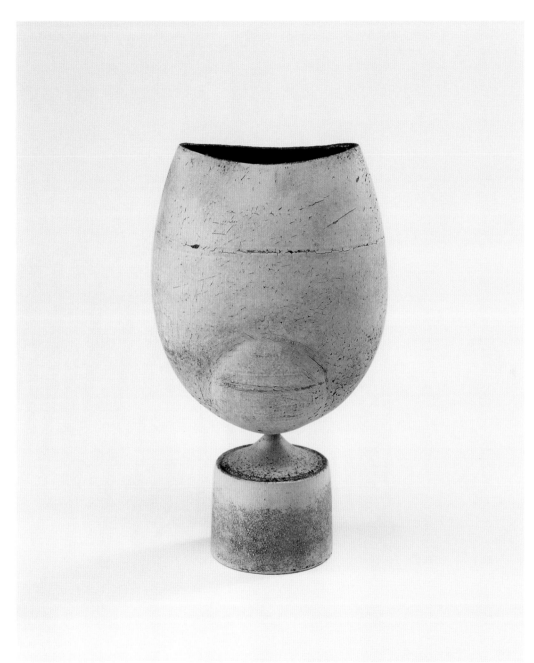

Representing:
Claudi Casanovas
Hans Coper
Ryoji Koie
Jennifer Lee
Lucie Rie
Alev Ebüzziya Siesbye
Annie Turner
Kwang-Cho Yoon

Hans Coper, **White Composite Form,** *c. 1972*
stoneware, 7h

Annie Turner, **River Funnels,** *2003*
stoneware, 13.75h

Lucie Rie, Knitted Bowl, *1987*
stoneware, 10d

Yan Zoritchak, **Space Signal,** *2003*
optical glass, 16h
photo: Michel Wirth

Galerie Daniel Guidat

Contemporary glass

Staff: Daniel Guidat; Albert Feix III

142 Rue D'Antibes
Cannes 06400
France
voice 33.49.394.3333
fax 33.49.394.3334
gdg@danielguidat.com
danielguidat.com

Representing:
Alain Bégou
Francis Bégou
Marisa Bégou
Elisabeth Decobert
Nad Vallee
Yan Zoritchak
Czeslaw Zuber

Nad Vallee, **Point Primal**
moulded glass, raku, 16h
photo: Romero

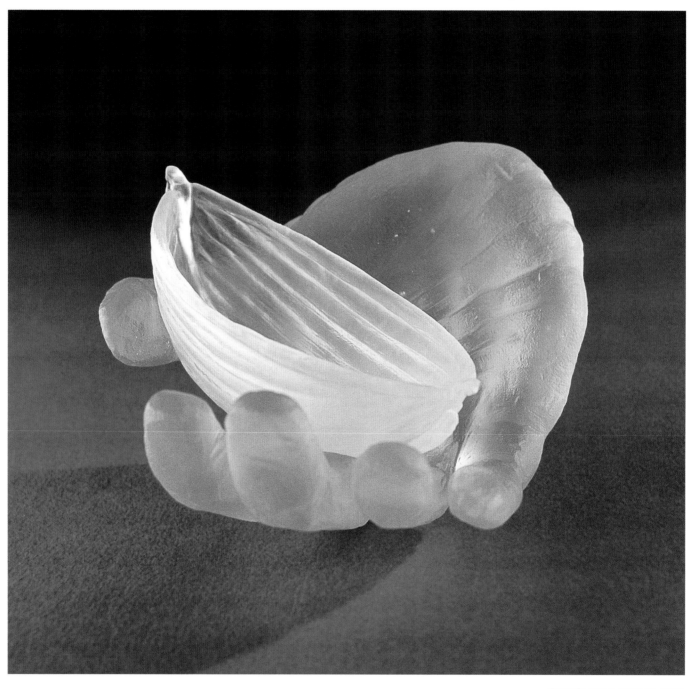

Brad Copping, **Entrust,** *2003*
hot-worked and blown glass, carved, sand and acid-etched, 5 x 3 x 5.5
photo: Brad Copping

Galerie Elena Lee

New directions of contemporary art glass for over 27 years

Staff: Elena Lee, president; Joanne Guimond, director; Cinzia Colella; Josée St-Onge; Sylvia Lee

1460 Sherbrooke West
Montreal, Quebec H3G 1K4
Canada
voice 514.844.6009
fax 514.844.1335
info@galerieelenalee.com

Representing:
Annie Cantin
Brad Copping
Kevin Lockau
Tanya Lyons
Caroline Ouellette
Donald Robertson
Cathy Strokowsky

Annie Cantin, **Brins de Foile***, 2003*
blown glass wall installation, textile, raffia, 11.5 x 11 x 15
photo: Olivier Samson Arcand

Sten Bülow Bredsted, **Animal in Room Room in Animal**, *2002*
silver, rubber, 5 x 5
photo: Jesper Hyllemose

Galerie Metal

Experimental jewelry of ten young Danish artists
Staff: Nicolai Appel, director; Else Nicolai Hansen, sales manager

Nybrogade 26
Copenhagen K, 1203
Denmark
voice 45.33.145540
fax 45.33.145540
galeriemetal@mail.dk
galeriemetal.dk

Representing:
Nicolai Appel
Gitte Bjørn
Sten Bülow Bredsted
Yvette Strenge
 Bredsted
Carsten From-
 Andersen
Lars Glad
Mette Laier
Helle Løvig
Karina Noyons
Lene Wolters

Gitte Bjørn, **Disquieting Pocket Charms,** *2003*
silver, 2 x 2
photo: Jesper Hyllemose

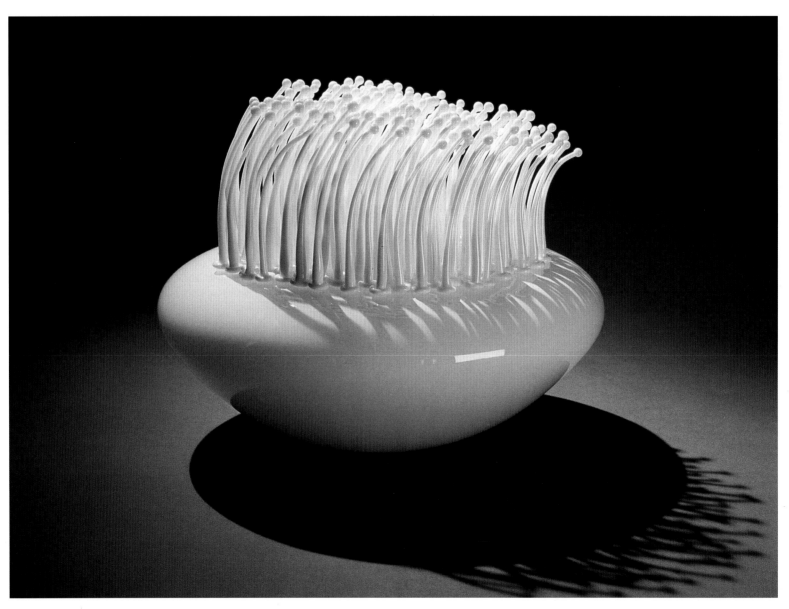

Maude Bussières, **Spirit of Growth, That's the Way...,** *2002*
blown glass, torch work, 8.5 x 11
photo: Michel Dubreuil

Galerie des Métiers d'Art du Québec

Works by contemporary Quebec artists in a variety of media

Staff: Yvan Gauthier, executive director; France Bernard, gallery director; Chantale Clarke, export officer; Pascal Beauchesne, communications officer

350 Saint-Paul East
Suite 400
Montreal, Quebec H2Y 1H2
Canada
voice 514.861.2787, ext. 310
fax 514.861.9191
france.bernard@metiers-d-art.qc.ca
galeriedesmetiersdart.com

Representing:
Jacinthe Baribeau
Gildas Bertheldt
Maude Bussières
Laurent Craste
Roland Dubuc
Carole Frève
Bruno Gérard
Monique Giard
Jean-Marie Giguère
Chantal Gilbert
Antoine Lamarche
Eva Lapka
Claudio Pino
Stephen Pon
John Paul Robinson
Natasha St. Michael
Luci Veilleux

Claudio Pino, **Extravaganza***, 2003*
kinetic ring; 18k red gold, sterling silver, citrines, opal, 0.5 x 1.5 x 1
photo: Philomène Longpré

René Roubíček, **Yellow Rastr** from the **Picture Gallery Series,** *2000*
cut and laminated glass, 20 x 17 x 5

Galerie Pokorná

Contemporary art and design with special accent on glass material
Staff: Jitka Pokorná; Lucie Čepková

Jańský Vršek 15
Prague 2, 12000
Czech Republic
voice 420.222.518635
fax 420.222.518635
jitka@galeriepokorna.cz
lucie@galeriepokorna.cz
galeriepokorna.cz

Representing:
Jaroslava Brychtová
Václav Cigler
Bohumil Eliáš
Jan Frydrych
Cyril Hančl
Pavel Hlava
Vladimír Kopecký
Stanislav Libenský
Břetislav Novák
Štěpán Pala
Zora Palová
René Roubíček
Miluše Roubíčková
František Vízner

František Vízner, **Oblong,** *2000*
cut and acid-washed crystal glass, 6 x 12 x 12
photo: Gabriel Urbánek

161

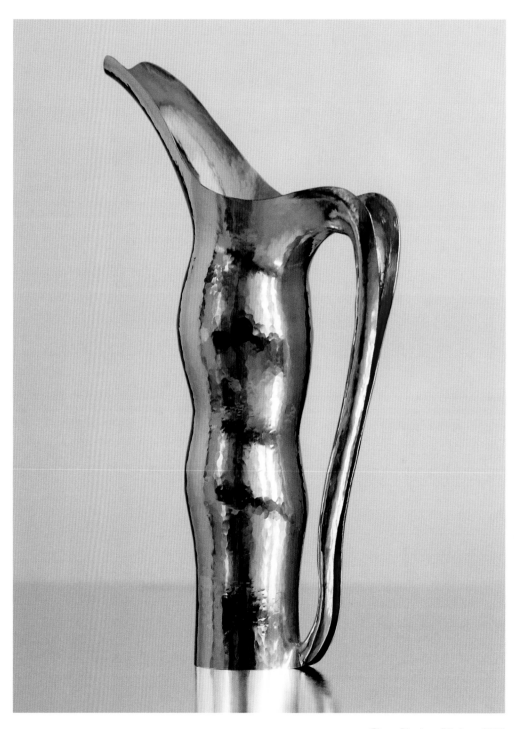

Claus Bjerring, **Pitcher***, 2003*
925 silver, 16 x 8.75 x 4
photo: Lars Gundersen

Galerie Tactus

Contemporary European hollowware and a touch of jewelry
Staff: Lina and Peter Falkesgaard

54 Gothersgade
Copenhagen 1123
Denmark
voice 45.33.933105
fax 45.35.431547
tactus@galerietactus.com
galerietactus.com

Representing:
Lasse Baehring
Tobias Birgersson
Claus Bjerring
Anette Dreyer
Jens Eliasen
Klara Eriksson
Petronella Eriksson
Lina Falkesgaard
Castello Hansen
Torben Hardenberg
David Huycke
Karen Ihle
Sidsel Dorph Jensen
Ragnar Joergensen
Leon Kastberg
Martin Kaufmann
Ulla Kaufmann
Tina Kronhorst
Aasa Lockner
Allan Scharff
Tore Svensson
David Taylor
Erik Tidäng

Torben Hardenberg, **Celery Holder and Salt Cellar**
rock crystal, 925 silver, 7.5 x 5.5 x 2.5; 1.75 x 2.75 x 2
photo: Torsten Graae

Anna Chromy, **Nile,** *2000*
bronze, 68.5h

Galerie Vivendi

Contemporary art gallery with an emphasis on sculpture and painting
Staff: Mark Hachem; Serge Izzard

28 Place des Vosges
Paris 75003
France
voice 33.14.276.9076
fax 33.14.276.9547
vivendi@vivendi-gallery.com
vivendi-gallery.com

Representing:
Jean-Jacques
 Arguerolles
Ruth Bloch
Anna Chromy
Dirk de Keyzer
Vincent Magni
Carlos Mata

Carlos Mata, **Horse,** *2001*
bronze

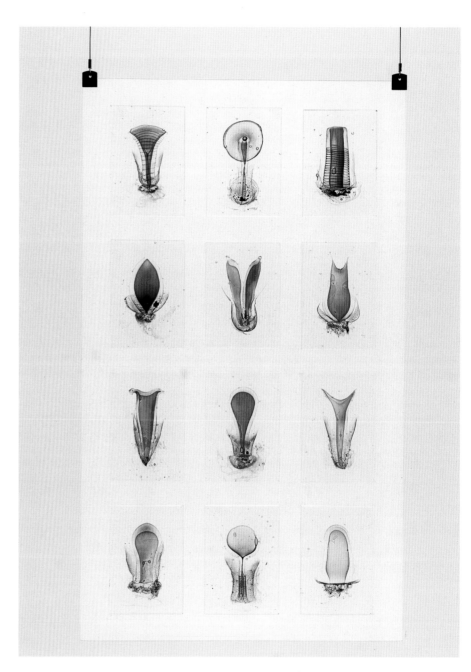

Steffen Dam, **Flowers Board**, *2003*
glass, iron frame

Galleri Grønlund

Contemporary Danish glass
Staff: Anne Merete Grønlund; Kirstine Grønlund; Stig Persson

Birketoften 16a
Vaerloese 3500
Denmark
voice 45.44.442798
fax 45.44.442798
groenlund@get2net.dk
glassart.dk

Representing:
Steffen Dam
Darryle Hinz
Jørgen Karlsen
Per-Rene Larsen
Tobias Møhl
Tchai Munch
Else Leth Nissen
Stig Persson

Darryle Hinz, **Vase Murrini Technique SM**, *2003*
glass, 13.5h, photo: Ole Akhøj

Bodil Manz, **Cylinders,** *2003*
porcelain, 4 x 4.8; 4.8 x 5.8
photo: Ole Akhøj

Galleri Nørby

Contemporary Danish ceramics
Staff: Bettina Køppe, director; Jeanette Hiiri, assistant

Vestergade 8
Copenhagen K, 1456
Denmark
voice 45.33.151920
fax 45.33.151963
info@galleri-noerby.dk
galleri-noerby.dk

Representing:
Karen Bennicke
Michael Geertsen
Nina Hole
Steen Ipsen
Martin Bodilsen
 Kaldahl
Bodil Manz
Bente Skjøttgaard

Karen Bennicke, **Formscape***, 2003*
faience, 7.2 x 12.8 x 16.5
photo: Ole Akhøj

Silvia Levenson, **Little Ulysses**, *2003*
glass, rubber, 30 x 65 x 45

Galleria Caterina Tognon

Contemporary fine art gallery
Staff: Caterina Tognon, director; Sergio Gallozzi, assistant; Sara Rubbi, assistant

San Marco 2671
Campo San Maurizio
Venice 30124
Italy
voice 39.041.520.7859
fax 39.041.520.7859

Via San Tomaso, 72
Bergamo 24121
Italy
voice 39.035.243300
fax 39.035.243300
caterinatognon@tin.it

Representing:
Silvia Levenson
Richard Meitner
Gisela Sabokova

Richard Meitner, **A Hemispheric Question,** *2003*
blown and enameled glass, carved wood, book, paint, 16.5 x 9.5 x 6.5
photo: Ron Zijlstra

Mark Chatterley, **Airplane Girl**
high-fired crater glaze stoneware, hand-built, 78 x 22 x 27

Gallery 500

Celebrating 35 years of service to collectors of contemporary fine art and craft in all media

Staff: Rita Greenfield, owner

3502 Scotts Lane
Suite 303
Philadelphia, PA 19129
voice 215.849.9116
fax 215.849.9116
gallery500@hotmail.com
gallery500.com

Representing:
Carolyn Morris Bach
Mark Chatterley
Dale Gottlieb
Linda Leviton
Kaiser Suidan
Tom Wargin

Carolyn Morris Bach, **Winged Goddess** *pendant, 2003*
18 and 22k gold, ammonite, rutilated quartz, fossilized ivory, 4.5 x 3

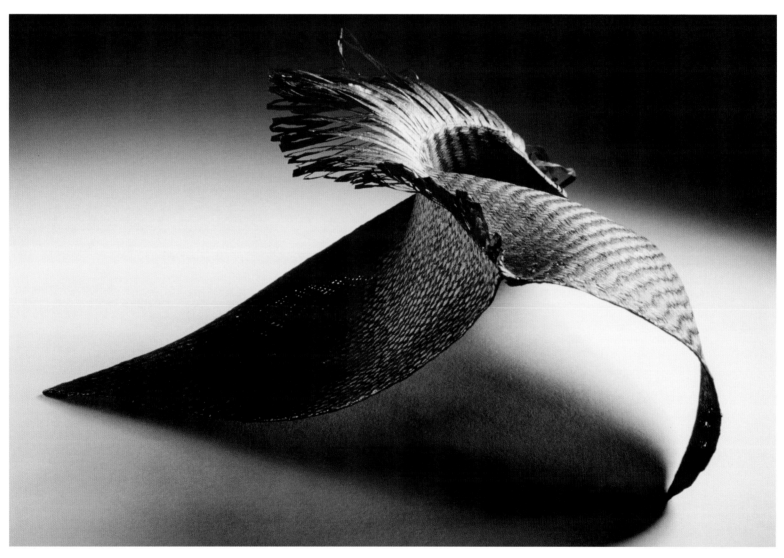

Grethe Wittrock, **Shell of Animal,** *2002*
woven Japanese paper yarn, 5.5 x 8.7 x 11.8
photo: Ole Akhøj

Gallery deCraftig

Contemporary Danish textile art
Staff: Astrid Krogh, director

Dag Hammarskjölds Allé 7
Copenhagen 2100
Denmark
voice 45.20.823771
info@astridkrogh.com

Representing:
Anne Fabricius-Møller
Lisbeth Friis
Helle Graabæk
Bitten Hegelund
Charlotte Houman
Astrid Krogh
Puk Lippmann
Ane Lykke
Kirsten Nissen
Grethe Wittrock

Astrid Krogh, **Blue,** *2002*
woven optical fibers, 118 x 98 x 20
photo: Bent Ryberg

175

Seung-Hee Kim, **You, Me and Us** brooch, *2003*
agate, blue topaz, 14k gold, 2 x 1.5 x .5

Gallery Gainro

The only gallery in Korea specializing in jewelry and light metal craft
Staff: Hyun-Jung Won, director; Song-Hee Lee, curator; A-Jung Kim, curator

Gaonix Bldg., 1F
Sinsa-Dong 575
Kangnam-Gu
Seoul 135-100
Korea
voice 822.541.0647
fax 822.541.0677
gainro@hanmail.net
gainro.co.kr

Representing:
Soo-Jung Back
Yu-Jin Cho
Seo-Yoon Choi
Ji-Hee Hong
Sun-Young Jang
Eun-Mi Jeon
In-Kang Jeon
Bong-Hee Kim
Jae Young Kim
Jong-Ryeol Kim
Seung-Hee Kim
Seung-Hyun Koh
Soon-Hwa Kwak
Hyung-Kyw Lee
Young-Hee Park
Sung-Soo Park
My-Hyun Ryu

Jae Young Kim, **Square in the Sky I, II,** *2003*
silver, gold, bamboo, jade, 2.5 x 2; 3.7 x 1.5

Eleri Mills, O'r Tir Rhif 2 (Of the Land 2), *2001*
paint, hand-stitched and appliqué on cloth, 46.5 x 15
photo: Dewi Tanatt Lloyd

The Gallery at Ruthin Craft Centre

Contemporary craft and applied art from Wales
Staff: Philip Hughes; Jane Gerrard; Ceri Jones

Park Road
Ruthin, Denbighshire
Wales LL15 1BB
UK
voice 44.182.470.4774
fax 44.182.470.2060
thegallery@rccentre.co.uk

Representing:
Daniel Allen
Julia Griffiths-Jones
Catrin Howell
Christine Jones
Eleri Mills
Audrey Walker

Daniel Allen, **Sunday Supplement***, 2002*
stoneware, tin glaze, ceramic decals, 37.5h
photo: Daniel Allen

Audrey Walker, **Observed Incident,** *2002*
hand stitching on cloth, 52 x 55
photo: Audrey Walker

Christine Jones, **Vessels,** *2002*
coiled earthenware, various sizes
photo: Nicola O'Neill

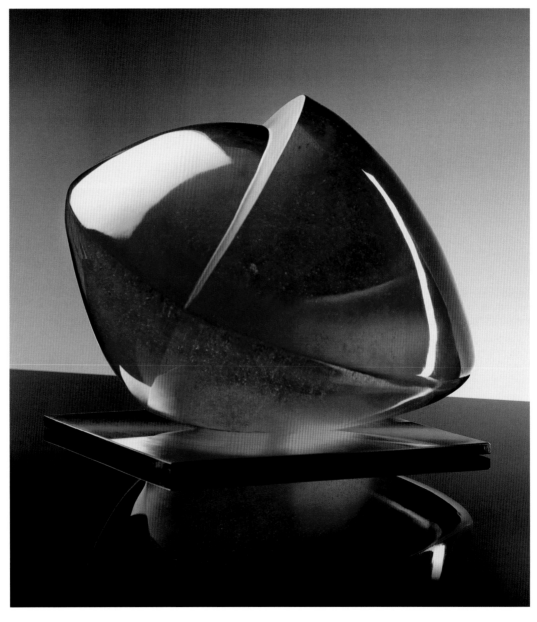

Claudio Tiozzo, **Numero Uno,** *2002*
kiln-formed, cold-worked Murano glass, 13 x 19.5 x 13.5

Genninger Studio

Contemporary glass sculpture and studio Murano glass jewelry and functional art
Staff: Leslie Genninger; Michelle Benzoni; Donna Routt; Alan Routt

2793/A Dorsoduro
Calle del Traghetto
Venice 30123
Italy
voice 39.041.522.5565
fax 39.041.522.5565
leslieg@tin.it
genningerstudio.com

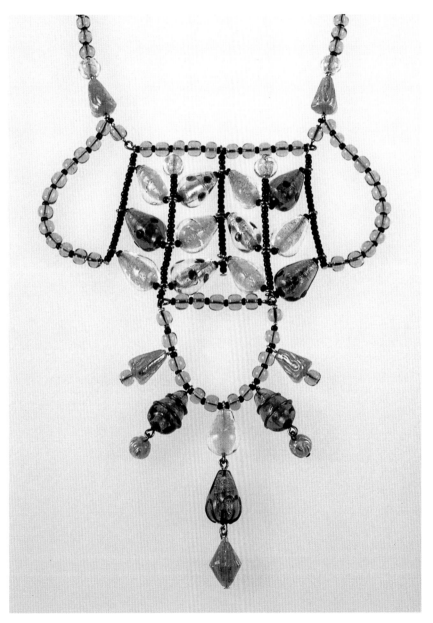

Representing:
Leslie Ann Genninger
Claudio Tiozzo

Leslie Ann Genninger, **Harvest,** *2003*
flame-worked Murano glass beads, 24k gold leaf, silver leaf inclusions
photo: Gian Mauro La Penna

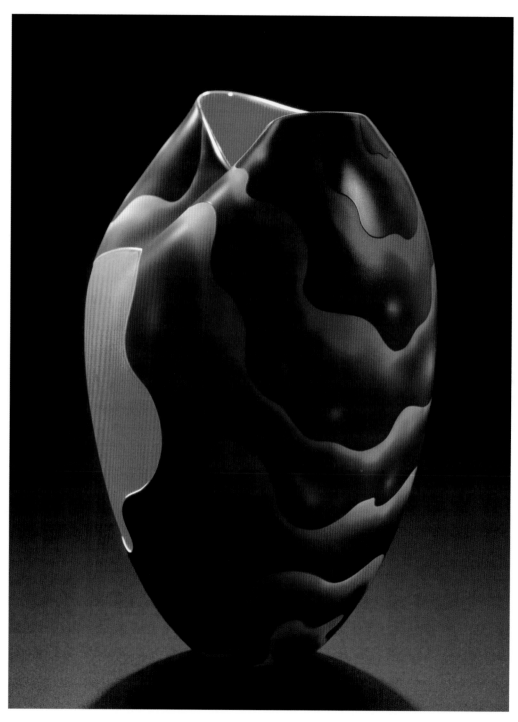

David Hay, **Red Centre***, 2003*
blown glass, overlaid, carved and kiln-polished, 15.5 x 10 x 10

Glass Artists' Gallery

Australia's only specialist glass gallery with a resource of over 80 Australian and New Zealand artists
Staff: Maureen Cahill

70 Glebe Point Road
Glebe, Sydney, NSW 2037
Australia
voice 61.29.552.1552
fax 61.29.552.1552
glassartistsgallery@bigpond.com
glassartistsgallery.com.au

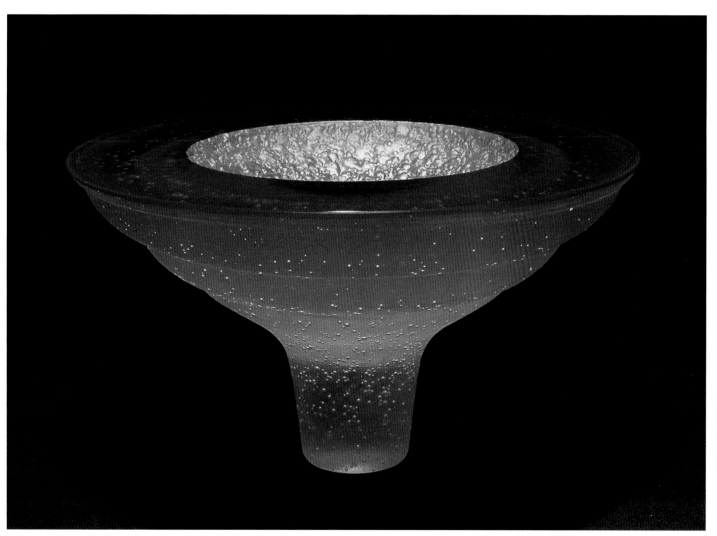

Representing:
Simon Butler
Kevin Gordon
David Hay
Rodney Monk
Keith Rowe
Tim Shaw

Simon Butler, **Purple Haze***, 2003*
lost wax cast crystal, 6.25 x 12 x 12

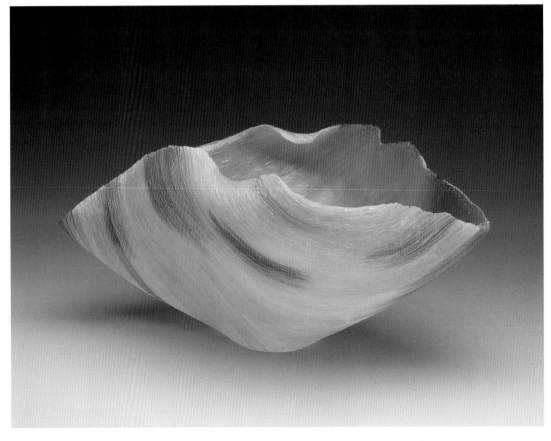

Toots Zynsky, **Scoperta,** *2003*
glass monofilaments, 5.5 x 11.75 x 7

Habatat Galleries

Contemporary glass sculpture by the world's most renown artists
Staff: Linda J. Boone, president; Lindsey Scott, director

117 State Road
Great Barrington, MA 01230
voice 413.528.9123
fax 413.644.9981

608 Banyan Trail
Boca Raton, FL 33431
voice 561.241.4544
fax 561.241.5793
info@habatatgalleries.com
habatatgalleries.com

Dan Dailey, **Feelers**, 2003
*blown glass, nickel, gold plated bronze, 22 x 8 x 8
photo: Bill Truslow*

Representing:
José Chardiet
KéKé Cribbs
Dan Dailey
Noel Hart
Colin Heaney
Jon Kuhn
Robert Mickelsen
Debora Moore
William Morris
Joseph Pagano
Peter Powning
Michael Taylor
Toots Zynsky

Ann Wolff, **Anna 3** from the **Berlin Faces Series**, *2003*
sculptural collages, glass, 20 x 16.75 x 4.25
photo: Andrea Kroth

Habatat Galleries

The finest in international contemporary glass sculpture

Staff: Ferdinand Hampson, president; Kathy Hampson; John Lawson, director; Shannon Trudell; Anthea Noonan

202 East Maple Road
Birmingham, MI 48009
voice 248.203.9900
fax 248.282.5019

4400 Fernlee Avenue
Royal Oak, MI 48073
voice 248.554.0590
fax 248.554.0594
info@habatat.com
habatat.com

Representing:
Herb Babcock
Philip Baldwin
Martin Blank
Latchezar Boyadjiev
Daniel Clayman
Monica Guggisberg
Kimiake Higuchi
Shin-Ichi Higuchi
Petr Hora
Steve Linn
Leah Wingfield
Ann Wolff

Petr Hora, **Neptune,** *2003*
cast glass, 18 x 13.5 x 4
photo: Miroslav Vojtechovsky

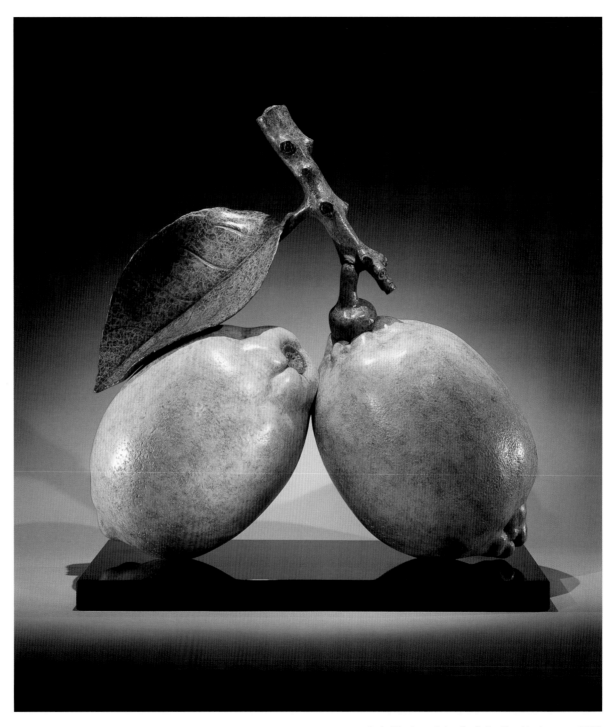

Luis Montoya & Leslie Ortiz, **Double Lemon**, *2002*
patinated bronze, 24 x 23 x 11

Hawk Galleries

Contemporary work by modern masters
Staff: Tom Hawk, director; Tyler Steele, manager

153 East Main Street
Columbus, OH 43215
voice 614.225.9595
fax 614.225.9550
tom@hawkgalleries.com
hawkgalleries.com

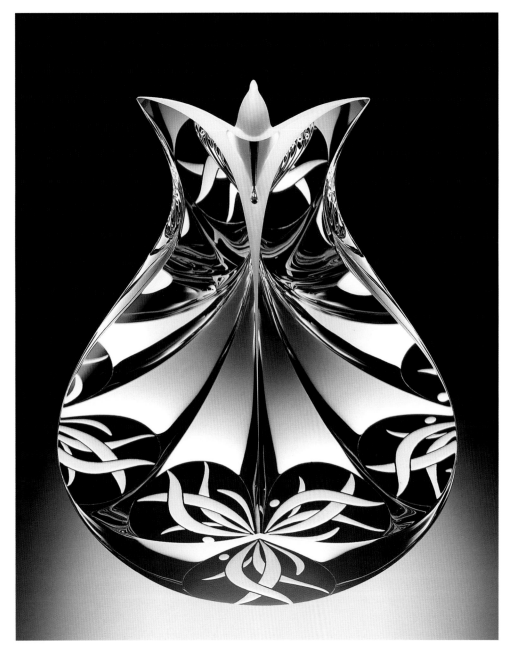

Representing:
Dante Marioni
Julie Mihalisin
Luis Montoya
Leslie Ortiz
Albert Paley
Flo Perkins
Christopher Ries
Paul Schwieder
Philip Walling

Christopher Ries, **Wild Orchid,** *2001*
glass; cut, ground and polished, 20.5 x 15 x 5.75

Julie Mihalisin & Philip Walling, **Scattered Squares***, 2002*
glass, metal, concrete, 44.5 x 56 x 4

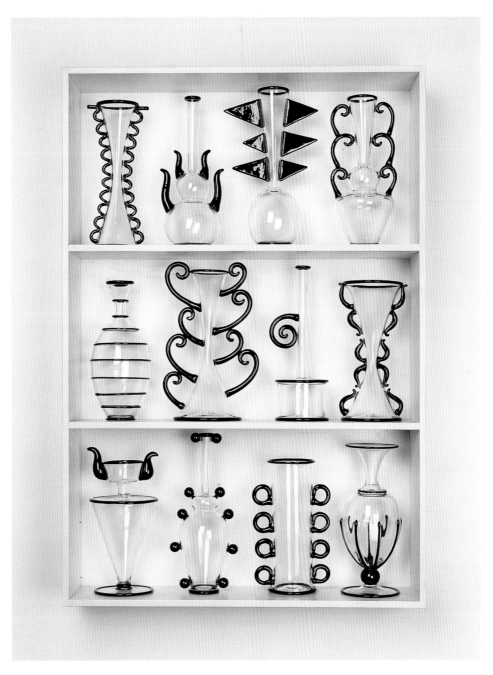

Dante Marioni, **Vessel Display,** *2003*
blown glass, 27 x 18.5 x 5
photo: Roger Schreiber

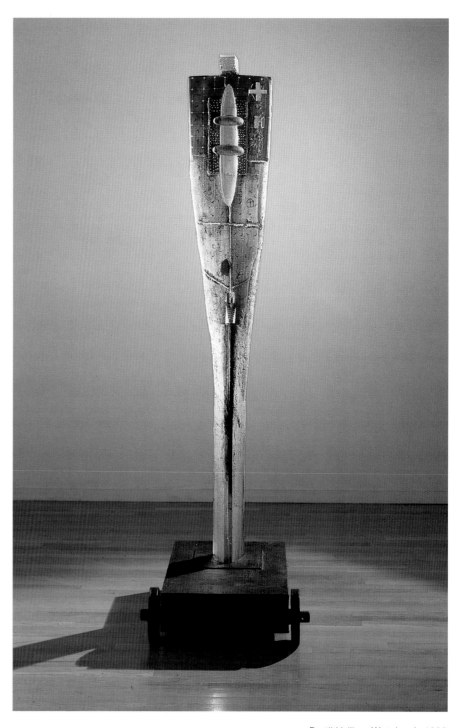

Bertil Vallien, **Watcher I,** *1998*
glass, wood, 79 x 23 x 29

Heller Gallery

Celebrating 30 years exhibiting sculpture using glass as a fine art medium
Staff: Douglas Heller; Katya Heller; Michael Heller

420 West 14th Street
New York, NY 10014
voice 212.414.4014
fax 212.414.2636
info@hellergallery.com
hellergallery.com

Representing:
Tom Patti
Bertil Vallien

Tom Patti, **Bi-Lumina Monitor,** *2003*
architectural glass, 52 x 20 x .875

Michael Heltzer, **Woven Trellis System,** *2002*
stainless steel, teak, blue stone, various sizes
photo: Jim Hedrich, Hedrich Blessing

Heltzer

Contemporary furniture, textiles and fiber works
Staff: Michael Heltzer; Judith Simon; Michael Shaw

The Merchandise Mart
Suite 1800
Chicago, IL 60654
voice 312.527.3010
fax 312.527.3176
info@heltzer.com
heltzer.com

Representing:
Frank Connet
Michael Heltzer
Kyoko Ibe

Frank Connet, **Untitled T-104,** *2002*
wool, collaged shibori textile, natural dyes, 73.5 x 58
photo: Larry Fritz

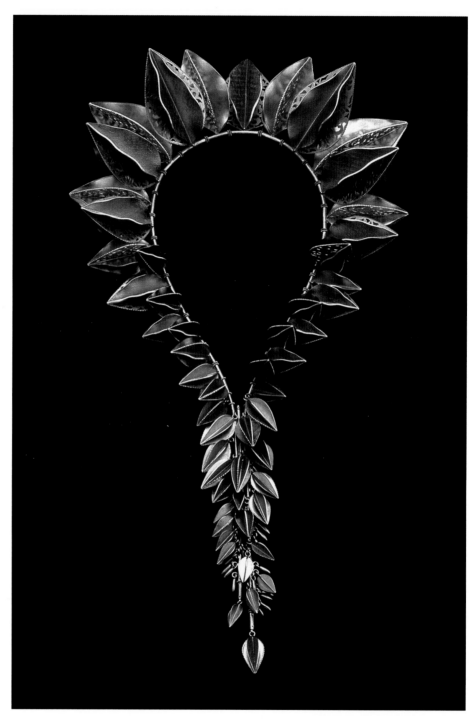

Lori Talcott, **Brising's Mantle,** *2002*
silver on steel cable, 19 x 12 x 4
photo: Gina Rymarcsuk

Hibberd McGrath Gallery

Contemporary American fiber, ceramics, and jewelry
Staff: Martha Hibberd, partner; Terry McGrath Craig, partner

101 North Main Street
Breckenridge, CO 80424
voice 970.453.6391
fax 970.453.6391
terry@hibberdmcgrath.com
hibberdmcgrath.com

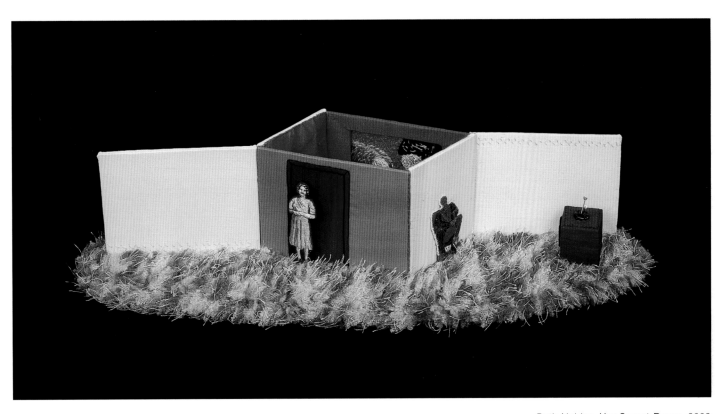

Representing:
Mical Aloni
Dan Anderson
Jean Cacicedo
Olga Cinnamon
Anne Forbes
Laurie Hall
Kay Khan
Jim Kraft
Edward Larson
Connie Lehman
Tom Lundberg
Marcia Macdonald
Lee Malerich
Peg Malloy
Anne McKenzie
 Nickolson
Beth Nobles
Sang Roberson
Carol Shinn
Richard St. John
Missy Stevens
Lori Talcott
Laura Willits

Beth Nobles, **Her Secret Room,** *2003*
embroidery, hand-painted silk, 5.5 x 15 x 3
photo: Steven Tatum

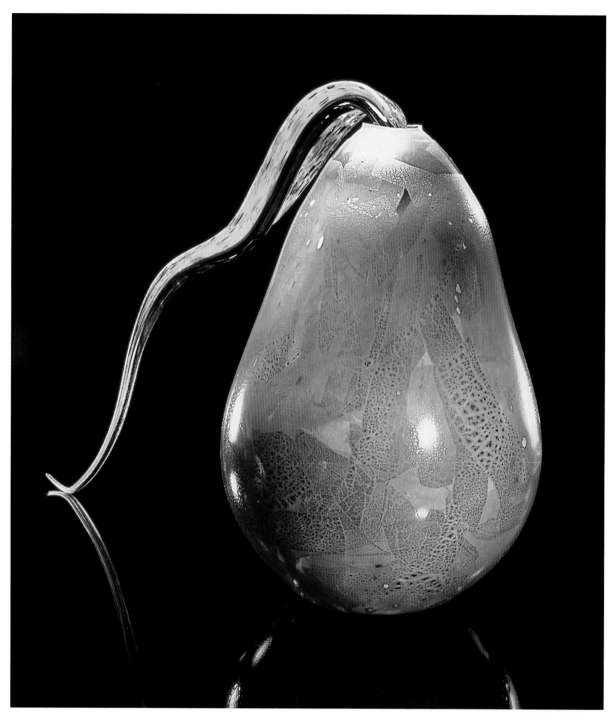

Dale Chihuly, **Gilded Sienna Ikebana Gourd with One Leaf**
blown glass, 31 x 52 x 22
photo: Scott M. Leen

Holsten Galleries

Contemporary glass sculpture and installations

Staff: Kenn Holsten, owner; Jim Schantz, director; Mary Childs, associate director; Joe Rogers, preparator; Christine Warren and Kim Saul, associates

3 Elm Street
Stockbridge, MA 01262
voice 413.298.3044
fax 413.298.3275
artglass@holstengalleries.com
holstengalleries.com

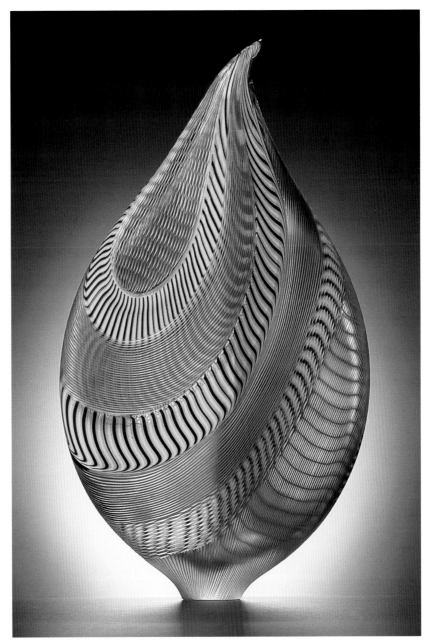

Representing:
Dale Chihuly
Lino Tagliapietra

Lino Tagliapietra, **Bilbao***, 2003*
blown glass, 22.5 x 13.5 x 8
photo: Russell Johnson

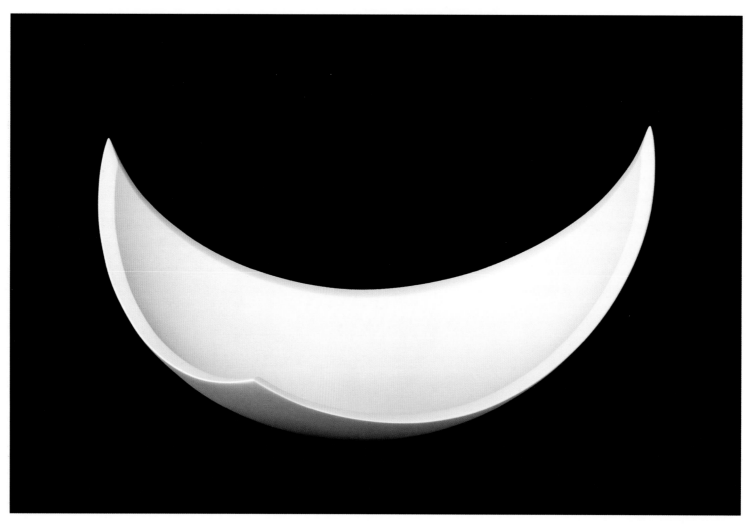

*Kazuya Takahashi, **Kumoi**, 2003*
porcelain, 11.5 x 15 x 10,5
photo: Ralph Koch

James Singer

Contemporary Japanese ceramics
Staff: James Singer

PO Box 1396
Tiburon, CA 94920
voice 415.789.1871
fax 415.789.1879
jamessinger@earthlink.net
jamessinger.com

Representing:
Sueharu Fukami
Masahiko Ichino
Eiko Kishi
Gerd Knapper
Zenji Miyashita
Shigekazu Nagae
Kazuya Takahashi
Mutsuo Yanagihara

Masahiko Ichino, **Saidei-ki,** *2002*
glazed pottery, 10 x 10.5 x 10.5

Jon Eric Riis, **Hands of the Oracle**, *1999*
silk tapestry, hand sewn pearls and natural coral beading, 10 x 6 x 3
photo: Bart's Art

James Tigerman Gallery

Contemporary fine art across a diverse range of media and cultural traditions
Staff: James Tigerman, owner/designer; John Becker, gallery director

212 West Chicago Avenue
Chicago, IL 60610
voice 312.337.8300
fax 312.337.2726
tigerman-bigplanco@ameritech.net
jamestigermangallery.com

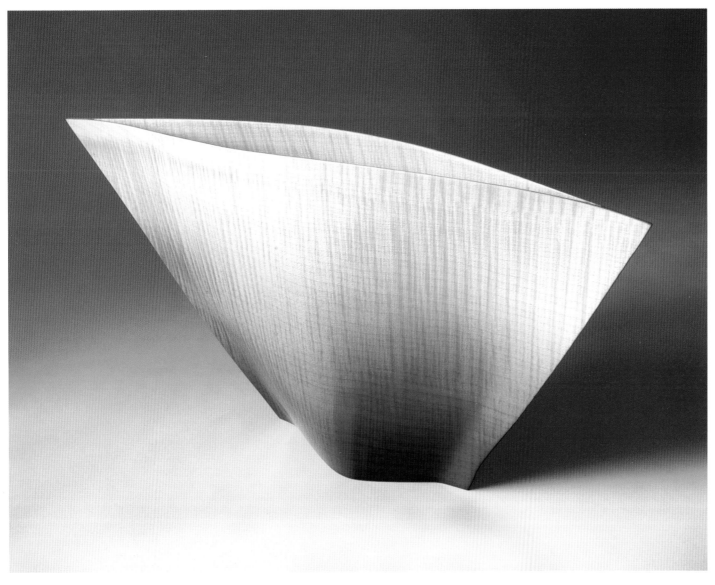

Representing:
Chunghie Lee
Jon Eric Riis
Colin Schleeh
Rusty Wolfe
Jiro Yonezawa

Colin Schleeh, **Baby Blue Rift Vase,** *2003*
flamed sycamore, epoxy resin, lacquer, pigments, lead, 10 x 20 x 3.5
photo: C. Schleeh

Rusty Wolfe, **Diamond,** *2003*
lacquer, MDF, wood, 72 x 72 x 7

Rusty Wolfe, **Open Book**, *2002*
lacquer, MDF, wood, 71 x 35 x 6

Diane Cooper, **Jintai,** *2003*
mixed media, 24 x 13 x 7
photo: Tom Van Eynde

Jean Albano Gallery

Contemporary painting, sculpture and constructions
Staff: Jean Albano Broday; Sarah Kaliski; Merry-Beth Noble

215 West Superior Street
Chicago, IL 60610
voice 312.440.0770
fax 312.440.3103
jeanalbano@aol.com
jeanalbanogallery.com

Representing:
Greg Constantine
Diane Cooper
Claudia DeMonte
John Geldersma
Sandy Swirnoff
John Torreano

Sandy Swirnoff, **Daum: Flowers and Berries**
nylon and silk cord, vintage beads, daum glass shard

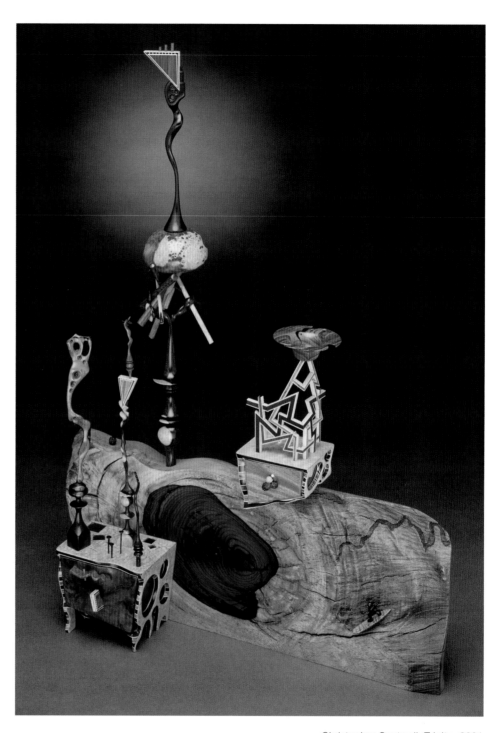

Christopher Cantwell, **Trinity**, *2001*
wood, 18 x 15 x 4
photo: G. Post

Jeffrey Weiss Gallery

Underscoring the interactions and affinities between artists; national and international artists represented
Staff: Jeffrey Weiss, owner; David Pollack, director; Sallie Brown, manager

2938 Fairfield Avenue
Bridgeport, CT 06605
voice 203.333.7733
fax 203.362.2628
jeff@jeffreyweissdesigns.com
jeffreyweissdesigns.com

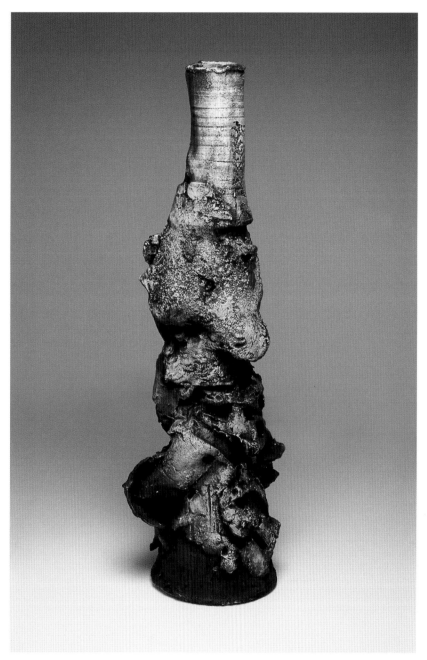

Representing:
Christopher Cantwell
Beth Cassidy
Tim Harding
Jim Leedy
Hideaki Miyamura
Thomas Throop
Kiwon Wang

Jim Leedy, **Baroque Vessel***, 2002*
smoked stoneware, 57 x 24
photo: Jim Leedy

211

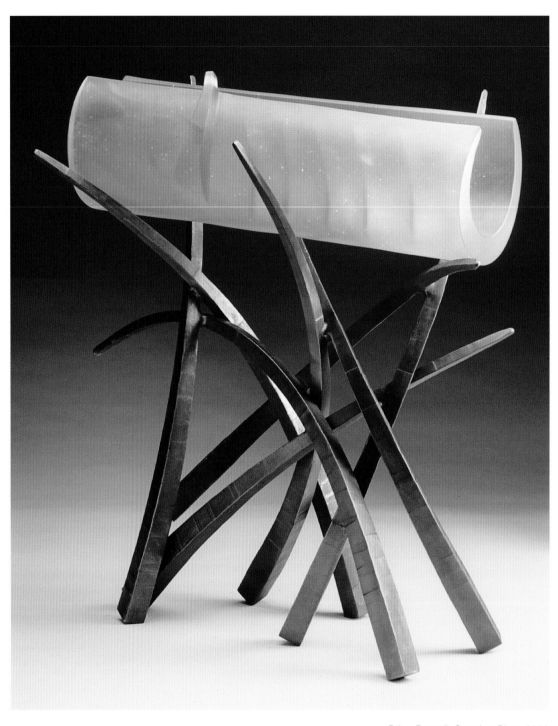

Brian Russell, **Cresting Pipe,** *2003*
cast glass, steel, 22 x 23 x 10

Jerald Melberg Gallery

Contemporary American art by nationally and internationally known artists
Staff: Jerald Melberg; Mary Melberg; Gaybe Johnson; Chris Clamp

3900 Colony Road
Charlotte, NC 28211
voice 704.365.3000
fax 704.365.3016
nc@jeraldmelberg.com
jeraldmelberg.com

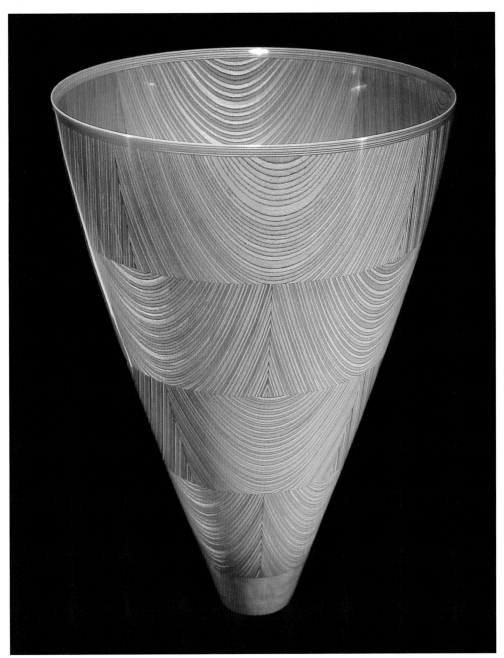

Representing:
Stephen Gleasner
Alice Ballard Munn
Brian Russell
Ramon Urbán
Emily Wilson

Stephen Gleasner, **True,** *2002*
plywood, dyes, 13.25 x 9.25 x 9.25

William Plumptre, **Press Moulded Square Bottle Vase,** *2003*
stoneware with rope inlaid roundels, ash glaze, 9.5 x 4.25 x 4.25
photo: Jonathan Lynch

Joanna Bird Pottery

Studio pottery by contemporary artists and past masters
Staff: Joanna Bird, owner; Bunny Bird, director; Fredrika Teale, assistant

By Appointment
19 Grove Park Terrace
London W43QE
England
voice 44.208.995.9960
fax 44.208.742.7752
joanna.bird@ukgateway.net
joannabirdpottery.com

Representing:
Danlami Aliyu
Svend Bayer
Michael Cardew
Joanna Constantinidis
Daniel Fisher
Shoji Hamada
Chris Keenan
Bernard Leach
David Leach
John Maltby
Catriona McLeod
Paul Philp
William Plumptre
Lucie Rie
Tatsuzo Shimaoko
John Spearman
Julian Stair
Jason Wason

Chris Keenan, **Bowl with Meander,** *2003*
porcelain with crazed celadon glaze, 5 x 10
photo: Sara Morris

Shoji Hamada, **Bottle Vase**, *c. 1966*
stoneware with Nuka glaze, 9 x 6.25 x 3.5

Lucie Rie, **Bottle Vase with Flared Lip,** *c. 1980-81*
porcelain, manganese bronze pigment with sgraffito lines through slip, 9.5 x 5.25
photo: Rodney Todd-White & Son

Peter VandenBerge, **Dress Rehearsal,** *2003*
ceramic, 37.5 x 18 x 12.5

John Natsoulas Gallery

California funk art and figurative ceramics, 1950s to present
Staff: John Natsoulas, gallery director; Vanessa Bolden

521 First Street
Davis, CA 95616
voice 530.756.3938
fax 530.756.3961
art@natsoulas.com
natsoulas.com

Representing:
Mark Abildgaard
Robert Arneson
Vicky Chock
David Gilhooly
Arthur Gonzalez
Keith Schneider
Esther Shimazu
Peter VandenBerge

Roy De Forest, **Dog Bench,** *2003*
bronze and powder coat with steel, 40 x 68 x 42

Ty Gillespie, **Hulls,** *2003*
wood, various sizes

Katie Gingrass Gallery

Contemporary fine craft
Staff: Katie Gingrass; Elaine Hoth; Sarah Gingrass

241 North Broadway
Milwaukee, WI 53202
voice 414.289.0855
fax 414.289.9255
katieg@execpc.com
gingrassgallery.com

Representing:
Jackie Abrams
Jeanette Ahlgren
Darryl Arawjo
Karen Arawjo
Bimas Ciurlionis
Susie Colquitt
Lucy Feller
Jack Fifield
Linda Fifield
Ty Gillespie
Ron Isaacs
David Lory
Mary Merkel-Hess
Laura Foster
 Nicholson
Tom Rauschke
John Skau
Fraser Smith
Polly Adams Sutton
Kaaren Wiken
Jiro Yonezawa

Mary Merkel-Hess, **Leighton,** *2003*
reed, paper, 30 x 20 x 11

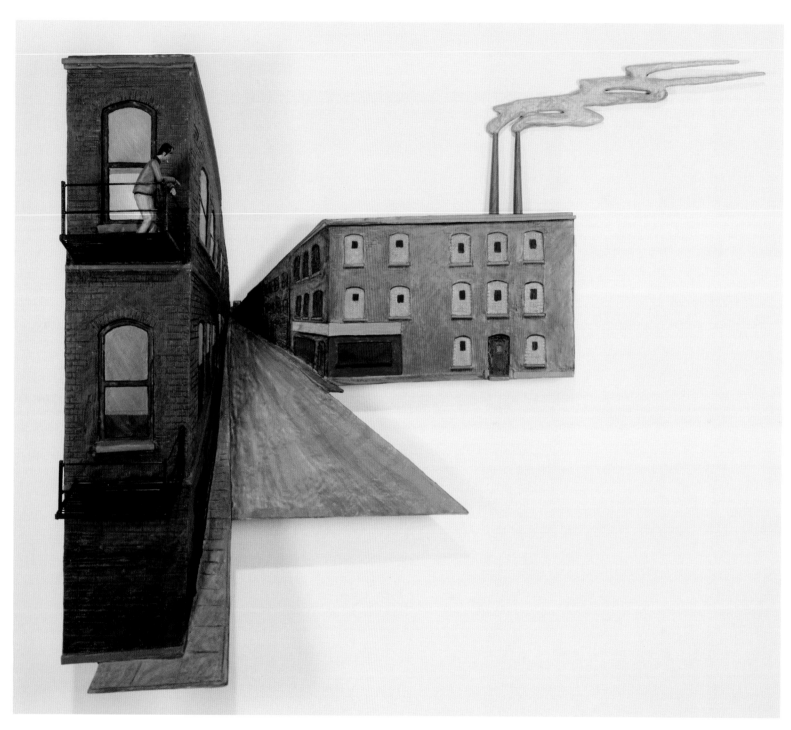

Philip Soosloff, **Fire Escape,** *2003*
mixed media, 68 x 78 x 19
photo: Barbara Broeske

Kraft Lieberman Gallery

Modern and contemporary art in all media by national and European artists
Staff: Jeffrey Kraft, director; Paul Lieberman, director; Laurie Lieberman; Galya Kraft

835 West Washington Street
Chicago, IL 60607
voice 312.948.0555
fax 312.948.0333
klfinearts@aol.com
klfinearts.com

Representing:
Philip Soosloff
Ron Starr

Ron Starr, **Zorb I***, 2003*
ceramic, leather straps, 37 x 18 x 18

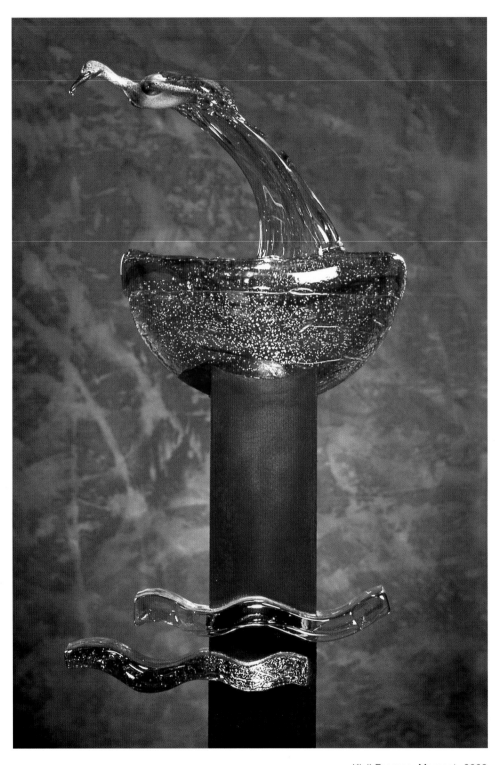

Kjell Engman, **Moment,** *2003*
glass, stainless steel, metal, 67 x 16 x 6

Leif Holmer Gallery

Contemporary art and glass
Staff: Leif Holmer; Marcus Holmer

Storgatan 19
Nässjö 57121
Sweden
voice 46.380.12490
fax 46.380.12494
leif@holmergallery.com
marcus@holmergallery.com
holmergallery.com

Representing:
Kjell Engman

Kjell Engman, **From the Bottom of the Ocean,** *2003*
cast and polished glass, wood, 63 x 55 x 6

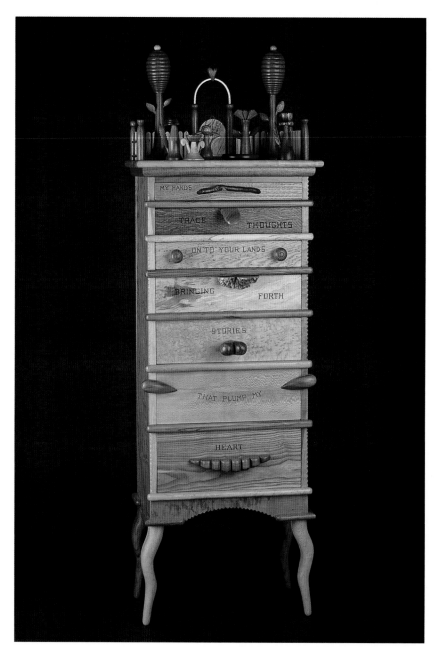

Tommy Simpson, **On Our Land**, *2003*
wood, 67 x 20 x 16

Leo Kaplan Modern

Established artists in contemporary glass sculpture and studio art furniture
Staff: Scott Jacobson; Terry Davidson; Lynn Leff; Courtney Fox

41 East 57th Street
7th floor
New York, NY 10022
voice 212.872.1616
fax 212.872.1617
lkm@lkmodern.com
lkmodern.com

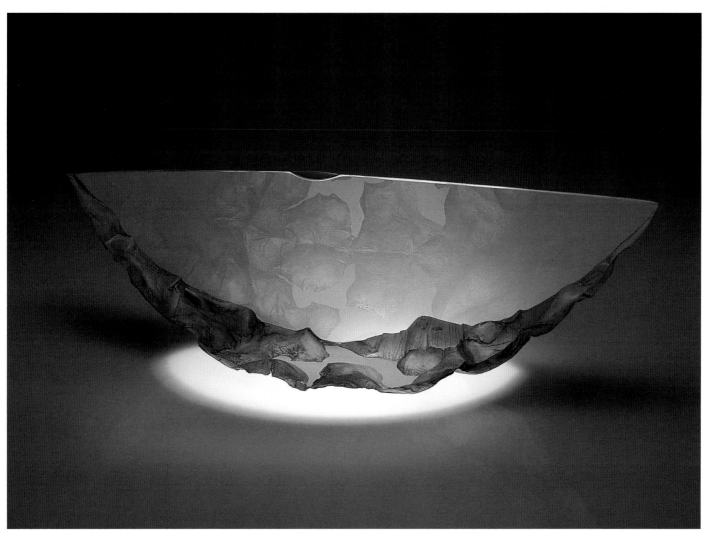

Representing:
Garry Knox Bennett
Greg Bloomfield
Yves Boucard
Wendell Castle
José Chardiet
Scott Chaseling
KéKé Cribbs
Dan Dailey
David Huchthausen
Richard Jolley
Kreg Kallenberger
John Lewis
Thomas Loeser
Linda MacNeil
Albert Paley
Paul Seide
Tommy Simpson
Jay Stanger
Michael Taylor
Cappy Thompson
Gianni Toso
Mary Van Cline
Steven Weinberg
Ed Zucca

Kreg Kallenberger, **View at Pigeon Lake,** *2003*
glass, oil paint, 8 x 24 x 5

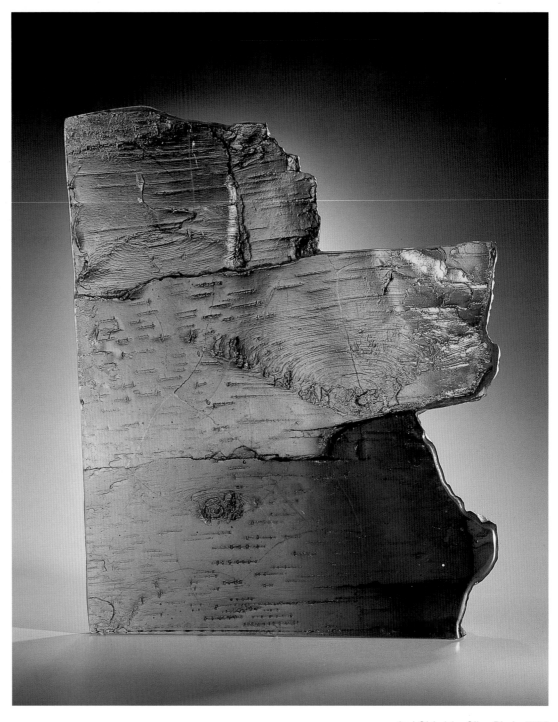

Joel O'dorisio, **Olive Birch**, *2000*
cast and hand-polished glass, 20 x 16 x 4
photo: Frank Burkowski

Lost Angel Glass

Handmade fine art and craft
Staff: Mary Pollack; Meghan D. Bunnell

Hawkes Crystal Building
79 West Market Street
Corning, NY 14830
voice 607.937.3578
fax 607.937.3578
odo@lostangelglass.com
lostangelglass.com

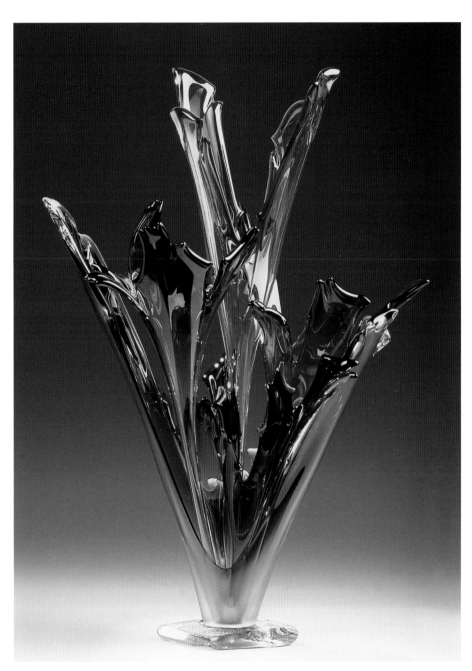

Representing:
Barry Entner
Joel O'dorisio

Barry Entner, **Flora Loose Group,** *2003*
hand-blown, steamed and cast glass, 32 x 26 x 16
photo: Bob Barrett

Pottery Hu, Warring States, 745-206 B.C.
15h

Marc Richards

Ancient Chinese ceramics
Staff: Marc Richards; Joey Richards

170 South La Brea
Los Angeles, CA 90036
voice 323.634.0838
fax 323.634.0834
marc@marcrichards.com
marcrichards.com

Pottery Horse, Tang Dynasty, 618-907 A.D.
16h

Thomas Scoon, **Branched Figures,** *2003*
cast bronze, cast glass, stone, 38 x 25 x 13
photo: Jim Thomas

Marx-Saunders Gallery

Contemporary glass sculpture by the most innovative artists in the world
Staff: Bonita Marx; Ken Saunders; Sybil Larney; James Geisen; Dan Miller

230 West Superior Street
Chicago, IL 60610
voice 312.573.1400
fax 312.573.0575
marxsaunders@earthlink.net
marxsaunders.com

Representing:
Rick Beck
William Carlson
José Chardiet
KéKé Cribbs
Benjamin Edols
Kathy Elliott
Stephen Hodder
Sidney Hutter
Jon Kuhn
Jay Musler
Joel Philip Myers
Mark Peiser
Stephen Rolfe Powell
Richard Ritter
David Schwarz
Thomas Scoon
Mary Shaffer
Paul Stankard
Janusz Walentynowicz
Richard Whiteley
Hiroshi Yamano

Mary Shaffer, **Red Grid,** *2003*
slumped glass, metal, 11 x 11 x 7
photo: Dan Morse

233

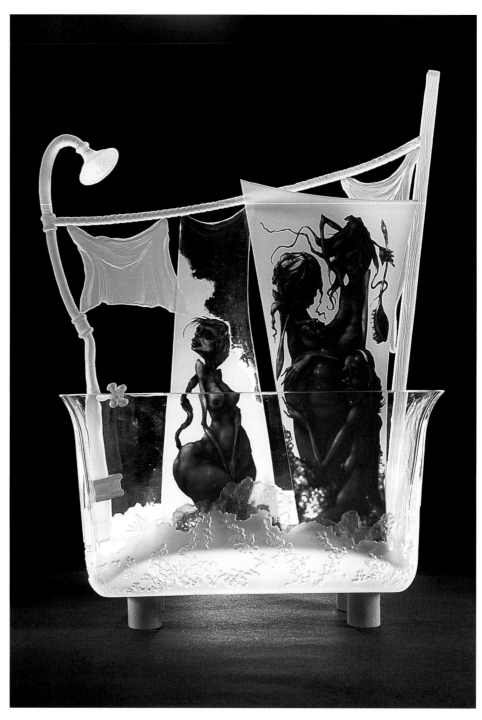

Miroslaw Stankiewicz & Rafal Galazaka, **Bathtub,** *2003*
glass; cased, engraved, sculpted, sand-blasted, polished and glued, 13.75 x 10.75 x 3.25
photo: Jacek Sliwczynski

Mattson's Fine Art

Contemporary art glass

Staff: Greg Mattson, director; Skippy Mattson; Walter Mattson

2579 Cove Circle NE
Atlanta, GA 30319
voice 404.636.0342
fax 404.636.0342
sundew@mindspring.com

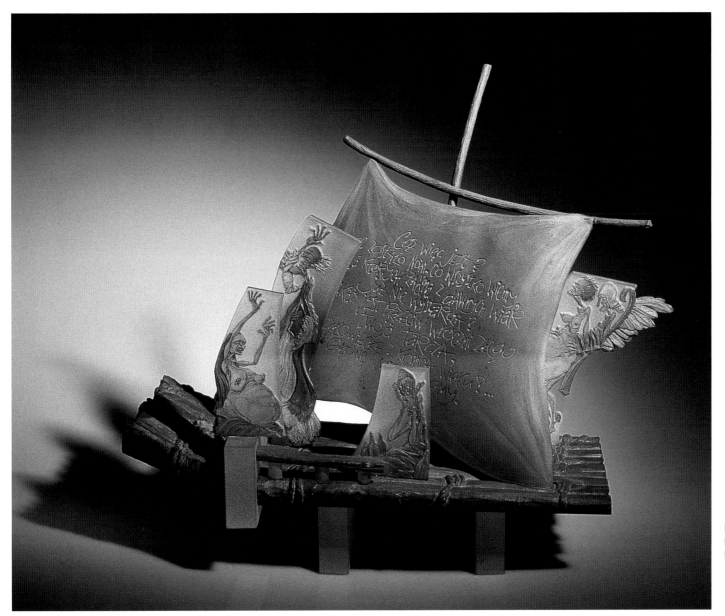

Representing:
Rafal Galazaka
Miroslaw Stankiewicz

Miroslaw Stankiewicz & Rafal Galazaka, Raft, 2001
glass stained with metal oxides; fused, engraved, sand-blasted and glued, 12.25 x 12 x 6.5
photo: Monika Mroczkowska-Bialasik

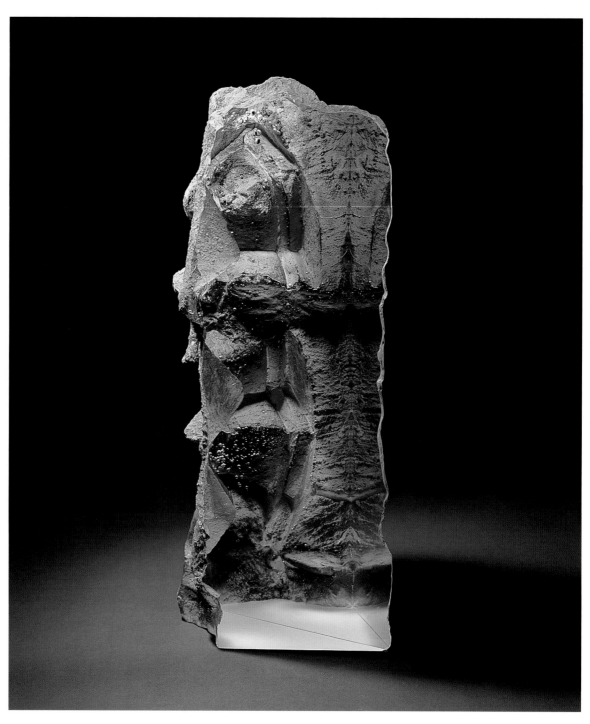

Colin Reid, **Untitled**, *2003*
glass, 26.5 x 13.5 x 6

Maurine Littleton Gallery

Sculptural work of contemporary masters in glass
Staff: Maurine Littleton; Michael Eaton; Seth Campbell

1667 Wisconsin Avenue NW
Washington, DC 20007
voice 202.333.9307
fax 202.342.2004
littletongallery@aol.com

Representing:
Mark Bokesch-
 Parsons
Harvey Littleton
John Littleton
Don Reitz
Therman Statom
James Tanner
Kate Vogel

John Littleton & Kate Vogel, **Swan Arms**, *2003*
glass, gold leaf, mica dust, fiberglass, 16.5 x 12.5 x 4.75
photo: John Littleton

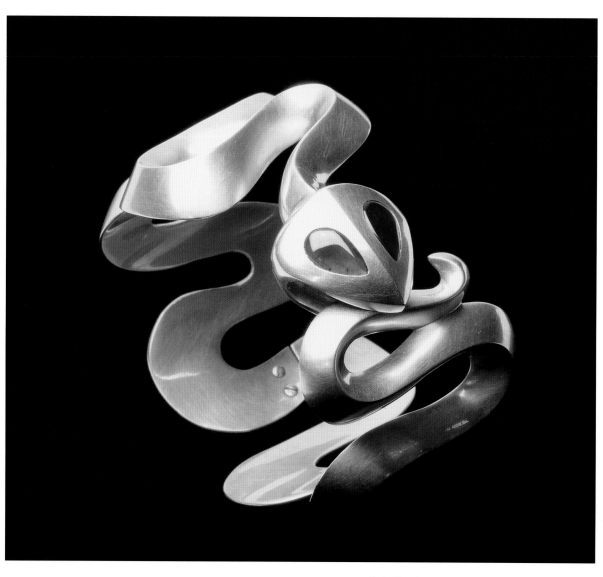

Judy Kensley McKie, **Sidewinder Bracelet,** *2001*
20k yellow gold, jade, 2.75 x 2.25 x 1.5
photo: Kevin Sprague

McTeigue & McClelland Jewelers

New directions in contemporary precious jewelry

Staff: Walter J McTeigue III and Tim McClelland, co-founders; Andrew Higgins; Steve Hyer; Barbara Crocker; Cindy Race

597 South Main Street
Great Barrington, MA 01230
voice 413.528.6262
fax 413.528.6644
info@mc2jewels.com
mc2jewels.com

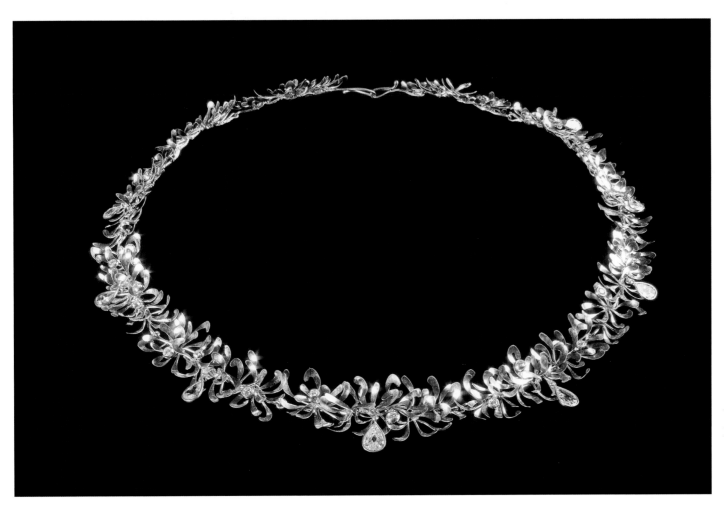

Representing:
Tim McClelland
Judy Kensley McKie
Tommy Simpson

Tim McClelland, **Flora Necklace***, 2003*
18k yellow gold, diamonds, 16 x.5 x.25
photo: Kevin Sprague

Giancarlo Teoli, **Teso Esporre,** *1996*
stainless, aluminum, glass, 50 x 26 x 26

Michelson Gallery

Innovative functional design

Staff: Denis Michelson, owner; Steven Nettere, manager; Dave Avery, designer; Rick Whitehouse; Jack Craig; Ashley Michelson; Robert Holt

4001 North Ravenswood, #404
Chicago, IL 60613
voice 773.879.8825
fax 773.665.7117
denisootww@yahoo.com

Representing:
Robert Frazier
Tim Gates
Denis Michelson
Giancarlo Teoli

Denis Michelson, **Mahogany Floor Lamp,** *2002*
veneer, lacquer, chromed base and top, 75 x 25 x 13
photo: Jack Craig

Linda Behar, **Porter's Cove,** *2003*
embroidery, 4.25 x 6
photo: David Caras

Mobilia Gallery

The Teapot Redefined; studio jewelry, textiles, studio furniture, ceramics
Staff: Libby Cooper; JoAnne Cooper; Susan Cooper

358 Huron Avenue
Cambridge, MA 02138
voice 617.876.2109
fax 617.876.2110
mobiliaart@aol.com
mobilia-gallery.com

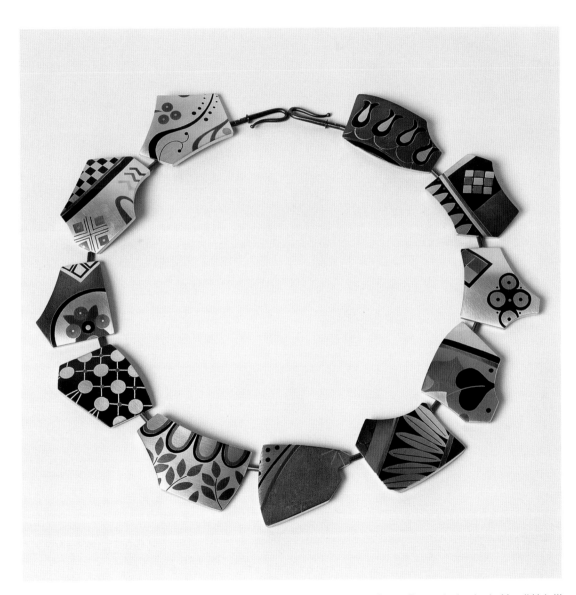

Suzan Rezac, Archeologia Mundi Vol. III
silver, shakudo, 18k gold, shibuichi, copper, brass, .25 x 20 x 1.5
photo: Tom Van Eynde

Representing:

Renie Breskin Adams	Richard Mawdsley
Dan Adams	Elizabeth McDevitt
Jeanette Ahlgren	John McNaughton
Jeannine Anderson	John McQueen
Linda Behar	Ellen Moon
Hanne Behrens	Marilyn Moore
Lanny Bergner	Merrill Morrison
Harriete Estel Berman	Jay Musler
Flora Book	Harold O'Connor
Jane Bowden	Joan Parcher
Michael Boyd	Karen Paust
Klaus Bürgel	Sarah Perkins
Kirsten Clausager	Louise Perrone
Jim Cole	Gugger Petter
Jack da Silva	Mary Preston
Marilyn da Silva	Giovanna Quadri
Roy De Forest	Robin Quigley
Linda Dolack	Gerri Rachins
Jack Earl	Kim Rawdin
Helen Ellison-Dorion	Todd Reed
Dawn Emms	Suzan Rezac
Dorothy Feibleman	Tom Rippon
Arline Fisch	Scott Rothstein
Gerda Flockinger, CBE	Caroline Rügge
David Freda	Axel Russmeyer
Lisa Gralnick	Marjorie Schick
Mielle Harvey	Joyce J. Scott
Makoto Hieda	Richard Shaw
Jan Hopkins	Kiff Slemmons
Mary Lee Hu	Christina Smith
Dan Jocz	Etsuko Sonobe
Rosita Johanson	Billie Jean Theide
Kimberly Kelzer	Rachelle Thiewes
Candace Kling	Linda Threadgill
Rena Koopman	Cynthia Toops
Fritz Maierhofer	Jennifer Trask
Patricia Malarcher	Andrea Uravitch
Mia Maljojoki	Ginny Whitney
Donna Rhae Marder	Joe Wood
Tomomi Maruyama	Mizuko Yamada

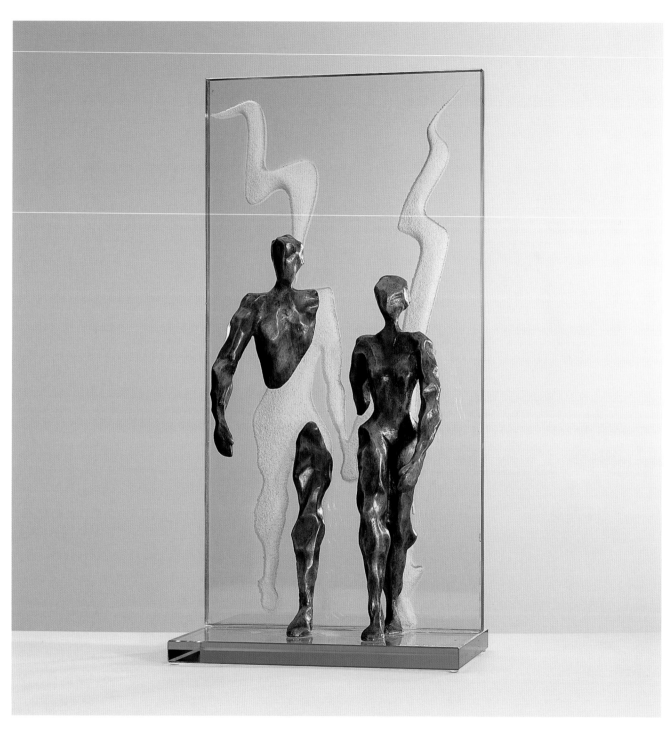

Dominique Dardek, **Rencontre,** *2001*
bronze, glass, 18 x 11 x 9

Modus Gallery

Contemporary and modern art in a variety of media
Staff: Karl Yeya, director; Richard Elmir; Mana Asselli; Sophie Montcarat; Suzan Illing; Laura Rathe

23 Place des Vosges
Paris 75003
France
voice 33.14.278.1010
fax 33.14.278.1400
modus@galerie-modus.com
galerie-modus.com

Representing:
Françoise Abraham
Giampaolo Amoruso
Dominique Dardek
Marie Gautier
Loni Kreuder
Vincent Magni
Jean-Pierre
 Umbdenstock

Giampaolo Amoruso, **Dancer***, 2002*
glass, 15 x 10 x 10

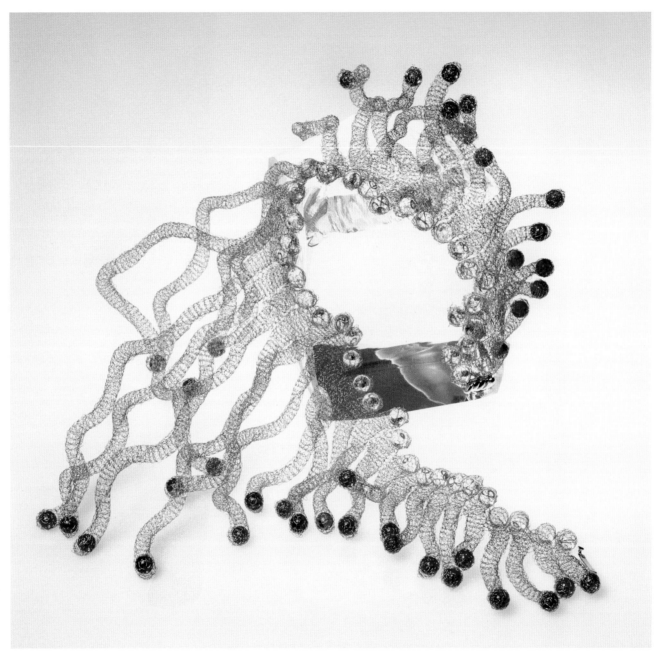

Ema Tanigaki, SunRay Necklace
crystal and amethyst spheres, 24k gold plated stainless steel, 14k gold finding, 7.5 x 18
photo: John L. Healey

Morgan Contemporary Glass Gallery

Unique contemporary studio glass by established and emerging artists
Staff: Amy Morgan, owner/director; Heather McElewee

5833 Ellsworth Avenue
Pittsburgh, PA 15232
voice 412.441.5200
fax 412.441.0655
morglass@sgi.net
morganglassgallery.com

Representing:
Nicole Chesney
Philip Crooks
Karen Gilbert
Caitlin Hyde
Marshall Hyde
Claire Kelly
Ray King
Masayo Odahashi
Alison Osborne
Anthony Schafermeyer
Ema Tanigaki
Beth Williams

Nicole Chesney, **A Silence that Breathes I,** *2003*
slumped plate glass, mirror, 31 x 20 x 1.5

Steve Tobin, **Autumn,** *2000*
cast bronze, 60 x 48 x 12
photo: George Erml

Mostly Glass Gallery

Innovative art that is aesthetically appealing and technically challenging
Staff: Sami Harawi; Charles Reinhardt

3 East Palisade Avenue
Englewood, NJ 07631
voice 201.816.1222
fax 201.816.9582
info@mostlyglass.com
mostlyglass.com

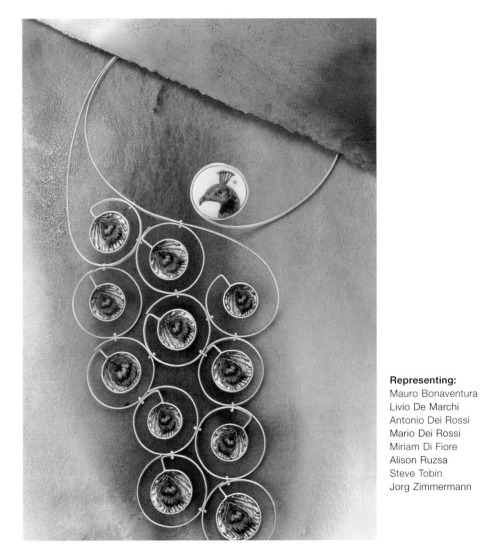

Antonio Dei Rossi, **Peacock Neckpiece**, *2003*
murrini, gold, 10 long

Representing:
Mauro Bonaventura
Livio De Marchi
Antonio Dei Rossi
Mario Dei Rossi
Miriam Di Fiore
Alison Ruzsa
Steve Tobin
Jorg Zimmermann

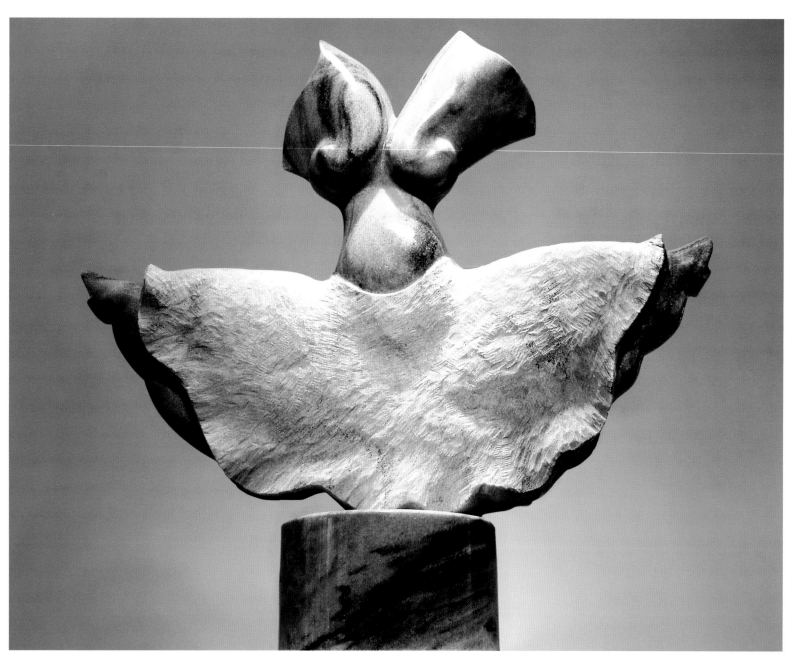

*Fritz Olsen, **Dancer**, 2002*
marble, 37 x 37 x 12
photo: Richard Hellyer

Niemi Sculpture Gallery & Garden

Contemporary sculpture
Staff: Bruce Niemi, owner; Susan Niemi, director

13300 116th Street
Kenosha, WI 53142
voice 262.857.3456
fax 262.857.4567
gallery@bruceniemi.com
bruceniemi.com

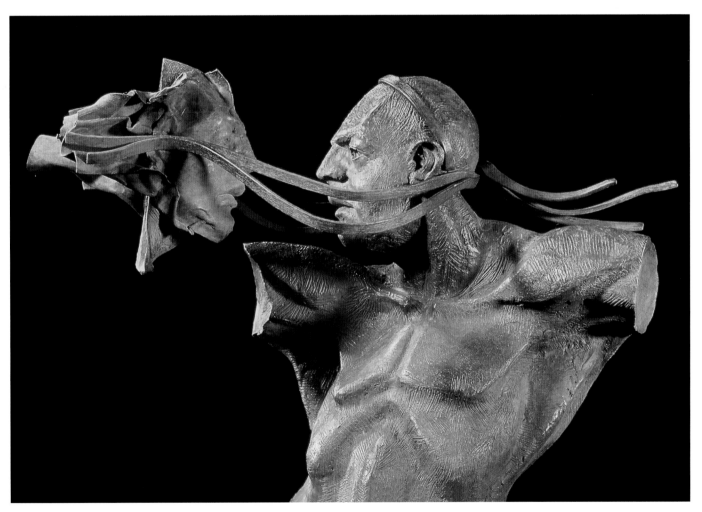

Representing:
Theodore T. Gall
Bruce A. Niemi
Fritz Olsen

Theodore T. Gall, **Muse,** *2003*
cast bronze, 18 x 19 x 16
photo: Wayne Smith

David Samplonius, **Tree**, *2003*
mahogany, leather, aluminum, 51 x 20 x 18

Option Art

Excellence in Canadian contemporary art furniture, jewelry, ceramics, fiber and glass
Staff: Barbara Silverberg, director; Dale Barrett, assistant

4216 de Maisonneuve Blvd. West
Suite 302
Montreal, Quebec H3Z 1K4
Canada
voice 514.932.3987
fax 514.932.6182
info@option-art.ca
option-art.ca

Representing:
Elyse De Lafontaine
Rosie Godbout
Janis Kerman
Ronald Labelle
Michèle LaPointe
Sylvie Lupien
Gilbert Poissant
David Samplonius

Elyse De Lafontaine, Aujourd'hui vers demain avec un souvenir me rappelant qu'il y en une fois, *2003*
fiber, hand-dyed horse hair, nylon thread, 39 x 55 x 4
photo: Guy L'Heureux

Gilbert Poissant, **Six Variations,** *2003*
earthenware, stainless steel frame, 20 x 20 x 2 each

Janis Kerman, **Brooch***, 2003*
sterling silver, 18k gold, mother of pearl, peridot

Bahram Shabahang, **Persepolis (Gate to Heaven),** *2000*
162 x 198

Orley & Shabahang Persian Carpets

The finest 19th century and contemporary artistic hand woven carpets the world has to offer
Staff: Bahram Shabahang; Geoffrey A. Orley

5841 Wing Lake Road
Bloomfield Hills, MI 48301
voice 586.996.5800
shabahangorley@aol.com

Representing:
Ardal
Bakhtiari
Haj Jalili
Javan
Mobashri
Mohtasham
Bahram Shabahang
Shirfar
Zolan Vari

Bahram Shabahang, **Light and Shadow,** *2002*
144 x 216

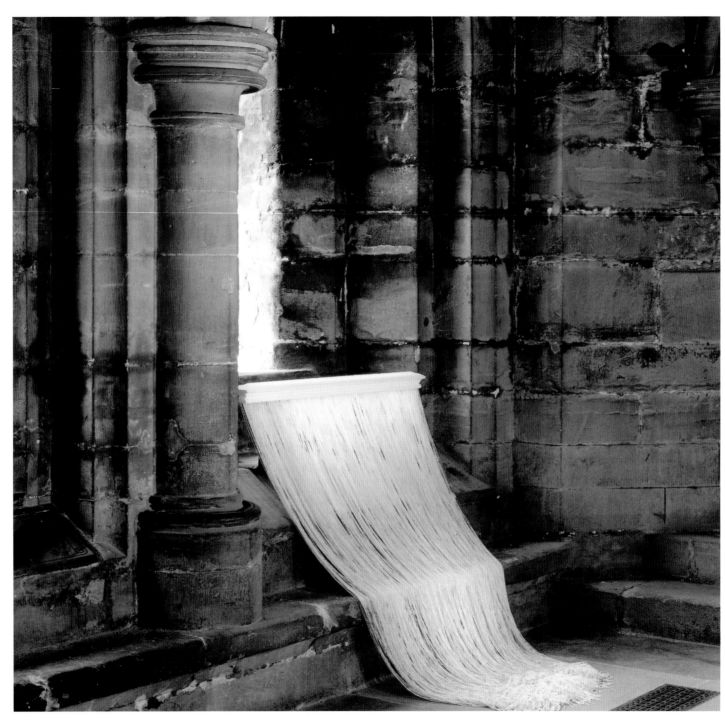

Jeffrey Mongrain, **Litany Rail***, 2001*
installation at Glascow Cathedral, Glascow Scotland
clay, beads, 72 x 42 x 4

Perimeter Gallery, Inc.

Contemporary painting, sculpture, works on paper and master crafts
Staff: Frank Paluch, Chicago director; Meredith Keay and Andrea Hazen, New York directors;
Scott Ashley, Chicago assistant director; Arielle Sandler, registrar

210 West Superior Street
Chicago, IL 60610
voice 312.266.9473
fax 312.266.7984
perimeterchicago@perimeter
 gallery.com

511 West 25th Street, #402
New York, NY 10001
voice 212.675.1585
fax 212.675.1607
perimeterNYC@perimeter
 gallery.com
perimetergallery.com

Representing:
John Balsley
Christie Brown
Lia Cook
Jack Earl
Edward Eberle
Kiyomi Iwata
Dona Look
John Mason
Karen Thuesen
 Massaro
Beverly Mayeri
Jeffrey Mongrain
Toshiko Takaezu

Karen Thuesen Massaro, **Half Moon,** *2003*
porcelain, 7 x 10 x 20

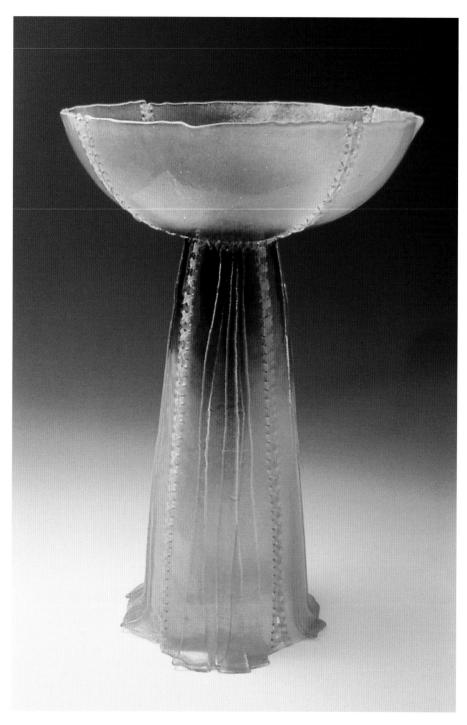

Susan Taylor Glasgow, **If Glass Wore Fabric**
glass, thread, 27 x 17 x 17

R. Duane Reed Gallery

Contemporary painting, glass, fiber, ceramics and sculpture
Staff: R. Duane Reed, owner; C. Glenn Scrivner, director of off-site exhibitions;
Kate Anderson, director; Merrill Strauss; Jacqueline Hunt

711 East Las Olas Blvd.
Fort Lauderdale, FL 33301
voice 954.525.5210
fax 954.525.5206
flareedart@primary.net

7513 Forsyth Boulevard
St. Louis, MO 63105
voice 314.862.2333
fax 314.862.8557
reedart@primary.net
rduanereedgallery.com

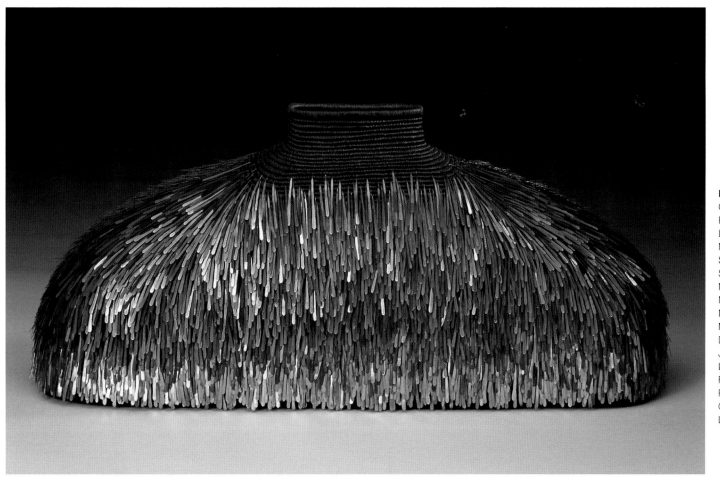

Representing:
Christina Antemann
Rudy Autio
Laura Donefer
Mary Giles
Susan Taylor Glasgow
Sabrina Knowles
Marvin Lipofsky
Michael Lucero
Nancy Mee
Mari Meszaros
Danny Perkins
Jenny Pohlman
Lindsay Rais
Ross Richmond
Richard Royal
Ginny Ruffner
Lisabeth Sterling

Mary Giles, **Mesa Profile,** *2003*
waxed linen, copper, iron, 13.5 x 32 x 8.5
photo: Tony Deck

Victor Greenaway, **Blue,** *2003*
porcelain, celadon, spiral lipped, 17 x 8.5 x 8.5

Raglan Gallery

Contemporary Australian work in glass, ceramic, sculpture, painting, and Aboriginal art
Staff: Jan Karras

5-7 Raglan Street
Manly, Sydney, NSW 2095
Australia
voice 61.29.977.0906
fax 61.29.977.0906
jankarras@hotmail.com
raglangallery.com.au

Representing:
Grant Donaldson
Victor Greenaway
Angela Mellor
Amanda Schelster
Melis Van der Sluis
Robert Wynne

Robert Wynne, **Shimmer Bowl,** *2003*
iridised and sand-carved glass, 6 x 11 x 11
designed in conjunction with Yuri Yanai

Alex Sepkus, **Orchard Collection**, *2002*
18k yellow gold, diamonds, sapphires, tsavorites
photo: Dange Sirvyte

Sabbia

Elegant and imaginative jewelry—A blend of modern designs with classic motifs
Staff: Deborah Friedmann; Tina Vasiliauskaite

455 Grand Bay Drive
Key Biscayne, FL 33149
voice 305.365.4570
fax 305.365.4572

Representing:
Pedro Boregaard
Lina Fanourakis
Saundra Messinger
Alex Sepkus
Michael Zobel

Lina Fanourakis, **Klimt Bracelet,** *2001*
22k yellow gold, brown princess cut diamonds
photo: James Imbrogno

Sara Brennan, **Pale Blue Line**
tapestry; linen, wool, silk, cotton, 68 x 62

The Scottish Gallery

Scotland's leading gallery for modern ceramics, jewelry, silver, glass and textiles
Staff: Amanda Game; Andrew Doherty; Christina Jansen; Linda Green

16 Dundas Street
Edinburgh EH3 6HZ
Scotland
voice 44.131.558.1200
fax 44.131.558.3900
mail@scottish-gallery.co.uk
scottish-gallery.co.uk

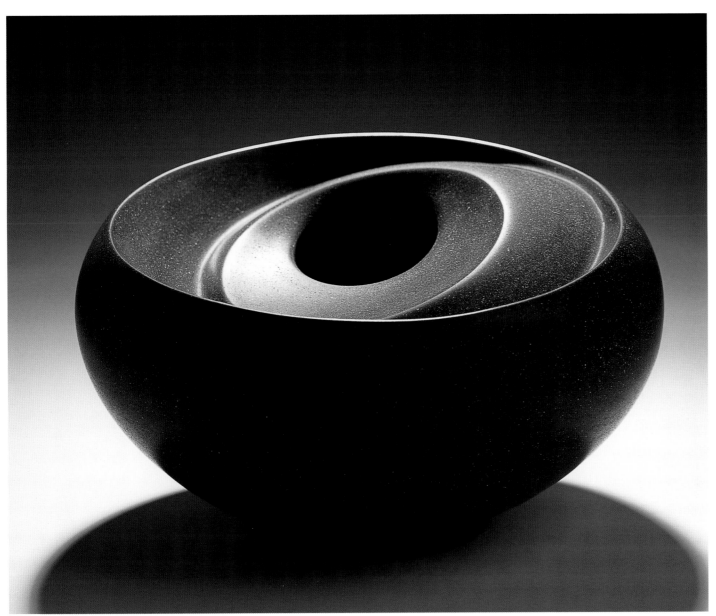

Representing:
Stephen Bird
Sara Brennan
Ray Flavell
Linda Green
Dorothy Hogg
Jane Keith
Alison Kinnaird
Grant McCaig
Grainne Morton
Jim Partridge
Adam Paxon
Frances Priest
Wendy Ramshaw
Colin Rennie
David Roberts
Sarah-Jane Selwood
Ed Teasdale

Sarah-Jane Selwood, **Triple Horizontal Inversion II**
polished terracotta, 8 x 11
photo: John Mackenzie

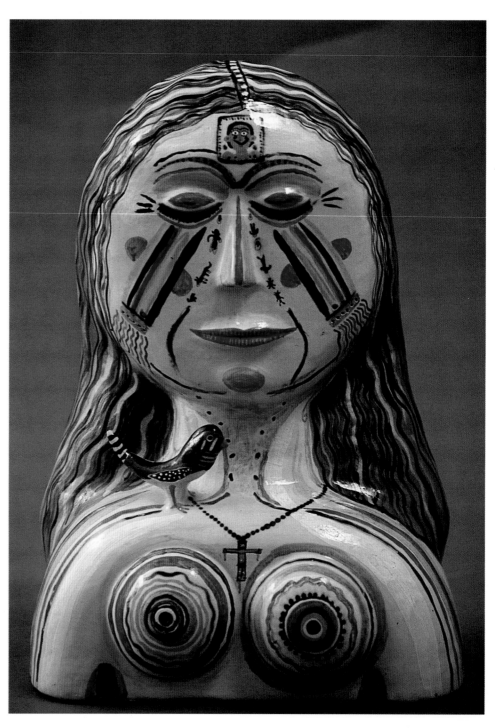

Stephen Bird, **Woman with Zebra Finch,** *2003*
stoneware, enamels, 12h

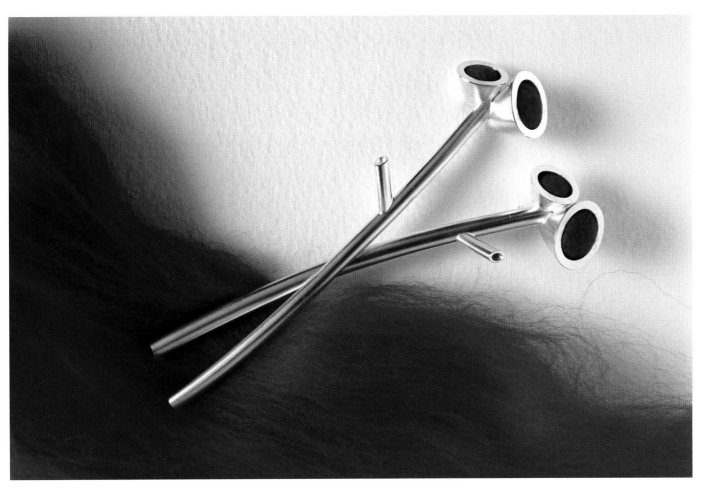

Dorothy Hogg, **Artery Series** *brooch, 2003*
silver, felt, 2.75 x 4.5

Judy Onofrio, **Magic Trick,** *2003*
carved wood, glass, mirror, glass beads, 34 x 25 x 14
photo: Jerry Olson

Sherry Leedy Contemporary Art

Contemporary art in all media
Staff: Sherry Leedy, director; Jennifer Bowerman, assistant director

2004 Baltimore Avenue
Kansas City, MO 64108
voice 816.221.2626
fax 816.221.8689
sherryleedy@sherryleedy.com
sherryleedy.com

Jun Kaneko, **Untitled**, 03-04-24, *2003*
ceramic, 21.5 x 29 x 2.5
photo: Dirk Bakker

Representing:
Laura de Angelis
Yoshiro Ikeda
Jun Kaneko
Judy Onofrio
Charles Timm-Ballard
Peter Voulkos

271

Johan van Aswegan, **Neckpiece,** *2003*
white gold, silver, enamel, amethyst
photo: Kevin Sprague

Sienna Gallery

Contemporary jewelry
Staff: Sienna Patti; Sherida Lincoln

80 Main Street
Lenox, MA 01240
voice 413.637.8386
fax 413.637.8387
sienna@siennagallery.com
siennagallery.com

Representing:
Giampaolo Babetto
Jamie Bennett
Lola Brooks
Noam Elyashiv
Donald Friedlich
Alyssa Dee Krauss
Seung Hea Lee
Jacqueline Lillie
Barbara Seidenath
Sondra Sherman
Bettina Speckner
Johan van Aswegen

Bettina Speckner, Brooch, 2002
photo in enamel, silver, pearl
photo: Kevin Sprague

Kate Anderson, **Jim Dine & Frank Stella Teapots,** *2003*
knotted waxed linen, stainless steel
photo: Tony Deck

Snyderman-Works Galleries

Contemporary fiber, ceramics, glass, art furniture, jewelry, sculpture, paintings and architectural installations
Staff: Rick and Ruth Snyderman, owners; Bruce Hoffman, director; Laurie Switzer and Francis Hopson, assistant directors; Jennifer Macartney and Leeor Sabbah, associates

303 Cherry Street
Philadelphia, PA 19106
voice 215.238.9576
fax 215.238.9351
bruce@snyderman-works.com
snyderman-works.com

Representing:
Kate Anderson
Karin Birch
Reina Mia Brill
Jon Brooks
Paul Chaleff
Barbara Cohen
Mardi Jo Cohen
Joyce Crain
Nancy Crow
Lisa Cylinder
Scott Cylinder
Steven Ford
David Forlano
Kathleen Hayes
Judith Hoyt
Kiyomi Iwata
Ritzi Jacobi
Ferne Jacobs
Kay Khan
Nancy Koenigsberg
Gary Magakis
Marilyn Pappas
Mary Roehm
Michelle Sales
Merryll Saylan
Karyl Sisson
Susan Skinner
Barbara Lee Smith
Pamina Traylor
Rex Trimm
Carmen Valdes
Kathy Wegman
Tom Wegman
Howard Werner
Dave Williamson
Roberta Williamson
Rachael Woodman

Karyl Sisson, **Heavy Hearted**
cotton, rayon, ribbon, thread, mini clothes pins, 10 x 23

Honma Hideaki, **Sign of Wind,** *1998*
bamboo, rattan, 31.5 x 23 x 3
photo: Lois Ellen Frank

Tai Gallery/Textile Arts

Japanese bamboo arts and historic textiles from Asia, Africa and the Americas
Staff: Robert T. Coffland; Koichiro Okada; Steve Halvorsen

616 1/2 Canyon Road
Santa Fe, NM 87501
voice 505.983.9780
fax 505.989.7770
gallery@textilearts.com
textilearts.com

Representing:
Kajiwara Aya
Honma Hideaki
Morigami Jin
Honma Kazuaki
Nagakura Kenichi
Monden Kogyoku
Kajiwara Koho
Abe Motoshi
Fujinuma Noboru
Yamaguchi Ryuun
Kawashima Shigeo
Kawano Shoko
Hayakawa Shokosai V
Fujitsuka Shosei
Katsushiro Soho
Honda Syoryu
Higashi Takesonosai
Shono Tokuzo

Kawano Shoko, **Birth,** *2002*
bamboo, rattan, 11 x 14.5

*William Morris, **Idolo**, 2003*
blown glass, steel stand, 29 x 8 x 10
photo: Rob Vinnedge

Thomas R. Riley Galleries

Timeless three-dimensional fine art forms
Staff: Cindy and Tom Riley, owners; Jeff Allen, Kirkland director; Cheri Discenzo, Cleveland director; Bridget Buescher, Columbus director

2026 Murray Hill Road
Cleveland, OH 44106
voice 216.421.1445
fax 216.421.1435

642 North High Street
Columbus, OH 43215
voice 614.228.6554
fax 614.228.6550

16 Central Way
Kirkland, WA 98033
voice 425.576.0762
fax 425.576.0772
tom@rileygalleries.com
rileygalleries.com

Representing:
David Bennett
Don Charles
Deanna Clayton
Keith Clayton
Donald Derry
Kyohei Fujita
Steve Jensen
Hitoshi Kakizaki
Tracey Ladd
Lucy Lyon
Mark Matthews
Duncan McClellan
Sharon Meyer
William Morris
Ralph Mossman
Nick Mount
Shelly Muzylowski-Allen
Marvin Oliver
Marc Petrovic
Seth Randal
Mel Rea
David Reekie
Joseph Rossano
Kari Russell-Pool
František Vízner
Delross Webber
Karen Willenbrink-Johnsen

Seth Randal, **Sconces,** *2003*
pate de cristal, 21 x 13 x 5

David Reekie, **Rising Tension,** *2002*
glass, 21 x 22.5 x 21

David Bennett, **Brown Gallop**, *2003*
hand-blown glass, bronze, 37 x 25 x 16

Keith & Deanna Clayton, **Untitled**, *2003*
cast glass, metal, 76 x 20

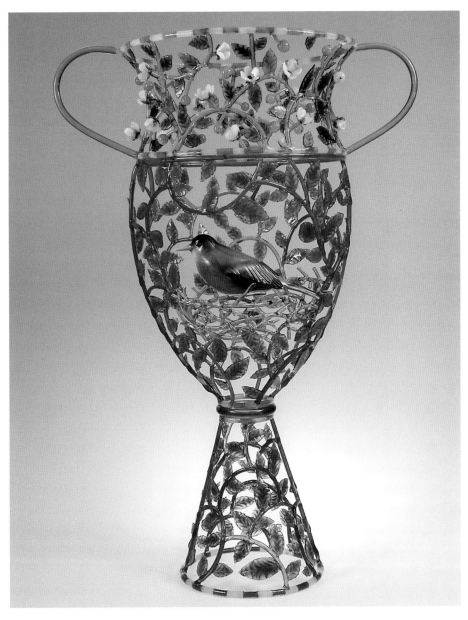

Kari Russell-Pool & Marc Petrovic, Give Yourself a Hand Series: Robin Trophy, *2003*
blown and flameworked glass, 21 x 15.25 x 9

Kanik Chung, **Red Menace,** *2003*
blown glass, 18 x 14 x 10

UrbanGlass

An international center for new art made from glass
Staff: Dawn Bennett, executive director; Brooke Benaroya, development officer

647 Fulton Street
Brooklyn, NY 11217-1112
voice 718.625.3685
fax 718.625.3889
info@urbanglass.org
urbanglass.org

Kevin Huang-Cruz, **Kimono 302**, *2003*
fused glass, metal leaf, 18 x 18
photo: Laurie Korowitz-Coutu

Representing:
Kanik Chung
Kevin Huang-Cruz
Laurie Korowitz-Coutu
Erica Rosenfeld
Annette Rose-Shapiro
Helene Safire
Melanie Ungvarsky

Stephen Knapp, **Cantabile,** *2003*
glass, light, stainless steel, 160 x 72 x 9
photo: S. Knapp

Walker Fine Art

Modern and contemporary sculpture featuring new paintings in light

Staff: Rock J. Walker; Sarah C. Langham; Talia K. Smith; Stephen Knapp; Robert St. Croix; Biba St. Croix

13223-1 Black Mountain Road
#303
San Diego, CA 92129-2658
voice 858.673.9942
fax 831.462.9109
rjewal@msn.com
artnet.com/walkerfineart.html

Representing:
Dale Chihuly
Clara Duque
Stephen Knapp
Jon Kuhn
Robert St. Croix
Ernest Trova

Stephen Knapp, **Arabesque**
glass, light, stainless steel, 44 x 32 x 9
photo: S. Knapp

Wounaan People, Darien Rainforest, Panama, Hösig Di Baskets, *21st century*
chunga, naguala, natural dyes, various sizes
photo: Lorran Meares

William Siegal Galleries

Ancient textiles and objects from Pre-Columbian, Aymara, Chinese, Indonesian and African cultures
Staff: Bill Siegal, owner; Norberto Zamudio, director; Matthew Ellis, assistant

135 West Palace Avenue
Suite 101
Santa Fe, NM 87501
voice 505.820.3300
fax 505.820.7733
consiegal@aol.com
williamsiegalgalleries.com

*Unknown, Palembang, Sumatra, Indonesia, Kain Lawan, late 19th- early 20th century
silk, various sizes
photo: Lorran Meares*

Gareth Neal, **Tendril**
rippled sycamore, walnut, stainless steel, silver, 40 x 13.5

William Zimmer Gallery

International masterworks emphasizing sustainable and managed materials for conscientious collectors
Staff: William and Lynette Zimmer, owners; Yarrow Summers, Lauren Drever, Pamela Wilson and Joan Hayes, associates

10481 Lansing Street
Box 263
Mendocino, CA 95460
voice 707.937.5121
fax 707.937.2405
wzg@mcn.org
williamzimmergallery.com

Representing:
Elmer Adams
Jeff Brown
R.W. Butts
Graham Carr
Tanija Carr
John Dodd
David Ebner
Gretchen Ewert
Peter Hayes
Barbara Heinrich
Archie Held
Tai Lake
Mark Levin
Sydney Lynch
Guy Michaels
Hiroki Morinoue
Gareth Neal
Sang Roberson
Cheryl Rydmark
Michael Smith
Noi Volkov

David Ebner, **Bamboo Sideboard,** *2003*
bamboo, 34 x 60 x 15
photo: Steven Amiaga

Harlan Butt, **Earth Beneath Our Feet: Incense Burner II,** *2002*
metal, 6 x 6.5 x 6.5
photo: R.H. Hensleigh

Yaw Gallery

National and international goldsmiths and silversmiths
Staff: Nancy Yaw, director; Jim Yaw; Edith Robertson

550 North Old Woodward
Birmingham, MI 48009
voice 248.647.5470
fax 248.647.3715
yawgallery@msn.com
yawgallery.com

Representing:
Joe Reyes Apodoca
Curtis H. Arima
Maureen Banner
Michael Banner
Allison Black
Falk Burger
Harlan Butt
Bridget Catchpole
Jack da Silva
Marilyn da Silva
Susan Hoge
David Huang
Olle Johanson
Christina A. Lemon
Thomas Madden
Barbara Minor
Paulette Myers
Mary Ann Spavins Owen
Jon Michael Route
Billie Jean Theide
Pamela Morris
 Thompford
Carol Warner
Yoshiko Yamamoto

Kevin Glenn Crane, Circus Queen - A Carousel Horse, *2001*
jewelry, 2 x 1 x .25
photo: R.H. Hensleigh

293

Res

ources

CLAY IN DANISH HANDS

BY DEBORAH KRASNER • PHOTOGRAPHS BY OLE AKHØJ

Living in Denmark for two years in the mid-80s was my opportunity to experience design heaven — it actually took work to find anything ugly or poorly made. Impeccable craftsmanship and quiet confidence in stark form are hallmarks of Danish object making, as they have been for most of the 20th century. These strengths are beautifully on view in "From the Kilns of Denmark," featuring 30 ceramics. The exhibition, curated by Wendy Tarlow Kaplan and Hope Barkan in association with the Danish Museum of Decorative Art, Copenhagen, and the Fitchburg Art Museum, Massachusetts, is touring in the United States before heading back to Europe in 2004."

Those who can't get to the exhibit will still be able to get a good sense of the work from the catalog and the video accompanying it. Although the book format somewhat limits our understanding of the scale of the pieces, their strong forms shine through. The video is a useful adjunct, as it introduces us to the potters and their process, information that was lacking in the exhibition labels.

It's a curious fact of Danish life that Danes, citizens of a tiny country with a total population of around 5.3 million, still feel as if they are at the center of the world. They find it quite unsurprising that they've held a leadership position in the design world for more than 50 years — they know they're that good. For the rest of us, particularly in this country, Danish pots teach us something we've lost touch with: the power of simple form and the seductive beauty of glaze. Training its potters is essentially two major craft schools — the Danish School of Arts and Crafts, Copenhagen, and the School of Arts and Crafts, Kolding — Denmark has created and extended a tradition of thinking analytically and rigorously about shape, and of letting glaze amplify the power of form.

The majority of pots in this exhibition, whether wheel-thrown, hand-built or cast, are based on the cylinder. This shape, the first that potters learn to throw, is akin to learning the alphabet by the letter "A" and then pursuing endless, deep explorations of all that "A" can do. Here, cylinders are quiet moving elegies to the form — as in works by Inger Rokkjaer, Bodil Manz, Gertrud Vasegaard — or made rich with texture — as in those by Morten Løbner Espersen and Jane Reumert.

CRAFT

AUG/SEPT 02 $5

CRAFT

JUNE/JULY 02 $5

QUILT NATIONAL '03

In the 24 years since its inception, the juried biennial exhibition Quilt National has become a distinguished showcase for the art quilt. The 13th edition of this event, "Quilt National '03," opened at the Dairy Barn Southeastern Ohio Cultural Arts Center, Athens, May 24 through September 1), presenting 86 quilts by artists from 27 states and 11 foreign countries. The jurors, quilt artists Liz Axford and Wendy Huhn and Robert Shaw, author of the Art Quilt and other publications, drew their selection from 1,482 entries. Their statement in the catalog details the extensive jurying process and the general criteria that applied — good composition and color, a sense of context or theme, a coherent body of work, appropriate size, scale and workmanship. The works pictured here are among the 16 chosen by the jurors to receive awards.

Portions of the exhibition will travel to other venues through 2005. The itinerary and other information can be accessed at www.dairybarn.org. Quilt National 2003 The Best of Contemporary Quilts (Lark Books), 112 pages, introduction by Project Director Hilary Morrow Fletcher, illustrated, is $24.95 from the Dairy Barn, 740-592-4981 or michol.tdairybarn.org.

AMERICAN CRAFT 54 AUGUST/SEPTEMBER 2004

THE ART OF CRAFT

AMERICAN CRAFT is published bimonthly by the American Craft Council, the national organization providing leadership in the craft field since 1943. Annual membership in the Council, including a subscription to the magazine, $40, by contacting www.craftcouncil.org or 1-888-313-5527.

AMERICAN CRAFT

JUNE/JULY 03 $5

Originally two levels, the house now terraces down the hillside on four levels, with a series of decks that fully exploit a 230-degree, four-volcano view.

have many. So in the Bullseye … Their home is a mixture of what … e" in glass and the art the cou- … g with Bullseye's technicians … cket to be collectors," McGre-

ous promenade continues, but in the form of more conventional glass art-works. Some are delicate, some muscular, but like the driveway and porch, every piece of glass in this collection was in a sense formed by Schwoer-er and McGregor, not as artists but as manufacturers of the actual mater-ial, at their firm, the Bullseye Glass Company, in Portland, Oregon (which Schwoerer, its current CEO, founded in 1974 with Ray Ahlgren and Boyce Lundstrom).

Bullseye produces some of the most vibrant colored glass in the world and has also been one of the most influential supporters of contemporary glass art through the technologies it has developed to make different glasses compatible (expansion and shrinkage variations being the chief problem in mixing glasses) and for its artist-in-residence programs and resource center/gallery, the Bullseye Connection. The company has grown from a start-up by what Schwoerer quips were "three hippies in a back-yard" of a rundown Victorian house to a factory covering nearly two city blocks where that house once stood. With similarly energetic improvisa-tion, they grew their home from an unremarkable 1,500-square-foot ranch-style bungalow bought in 1979 to what is now a 3,900-square-foot villa that Schwoerer calls "a great place to entertain," but which, McGregor unabashedly admits, is also very much "an extension of the business."

"We wanted to make a lab for the uses of the material to see how it can exist in the home beyond the usual method of putting things on shelves," Schwoerer says. "Glass collectors want to see the homes of other glass col-

Given the many artists Bullseye has hosted, the collection is extraordi-narily focused on those the couple believe have achieved technical or con-ceptual advances in the medium. On a wall over a counter, for instance, are a series of shelves lined with the ethereal goblets Dante Marioni blows each holiday season at Bullseye. The collection is a record of a collabora-tion now in its eighth year between Marioni and the Bullseye technician Sam Andreakos—one McGregor describes as "America's best young glassblower working with America's best glass color chemist."

Marioni requests a type of glass. Andreakos brews a batch. Marioni then uses it to blow goblets—or *Cups*, as he prefers to title them—so delicate they seem spun out of soap bubbles. Year one was clear crystal. Year two, Venetian topaz. Year three, a rare earth mineral called urbinium that results in a color best described as dichroic champagne. And so on, from cobalts to an opaque white to a straw-colored Italian glass known as "pagliesco."

Marioni's 00-ah example of blown-glass mastery is the exception in this collection, however. For the most part, Schwoerer and McGregor have turned their home, like their business, into an extended argument for the artistic equality of cast and fused glass, whose creators represent Bulls-eye's main clientele. In fact, in one prominent case, blown glass actually plays the foil in this collection.

Enter Schwoerer and McGregor's front door and the first piece to be noticed is their Dale Chihuly—a cluster of his *Reeds*—but positioned right next to what is easily their most valued piece, Klaus Moje's *Aperto 96.*

Material Matters
At Home with
Dan Schwoerer and Lani McGregor

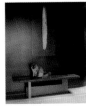

ABOVE: Jun Kaneko's 300-pound, six-feet-long arti… of slumped glass create a focal point in the garde… LEFT: Sweden's Bertil Vallien comes every few ye… to the Bullseye factory to create a body of work i… sand-cast method of which he is a master. *Anon*… rare, up-turned wall-mounted piece made in 200… Anne is poised on a mahogany and steel bench … the late Seattle artist/designer David Gulassa.

Barrett Marsden Gallery
17-18 Great Sutton Street, London EC1V 0DN, England
T: +44 (0) 20 7336 6396 F: +44 (0) 20 7336 6391 E: info@bmgallery.co.uk

Ken Eastman

British Crafts Council
44a Pentonville Road, London N1 9BY, England
T: +44 (0) 20 7806 2559 F: +44 (0) 20 7837 6891 E: trading@craftscouncil.org.uk www.craftscouncil.org.uk

Edmund de Waal

Clare Beck at Adrian Sassoon
14 Rutland Gate, London SW7 1BB, England
T: + 44 (0) 207 581 9888 F: + 44 (0) 207 823 8473 E: email@adriansassoon.com www.adriansassoon.com

Kate Malone

The Gallery, Ruthin Craft Centre
Park Road, Ruthin, Denbighshire LL15 1BB, North Wales
T: +44 (0) 1824 704774 F: +44 (0) 1824 702060 E: thegallery@rccentre.co.uk

Catrin Howell

The Scottish Gallery
16 Dundas Street, Edinburgh EH3 6HZ, Scotland
T: +44 (0) 131 558 1200 F: +44 (0) 131 558 3900 E: mail@scottish-gallery.co.uk www.scottish-gallery.co.uk

Grant McCaig

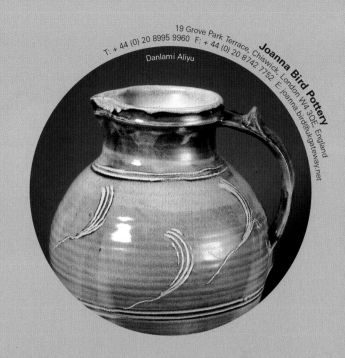

British Craft at
SOFA CHICAGO
16–19 October 2003

www.craftscouncil.org.uk/sofa2003

CRAFTS COUNCIL

ARTS COUNCIL ENGLAND

CHARTER AWARD
Awarded for excellence

Supported by
TRADE PARTNERS UK
www.tradepartners.gov.uk

SOFA CHICAGO
16–19 October 2003
Navy Pier, Chicago
www.SOFAEXPO.com

Ceramic Review

The International Magazine of Ceramic Art and Craft

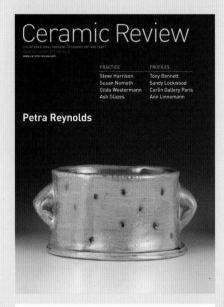

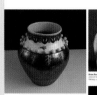
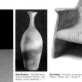
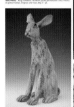

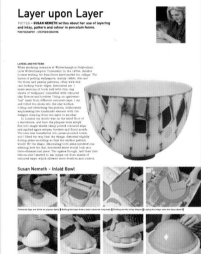
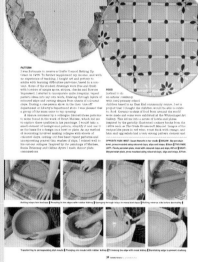
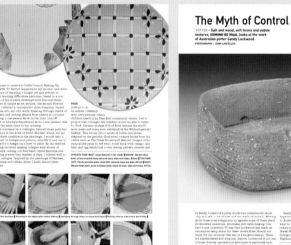
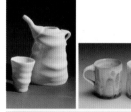
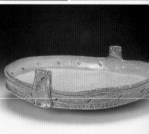

CERAMIC REVIEW

The leading British magazine of studio pottery, read by all those engaged with contemporary ceramic art and craft around the world **CRITICAL** Contemporary and historical overviews, surveys and reviews from potters, critics, curators and commentators **PRACTICAL** Artists' inspirations, ambitions and experiences. Step by step sequences and technical articles cover methods, materials and equipment **INFORMATIVE** Leading figures give an insight into the framework of contemporary craft, from potters to directors of national institutions and individual collectors **INCLUSIVE** Subscribers play a vital role in the magazine's debates and surveys through the Letters, Gallery, Reports and Reviews pages. www.ceramicreview.com Subscribe, search, contribute: visit the Ceramic Review website.

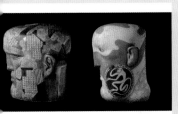

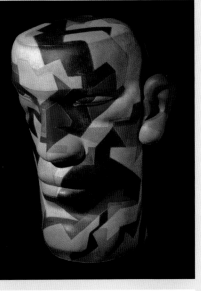

...ad Lines

PAT BENNETT considers Tony Bennett's forceful figures ...cribes recent changes in his forms and techniques.

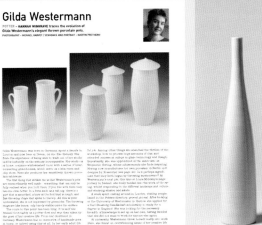

Gilda Westermann

POTTER – HANNAH WINGRAVE traces the evolution of Gilda Westermann's elegant thrown porcelain pots.

PHOTOGRAPHY – MICHAEL HARVEY / SEQUENCE AND PORTRAIT – MARTIN PROTHERO

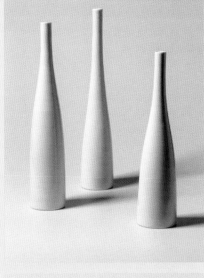

Raising a Smile

PROFILE – JULIA PITTS travels to a railway arch in Peckham, South London, to meet Jane Muir.

PHOTOGRAPHY – MICHAEL HARVEY / SEQUENCE – STEPHEN BRAYNE

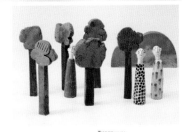

Ceramic Review
THE INTERNATIONAL MAGAZINE OF CERAMIC ART AND CRAFT
ISSUE 201 MAY/JUNE 2003 £5.95
www.ceramicreview.com

Jane Muir

PRACTICE	PROFILES
Andrew Wicks	Susan Daniel McElroy
Anagama Kilns	Bernard Leach
German Ceramics	Alun Graves
Fibres in Clay	Sean Miller

CERAMICS: ART & PERCEPTION

Ceramics: Art and Perception sets the standard
a dedicated magazine on ceramic art. With wel
written articles on a broad range of subjects on
ceramics and excellent colour photographs, this
a high quality quarterly publication both in conte
and presentation. With an international and mult
cultural viewpoint, subjects range from the avan
garde to the traditional and philisophical, the
provocative and contemporary to the historical.

Ceramics TECHNICAL

Ceramics TECHNICAL is a biannual magazine devoted to research in the field of ceramic art which is of interest to ceramic artists, studio potters and all involved in furthering the knowledge and skill of this art form. Subjects range from clay research, techniques, kilns and firing, forms, slips and glazes, decorative methods, workshops and book reviews and more. Innovative and traditional uses of materials and processes are covered.

120 Glenmore Road Paddington NSW 2021 Australia
Tel +61 (0)2 9361 5286 Fax +61 (0)2 9361 5402
ceramics@ceramicart.com.au www.ceramicart.com.au

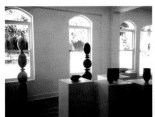

Ceramics
MONTHLY

The core of every good collection

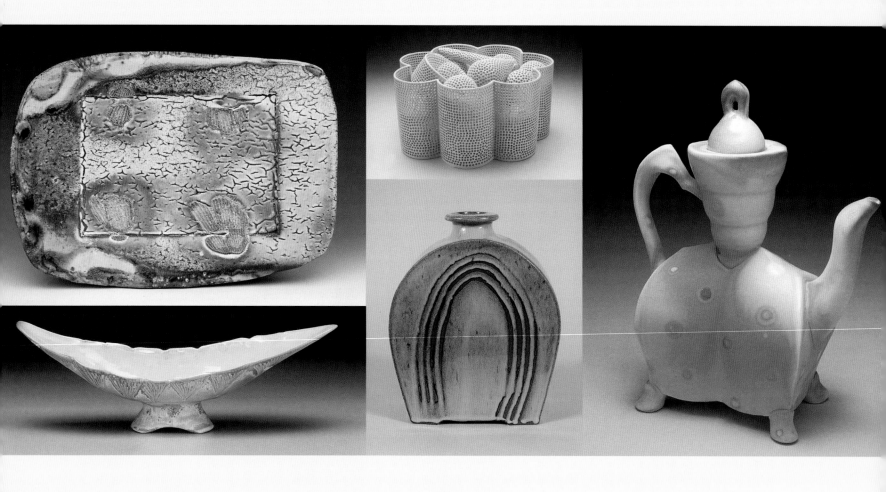

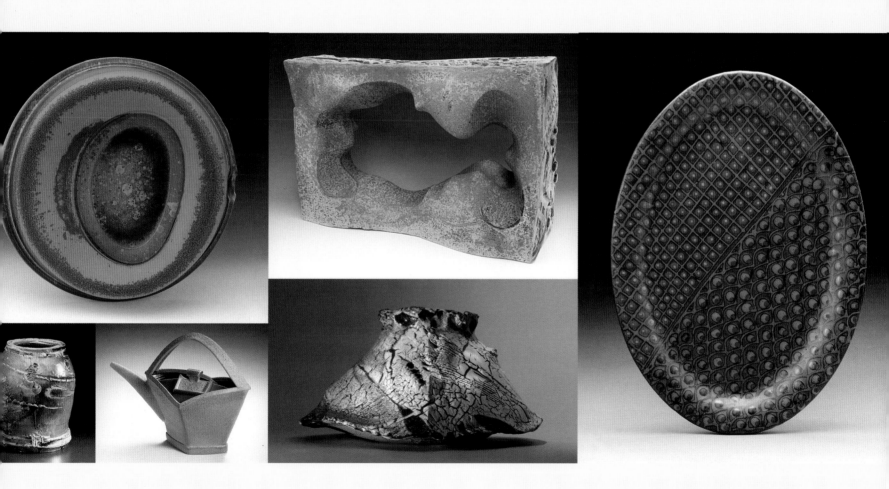

is knowledge.

Ceramics Monthly, 735 Ceramic Place, Westerville, OH 43081; telephone (614) 794-5890; fax (614) 891-8960; www.ceramicsmonthly.org

CAC publishes the monthly newspaper, *Chicago Artists' News*, which includes features on current events in the regional, national and international art worlds written by top arts writers. The extensive classified section lists exhibition opportunities, jobs, studio space, openings, member announcements, and much more, useful to artists all over the country. *Chicago Artists' News* **is a great resource for keeping readers in touch with the visual art scene.**

CAC also publishes several books, guides and lists. Books include the **Artists' Gallery Guide** and the **Artists' Self-Help Guide**. Our informative lists focus on everything from Public Art Commissions to Art Reps and Artists' Retreats.

CAC provides artists with a **slide registry** (perused regularly by prospective art buyers); a **job referral** service; access to **health insurance** plans; a **credit union** that provides free checking and low-interest loans; **discounts** at many leading art supply stores; special **programs** on such practical matters as taxes, and marketing your art; monthly **artists' "salons"** where artists can network in an informal environment; and a host of other services that promote visual artists as practicing professionals in today's world.

Our web site, CAC Online, includes information on CAC, excerpts from *Chicago Artists' News*, detailed descriptions of our publications, and more. The site includes a slide registry, which is helping our members to reach the global art marketplace.

Since 1998, CAC has sponsored the **Chicago Art Open**, an annual exhibition of 300 or more Chicago-area artists under one roof, the largest non-juried show dedicated solely to local artists in decades. This year's show will run from **October 11 - 19**, with an opening night benefit for the Chicago Artists' Coalition. Artists, art buyers, dealers and all friends of the arts will want to attend. The Art Open is part of Chicago Artists' Month, sponsored by the Chicago Department of Cultural Affairs.

Chicago's most comprehensive guide to the city's art galleries and services.

Published three times per year: January / April / September
Subscriptions: $12 per year

CHICAGO GALLERY NEWS
730 N. Franklin, Chicago, Il. 60610
phone: (312) 649-0064
fax: (312) 649-0255
e mail: cgnchicago@aol.com

Visit us on the web at
www.chicagogallerynews.com

September – December 2003 • Volume 18 • #3

Chicago Gallery News

Chicago's Most Comprehensive Guide to the City's Art Galleries and Services

Hollis Taggart Galleries
celebrate one year in Chicago

Wood Art by Todd Hoyer (USA)

WOOD ART BY **TODD HOYER** & HAYLEY SMITH,
LOUISE HIBBERT & **WILLIAM HUNTER**: ART GLASS BY
TONY HANNING, MARK THIELE & MATTHEW LARWOOD
TERTIARY ART EDUCATION IN AUSTRALIA & NZ

55

Glass by Kevin Gordon (Australia)

THE ART OF ALBERT NAMATJIRA 1902–59
THE LIFE-SIZED CLOISONNE FIGURES OF AH XIAN
GLASS BY NEIL WILKIN, PETER BREMERS & THE GORDONS
CERAMICS BY ANITA McINTYRE & CHERYL LUCAS

56

Jewellery & Sculpture by Peter Chang (UK)

JEWELLERY, OBJECTS & SCULPTURE BY PETER CHANG
CERAMICS BY LOTTE REIMERS, IAN JONES & ROD BUTLER
GLASS BY KJELL ENGMAN, EMMA CAMDEN & GEORGE ASLANIS
WOOD SCULPTURE BY ARTHUR JONES & JILLY SUTTON

57

The collectors' magazine

YES! Please accept my subscription order for four issues of **_Craft Arts International_** at the special SOFA price of **$52.00**

Start my subscription with the current issue ☐ *, the next issue* ☐ TICK BOX

Name ... Ph: ...

Address ..

City/State ... Zip Country

Or please forward a gift subscription to:

Name ... Ph: ...

Address ..

City/State ... Zip Country

I enclose a check/money order for **$52.00**, or debit my **Amex** ☐ , **Visa** ☐ , **MasterCard** ☐ TICK BOX

Card No. —— —— —— —— —— —— —— —— —— —— —— —— —— —— —— —— Expiry Date: ——/——

Signature ... Email: ...

craft arts
INTERNATIONAL

NEW CONCEPTS IN BASKETRY BY JAN HOPKINS
ENVIRONMENTAL SCULPTURE OF NEIL DAWSON. GLASS BY
RICHARD WHITELEY, STEPHEN SKILLITZI & JULIO SANTOS
NEW BIOMORPHIC CERAMICS OF BELA KOTAI

58

ISSN 1038-846X

Environmental Sculpture by Neil Dawson (NZ)

Comprehensive index now on-line!

We have revised and updated the index for every issue of *Craft Arts International* and made it available free on-line. This means you can instantly search the entire contents of all past editions of this magazine since it was launched in 1984 in order to find what you are looking for. This access represents almost two decades of continuous publishing in the fields of visual art and designer/making and is one of the most comprehensive information sources of its kind on the Internet. Each issue contains 128 pages and over 400 colour plates of innovative concepts and new work by leading artists and designer/makers across a wide spectrum of styles, techniques and media, supported by authoritative and comprehensive text that is essential reading for people interested in the visual and applied arts.

Limited stocks of most back issues are still available and may be ordered directly from our web site, along with subscriptions and advertising space bookings.

craft arts
INTERNATIONAL

ISSN 1038-846X

9 771038 846007

PAINTED WOODEN ZEN FORMS OF BINH PHO
HOT & COLD-WORKED GLASS BY NICK WIRDNAM,
MEL DOUGLAS AND MARI MÉSZÁROS.
METAL & ENAMEL ARTIST HARLAN W. BUTT

59

Painted Wooden Forms by Binh Pho (USA)

Mail or fax a photocopy of the subscription coupon to:

Craft Arts International
PO Box 363, Neutral Bay, Sydney, NSW 2089, Australia.
Tel: +61-2 9908 4797, Fax: +61-2 9953 1576
Email: subs@craftarts.com.au

www.craftarts.com.au

CRAFTS

BUILDING THE
FUTURE:
ALAN POWERS
ON THE NEW
VERNACULAR
ARCHITECTURE

CRAFTS

A WAY WITH THE FAIRIES:
THE ENCHANTED WORLD
OF SAMANTHA BRYAN

CRAFTS

FOCUS ON PATTERN
HISTORY REPEATS ITSELF?

THE EYE OF THE BEHOLDER: PART TWO

MONUMENTAL MAKER:
APPRECIATION OF PETER VOULKOS

CRAFTS

MASTER OF FOLDING:
TOM MEHEW'S PLASTIC ART

SECRETS OF THE DEEP:
HOW PLANKTON INSPIRED A COLLECTION OF NEW WORKS

NORTHERN LIGHTS:
RETRACING THE STEPS OF MORRIS'S ICELANDIC JOURNAL

CRAFTS

WHITE MAGIC:
THE WIZARDRY OF DANIEL FISHER

LOOMING LARGE:
THE RENAISSANCE OF THE DOVECOT STUDIOS

ROOM FOR CONTEMPLATION:
THE ARTISTS' HOUSE AT ROCHE COURT

CRAFTS

TOY STORY:
DAVID SWIFT'S
CURIOUS CREATURES

MATERIAL GIRL:
REASSESSING EVA HESSE

MAKING HISTORY:
RE-EXAMINING THE STUDIO
POTTERY MOVEMENT

CRAFTS

30

1973 – 2003

THE FUTURE OF
THE CRAFTS:
VIEWS FROM
ROUND THE WORLD

REASONS TO BE CHEERFUL:
30 TOP EXAMPLES OF
CRAFTS AND DESIGN

crafts

ART OF IRAQ
The fragile future?

PRODUCTION VALUES
Olivier Geoffroy's
affordable furniture

STRONG STUFF
Deirdre Nelson's
textile art

crafts

FERTILE
IMAGINATIONS:
Art for gardens

THE MAGAZINE OF TEXTILES

THE BEST OF CONTEMPORARY AND TRADITIONAL FIBER:

surface design, wearables, quilting, weaving, basketry, needlework, handmade paper, sculpture and mixed media.

IT'S ALL THERE.

FIB

Sculptural basketry
New ways of weaving
Embroidered graffiti
Gild the Lily's wearable art

FIBERARTS
THE MAGAZINE OF TEXTILES
SUMMER 2003

The Tapestries of Jon Eric Riis
Miniature Textiles Make It Big
3 Generations: Mentors & Students
Fiber Meets Glass

THE HOME ISSUE
READER STUDIOS
ART TO WALK, SIT, AND LIE ON
LIVING WITH A COLLECTION

ERARTS

subscribe:
FIBERARTS Magazine ■ 67 Broadway, ■ Asheville NC 28801 ■ 800.284.3388 ■ fiberartsmagazine.com

1 year (5 issues) $24.00 2 years (10 issues) $42.00

advertise:
Eleanor Ashton ■ FIBERARTS Magazine ■ 67 Broadway ■ Asheville NC 28801 ■ 877.273.5275

ads@fiberartsmagazine.com

glass Quarterly brings you the best of the global glass community. Consider us your personal guide to artists, designers, museums, writers, and events that are both continuing traditions and breaking all the rules.

glass Quarterly's stunning four-color photography and award-winning design showcase both well-known artists and debut the newest talent. Leading experts cover important trends in making and collecting art.

glass Quarterly is your invitation to international events, commissions, museum openings, and breaking news from the worlds of art, architecture, and design. Our international correspondents review the latest exhibitions, shows, and books. For nearly 25 years, Glass Quarterly has been the one source for all things glass.

Subscribe Today. 1.800.607.4410

HAUS. DER. KÜNSTLER. GARBER. JOH: 1993

Intuit: The Center for Intuitive and Outsider Art promotes public awareness, understanding, and appreciation of intuitive and outsider art through aprogram of education and exhibition

Gugging: An Artists' House

The Artists' House in Gugging, Austria, was started in the 1960s by Dr. Leo Navratil. Unlike traditional art therapy programs, the Gugging artists are not required to participate in organized studio sessions but rather they make art whenever they feel motivated to do so.

Featuring works by Johann Hauser, August Walla and Oswald Tschirtner.

Through December 20, 2003

Intuit: The Center for Intuitive and Outsider Art
756 North Milwaukee Ave.
Chicago, IL 60622
312.243.9088
Gallery hours: Wed - Sat, noon-5 pm
Admission is free.
Visit Intuit's website at www.art.org

Published 6 times a year

KeramikMagazin

CeramicsMagazine

Magazine for Art and Ceramics

As european orientated specialist journal KeramikMagazin draws the bow between art and trade.
Every other month there are interesting reports about studios and workshops, artists, exhibitions, international competitions and symposiums.

KeramikMagazin gathers profiles of galleries, museums and trading centres, it discusses topical questions of the scene and devotes itself to historical themes.
Detailed interviews with ceramic artists, exhibition organizers, collectors are an integral part of the magazine.

German language with english abstracts.

Our tip:

Order three up-to-date issues.

There is no delivery charge.

Subscribe to:

KeramikMagazin
P.O. Box 1820
50280 Frechen

Fax: 00 49/22 34/18 66-90
E-Mail: zeitschriften@ritterbach.de
Internet: www.ritterbach.de

Kerameiki Techni International Ceramic Art Review

SUBSCRIPTIONS:

• European Union Countries: €36.00 Price per copy: €12.00 • Other countries: US: $36.00 Price per copy: $12.00 (Air Mail Priority postage included) •

SUBSCRIPTIONS AND ORDERS AVAILABLE:

• Through our website, www.kerameikitechni.gr (covered by security) • International bank and/or personal checks payable to Kostas Tarkassis •
• Credit card (VISA and MasterCard). Send info (credit card number, expiration date, name on card) by post/fax/email •

Published three times a year in Greece, in the English language, and is distributed all over the world

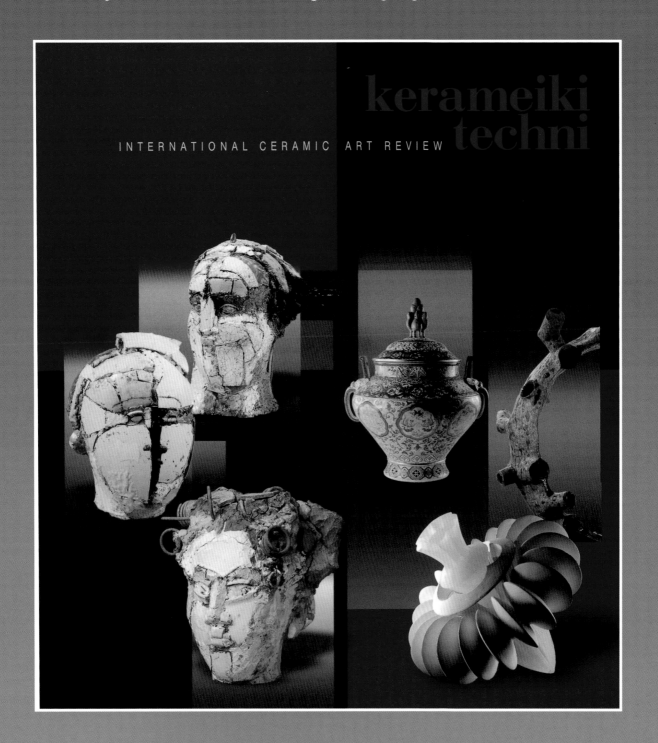

INTERNATIONAL CERAMIC ART REVIEW

kerameiki
techni

Kerameiki Techni International Ceramic Art Review
PO Box 80653, Piraeus 185 10, Greece
Tel/Fax 0030.210.9325.551
kerameiki@otenet.gr
www.kerameikitechni.gr

METALSMITH

JEWELRY ▪ DESIGN ▪ METAL ARTS

EXHIBITION IN PRINT 2003

volume 23 number 4
www.snagmetalsmith.org

Curated Exhibition in Print

Contemporary Enamel

Serving up *style*

The MCA Store offers a vast array of artful works, books, and toys. It's art you can take home!

Always à la mode on the table or a shelf, the High Heel Server is stainless-steel and features a removable magnetic heel. It will dazzle and delight you, your guests, and anyone on your gift list.
MCA members $21.60, nonmembers $24.

LEFT
Balloon Dog (blue), 2002, by Jeff Koons
hand numbered
Make your grandmother's china jealous. This cast-porcelain sculpture with a mirrored finish is a reproduction of Koons's large-scale original and a "sequel" to his *Balloon Dog (red)*. Stand and giftbox included. Limited edition of 2,300.
MCA members $448, nonmembers $560.

Museum of Contemporary Art

220 East Chicago Avenue
312.280.2660
mcachicago.org

The Best of International Glass Art around the world

NEUES GLAS
NEW GLASS

www.neuesglas.de

object

object magazine

object stores

object galleries

Object – Australian Centre for Craft and Design
promoting the best new craft and design in Australia.

Object **magazine** explores a dynamic range of design, art and contemporary ideas.
Object stores focus on contemporary gifts and homewares by Australia's leading designer-makers. **Object galleries** presents the very best changing exhibitions of contemporary craft and design. Object galleries and offices will be relocating in 2003, for updates – www.object.com.au.

"Object magazine's creative vision and commitment to innovative design has been a breath of fresh air."
Lisa Berman Director Sculpture to Wear Gallery Los Angeles February 2001

Sculpture

A publication of the International Sculpture Center

www.sculpture.org

Sculpture is the only international monthly publication
devoted exclusively to the world of sculpture.
It features lively dialogue, penetrating interviews,
intimate studio visits and provocative criticism
on both emerging and internationally renowned artists.

Sculpture magazine is published monthly (except February and August) by the International Sculpture Center (ISC), a not-for-profit organization founded in 1960 that advances the creation and understanding of sculpture and its unique, vital contribution to society. The ISC distributes *Sculpture* magazine as a member benefit and through subscription to non-members. Membership is open to anyone.

To become an ISC Member and subscribe to *Sculpture*:
Sarah Schiffer
phone 609.689.1051 ext. 111
fax 609.689.1061
email sarah@sculpture.org

To advertise in *Sculpture*:
Kristine Smith
phone 609.689.1051, ext. 128
fax 609.689.1061
email kristine@sculpture.org

Or visit www.sculpture.org

RATES

BASIC MEMBERSHIP: $95 (add $20 outside of US/Canada/Mexico)
Includes:

— One year subscription (10 issues) to *Sculpture* magazine—the world's foremost publication on contemporary sculpture with an annual readership of over 300,000 in 70 countries

— One year subscription (10 issues) to *Insider*, the ISC's members-only newsletter bound into *Sculpture*, including opportunities listings for artists

— Access to password-protected areas of ‹www.sculpture.org› the ISC's website which received the BBC award for Outstanding Educational Website and averages over 50,000 hits a day

— Listing on *Portfolio* on the ISC's website ‹www.sculpture.org›— 2 images, 2 pages text, 1 link

— 25% discount on advertisements in *Sculpture*

— Up to 50% discount on back issues of *Sculpture*, bulk purchases of ISC publications and products, and tearsheets/overruns of *Sculpture*

— Reduced registration fees for ISC conferences, workshops and special events

— Discounts on supplies, art magazines, and art transportation

— Awards, solo exhibitions, and other notable news eligible to be published in "On Record" in *Sculpture*

SCULPTURE SUBSCRIPTION ONLY (10 ISSUES)

$50 (add $20 outside of US/Canada/Mexico)

SPECIAL RATE FOR SOFA CHICAGO:

Mention "SOFA Chicago 2003" and you will receive $10 off the regular membership and subscription prices.

Additional discounts available for Students, Young Professionals (within 3 years of graduation) and Seniors (65+).

Association

Member Benefits:
- Four issues of the Surface Design Journal
- Four issues of the SDA Newsletter
- National and regional conferences
- Networking opportunities
- Inclusion in SDA Slide Library
- SDA Instructors Registry
- Avenues for promoting of your work
- Opportunities for professional
 development
- Free 30-word non-commercial
 classified ad in the newsletter
- Exhibition opportunities

Member Services:
- Access to fabric sample library
 and slide library
- Access to instructor directory
- Resource recommendations

For membership information, visit our
web site www.surfacedesign.org

Surface Design Association
PO Box 360
Sebastopol CA 95473
707.829.3110
surfacedesign@mail.com

Art Alliance for
Contemporary Glass

The Art Alliance for Contemporary Glass
is a not–for–profit organization whose mission is to further the
development and appreciation of art made from glass. The Alliance
informs collectors, critics and curators by encouraging and
supporting museum exhibitions, university glass departments and
specialized teaching programs, regional collector groups, visits
to private collections, and public seminars.

Support
Glass

Membership $65
Your membership entitles you to a
subscription to "Glass Focus", the AACG
newsletter, and opportunities to attend
private events at studios, galleries,
collectors homes, Glass Weekend
and SOFA. For more information visit our
web site at www.ContempGlass.org,
email at admin@contempglass.org or
call at 847-869-2018.

Jaime Bennett

The Art Jewelry Forum congratulates
SOFA Chicago on its 10 year run!

We invite you to join the Art Jewelry Forum and

participate with other collectors who share your enthusiasm for contemporary art jewelry.

OUR MISSION To promote education, appreciation, and support for contemporary art jewelry.

OUR GOALS To sponsor educational programs, panel discussions, and lectures about national and international art jewelry.

To encourage and support exhibitions, publications, and programs which feature art jewelry.

To organize trips with visits to private collections, educational institutions, exhibitions, and artists' studios.

Mary Lee Hu

Join the Art Jewelry Forum today!

E-mail: **info@artjewelryforum.org**

Call: **415.522.2924**

Write us at: Art Jewelry Forum,

P.O. Box 590216, San Francisco, CA

94159-0216

Yeon Mi Kang
AJF's first Emerging Artist Award winner

Divan Japonais (detail) from Toulouse Lautrec: Woman as Myth, published by Bsil & Elise, Goulandris Foundation 2001

UK tel : +44 (0)20 7735 3331
US tel : +1 212 343 0727
contact@theartnewspaper.com
www.theartnewspaper.com

INTERNATIONAL EDITION
THE ART NEWSPAPER
INSIDE ART

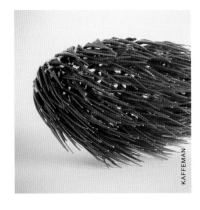

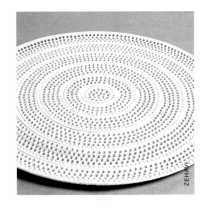

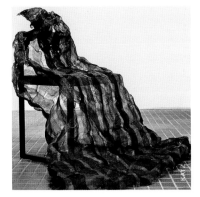

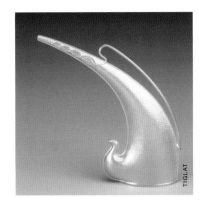

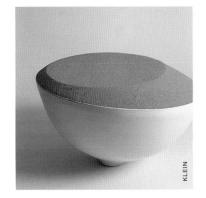

association of israel's decorative arts

375 Park Avenue
Suite 401
New York, New York 10152
212.572.1240 p
212.572.7127 f
aidasofa@aol.com

Innovation & Influences

AIDA FOUNDERS

Dale and Doug Anderson

Andy and Charles Bronfman

AIDA ADVISORS

Jane Adlin
METROPOLITAN MUSEUM
OF ART

Mark Lyman
SOFA

Anne Meszko
SOFA

Rivka Saker
SOTHEBY'S

Norman Sandler
SANDLER ARCHITECTS

Elisabeth Sandler
SANDLER ARCHITECHS

Aviva Ben Sira
ERETZ ISRAEL MUSEUM

Jeff Solomon
ACBP

Jason Soloway
ACBP

Davira S. Taragin
RACINE ART MUSEUM

PROJECT DIRECTOR

Jo Mett

Ateliers d'Art de France presents

projections
d'argile

4th international festival of films on ceramics

guest theme: glass

from march 12 to 14, 2004 montpellier, france

register to attend on www.projectionsdargile.com

Ateliers d'Art DE FRANCE

CCa CALIFORNIA COLLEGE OF THE ARTS

MAKING ART THAT MAKES A DIFFERENCE

Offering **18** undergraduate programs including:

{
CERAMICS SCULPTURE

GLASS TEXTILES

JEWELRY/METAL ARTS WOOD/FURNITURE

PAINTING
}

And **6** graduate programs in:

{
ARCHITECTURE (new in '04) FINE ARTS

CURATORIAL PRACTICE VISUAL CRITICISM

DESIGN WRITING
}

CCA.EDU

800.447.1ART

California College of the Arts San Francisco / Oakland Art, Architecture, Design, Writing

formerly California College of Arts and Crafts (CCAC)

DOWNTOWN. UPTOWN.
OUR TOWN. ART TOWN.

CHICAGO ARTISTS' MONTH
ARTISTS ON THE MAP | OCTOBER 2003

Sara Lee Foundation
Lead Corporate
Sponsor

→ MEET ARTISTS AND SEE THEIR WORK AT OVER 100
LOCATIONS THROUGHOUT CHICAGO.

 City of Chicago
Richard M. Daley,
Mayor

JCDecaux
WTTW11
98.7WFMT
Media Sponsors

Photography
by Jeff Sciortino

312/744-6630

WWW.CITYOFCHICAGO.ORG/CULTURALAFFAIRS

**Department of
Cultural Affairs
Lois Weisberg,
Commissioner**

**Lettuce Entertain
You Enterprises**
Official Dining
Partner

Design +
Communications
by Good Studio

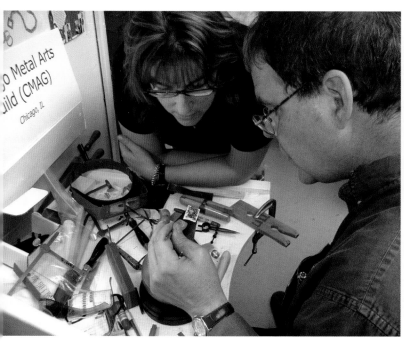
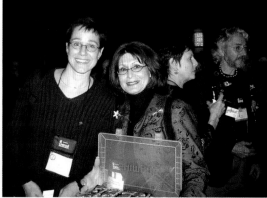
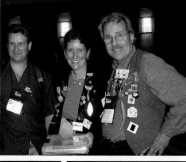

Chicago Metal Arts Guild (CMAG) offers anyone interested in the metal arts, from students to professionals, the opportunity to become a part of a strong metalsmithing community. This dynamic community enriches the careers of its members, strengthens public perceptions about the field, and advances the place of metal artists in the Chicago art community. It is a forum for sharing business practices and tips, getting artistic feedback from peers, learning new skills in sponsored workshops, gaining exposure to new work and ideas through visiting artists' lectures, providing exhibition opportunities, and promoting our field through educational outreach programs. The Chicago Metal Arts Guild has been recognized as a significant and reliable organization; we've been chosen to host the SNAG (Society of North American Goldsmiths) conference in 2006.

A non-profit organization, we have an eleven member volunteer board of directors. We host our events primarily in the Chicago area, but welcome members from all parts of the Midwest. In our first year we've attracted over one hundred members! Join us in creating a vibrant and active organization that will promote and enhance the Chicago area metals community!

CMAG OFFERS:

- workshops
- lectures
- panel discussions
- quarterly newsletter
- community outreach
- local exhibitions
- membership directory
- website
- studio visits
- social activities

For more information write to:
Chicago Metal Arts Guild
P.O.Box 1382
Oak Park, IL 60304-0382
phone: 708-358-0019

CMAG
CHICAGO METAL ARTS GUILD

SOFA
so good.

While art nourishes the soul, entertainment can lift the spirit.
Like SOFA, we're big believers in both.

ARTS
& ENTERTAINMENT

Chicago Tribune

beyond words

The Chicago Women's Caucus for Art

CWCA Members' Show Beverly Art Center

The Chicago Women's Caucus for Art is one of 39 local chapters of the National Women's Caucus for Art and is the largest national organization for women in the visual arts. The 4000+ membership is diverse, open to men and women, and ranges widely in age, culture, color, sexual persuasion and political preference.

The WCA is committed to:
- Educating the public about the contributions of women and minorities in the visual arts.
- Incorporating a culturally diverse and gender neutral approach to arts curricula at all educational levels.
- Ensuring inclusion of women and minorities in the history of art.
- Promoting a system that provides the opportunity for economic survival in the arts.
- Writing and supporting legislation that contributes to the goals outlined above.

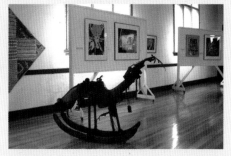

Regional Juried Exhibition
Redefining Feminism, 1999

Why become a member of CWCA?

Programs
- hosted 1999 regional conference & exhibition, *Redefining Feminism*
- hosting 2001 WCA National Conference February 26-28
- prominent speakers
- interface with larger Chicago art community
- opportunity for members to discuss their work

Networking
- social events
- summer picnic
- winter members' party
- smaller groups based on interest

Exhibitions
- national, regional and local
- distinguished jurors and curators
- annual members exhibition
- traveling WCA members' exhibition

Outreach
- developing a program for the Chicago schools which document women in the visual arts in Chicago

History
- Celebrating our 27th year

Newsletter
- published quarterly
- articles on artists, poets, exhibitions and professional development
- commentaries
- exhibition opportunities listed
- members may submit articles

for more information:
The Chicago Women's Caucus for Art
c/o Chicago Artists' Coalition
11 E. Hubbard St., 7th floor
Chicago, IL 60611
voice mail: 773/883-4407

The Clay Studio

Education Innovation Celebration

Classes

Workshops

Lectures

Exhibitions

Installations

Community Outreach

Resident Artist Program

Associate Artist Program

Guest Artist Residencies

Sales Gallery

Rain Harris

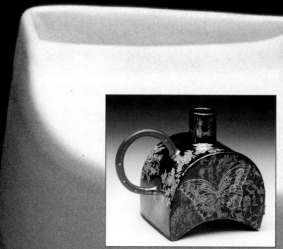
Candy Depew

Christyl Boger

Byung Joo Suh

Heeseung Lee

Julie York

Hide Sadohara

Background Image: Rebekah Wostrel

Mastery in Clay

Exhibition / Auction

Collectors Weekend

November 14-16, 2003

139 North Second Street Philadelphia PA 19106 215-925-3453 info@theclaystudio.org www.theclaystudio.org

a non-profit multifaceted ceramic arts learning center in the heart of Old City Philadelphia

THE CLAY STUDIO

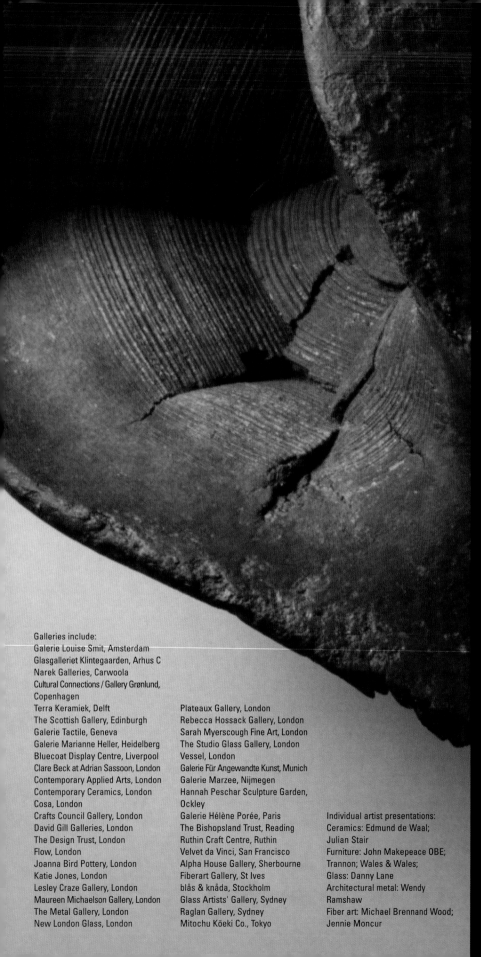

The new art fair for contemporary objec
Presented by the British Crafts Council

Friday 20 – Tuesday 24 February 2004
At the V&A, London

col lect

Venue
Temporary Exhibition Galleries
Victoria and Albert Museum, South Kensington,
London, UK

Organizers
British Crafts Council
44a Pentonville Road, London N1 9BY, UK

For visitor information
+44 (0)20 7806 2512

Email: collect@craftscouncil.org.uk
Web: www.craftscouncil.org.uk/collect

Galleries include:
Galerie Louise Smit, Amsterdam
Glasgalleriet Klintegaarden, Arhus C
Narek Galleries, Carwoola
Cultural Connections / Gallery Grønlund,
Copenhagen
Terra Keramiek, Delft
The Scottish Gallery, Edinburgh
Galerie Tactile, Geneva
Galerie Marianne Heller, Heidelberg
Bluecoat Display Centre, Liverpool
Clare Beck at Adrian Sassoon, London
Contemporary Applied Arts, London
Contemporary Ceramics, London
Cosa, London
Crafts Council Gallery, London
David Gill Galleries, London
The Design Trust, London
Flow, London
Joanna Bird Pottery, London
Katie Jones, London
Lesley Craze Gallery, London
Maureen Michaelson Gallery, London
The Metal Gallery, London
New London Glass, London

Plateaux Gallery, London
Rebecca Hossack Gallery, London
Sarah Myerscough Fine Art, London
The Studio Glass Gallery, London
Vessel, London
Galerie Für Angewandte Kunst, Munich
Galerie Marzee, Nijmegen
Hannah Peschar Sculpture Garden,
Ockley
Galerie Hélène Porée, Paris
The Bishopsland Trust, Reading
Ruthin Craft Centre, Ruthin
Velvet da Vinci, San Francisco
Alpha House Gallery, Sherbourne
Fiberart Gallery, St Ives
blås & knåda, Stockholm
Glass Artists' Gallery, Sydney
Raglan Gallery, Sydney
Mitochu Kōeki Co., Tokyo

Individual artist presentations:
Ceramics: Edmund de Waal;
Julian Stair
Furniture: John Makepeace OBE;
Trannon; Wales & Wales;
Glass: Danny Lane
Architectural metal: Wendy
Ramshaw
Fiber art: Michael Brennand Wood;
Jennie Moncur

Image: Yoh Akiyama represented
Mitochu Kōeki Co., Tokyo

Registered Charity Number 280956

Contemporary
Art Workshop

painting

printmaking

photography

drawing

sculpture

installation

gallery

studios

workshop

tours

Jelena Berenc, *Self Among Self-Among Others,* 2002, ink and paper, dimensions variable

CONTEMPORARY ART WORKSHOP is one of the oldest alternative artists' spaces in the country. Founded in 1949 by a small group of artists including sculptor John Kearney, Leon Golub, and Cosmo Campoli, the workshop has maintained a commitment and dedication to the work of emerging and under-represented artists of Chicago and the Midwest. In addition to monthly gallery exhibitions and open sculpture workshop,

the Contemporary Art Workshop houses John Kearney's studio and over twenty-one active studio spaces.

The current gallery exhibition features paintings by Katherine Drake Chial and Elizabeth Tyson, and runs through November 4, 2003.

Contemporary Art Workshop

542 West Grant Place, Chicago, IL 60614

phone: 773.472.4004

email: info@contemporaryartworkshop.org

web: www.contemporaryartworkshop.org

A non-profit, tax exempt corporation dedicated to the arts

Corning Museum of Glass

One Museum Way • Corning, New York 14830 • www.cmog.org

CM OG Corning Museum of Glass

© John Polak

craft emergency relief fund raffle

cerf@heart is a work consisting of 26 miniature one-of-a-kind hearts encased as a single collection. The collection will be raffled to raise funds for the **Craft Emergency Relief Fund.**

Tickets are $50 each or five for $200. To purchase tickets, please contact CERF at (802) 229-2306 or info@craftemergency.org. www.craftemergency.org

Drawing: Oct. 19, 2003 at SOFA Chicago.
You do not need to be present to win.

collection artists: · Boris Bally · Jean Cacicedo · Beth Cassidy · Olga Dvigoubsky Cinnamon · Donna D'Aquino · Josh DeWeese · Lucy Feller · Pamela Hastings · William Hunter · Linda Kaye-Moses · Linda Leviton · Marilyn Moore · Steve Maslach · Beth Nobles · Craig Nutt · Gina Pankowski · Flo Perkins · Karen Portaleo · Kait Rhoads · Susan Silvy · Susan Skinner · Paul Stankard · Pamina Traylor · Jacques Vesery · Kathy Wegman · Rosalie Wynkoop

www.furnituresociety.org

Advancing the art of furniture making by inspiring creativity, promoting excellence, and fostering understanding of this art and its place in society.

MEMBERSHIP	EXHIBITIONS	PUBLICATIONS	CONFERENCES

The Furniture Society
111 Grovewood Rd., Asheville, NC 28804

ph: 828 255 1949 | fax: 828 255 1950
mail@furnituresociety.org

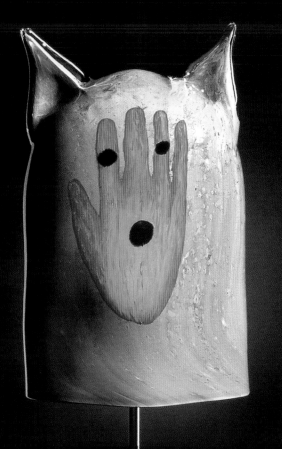

Membership is open to anyone interested in glass art:

Artists	Galleries	Manufacturers
Educators	Museums	Suppliers
Students	Collectors	Writers

RECEIVE:

GASnews: 6 newsletters each year
Journal documenting the annual conference
Member and Education Roster
Resource Guide
Link from the G.A.S. web site
Access to the web message board
Newsletter ad discounts
Discount on membership at The Corning Museum of Glass

TAKE ADVANTAGE OF:

Annual conference, networking opportunities
Database information, mailing lists

glass art society

GLASS ART
SOCIETY

1305 Fourth Avenue, Suite 711
Seattle, Washington 98101 USA
Phone: 206.382.1305
Fax: 206.382.2630
E-mail: info@glassart.org
Web: www.glassart.org

34th Annual Glass Art Society Conference

New Orleans, LA June 10-13, 2004

Demonstrations	Resource Centers
Lectures	Gallery Forum
Exhibitions	Goblet Grab
Technical Display	Auctions
Panel Discussions	Parties...and More!

Over 3800 members in 50 countries

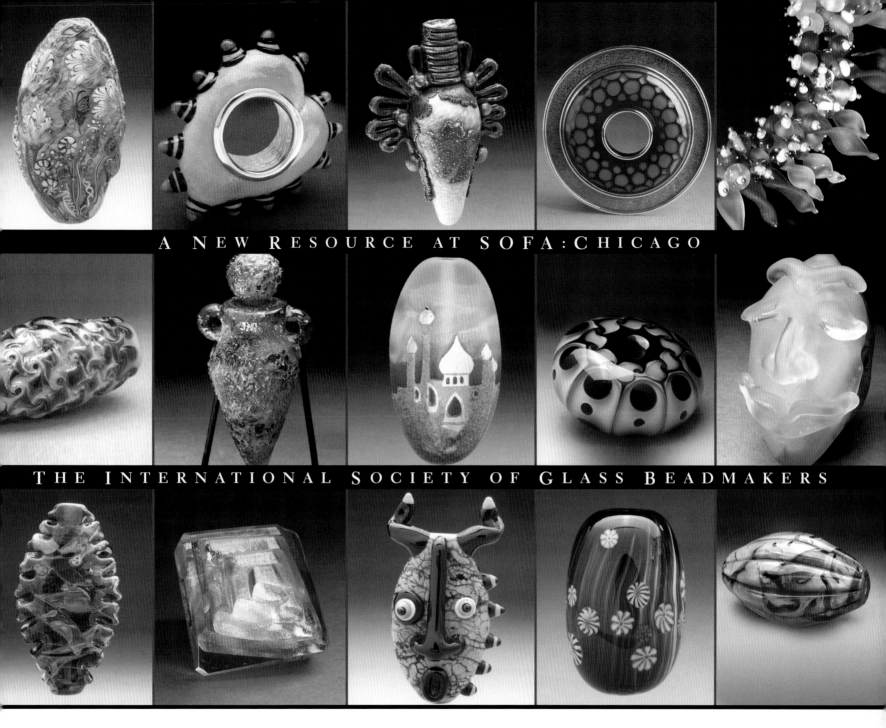

A NEW RESOURCE AT SOFA:CHICAGO

THE INTERNATIONAL SOCIETY OF GLASS BEADMAKERS

The International Society of Glass Beadmakers is a non profit organization. It's mission is to provide education related to contemporary glassbeadmaking, to promote the continued renaissance of glassbeadmaking and related glassworking techniques, and to preserve the historic tradition of glassbeadmaking.

International Society of Glass Beadmakers
1120 Chester Avenue #470 • Cleveland, OH 44114 USA
1 888 742-0242 • www.isgb.org

CELEBRATE AMERICAN CRAFT ART AND ARTISTS
JOIN THE JAMES RENWICK ALLIANCE.

LEARN
about contemporary crafts at our seminars,

SHARE
in the creative vision of craft artists at workshops,

REACH OUT
by supporting our programs for school children,

INCREASE
your skills as a connoisseur,

ENJOY
the comaraderie of fellow craft enthusiasts,

PARTICIPATE
in Craft Weekend including symposium and auction, and

TRAVEL
with fellow members on our craft study tours.

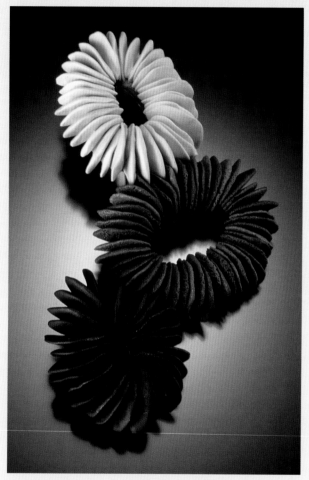

Steven Ford and David Forlano Triple Urchin Pin **P**Photograph by Robert R. Diamante

As a member you will help build our nation'spremiere collection of contemporary American craft art at the Renwick Gallery.

The James Renwick Alliance, founded in 1982, is the exclusive support group of the Renwick Gallery of the Smithsonian American Art Museum.

For more information: Call 301-907-3888. Or visit our website: www.jra.org

Exhibitions: October 11 – November 9, 2003
Opening Reception at New Home:
Saturday, October 18 4-8pm

JASON WALKER & DAVID CRANE

Jason Walker: Exquisite drawings on subtly altered porcelain forms.
Davic Crane: Functional ceramics combining careful geometric surface design on clean geometric forms.

David Crane

Jason Walker

ANDERSON RANCH GROUP SHOW

Seventeen current and former artists-in-residence were selected from the many talented potters, sculptors and installation artists who have been through the outstanding Anderson residency program. Participating in this exhibition are: **Doug Casebeer** (Program Director), **Jill Oberman, Rick Parsons, Pelusa Rosenthal, Bradley Walters, Sam Harvey, Giselle Hicks, Christa Assad, Alleghany Meadows, Julia Galloway, Sam Chung, Brad Miller** (former Program Director), **Michael Wisner, Jae Won Lee, Ruth Borgenicht, Michael Connelly** and **Sinisa Kukee**.

Alleghany Meadows

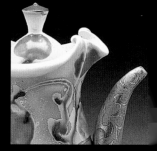
Julia Galloway

Sam Chung

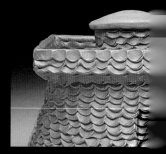
Sam Harvey

NEW HOME:
4401 North Ravenswood
Chicago, Illinois 60640
Phone 773.769.4226
www.lillstreet.com

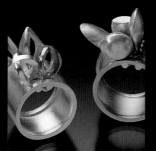
Nancy Deal

FINE JEWELRY: CHRISTINE SIMPSON & NANCY DEAL

Contemporary metalwork and small sculpture.

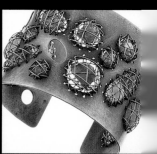
Christine Simpson

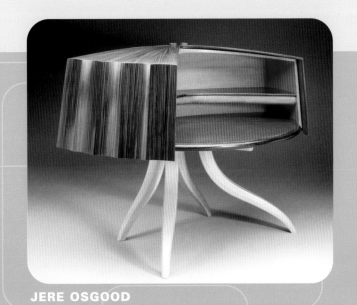

2 columbus circle

Current Exhibition
USDesign 1975-2000
June 19, 2003 - November 2, 2003

Upcoming Exhibitions
Corporal Identity-Body Language
November 13, 2003 - June 6, 2004

40 West 53rd Street
New York, New York 10019
212-956-3535
nyc.mad.museum

Museum of Arts & Design

Meanwhile, please continue
to visit us on 53rd Street.

N·C·E·C·A

NATIONAL COUNCIL ON EDUCATION FOR THE CERAMIC ARTS

Peter Lee

Margaret Bohls, *Teapot and Trivet,* 14" x 8" x 8", Porcelain and earthenware, 2002

NCECA 2004
38TH ANNUAL CONFERENCE

INvestigations
INspirations:
The Alchemy of Art and Science

March 17-20, 2004
INDIANAPOLIS, IN

OVERVIEW

Founded in 1966, the **National Council on Education for the Ceramic Arts** is a not-for-profit educational organization that provides valuble resources and support for individuals, schools, and organizations with a passion for the ceramic arts.

PURPOSE

The purpose of **NCECA** is to promote and improve ceramic arts through education, research, and creative practice. **NCECA** offers programs, exhibitions and publications that are uniquely beneficial and rewarding to its membership, which includes artists, educators, students and patrons. As a dynamic, member-driven organization, **NCECA** strives to be both flexible in its programming and responsive to the changing needs of its membership.

N·C·E·C·A

77 Erie Village Square
Suite 280
Erie, CO 80516-6996
866.266-2322 (toll free)
www.nceca.net

NAVY PIER WALK 2003

David Pagel, Juror
MAY 8 – OCTOBER 19, 2003

Navy Pier
600 East Grand Avenue
Chicago, IL 60611
(312) 595-5019
www.pierwalk.org

Special thanks to Gallery 37 for their
cooperation in Navy Pier Walk 2003.

Navy Pier Walk 2003 Artists

Actual Size Artworks – Stoughton, W
Heinz Aeschlimann – Switzerland
Jonathan Auger – Princeton, N
Bill Barrett – Sante Fe, NM
Albert Belleveau – Puposky, MN
Steve Benneyworth – Nashville, TN
Douglas Bentham – Saskatoon, Canada
Fletcher Benton – San Francisco, CA
Michael Bishop – Chico, CA
Dee Christy Briggs – New Haven, CT
Ned Cain – DePere, W
Cambid-J Choy – LaCrosse, W
Robert Craig – Des Moines, IA
Stephen Fischer – Sullivan, W
Wendel Gladstone – Los Angeles, CA
Mike Hansel – Newport, R
Lynda Jarman – London, England
Irina Koukhanova – Cleveland, OH
Wayne Littlejohn – Las Vegas, NV
Pat McDonald – Oak Park, IL
Clement Meadmore – New York, NY
Zoran Mojsilov – Minneapolis, MN
Pentti Monkkonen – Los Angeles, CA
Eric Nelson – Middlebury, VT
Nic Noblique – Clyde, TX
Bret Price – Orange, CA
Jason Rogenes – New York, NY
Rahul Saggar – Brooklyn, NY
Antoinette Prien Schultze – Eliot, ME
Peter Shelton – Malibu, CA
Bill Vielehr – Boulder, CO
Plamen Yordanov – Chicago, IL
Joyce Audy Zarins – Merrimac, MA
Almond Zigmund – East Hampton, NY

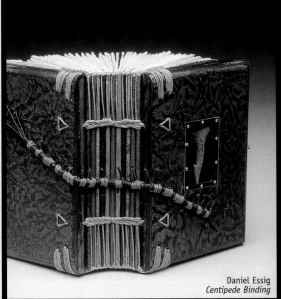

Daniel Essig
Centipede Binding

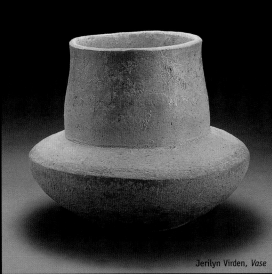

Jerilyn Virden, *Vase*

Susie Ganch
Salt and Pepper Shakers

Elizabeth Brim
Odessa

Rigorous. Exhilarating. Transformative.

risd
rhode island school of design
PROVIDENCE, RI

For more information, call 401 454-6100
or check www.risd.edu

From top: Eunjung Park, MFA Ceramics '99,
Steve Withicombe, Furniture Design '99,
Ruth Adler Schnee, Interior Architecture '45

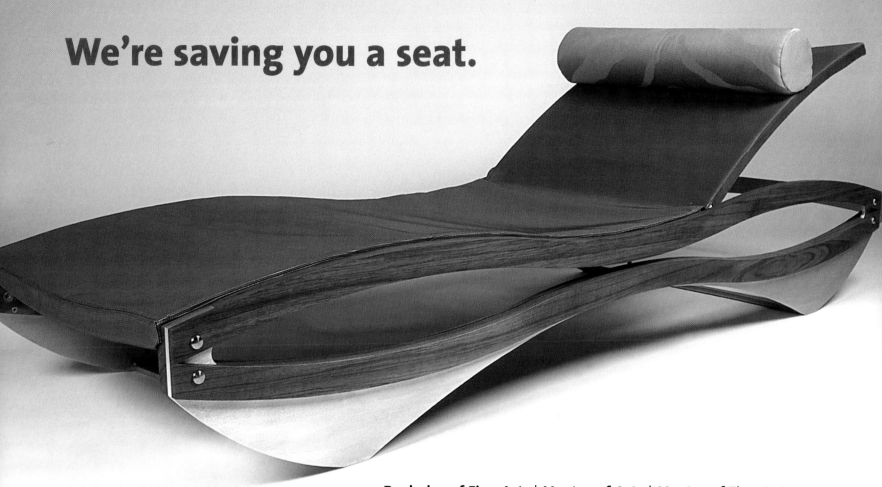

We're saving you a seat.

Bachelor of Fine Arts | Master of Arts | Master of Fine Arts

Animation | Architectural History | Architecture | Art History
Broadcast Design | Fashion | Fibers | Film and Television | **Furniture Design**
Graphic Design | Historic Preservation | Illustration | Industrial Design
Interactive Design and Game Development | Interior Design
Media and Performing Arts | Metals and Jewelry | Painting | Photography
Sequential Art | Sound Design* | Visual Effects

 Savannah College *of* **Art** *and* **Design**

Savannah, Georgia USA | 800.869.7223 | www.scad.edu

* B.F.A. degree and minor programs offered

Rachel Dacks · Toronto, Ontario · M.F.A., furniture design, 2003 · *Relax* · teak, aluminum and SheerWeave

www.abatezanetti.it

scuola del vetro abate zanetti

original glass school.

scuola del vetro abate zanetti murano

Calle Briati 8/b 30141 Murano Venezia Italy tel. +39 0415275757 fax +39 0415274639 www.abatezanetti.it info@abatezanetti.it

Wood Turning Center

EDUCATION•PRESERVATION•PROMOTION
Wood And Other Lathe-Turned Material

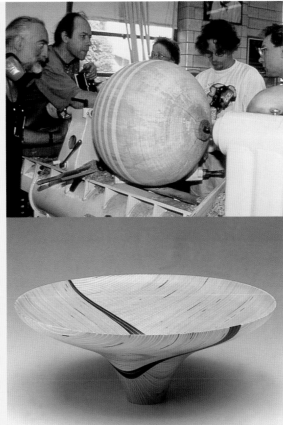

Invites you to become a member

The Wood Turning Center, a Philadelphia-based not-for-profit arts institution, gallery and resource center, is dedicated to the art and craft of lathe-turned objects. Through its programs, the WTC encourages existing and future artists, and cultivates a public appreciation of the field.

Founded in 1986, the Wood Turning Center has become an internationally recognized source of information and assistance to artists, hobbyists, galleries, museums, collectors and educators.

Member Benefits

- A year's subscription to *Turning Points*, our quarterly magazine dedicated to expanding the general understanding and critical analysis of the lathe-turning field.

- 10% discount on purchases of books, slides and videotapes.

- New members also receive a set of 250 decoratively turned Japanese toothpicks.

- Invitations to all exhibition openings.

- Discounted admission to conferences, workshops and symposia.

Members of the Wood Turning Center play a vital role by helping to fulfill its mission of education, preservation and promotion. Because you may share an interest in lathe turning or related arts, we invite you to support WTC with your membership.

As a member, you will deepen both your knowledge and appreciation of the art of lathe-turning and gain insight into the artists who are expanding the art and craft of wood turning.

Turning Points

Turning Points includes reviews of exhibitions, conferences and symposia; articles on the art of lathe-turning, from authentic historical reproductions to the most avant-garde; conservation, collector and artist issues; and a comprehensive calendar of international events.

Wood Turning Center
501 Vine Street, Philadelphia, PA 19106
tel: 215.923.8000 fax: 215.923.4403
turnon@woodturningcenter.org
www.woodturningcenter.org

Hours: Monday–Friday 10am-5pm
 Saturday 12pm-5pm

American Airlines, the exclusive airline of SOFA CHICAGO 2003, congratulates SOFA on its Tenth Anniversary !

To find out more about American, visit us at AA.com.

hibitors

Aaron Faber Gallery
666 Fifth Avenue
New York, NY 10103
212.586.8411
fax 212.582.0205
info@aaronfaber.com
aaronfaber.com

Adamar Fine Arts
177 NE 39th Street
Miami, FL 33137
305.576.1355
fax 305.576.0551
adamargal@aol.com
adamargallery.com

Ann Nathan Gallery
212 West Superior Street
Chicago, IL 60610
312.664.6622
fax 312.664.9392
nathangall@aol.com
annnathangallery.com

Barrett Marsden Gallery
17-18 Great Sutton Street
London EC1V 0DN
England
44.207.336.6396
fax 44.207.336.6391
info@bmgallery.co.uk

Beaver Galleries
81 Denison Street, Deakin
Canberra, ACT 2600
Australia
61.26.282.5294
fax 61.26.281.1315
mail@beavergalleries.com.au

Bellas Artes/Thea Burger
Bellas Artes
653 Canyon Road
Santa Fe, NM 87501
505.983.2745
fax 505.983.1271
bc@bellasartesgallery.com
bellasartesgallery.com

Thea Burger
39 Fifth Avenue, Suite 3B
New York, NY 10003
802.234.6663
fax 802.234.6903
burgerthea@aol.com

Berengo Fine Arts
Fondamenta Vetrai 109/A
Murano, Venice 30141
Italy
39.041.527.6364
fax 39.041.527.6588
adberen@berengo.com
berengo.com

British Crafts Council
44a Pentonville Road
London N1 9BY
England
44.207.806.2557
fax 44.207.837.6891
trading@craftscouncil.org.uk
craftscouncil.org.uk

browngrotta arts
Wilton, CT
203.834.0623
800.666.0623
fax 203.762.5981
art@browngrotta.com
browngrotta.com

The Bullseye
Connection Gallery
300 NW Thirteenth
Portland, OR 97209
503.227.0222
fax 503.227.0008
gallery@bullseye-glass.com
bullseyeconnectiongallery.com

Chappell Gallery
14 Newbury Street
Boston, MA 02116
617.236.2255
fax 617.236.5522
amchappell@aol.com
chappellgallery.com

526 West 26th Street, #317
New York, NY 10001
212.414.2673
fax 212.414.2678

Charon Kransen Arts
By Appointment Only
357 West 19th Street
New York, NY 10011
212.627.5073
fax 212.633.9026
chakran@earthlink.net
charonkransenarts.com

Clare Beck at
Adrian Sassoon
By Appointment
14 Rutland Gate
London SW7 1BB
England
44.207.581.9888
fax 44.207.823.8473
email@adriansassoon.com
adriansassoon.com

Contemporary Applied Arts
2 Percy Street
London W1T 1DD
England
44.207.436.2344
fax 44.207.436.2446
caa.org.uk

Coplan Gallery
10667 Stonebridge Boulevard
Boca Raton, FL 33498
561.451.3928
coplan@bellsouth.net

The David Collection
44 Black Spring Road
Pound Ridge, NY 10576
914.764.4674
fax 914.764.5274
jkdavid@optonline.net
thedavidcollection.com

del Mano Gallery
11981 San Vicente Boulevard
Los Angeles, CA 90049
310.476.8508
fax 310.471.0897
gallery@delmano.com
delmano.com

Despard Gallery
15 Castray Esplanade
Hobart, Tasmania 7000
Australia
61.36.223.8266
fax 61.36.223.6496
steven@despard-gallery.com.au
despard-gallery.com.au

Donna Schneier Fine Arts
By Appointment Only
New York, NY
212.472.9175
fax 212.472.6939

Douglas Dawson
222 West Huron Street
Chicago, IL 60610
312.751.1961
fax 312.751.1962
info@douglasdawson.com
douglasdawson.com

Dubhe Carreño Gallery
5415 West Grace Street
Chicago, IL 60641
773.931.6584
fax 773.442.0279
info@dubhecarrenogallery.com
dubhecarrenogallery.com

Elliott Brown Gallery
Seattle, WA
206.660.0923
fax 425.831.3709
kate@elliottbrowngallery.com
elliottbrowngallery.com

Ferrin Gallery
56 Housatonic Street
Lenox, MA 01240
413.637.4414
info@ferringallery.com
ferringallery.com

Postal address:
163 Teatown Road
Croton on Hudson, NY 10520
914.271.9362
fax 914.271.0047

Finer Things Gallery
1898 Nolensville Road
Nashville, TN 37210
615.244.3003
fax 615.254.1833
kkbrooks@bellsouth.net
finerthingsgallery.com

**Franklin Parrasch
Gallery, Inc.**
20 West 57th Street
New York, NY 10019
212.246.5360
fax 212.246.5391
info@franklinparrasch.com
franklinparrasch.com

Function + Art
1046 West Fulton Market
Chicago, IL 60607
312.243.2780
director@functionart.com
functionart.com

Galerie Aspekt
Udolni 13
Brno 60200
Czech Republic
420.60.316.7181
fax 420.54.123.6494
galerie@galerieaspekt.com
galerieaspekt.com

**Galerie Ateliers d'Art
de France**
22 Avenue Niel
Paris 75017
France
33.14.888.0658
fax 33.14.440.2368
galerie@ateliersdart.com
createdinfrance.com/artwork

Galerie Besson
15 Royal Arcade
28 Old Bond Street
London W1S 4SP
England
44.207.491.1706
fax 44.207.495.3203
enquiries@galeriebesson.co.uk
galeriebesson.co.uk

Galerie Daniel Guidat
142 Rue D'Antibes
Cannes 06400
France
33.49.394.3333
fax 33.49.394.3334
gdg@danielguidat.com
danielguidat.com

Galerie Elena Lee
1460 Sherbrooke West
Montreal, Quebec H3G 1K4
Canada
514.844.6009
fax 514.844.1335
info@galerieelenalee.com

Galerie Metal
Nybrogade 26
Copenhagen K, 1203
Denmark
45.33.145540
fax 45.33.145540
galeriemetal@mail.dk
galeriemetal.dk

**Galerie des Métiers
d'Art du Québec**
350 Saint-Paul East, Suite 400
Montreal, Quebec H2Y 1H2
Canada
514.861.2787, ext. 310
fax 514.861.9191
france.bernard@metiers-d-art.qc.ca
galeriedesmetiersdart.com

Galerie Pokorná
Janský Vršek 15
Prague 2, 12000
Czech Republic
420.222.518635
fax 420.222.518635
jitka@galeriepokorna.cz
lucie@galeriepokorna.cz
galeriepokorna.cz

Galerie Tactus
54 Gothersgade
Copenhagen 1123
Denmark
45.33.933105
fax 45.35.431547
tactus@galerietactus.com
galerietactus.com

Galerie Vivendi
28 Place des Vosges
Paris 75003
France
33.14.276.9076
fax 33.14.276.9547
vivendi@vivendi-gallery.com
vivendi-gallery.com

Galleri Grønlund
Birketoften 16a
Vaerloese 3500
Denmark
45.44.442798
fax 45.44.442798
groenlund@get2net.dk
glassart.dk

Galleri Nørby
Vestergade 8
Copenhagen K, 1456
Denmark
45.33.151920
fax 45.33.151963
info@galleri-noerby.dk
galleri-noerby.dk

Galleria Caterina Tognon
Via San Tomaso, 72
Bergamo 24121
Italy
39.035.243300
fax 39.035.243300
caterinatognon@tin.it

San Marco 2671
Campo San Maurizio
Venice 30124
Italy
39.041.520.7859
fax 39.041.520.7859
caterinatognon@tin.it

Gallery 500
3502 Scotts Lane
Suite 303
Philadelphia, PA 19129
215.849.9116
fax 215.849.9116
gallery500@hotmail.com
gallery500.com

Gallery deCraftig
Dag Hammarskjolds Alle 7
Copenhagen 2100
Denmark
45.20.823771
info@astridkrogh.com

Gallery Gainro
Gaonix Bldg., 1F
Sinsa-Dong 575
Kangnam-Gu, Seoul 135-100
Korea
822.541.0647
fax 822.541.0677
gainro@hanmail.net
gainro.co.kr

The Gallery at Ruthin Craft Centre
Park Road
Ruthin, Denbighshire
Wales LL15 1BB
UK
44.182.470.4774
fax 44.182.470.2060
thegallery@rccentre.co.uk

Genninger Studio
2793/A Dorsoduro
Calle del Traghetto
Venice, 30123
Italy
39.041.522.5565
fax 39.041.522.5565
leslieg@tin.it
genningerstudio.com

Glass Artists' Gallery
70 Glebe Point Road
Glebe, Sydney, NSW 2037
Australia
61.29.552.1552
fax 61.29.552.1552
glassartistsgallery@bigpond.com
glassartistsgallery.com.au

Habatat Galleries
608 Banyan Trail
Boca Raton, FL 33431
561.241.4544
fax 561.241.5793
info@habatatgalleries.com
habatatgalleries.com

117 State Road
Great Barrington, MA 01230
413.528.9123
fax 413.644.9981

Habatat Galleries
4400 Fernlee Avenue
Royal Oak, MI 48073
248.554.0590
fax 248.554.0594
info@habatat.com
habatat.com

202 East Maple Road
Birmingham, MI 48009
248.203.9900
fax 248.282.5019

Hawk Galleries
153 East Main Street
Columbus, OH 43215
614.225.9595
fax 614.225.9550
tom@hawkgalleries.com
hawkgalleries.com

Heller Gallery
420 West 14th Street
New York, NY 10014
212.414.4014
fax 212.414.2636
info@hellergallery.com
hellergallery.com

Heltzer
The Merchandise Mart
Suite 1800
Chicago, IL 60654
312.527.3010
fax 312.527.3176
info@heltzer.com
heltzer.com

Hibberd McGrath Gallery
101 North Main Street
Breckenridge, CO 80424
970.453.6391
fax 970.453.6391
terry@hibberdmcgrath.com
hibberdmcgrath.com

Holsten Galleries
3 Elm Street
Stockbridge, MA 01262
413.298.3044
fax 413.298.3275
artglass@holstengalleries.com
holstengalleries.com

James Singer
PO Box 1396
Tiburon, CA 94920
415.789.1871
fax 415.789.1879
jamessinger@earthlink.net
jamessinger.com

James Tigerman Gallery
212 West Chicago Avenue
Chicago, IL 60610
312.337.8300
fax 312.337.2726
tigerman-bigplanco@
 ameritech.net
jamestigermangallery.com

Jean Albano Gallery
215 West Superior Street
Chicago, IL 60610
312.440.0770
fax 312.440.3103
jeanalbano@aol.com
jeanalbanogallery.com

Jeffrey Weiss Gallery
2938 Fairfield Avenue
Bridgeport, CT 06605
203.333.7733
fax 203.362.2628
jeff@jeffreyweissdesigns.com
jeffreyweissdesigns.com

Jerald Melberg Gallery
3900 Colony Road
Charlotte, NC 28211
704.365.3000
fax 704.365.3016
nc@jeraldmelberg.com
jeraldmelberg.com

Joanna Bird Pottery
By Appointment
19 Grove Park Terrace
London W43QE
England
44.208.995.9960
fax 44.208.742.7752
joanna.bird@ukgateway.net
joannabirdpottery.com

John Natsoulas Gallery
521 First Street
Davis, CA 95616
530.756.3938
fax 530.756.3961
art@natsoulas.com
natsoulas.com

Katie Gingrass Gallery
241 North Broadway
Milwaukee, WI 53202
414.289.0855
fax 414.289.9255
katieg@execpc.com
gingrassgallery.com

Kraft Lieberman Gallery
835 West Washington Street
Chicago, IL 60607
312.948.0555
fax 312.948.0333
klfinearts@aol.com
klfinearts.com

Leif Holmer Gallery
Storgatan 19
Nässjö 57121
Sweden
46.380.12490
fax 46.380.12494
leif@holmergallery.com
marcus@holmergallery.com
holmergallery.com

Leo Kaplan Modern
41 East 57th Street
7th floor
New York, NY 10022
212.872.1616
fax 212.872.1617
lkm@lkmodern.com
lkmodern.com

Lost Angel Glass
Hawkes Crystal Building
79 West Market Street
Corning, NY 14830
607.937.3578
fax 607.937.3578
odo@lostangelglass.com
lostangelglass.com

Marc Richards
170 South La Brea
Los Angeles, CA 90036
323.634.0838
fax 323.634.0834
marc@marcrichards.com
marcrichards.com

Marx-Saunders Gallery
230 West Superior Street
Chicago, IL 60610
312.573.1400
fax 312.573.0575
marxsaunders@earthlink.net
marxsaunders.com

Mattson's Fine Art
2579 Cove Circle NE
Atlanta, GA 30319
404.636.0342
fax 404.636.0342
sundew@mindspring.com

Maurine Littleton Gallery
1667 Wisconsin Avenue NW
Washington, DC 20007
202.333.9307
fax 202.342.2004
littletongallery@aol.com

McTeigue & McClelland Jewelers
597 South Main Street
Great Barrington, MA 01230
413.528.6262
fax 413.528.6644
info@mc2jewels.com
mc2jewels.com

Michelson Gallery
4001 North Ravenswood, #404
Chicago, IL 60613
773.879.8825
fax 773.665.7117
denisootww@yahoo.com

Mobilia Gallery
358 Huron Avenue
Cambridge, MA 02138
617.876.2109
fax 617.876.2110
mobiliaart@aol.com
mobilia-gallery.com

Modus Gallery
23 Place des Vosges
Paris 75003
France
33.14.278.1010
fax 33.14.278.1400
modus@galerie-modus.com
galerie-modus.com

Morgan Contemporary Glass Gallery
5833 Ellsworth Avenue
Pittsburgh, PA 15232
412.441.5200
fax 412.441.0655
morglass@sgi.net
morganglassgallery.com

Mostly Glass Gallery
3 East Palisade Avenue
Englewood, NJ 07631
201.816.1222
fax 201.816.9582
info@mostlyglass.com
mostlyglass.com

Niemi Sculpture Gallery & Garden
13300 116th Street
Kenosha, WI 53142
262.857.3456
fax 262.857.4567
gallery@bruceniemi.com
bruceniemi.com

Option Art
4216 de Maisonneuve
Boulevard West
Suite 302
Montreal, Quebec H3Z 1K4
Canada
514.932.3987
fax 514.932.6182
info@option-art.ca
option-art.ca

Orley & Shabahang Persian Carpets
5841 Wing Lake Road
Bloomfield Hills, MI 48301
586.996.5800
shabahangorley@aol.com

Perimeter Gallery, Inc.
210 West Superior Street
Chicago, IL 60610
312.266.9473
fax 312.266.7984
perimeterchicago@perimeter
 gallery.com
perimetergallery.com

511 West 25th Street
Suite 402
New York, NY 10001
212.675.1585
fax 212.675.1607
perimeterNYC@perimeter
 gallery.com
perimetergallery.com

R. Duane Reed Gallery
7513 Forsyth Boulevard
St. Louis, MO 63105
314.862.2333
fax 314.862.8557
reedart@primary.net
rduanereedgallery.com

711 East Las Olas Boulevard
Fort Lauderdale, FL 33301
954.525.5210
fax 954.525.5206
flareedart@primary.net
rduanereedgallery.com

Raglan Gallery
5-7 Raglan Street
Manly, Sydney, NSW 2095
Australia
61.29.977.0906
fax 61.29.977.0906
jankarras@hotmail.com
raglangallery.com.au

Sabbia
455 Grand Bay Drive
Key Biscayne, FL 33149
305.365.4570
fax 305.365.4572

The Scottish Gallery
16 Dundas Street
Edinburgh, EH3 6HZ
Scotland
44.131.558.1200
fax 44.131.558.3900
mail@scottish-gallery.co.uk
scottish-gallery.co.uk

**Sherry Leedy
Contemporary Art**
2004 Baltimore Avenue
Kansas City, MO 64108
816.221.2626
fax 816.221.8689
sherryleedy@sherryleedy.com
sherryleedy.com

Sienna Gallery
80 Main Street
Lenox, MA 01240
413.637.8386
fax 413.637.8387
sienna@siennagallery.com
siennagallery.com

Snyderman-Works Galleries
303 Cherry Street
Philadelphia, PA 19106
215.238.9576
fax 215.238.9351
bruce@snyderman-works.com
snyderman-works.com

Tai Gallery/Textile Arts
616 1/2 Canyon Road
Santa Fe, NM 87501
505.983. 9780
fax 505.989.7770
gallery@textilearts.com
textilearts.com

Thomas R. Riley Galleries
16 Central Way
Kirkland, WA 98033
425.576.0762
fax 425.576.0772
tom@rileygalleries.com
rileygalleries.com

2026 Murray Hill Road
Cleveland, OH 44106
216.421.1445
fax 216.421.1435

642 North High Street
Columbus, OH 43215
614.228.6554
fax 614.228.6550

UrbanGlass
647 Fulton Street
Brooklyn, NY 11217-1112
718.625.3685
fax 718.625.3889
info@urbanglass.org
urbanglass.org

Walker Fine Art
13223-1 Black Mountain Road
Suite 303
San Diego, CA 92129-2658
858.673.9942
fax 831.462.9109
rjewal@msn.com
artnet.com/walkerfineart.html

William Siegal Galleries
135 West Palace Avenue
Suite 101
Santa Fe, NM 87501
505.820.3300
fax 505.820.7733
consiegal@aol.com
williamsiegalgalleries.com

William Zimmer Gallery
10481 Lansing Street
Box 263
Mendocino, CA 95460
707.937.5121
fax 707.937.2405
wzg@mcn.org
williamzimmergallery.com

Yaw Gallery
550 North Old Woodward
Birmingham, MI 48009
248.647.5470
fax 248.647.3715
yawgallery@msn.com
yawgallery.com

SOFA 2003

Abe, Motoshi
Tai Gallery/Textile Arts

Abildgaard, Mark
John Natsoulas Gallery

Abraham, Françoise
Modus Gallery

Abrams, Jackie
Katie Gingrass Gallery

Adams, Dan
Mobilia Gallery

Adams, Elmer
William Zimmer Gallery

Adams, Renie Breskin
Mobilia Gallery

Aguerre, Roberto
Berengo Fine Arts

Ahlgren, Jeanette
Katie Gingrass Gallery
Mobilia Gallery

Akers, Adela
browngrotta arts

Alepedis, Efharis
Charon Kransen Arts

Aliyu, Danlami
Joanna Bird Pottery

Allen, Daniel
The Gallery at Ruthin
Craft Centre

Aloni, Mical
Hibberd McGrath Gallery

Amoruso, Giampaolo
Modus Gallery

Amromin, Pavel
Ann Nathan Gallery

Amsel, Galia
The Bullseye Connection
Gallery

Anderson, Dan
Hibberd McGrath Gallery

Anderson, Dona
browngrotta arts
del Mano Gallery

Anderson, Jeannine
browngrotta arts
Mobilia Gallery

Anderson, Kate
Snyderman-Works Galleries

Angelino, Gianfranco
del Mano Gallery

Antemann, Christina
R. Duane Reed Gallery

Aoki, Mikiko
The David Collection

Apodoca, Joe Reyes
Yaw Gallery

Appel, Nicolai
Galerie Metal

Arata, Tomomi
The David Collection

Arawjo, Darryl
Katie Gingrass Gallery

Arawjo, Karen
Katie Gingrass Gallery

Ardal
Orley & Shabahang
Persian Carpets

Arentzen, Glenda
Aaron Faber Gallery

Arguerolles, Jean-Jacques
Galerie Vivendi

Arima, Curtis H.
Mobilia Gallery
Yaw Gallery

Arkell, Julie
Contemporary Applied Arts

Arleo, Adrian
Ferrin Gallery

Arneson, Robert
Franklin Parrasch Gallery, Inc.
John Natsoulas Gallery

Arp, Marijke
browngrotta arts

Austin, Joan
Mobilia Gallery

Austin, William
Charon Kransen Arts

Autio, Rudy
R. Duane Reed Gallery

Aya, Kajiwara
Tai Gallery/Textile Arts

Babcock, Herb
Habatat Galleries

Babetto, Giampaolo
Sienna Gallery

Babula, Mary Ann
Chappell Gallery

Bach, Carolyn Morris
Gallery 500

Bacharach, David
Mobilia Gallery

Back, Soo-Jung
Gallery Gainro

Baehring, Lasse
Galerie Tactus

Bakhtiari
Orley & Shabahang
Persian Carpets

Bakker, Ralph
Charon Kransen Arts

Baldwin, Gordon
Barrett Marsden Gallery

Baldwin, Louise
Contemporary Applied Arts

Baldwin, Philip
Habatat Galleries

Balsgaard, Jane
browngrotta arts

Balsley, John
Perimeter Gallery, Inc.

Banner, Maureen
Yaw Gallery

Banner, Michael
Yaw Gallery

Baribeau, Jacinthe
Galerie des Métiers
d'Art du Québec

Barker, Jo
browngrotta arts

Barnaby, Margaret
Aaron Faber Gallery

Barnes, Dorothy Gill
browngrotta arts

Bartlett, Caroline
browngrotta arts

Battaile, Bennett
The Bullseye Connection
Gallery

Batura, Tanya
Dubhe Carreño Gallery

Bayer, Svend
Joanna Bird Pottery

Beck, Rick
Marx-Saunders Gallery

Becker, Michael
Charon Kransen Arts

Bégou, Alain
Galerie Daniel Guidat

Bégou, Francis
Galerie Daniel Guidat

Bégou, Marisa
Galerie Daniel Guidat

Behar, Linda
Mobilia Gallery

Behennah, Dail
browngrotta arts

Behrens, Hanne
Mobilia Gallery

Belcher, Heather
Contemporary Applied Arts

Belliard, François
Galerie Ateliers d'Art de France

Benglis, Lynda
Franklin Parrasch Gallery, Inc.

Bennett, David
Thomas R. Riley Galleries

Bennett, Garry Knox
Leo Kaplan Modern

Bennett, Jamie
Sienna Gallery

Bennett, Sally
Adamar Fine Arts

Bennicke, Karen
Galleri Nørby

Benzoni, Luigi
Berengo Fine Arts

Bergner, Lanny
Mobilia Gallery

Berman, Harriete Estel
Charon Kransen Arts
Mobilia Gallery

Bernstein, Alex Gabriel
Chappell Gallery

Bero, Mary
Ann Nathan Gallery

Bertheldt, Gildas
Galerie des Métiers
 d'Art du Québec

Bess, Nancy Moore
browngrotta arts

Bettison, Giles
The Bullseye Connection
 Gallery

Bezold, Brigitte
Charon Kransen Arts

Biles, Russell
Ferrin Gallery

Birch, Karin
Snyderman-Works Galleries

Bird, Stephen
The Scottish Gallery

Birgersson, Tobias
Galerie Tactus

Birkkjaer, Birgit
browngrotta arts

Bjerring, Claus
Galerie Tactus

Bjørn, Gitte
Galerie Metal

Black, Allison
Yaw Gallery

Blacklock, Kate
Franklin Parrasch Gallery, Inc.

Blackman, Jane
Contemporary Applied Arts

Blank, Martin
Habatat Galleries

Blavarp, Liv
Charon Kransen Arts

Bloch, Ruth
Galerie Vivendi

Bloomfield, Greg
Leo Kaplan Modern

Bluestone, Rebecca
browngrotta arts

Bokesch-Parsons, Mark
Maurine Littleton Gallery

Bonaventura, Mauro
Mostly Glass Gallery

Book, Flora
Mobilia Gallery

Boregaard, Pedro
Sabbia

Borghesi, Marco
Aaron Faber Gallery

Borst, Andrea
Charon Kransen Arts

Bosch, Trent
del Mano Gallery

Boucard, Yves
Leo Kaplan Modern

Bowden, Jane
Mobilia Gallery

Boyadjiev, Latchezar
Habatat Galleries

Boyd, Michael
Mobilia Gallery

Bravura, Dusciana
Berengo Fine Arts

Bredsted, Sten Bülow
Galerie Metal

Bredsted, Yvette Strenge
Galerie Metal

Brennan, Sara
browngrotta arts
The Scottish Gallery

Briels, Clemens
Adamar Fine Arts

Brill, Reina Mia
Snyderman-Works Galleries

Brink, Joan
del Mano Gallery

Brinkeman, Beate
The David Collection

Britton, Alison
Barrett Marsden Gallery

Broadhead, Caroline
Barrett Marsden Gallery

Brooks, Jon
Snyderman-Works Galleries

Brooks, Lola
Sienna Gallery

Brown, Christie
Clare Beck at Adrian Sassoon
Perimeter Gallery, Inc.

Brown, Jeff
William Zimmer Gallery

Brychtová Jaroslava
Donna Schneier Fine Arts
Galerie Aspekt
Galerie Pokorná

Buckman, Jan
browngrotta arts

Burchard, Christian
del Mano Gallery

Burgel, Klaus
Mobilia Gallery

Burger, Falk
Yaw Gallery

Bussières, Maude
Galerie des Métiers
 d'Art du Québec

Butler, Simon
Glass Artists' Gallery

Butt, Harlan
Yaw Gallery

Butts, R.W.
William Zimmer Gallery

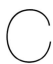

Cacicedo, Jean
Hibberd McGrath Gallery

Caleo, Lyndsay
Chappell Gallery

Campbell, Marilyn
del Mano Gallery

Campbell, Pat
browngrotta arts

Cantin, Annie
Galerie Elena Lee

Cantwell, Christopher
Jeffrey Weiss Gallery

Cardew, Michael
Joanna Bird Pottery

Carlson, William
Marx-Saunders Gallery

Carr, Graham
William Zimmer Gallery

Carr, Tanija
William Zimmer Gallery

Casanovas, Claudi
Galerie Besson

Cassidy, Beth
Jeffrey Weiss Gallery

Castagna, Pino
Berengo Fine Arts

Castle, Wendell
Donna Schneier Fine Arts
Leo Kaplan Modern

Catchpole, Bridget
Yaw Gallery

Cederquist, John
Franklin Parrasch Gallery, Inc.

Chaleff, Paul
Snyderman-Works Galleries

Chandler, Gordon
Ann Nathan Gallery

Chardiet, José
Habatat Galleries
Leo Kaplan Modern
Marx-Saunders Gallery

Charles, Don
Thomas R. Riley Galleries

Chaseling, Scott
Beaver Galleries
Leo Kaplan Modern

Chatterley, Mark
Gallery 500

Chavent
Aaron Faber Gallery

Chazaud-Telaar, Nicole
Mobilia Gallery

Chernoff, Renate
Mobilia Gallery

Chesney, Nicole
Morgan Contemporary
 Glass Gallery

Chihuly, Dale
Donna Schneier Fine Arts
Elliott Brown Gallery
Holsten Galleries
Walker Fine Art

Cho, Namu
Aaron Faber Gallery

Cho, Yu-Jin
Gallery Gainro

Chock, Vicky
John Natsoulas Gallery

Choi, Seo-Yoon
Gallery Gainro

Choo, Chunghi
browngrotta arts

Chotard, Cathy
Charon Kransen Arts

Christensen, Stopher
Chappell Gallery

Christie, Barbara
The David Collection

Chromy, Anna
Galerie Vivendi

Chung, Kanik
UrbanGlass

Cigler, Václav
Galerie Pokorná

Cinnamon, Olga
Hibberd McGrath Gallery

Ciurlionis, Bimas
Katie Gingrass Gallery

Class, Petra
Charon Kransen Arts

Clausager, Kirsten
Mobilia Gallery

Clayman, Daniel
Habatat Galleries

Clayton, Deanna
Thomas R. Riley Galleries

Clayton, Keith
Thomas R. Riley Galleries

Clegg, Tessa
Barrett Marsden Gallery

Cliffel, Kris
Mobilia Gallery

Cohen, Barbara
Snyderman-Works Galleries

Cohen, Mardi Jo
Snyderman-Works Galleries

Coignard, James
Berengo Fine Arts

Cole, Jim
Mobilia Gallery

Collins, Patrick
Despard Gallery

Colquitt, Susan
Katie Gingrass Gallery

Connet, Frank
Heltzer

Constantine, Greg
Jean Albano Gallery

Constantinidis, Joanna
Joanna Bird Pottery

Cook, Lia
Perimeter Gallery, Inc.

Cooper, Diane
Jean Albano Gallery

Cooper, Robert
British Crafts Council

Coper, Hans
Galerie Besson

Copping, Brad
Galerie Elena Lee

Cordell, Linda
Ferrin Gallery

Corvaja, Giovanni
Charon Kransen Arts

Cottrell, Simon
Charon Kransen Arts

Couradin, Jean-Christophe
del Mano Gallery

Crain, Joyce
Snyderman-Works Galleries

Craste, Laurent
Galerie des Métiers
 d'Art du Québec

Crawford, Sarah
Mobilia Gallery

Creed, John
Mobilia Gallery

Cribbs, KéKé
Habatat Galleries
Leo Kaplan Modern
Marx-Saunders Gallery

Crooks, Bob
Contemporary Applied Arts

Crooks, Philip
Morgan Contemporary
 Glass Gallery

Crow, Nancy
Snyderman-Works Galleries

Crowley, Jill
British Crafts Council

Cucchi, Claudia
Charon Kransen Arts

Curneen, Claire
Contemporary Applied Arts

Cutler, Robert
del Mano Gallery

Cylinder, Lisa
Snyderman-Works Galleries

Cylinder, Scott
Snyderman-Works Galleries

da Silva, Jack
Mobilia Gallery
Yaw Gallery

da Silva, Marilyn
Mobilia Gallery
Yaw Gallery

Dailey, Dan
Habatat Galleries
Leo Kaplan Modern

Dam, Steffen
Galleri Grønlund

Damas, Martine
Galerie Ateliers d'Art de France

Danberg, Leah
del Mano Gallery

Daraspe, Roland
Galerie Ateliers d'Art de France

Dardek, Dominique
Modus Gallery

Davis, Michael
del Mano Gallery

de Amaral, Olga
Bellas Artes/Thea Burger

de Angelis, Laura
Sherry Leedy Contemporary Art

de Both, Carol
The David Collection

De Forest, Roy
Mobilia Gallery

de Keyzer, Dirk
Galerie Vivendi

De Lafontaine, Elyse
Option Art

De Marchi, Livio
Mostly Glass Gallery

de Santillana, Laura
Elliott Brown Gallery

de Waal, Edmund
British Crafts Council

Decobert, Elisabeth
Galerie Daniel Guidat

Dei Rossi, Antonio
Mostly Glass Gallery

Dei Rossi, Mario
Mostly Glass Gallery

DeMonte, Claudia
Jean Albano Gallery

Dempf, Matina
The David Collection

Derry, Donald
Thomas R. Riley Galleries

DeStaebler, Stephen
Franklin Parrasch Gallery, Inc.

DeVore, Richard
Bellas Artes/Thea Burger

Di Fiore, Miriam
Mostly Glass Gallery

Dixon, Stephen
Contemporary Applied Arts

Dobson, Rob
del Mano Gallery

Dodd, John
William Zimmer Gallery

Dolack, Linda
Mobilia Gallery

Donaldson, Grant
Raglan Gallery

Donefer, Laura
R. Duane Reed Gallery

Dotson, Virginia
del Mano Gallery

Douglas, Mel
Beaver Galleries

Dowling, Gaynor
British Crafts Council

Dresang, Paul
Ferrin Gallery

Dreyer, Anette
Galerie Tactus

Druin, Marilyn
Aaron Faber Gallery

Drury, Chris
browngrotta arts

Dubois, Valentine
The David Collection

Dubuc, Roland
Galerie des Métiers
 d'Art du Québec

Duckworth, Ruth
Bellas Artes/Thea Burger

Duque, Clara
Walker Fine Art

Earl, Jack
Mobilia Gallery
Perimeter Gallery, Inc.

Eastman, Ken
Barrett Marsden Gallery

Eberle, Edward
Perimeter Gallery, Inc.

Ebner, David
William Zimmer Gallery

Edols, Benjamin
Marx-Saunders Gallery

Eglin, Philip
Barrett Marsden Gallery

Ehmck, Nina
The David Collection

Eismann, Beate
Charon Kransen Arts

Eliáš, Bohumil
Galerie Aspekt
Galerie Pokorná

Eliasen, Jens
Galerie Tactus

Elliott, Judi
The Bullseye Connection
 Gallery

Elliott, Kathy
Marx-Saunders Gallery

Ellison-Dorion, Helen
Mobilia Gallery

Ellsworth, David
del Mano Gallery

Ellsworth, Wendy
del Mano Gallery

Elyashiv, Noam
Sienna Gallery

Emmerichs, Bern
Despard Gallery

Emmerichs, Gerhard
Despard Gallery

Emms, Dawn
British Crafts Council
Mobilia Gallery

English, Joseph
Aaron Faber Gallery

Engman, Kjell
Leif Holmer Gallery

Entner, Barry
Lost Angel Glass

Erhardt, Karen
Aaron Faber Gallery

Erickson, Michelle
Ferrin Gallery

Eriksson, Klara
Galerie Tactus

Eriksson, Petronella
Galerie Tactus

Ewert, Gretchen
William Zimmer Gallery

F

Fabricius-Moller, Anne
Gallery deCraftig

Falkesgaard, Lina
Galerie Tactus

Fanourakis, Lina
Sabbia

Farey, Lizzie
browngrotta arts

Fawkes, Sally
Contemporary Applied Arts

Feibleman, Dorothy
Mobilia Gallery

Feller, Lucy
Katie Gingrass Gallery

Fifield, Jack
Katie Gingrass Gallery

Fifield, Linda
Katie Gingrass Gallery

Finlay, Gillian
Mobilia Gallery

Fisch, Arline
Mobilia Gallery

Fisher, Daniel
Joanna Bird Pottery

Flavell, Ray
The Scottish Gallery

Flockinger, CBE, Gerda
Mobilia Gallery

Fok, Nora
British Crafts Council

Follen, Steve
Clare Beck at Adrian Sassoon

Forbes, Anne
Hibberd McGrath Gallery

Ford, Steven
Snyderman-Works Galleries

Forlano, David
Snyderman-Works Galleries

Foster, Clay
del Mano Gallery

Frahm, Andrea
Charon Kransen Arts

Frazier, Robert
Michelson Gallery

Freda, David
Mobilia Gallery

Frève, Carole
Galerie des Métiers
 d'Art du Québec

Friedemann, Stefan
Mobilia Gallery

Friedl, Caroline
Charon Kransen Arts

Friedlich, Donald
Sienna Gallery

Friis, Lisbeth
Gallery deCraftig

Frith, Donald E.
del Mano Gallery

Fritsch, Elizabeth
Clare Beck at Adrian Sassoon

From-Andersen, Carsten
Galerie Metal

Frydrych, Jan
Galerie Pokorná

Fujinuma, Noboru
Tai Gallery/Textile Arts

Fujita, Emi
Mobilia Gallery

Fujita, Kyohei
Thomas R. Riley Galleries

Fukami, Sueharu
James Singer

Fukuchi, Kyoko
The David Collection

Funaki, Mari
Mobilia Gallery

Galazaka, Rafal
Mattson's Fine Art

Gall, Theodore T.
Niemi Sculpture Gallery
 & Garden

Gallas, Tania
Charon Kransen Arts

Galloway, Julia
Ferrin Gallery

Galloway-Whitehead, Gill
The David Collection

Gates, Tim
Michelson Gallery

Gautier, Marie
Modus Gallery

Geertsen, Michael
Galleri Nørby

Geldersma, John
Jean Albano Gallery

Genninger, Leslie Ann
Genninger Studio

Gérard, Bruno
Galerie des Métiers
 d'Art du Québec

Giard, Monique
Galerie des Métiers
 d'Art du Québec

Gignac, David
Ferrin Gallery

Giguère, Jean-Marie
Galerie des Métiers
 d'Art du Québec

Gilbert, Chantal
Galerie des Métiers
 d'Art du Québec

Gilbert, Karen
Morgan Contemporary
 Glass Gallery

Giles, Mary
browngrotta arts
R. Duane Reed Gallery

Gilhooly, David
John Natsoulas Gallery

Gillespie, Ty
Katie Gingrass Gallery

Gilson, Giles
del Mano Gallery

Glad, Lars
Galerie Metal

Glasgow, Susan Taylor
R. Duane Reed Gallery

Gleasner, Stephen
del Mano Gallery
Jerald Melberg Gallery

Gnaedinger, Ursula
Charon Kransen Arts
The David Collection

Godbout, Rosie
Option Art

Gonzalez, Arthur
John Natsoulas Gallery

Good, Michael
Aaron Faber Gallery

Gordon, Anna
British Crafts Council

Gordon, Kevin
Glass Artists' Gallery

Gottlieb, Dale
Gallery 500

Graabæk, Helle
Gallery deCraftig

Gralnick, Lisa
Mobilia Gallery

Greco, Krista
Ann Nathan Gallery

Green, George
Coplan Gallery

Green, Linda
browngrotta arts
The Scottish Gallery

Greenaway, Victor
Raglan Gallery

Griffiths-Jones, Julia
The Gallery at Ruthin
 Craft Centre

Gross, Michael
Ann Nathan Gallery

Grossen, Françoise
browngrotta arts

Guggisberg, Monica
Habatat Galleries

**Hafermalz-Wheeler,
Christine**
Aaron Faber Gallery

Hall, Laurie
Hibberd McGrath Gallery

Hall, Patrick
Despard Gallery

Hamada, Shoji
Joanna Bird Pottery

Hanagarth, Sophie
Charon Kransen Arts

Hančl, Cyril
Galerie Pokorná

Hancock, David
Elliott Brown Gallery

Hansen, Castello
Galerie Tactus

Hardenberg, Torben
Galerie Tactus

Harding, Tim
Jeffrey Weiss Gallery

Harmaala, Taru
The David Collection

Harris, Rain
Ferrin Gallery

Hart, Noel
Habatat Galleries

Harvey, Mielle
Mobilia Gallery

Hatekeyama, Norie
browngrotta arts

Haworth, Angela
Mobilia Gallery

Hay, David
Glass Artists' Gallery

Hayashibe, Masako
The David Collection

Hayes, Kathleen
Snyderman-Works Galleries

Hayes, Peter
William Zimmer Gallery

Heaney, Colin
Habatat Galleries

Hegelund, Bitten
Gallery deCraftig

Heindl, Anna
Charon Kransen Arts

Heinrich, Barbara
William Zimmer Gallery

Held, Archie
William Zimmer Gallery

Heltzer, Michael
Heltzer

Henriksen, Ane
browngrotta arts

Henton, Maggie
browngrotta arts

Hermsen, Herman
Charon Kransen Arts

Hernmarck, Helena
browngrotta arts

Hewitt, Mark
Ferrin Gallery

Hibbert, Louise
del Mano Gallery

Hicks, Sheila
browngrotta arts

Hideaki, Honma
Tai Gallery/Textile Arts

Hieda, Makoto
Mobilia Gallery

Higuchi, Kimiake
Habatat Galleries

Higuchi, Shin-Ichi
Habatat Galleries

Hildebrandt, Marion
browngrotta arts

Hill, Chris
Ann Nathan Gallery

Hill, Matthew
del Mano Gallery

Hinz, Darryle
Galleri Grønlund

Hiramatsu, Yasuki
Charon Kransen Arts

Hirte, Lydia
The David Collection

Hlava, Pavel
Galerie Pokorná

Hobin, Agneta
browngrotta arts

Hodder, Stephen
Marx-Saunders Gallery

Hoge, Susan
Yaw Gallery

Hogg, Dorothy
The Scottish Gallery

Holden, Michelle
British Crafts Council

Hole, Nina
Galleri Nørby

Hollibaugh, Nick
Mobilia Gallery

Holmes, Kathleen
Chappell Gallery

Holzinger, Susanne
Charon Kransen Arts

Hong, Ji-Hee
Gallery Gainro

Honma, Kazue
browngrotta arts

Hopkins, Jan
Mobilia Gallery

Hora, Petr
Habatat Galleries

Horn, Robyn
del Mano Gallery

Houman, Charlotte
Gallery deCraftig

Howe, Brad
Adamar Fine Arts

Howell, Catrin
The Gallery at Ruthin
 Craft Centre

Hoyer, Todd
del Mano Gallery

Hoyt, Judith
Snyderman-Works Galleries

Hu, Mary Lee
Mobilia Gallery

Huang, David
Mobilia Gallery
Yaw Gallery

Huang-Cruz, Kevin
UrbanGlass

Huber, Ursula
Berengo Fine Arts

Huchthausen, David
Leo Kaplan Modern

Huff, Melissa
Aaron Faber Gallery

Hunt, Kate
browngrotta arts

Hunter, Marianne
Aaron Faber Gallery

Hunter, William
del Mano Gallery

Hutter, Sidney
Marx-Saunders Gallery

Huycke, David
Galerie Tactus

Hyde, Caitlin
Morgan Contemporary
 Glass Gallery

Hyde, Marshall
Morgan Contemporary
 Glass Gallery

Hyman, Sylvia
Finer Things Gallery

Ibe, Kyoko
Heltzer

Ichino, Masahiko
James Singer

Ida, Shoichi
Bellas Artes/Thea Burger

Iezumi, Toshio
Chappell Gallery

Ihle, Karen
Galerie Tactus

Ikeda, Yoshira
Sherry Leedy Contemporary Art

Ingraham, Katherine
Mobilia Gallery

Inuzuka, Sadashi
Dubhe Carreño Gallery

Ipsen, Steen
Galleri Nørby

Isaacs, Ron
Katie Gingrass Gallery

Ishida, Meiri
Charon Kransen Arts

Ishiyama, Reiko
Charon Kransen Arts

Isphording, Anja
The Bullseye Connection
 Gallery

Isupov, Sergei
Ferrin Gallery

Iwata, Kiyomi
Perimeter Gallery, Inc.
Snyderman-Works Galleries

Jacobi, Ritzi
Snyderman-Works Galleries

Jacobs, Ferne
Snyderman-Works Galleries

Jalili, Haj
Orley & Shabahang
 Persian Carpets

Jang, Sun-Young
Gallery Gainro

Janich, Hilde
Charon Kransen Arts

Jarman, Angela
British Crafts Council

Javan
Orley & Shabahang
 Persian Carpets

Jensen, Sidsel Dorph
Galerie Tactus

Jensen, Steve
Thomas R. Riley Galleries

Jeon, Eun-Mi
Gallery Gainro

Jeon, In-Kang
Gallery Gainro

Jin, Morigami
Tai Gallery/Textile Arts

Jocz, Dan
Mobilia Gallery

Joergensen, Ragnar
Galerie Tactus

Johanson, Olle
Yaw Gallery

Johanson, Rosita
Mobilia Gallery

Johansson, Karin
Charon Kransen Arts

Johnston, Randy
Ferrin Gallery

Jolley, Richard
Leo Kaplan Modern

Jones, Arthur
del Mano Gallery

Jones, Christine
The Gallery at Ruthin
 Craft Centre

Jónsdóttir, Kristín
browngrotta arts

Jordan, John
del Mano Gallery

Joy, Christine
browngrotta arts

Juenger, Ike
Charon Kransen Arts

Kakizaki, Hitoshi
Thomas R. Riley Galleries

Kaldahl, Martin Bodilsen
Galleri Nørby

Kallenberger, Kreg
Leo Kaplan Modern

Kalman, Lauren
Mobilia Gallery

Kamenstein, Tracy Dara
The David Collection

Kammermeier, Traudl
Charon Kransen Arts

Kaneko, Jun
Sherry Leedy Contemporary Art

Kang, Dallae
Mobilia Gallery

Kang, Yeonmi
Charon Kransen Arts

Kaplan, Donna
del Mano Gallery
Mobilia Gallery

Karlsen, Jørgen
Galleri Grønlund

Kastberg, Leon
Galerie Tactus

Kaufman, Glen
browngrotta arts

Kaufmann, Martin
Charon Kransen Arts
Galerie Tactus

Kaufmann, Ruth
browngrotta arts

Kaufmann, Ulla
Charon Kransen Arts
Galerie Tactus

Kawata, Tamiko
browngrotta arts

Kazoun, Marya
Berengo Fine Arts

Kazuaki, Honma
Tai Gallery/Textile Arts

Keenan, Chris
Joanna Bird Pottery

Keith, Jane
The Scottish Gallery

Kelly, Claire
Morgan Contemporary
 Glass Gallery

Kelly, Linda
browngrotta arts

Kelzer, Kimberly
Mobilia Gallery

Kenichi, Nagakura
Tai Gallery/Textile Arts

Kent, Ron
del Mano Gallery

Kerman, Janis
Option Art

Khan, Kay
Hibberd McGrath Gallery
Snyderman-Works Galleries

Kim, Bong-Hee
Gallery Gainro

Kim, Jae Young
Gallery Gainro

Kim, Jong-Ryeol
Gallery Gainro

Kim, Kyung Shin
The David Collection

Kim, Seung-Hee
Gallery Gainro

Kim, Yoon
Charon Kransen Arts

Kindelmann, Heide
The David Collection

King, Ray
Morgan Contemporary
 Glass Gallery

Kinnaird, Alison
The Scottish Gallery

Kishi, Eiko
James Singer

Klančič, Anda
browngrotta arts

Klein, Steve
The Bullseye Connection
 Gallery

Kline, Michael
Ferrin Gallery

Kling, Candace
Mobilia Gallery

Knapp, Stephen
Walker Fine Art

Knapper, Gerd
James Singer

Knauss, Lewis
browngrotta arts

Knowles, Sabrina
R. Duane Reed Gallery

Kobayashi, Mazakazu
browngrotta arts

Kobayashi, Naomi
browngrotta arts

Koenigsberg, Nancy
browngrotta arts
Snyderman-Works Galleries

Kogelnik, Kiki
Berengo Fine Arts

Kogyoku, Monden
Tai Gallery/Textile Arts

Koh, Seung-Hyun
Gallery Gainro

Koho, Kajiwara
Tai Gallery/Textile Arts

Kohyama, Yasuhisa
browngrotta arts

Koie, Ryoji
Galerie Besson

Koopman, Rena
Mobilia Gallery

Kopecký, Vladimir
Galerie Aspekt
Galerie Pokorná

Korowitz-Coutu, Laurie
UrbanGlass

Kosonen, Markku
browngrotta arts

Krafft, Charles
Elliott Brown Gallery

Kraft, Jim
Hibberd McGrath Gallery

Krakowski, Yael
Charon Kransen Arts

Kranitzky, Robin
Ferrin Gallery

Krauss, Alyssa Dee
Sienna Gallery

Kreuder, Loni
Modus Gallery

Krogh, Astrid
Gallery deCraftig

Kronhorst, Tina
Galerie Tactus

Krupenia, Deborah
Charon Kransen Arts

Kuhn, Jon
Habatat Galleries
Marx-Saunders Gallery
Walker Fine Art

Kumai, Kyoko
browngrotta arts

Kuramoto, Yoko
Chappell Gallery

Kurz, Yvonne
Charon Kransen Arts

Kwak, Soon-Hwa
Gallery Gainro

Labelle, Ronald
Option Art

Lacoursiere, Leon
del Mano Gallery

Ladd, Tracey
Thomas R. Riley Galleries

Laier, Mette
Galerie Metal

Lake, Tai
William Zimmer Gallery

Laky, Gyöngy
browngrotta arts

Lamar, Stoney
del Mano Gallery

Lamarche, Antoine
Galerie des Métiers
 d'Art du Québec

Langley, Warren
Elliott Brown Gallery

Lapka, Eva
Galerie des Métiers
 d'Art du Québec

LaPointe, Michèle
Option Art

Larsen, Merete
del Mano Gallery

Larsen, Per-Rene
Galleri Grønlund

Larson, Edward
Hibberd McGrath Gallery

Larssen, Ingrid
The David Collection

Latven, Bud
del Mano Gallery

Layport, Ron
del Mano Gallery

Leach, Bernard
Joanna Bird Pottery

Leach, David
Joanna Bird Pottery

Lee, Chunghie
James Tigerman Gallery

Lee, Dongchun
Charon Kransen Arts

Lee, Hyung-Kyw
Gallery Gainro

Lee, Jae Won
Dubhe Carreño Gallery

Lee, Jennifer
Galerie Besson

Lee, Mike
del Mano Gallery

Lee, Seung Hea
Sienna Gallery

Leedy, Jim
Jeffrey Weiss Gallery

Lehman, Connie
Hibberd McGrath Gallery

Lemon, Christina A.
Yaw Gallery

Levenson, Silvia
Galleria Caterina Tognon

Levin, Mark
William Zimmer Gallery

Leviton, Linda
Gallery 500

Levy, Simon
del Mano Gallery

Lewis, John
Leo Kaplan Modern

Liao, Chun
Barrett Marsden Gallery

Libenský, Stanislav
Donna Schneier Fine Arts
Galerie Aspekt
Galerie Pokorná

Lillie, Jacqueline
Sienna Gallery

Lindqvist, Inge
browngrotta arts

Linn, Steve
Habatat Galleries

Linssen, Nel
Charon Kransen Arts

Lipofsky, Marvin
R. Duane Reed Gallery

Lippmann, Puk
Gallery deCraftig

Littleton, Harvey
Donna Schneier Fine Arts
Maurine Littleton Gallery

Littleton, John
Maurine Littleton Gallery

Ljones, Åse
browngrotta arts

Lockau, Kevin
Galerie Elena Lee

Lockner, Aasa
Galerie Tactus

Loeser, Thomas
Leo Kaplan Modern

Logan, Kristina
Aaron Faber Gallery

Lomné, Alicia
The Bullseye Connection
Gallery

Lønning, Kari
browngrotta arts

Look, Dona
Perimeter Gallery, Inc.

Lory, David
Katie Gingrass Gallery

Loughlin, Jessica
The Bullseye Connection
Gallery

Løvaas, Astrid
browngrotta arts

Løvig, Helle
Galerie Metal

Lucero, Michael
Donna Schneier Fine Arts
R. Duane Reed Gallery

Lundberg, Tom
Hibberd McGrath Gallery

Lupien, Sylvie
Option Art

Luxx, Rena
Charon Kransen Arts

Lykke, Ane
Gallery deCraftig

Lynch, Sydney
William Zimmer Gallery

Lyon, Lucy
Thomas R. Riley Galleries

Lyons, Tanya
Galerie Elena Lee

M

Macdonald, Marcia
Hibberd McGrath Gallery

MacNeil, Linda
Leo Kaplan Modern

MacNutt, Dawn
browngrotta arts

Madden, Thomas
Yaw Gallery

Magakis, Gary
Snyderman-Works Galleries

Magni, Vincent
Galerie Vivendi
Modus Gallery

Maierhofer, Fritz
Mobilia Gallery

Mailland, Alain
del Mano Gallery

Maisch, Eva
Charon Kransen Arts

Malarcher, Patricia
Mobilia Gallery

Malerich, Lee
Hibberd McGrath Gallery

Malinowski, Ruth
browngrotta arts

Maljojoki, Mia
Mobilia Gallery

Malloy, Peg
Hibberd McGrath Gallery

Malone, Kate
Clare Beck at Adrian Sassoon

Maloof, Sam
del Mano Gallery

Maltby, John
Joanna Bird Pottery

Mann, Ptolemy
Contemporary Applied Arts

Mann, Thomas
Gallery 500

Manz, Bodil
Galleri Nørby

Marchetti, Stefano
Charon Kransen Arts

Marder, Donna Rhae
Mobilia Gallery

Mares, Jan
Galerie Aspekt

Marioni, Dante
Hawk Galleries

Márquez, Noemí
Dubhe Carreño Gallery

Marquis, Richard
Elliott Brown Gallery

Marsden, Robert
Barrett Marsden Gallery

Marsh, Bert
del Mano Gallery

Martin, Christopher J.
Function + Art

Martin, Malcolm
British Crafts Council

Maruyama, Tomomi
Mobilia Gallery

Mason, John
Perimeter Gallery, Inc.

Massaro, Karen Thuesen
Perimeter Gallery, Inc.

Mata, Carlos
Galerie Vivendi

Mattar, Wilheim Tasso
The David Collection

Matthews, Mark
Thomas R. Riley Galleries

Mawdsley, Richard
Mobilia Gallery

Max, Floor
Charon Kransen Arts

Maxand, Christiane
Charon Kransen Arts

Mayeri, Beverly
Franklin Parrasch Gallery, Inc.
Perimeter Gallery, Inc.

McBride, Kathryn
Ferrin Gallery

McCaig, Grant
Mobilia Gallery
The Scottish Gallery

McClellan, Duncan
Thomas R. Riley Galleries

McClelland, Tim
McTeigue & McClelland
Jewelers

McDevitt, Elizabeth
Mobilia Gallery

McKeachie-Johnston, Jan
Ferrin Gallery

McKie, Judy Kensley
McTeigue & McClelland
Jewelers

McLeod, Catriona
Joanna Bird Pottery

McNaughton, John
Mobilia Gallery

McNicoll, Carol
Clare Beck at Adrian Sassoon

McQueen, John
Elliott Brown Gallery
Mobilia Gallery

Medel, Rebecca
browngrotta arts

Mee, Nancy
R. Duane Reed Gallery

Meitner, Richard
Galleria Caterina Tognon

Mellor, Angela
Raglan Gallery

Merkel-Hess, Mary
browngrotta arts
Katie Gingrass Gallery

Messinger, Saundra
Sabbia

Meszaros, Mari
R. Duane Reed Gallery

Metcalf, Bruce
Charon Kransen Arts

Metz, Matthew
Ferrin Gallery

Meyer, Sharon
Thomas R. Riley Galleries

Meyers, Ron
Ferrin Gallery

Michaels, Guy
William Zimmer Gallery

Michelson, Denis
Michelson Gallery

Mickelsen, Robert
Habatat Galleries

Miguel
Charon Kransen Arts

Mihalisin, Julie
Hawk Galleries

Millar, Roger
Mobilia Gallery

Mills, Eleri
The Gallery at Ruthin
 Craft Centre

Minkowitz, Norma
Bellas Artes/Thea Burger

Minnhaar, Gretchen
Adamar Fine Arts

Mirabito, Eric
Dubhe Carreño Gallery

Mitchell, Craig
Contemporary Applied Arts

Miyamura, Hideaki
Jeffrey Weiss Gallery

Miyashita, Zenji
James Singer

Mobashri
Orley & Shabahang
 Persian Carpets

Mode, Michael
del Mano Gallery

Møhl, Tobias
Galleri Grønlund

Mohtasham
Orley & Shabahang
 Persian Carpets

Mondro, Anne
Mobilia Gallery

Mongrain, Jeffrey
Perimeter Gallery, Inc.

Monk, Rodney
Glass Artists' Gallery

Monteagudo, Mariana
Dubhe Carreño Gallery

Montoya, Luis
Hawk Galleries

Moon, Ellen
Mobilia Gallery

Moore, Debora
Habatat Galleries

Moore, Marilyn
Mobilia Gallery

Moore, William
del Mano Gallery

Mori, Junko
Clare Beck at Adrian Sassoon

Morinoue, Hiroki
William Zimmer Gallery

Morris, William
Donna Schneier Fine Arts
Habatat Galleries
Thomas R. Riley Galleries

Morrison, Merrill
Mobilia Gallery

Morton, Grainne
The Scottish Gallery

Mossman, Ralph
Thomas R. Riley Galleries

Moulthrop, Philip
del Mano Gallery

Mount, Nick
Thomas R. Riley Galleries

Mueller, Louis
Elliott Brown Gallery

Muhl, Debora
del Mano Gallery

Mulford, Judy
browngrotta arts
del Mano Gallery

Munch, Tchai
Galleri Grønlund

Munn, Alice Ballard
Jerald Melberg Gallery

Munsteiner, Bernd
Aaron Faber Gallery

Munsteiner, Jutta
Aaron Faber Gallery

Munsteiner, Tom
Aaron Faber Gallery

Murphy, Kathie
The David Collection

Musler, Jay
Marx-Saunders Gallery
Mobilia Gallery

Muzylowski-Allen, Shelly
Thomas R. Riley Galleries

Myers, Joel Philip
Marx-Saunders Gallery

Myers, Paulette
Yaw Gallery

Nagae, Shigekazu
James Singer

Nahabetian, Dennis
del Mano Gallery

Neal, Gareth
William Zimmer Gallery

Nechita, Alexandra
Berengo Fine Arts

Negre, Suzanne Otwell
The David Collection

Newell, Steven
Barrett Marsden Gallery

Nicholson, Laura Foster
Katie Gingrass Gallery

Nickolson, Anne McKenzie
Hibberd McGrath Gallery

Niehues, Leon
browngrotta arts

Niemi, Bruce A.
Niemi Sculpture Gallery
 & Garden

Nio, Keiji
browngrotta arts

Niso
Adamar Fine Arts

Nissen, Else Leth
Galleri Grønlund

Nissen, Kirsten
Gallery deCraftig

Nittmann, David
del Mano Gallery

Nobles, Beth
Hibberd McGrath Gallery

Novák, Břetislav
Galerie Pokorná

Nowak, James
Coplan Gallery

Noyons, Karina
Galerie Metal

O'Connor, Harold
Mobilia Gallery

Odahashi, Masayo
Morgan Contemporary
 Glass Gallery

O'dorisio, Joel
Lost Angel Glass

Oliver, Marvin
Thomas R. Riley Galleries

Olsen, Fritz
Niemi Sculpture Gallery
& Garden

O'Meallie, Sean
Mobilia Gallery

Onofrio, Judy
Sherry Leedy Contemporary Art

Ortiz, Leslie
Hawk Galleries

Osborne, Alison
Morgan Contemporary
Glass Gallery

Osmer-Andersen, Anna
British Crafts Council

Ott, Helge
The David Collection

Ouellette, Caroline
Galerie Elena Lee

Overstreet, Kim
Ferrin Gallery

Owen, Mary Ann Spavins
Yaw Gallery

Oxman, Zachary
Coplan Gallery

Oyekan, Lawson
Barrett Marsden Gallery

Pacey, Wendy-Sarah
Mobilia Gallery

Paganin, Barbara
Charon Kransen Arts

Pagano, Joseph
Habatat Galleries

Pala, Štěpăn
Galerie Pokorná

Paley, Albert
Hawk Galleries
Leo Kaplan Modern

Palová, Zora
Galerie Pokorná

Pankowski, Gina
Mobilia Gallery

Papesch, Gundula
Charon Kransen Arts

Pappas, Marilyn
Snyderman-Works Galleries

Parcher, Joan
Mobilia Gallery

Pardon, Tod
Aaron Faber Gallery

Park, Sung-Soo
Gallery Gainro

Park, Young-Hee
Gallery Gainro

Pärnänen, Inni
The David Collection

Parsons, Greg
browngrotta arts

Partridge, Jim
The Scottish Gallery

Patti, Tom
Heller Gallery

Paust, Karen
Mobilia Gallery

Paxon, Adam
The Scottish Gallery

Peiser, Mark
Marx-Saunders Gallery

Pennebaker, Ed
Function + Art

Perez, Jesus Curia
Ann Nathan Gallery

Perkins, Danny
R. Duane Reed Gallery

Perkins, Flo
Hawk Galleries

Perkins, Sarah
Mobilia Gallery

Perrone, Louise
Mobilia Gallery

Persson, Stig
Galleri Grønlund

Peterson, Michael
del Mano Gallery

Petrovic, Marc
Thomas R. Riley Galleries

Petter, Gugger
Mobilia Gallery

Pheulpin, Simone
browngrotta arts

Phillips, Maria
The David Collection

Philp, Paul
Joanna Bird Pottery

Pho, Binh
del Mano Gallery

**Pimental, Alexandra
de Serpa**
The David Collection

Pino, Claudio
Galerie des Métiers
d'Art du Québec

Planteydt, Annelies
Charon Kransen Arts

Plumptre, William
Joanna Bird Pottery

Podgoretz, Larissa
Aaron Faber Gallery

Pohl, Karen
Aaron Faber Gallery

Pohlman, Jenny
R. Duane Reed Gallery

Poissant, Gilbert
Option Art

Pon, Stephen
Galerie des Métiers
d'Art du Québec

Portaleo, Karen
Ferrin Gallery

Powell, Stephen Rolfe
Marx-Saunders Gallery

Powers, Pike
Elliott Brown Gallery

Powning, Peter
Habatat Galleries

Pragnell, Valerie
browngrotta arts

Preston, Mary
Mobilia Gallery

Price, Ken
Donna Schneier Fine Arts
Franklin Parrasch Gallery, Inc.

Priest, Frances
The Scottish Gallery

Priest, Linda Kindler
Aaron Faber Gallery

Quadri, Giovanna
Mobilia Gallery

Quigley, Robin
Mobilia Gallery

R

Raab, Yvonne
The David Collection

Rachins, Gerri
Mobilia Gallery

Radstone, Sara
Barrett Marsden Gallery

Rais, John
Mobilia Gallery

Rais, Lindsay
R. Duane Reed Gallery

Ramshaw, Wendy
The Scottish Gallery

Randal, Seth
Thomas R. Riley Galleries

Rauschke, Tom
Katie Gingrass Gallery

Rawdin, Kim
Mobilia Gallery

Rea, Kirstie
Beaver Galleries

Rea, Mel
Thomas R. Riley Galleries

Reed, Todd
Mobilia Gallery

Reekie, David
Thomas R. Riley Galleries

Reichert, Sabine
The David Collection

Reitz, Don
Maurine Littleton Gallery

Rena, Nicholas
Barrett Marsden Gallery

Rennie, Colin
The Scottish Gallery

Reyes, Sydia
Dubhe Carreño Gallery

Rezac, Suzan
Mobilia Gallery

Rhoads, Kait
Chappell Gallery

Richmond, Ross
R. Duane Reed Gallery

Rie, Lucie
Galerie Besson
Joanna Bird Pottery

Rieger, Patricia
Dubhe Carreño Gallery

Ries, Christopher
Hawk Galleries

Rietmeyer, Rene
Adamar Fine Arts

Riis, Jon Eric
James Tigerman Gallery

Ring, Sabine
Charon Kransen Arts

Ripollés, Juan
Berengo Fine Arts

Rippon, Tom
Mobilia Gallery

Ritter, Richard
Marx-Saunders Gallery

Roberson, Sang
Hibberd McGrath Gallery
William Zimmer Gallery

Roberts, David
The Scottish Gallery

Robertson, Donald
Galerie Elena Lee

Robinson, John Paul
Galerie des Métiers
 d'Art du Québec

Roehm, Mary
Snyderman-Works Galleries

Roessler, Joyce
Chappell Gallery

Roiseland, Alida
Charon Kransen Arts

Romanelli, Bruno
Clare Beck at Adrian Sassoon

Rose, Jim
Ann Nathan Gallery

Rose, Marlene
Adamar Fine Arts

Rose-Shapiro, Annette
UrbanGlass

Rosenfeld, Erica
UrbanGlass

Rossano, Joseph
Thomas R. Riley Galleries

Rossbach, Ed
browngrotta arts

Rothstein, Scott
browngrotta arts
Mobilia Gallery

Roubíček, René
Galerie Pokorná

Roubíčková, Miluše
Galerie Pokorná

Rousseau-Vermette, Mariette
browngrotta arts

Route, Jon Michael
Yaw Gallery

Rowe, Keith
Glass Artists' Gallery

Rowe, Michael
Barrett Marsden Gallery

Royal, Richard
R. Duane Reed Gallery

Ruffner, Ginny
R. Duane Reed Gallery

Rugge, Caroline
Mobilia Gallery

Russell, Brian
Jerald Melberg Gallery

Russell-Pool, Kari
Thomas R. Riley Galleries

Russmeyer, Axel
Mobilia Gallery

Ruzsa, Alison
Mostly Glass Gallery

Ryan, Jackie
Charon Kransen Arts

Rydmark, Cheryl
William Zimmer Gallery

Ryterband, Ben
Dubhe Carreño Gallery

Ryu, My-Hyun
Gallery Gainro

Ryuun, Yamaguchi
Tai Gallery/Textile Arts

Sabokova, Gisela
Galleria Caterina Tognon

Sachs, Debra
browngrotta arts

Safire, Helene
UrbanGlass

Saito, Kayo
The David Collection

Sales, Michelle
Snyderman-Works Galleries

Salminen, Aki
The David Collection

Samplonius, David
Option Art

Sand, Toland
Function + Art

Sano, Takeshi
Chappell Gallery

Sano, Youko
Chappell Gallery

Sarneel, Lucy
Charon Kransen Arts

Sartorius, Norm
del Mano Gallery

Sato, Naoko
British Crafts Council

Saylan, Merryll
del Mano Gallery
Snyderman-Works Galleries

Scarpino, Betty
del Mano Gallery

Schafermeyer, Anthony
Morgan Contemporary
 Glass Gallery

Scharff, Allan
Galerie Tactus

Scheer, Sydney
Aaron Faber Gallery

Schick, Marjorie
Mobilia Gallery

Schlatter, Sylvia
Charon Kransen Arts

Schlech, Peter
del Mano Gallery

Schleeh, Colin
James Tigerman Gallery

Schmid, Renate
Charon Kransen Arts

Schmid, Annegret
Mobilia Gallery

Schneider, Keith
John Natsoulas Gallery

Schutz, Biba
Charon Kransen Arts

Schwaiger, Berthold
The David Collection

Schwarz, David
Marx-Saunders Gallery

Schwieder, Paul
Hawk Galleries

Scoon, Thomas
Marx-Saunders Gallery

Scott, Gale
Chappell Gallery

Scott, Joyce J.
Mobilia Gallery

Seegers, Larry
The David Collection

Seide, Paul
Leo Kaplan Modern

Seidenath, Barbara
Sienna Gallery

Sekiji, Toshio
browngrotta arts

Sekijima, Hisako
browngrotta arts

Sekimachi, Kay
browngrotta arts

Sells, Brad
Finer Things Gallery

Selwood, Sarah-Jane
The Scottish Gallery

Sengel, David
del Mano Gallery

Sepkus, Alex
Sabbia

Sergi, Sandro
Berengo Fine Arts

Sewell, Ben
Chappell Gallery

Shabahang, Bahram
Orley & Shabahang
 Persian Carpets

Shaffer, Mary
Donna Schneier Fine Arts
Marx-Saunders Gallery

Shapiro, Barbara
Mobilia Gallery

Shapiro, Mark
Ferrin Gallery

Shaw, Richard
Mobilia Gallery

Shaw, Tim
Glass Artists' Gallery

Shaw-Sutton, Carol
browngrotta arts

Shellenbarger, Jane
Ferrin Gallery

Shelster, Amanda
Raglan Gallery

Sherman, Sondra
Sienna Gallery

Sherrill, Michael
Ferrin Gallery

Shigeo, Kawashima
Tai Gallery/Textile Arts

Shimaoka, Tatsuzo
Joanna Bird Pottery

Shimazu, Esther
John Natsoulas Gallery

Shindo, Hiroyuki
browngrotta arts

Shinn, Carol
Hibberd McGrath Gallery

Shioya, Naomi
Chappell Gallery

Shirfar
Orley & Shabahang
 Persian Carpets

Shoko, Kawano
Tai Gallery/Textile Arts

Shokosai V, Hayakawa
Tai Gallery/Textile Arts

Shosei, Fujitsuka
Tai Gallery/Textile Arts

Shuler, Michael
del Mano Gallery

Sieber Fuchs, Verena
Charon Kransen Arts

Siesbye, Alev Ebüzziya
Galerie Besson

Sikora, Linda
Ferrin Gallery

Sills, Leslie
Mobilia Gallery

Sils, Alfred
del Mano Gallery

Simon, Marjorie
Charon Kransen Arts

Simon, Michael
Ferrin Gallery

Simpson, Tommy
Leo Kaplan Modern
McTeigue & McClelland
 Jewelers

Sinding, Charlotte
Charon Kransen Arts

Singletary, Preston
Chappell Gallery

Sinner, Steve
del Mano Gallery

Sisson, Karyl
browngrotta arts
Snyderman-Works Galleries

Skau, John
Katie Gingrass Gallery

Skinner, Susan
Snyderman-Works Galleries

Skjøttgaard, Bente
Galleri Nørby

Slee, Richard
Barrett Marsden Gallery

Slemmons, Kiff
Mobilia Gallery

Slentz, Jack
del Mano Gallery

Sloan, Susan Kasson
Aaron Faber Gallery

Smelvær, Britt
browngrotta arts

Smith, Barbara Lee
Snyderman-Works Galleries

Smith, Christina
Mobilia Gallery

Smith, Fraser
Katie Gingrass Gallery

Smith, Hayley
del Mano Gallery

Smith, Martin
Barrett Marsden Gallery

Smith, Michael
William Zimmer Gallery

Soho, Katsushiro
Tai Gallery/Textile Arts

Sonobe, Etsuko
Mobilia Gallery

Soosloff, Philip
Kraft Lieberman Gallery

Sørenson, Grethe
browngrotta arts

Spearman, John
Joanna Bird Pottery

Speckner, Bettina
Sienna Gallery

Sperkova, Blanka
Mobilia Gallery

Spira, Rupert
Contemporary Applied Arts

St. Amand, Melissa
Mobilia Gallery

St. Croix, Robert
Walker Fine Art

St. John, Richard
Hibberd McGrath Gallery

St. Michael, Natasha
Galerie des Métiers
 d'Art du Québec

Stair, Julian
Joanna Bird Pottery

Staley, Chris
Ferrin Gallery

Stanger, Jay
Leo Kaplan Modern

Stankard, Paul
Marx-Saunders Gallery

Stankiewicz, Miroslaw
Mattson's Fine Art

Starr, Ron
Kraft Lieberman Gallery

Statom, Therman
Maurine Littleton Gallery

Stebler, Claudia
Charon Kransen Arts

Stephenson, Kathleen
Finer Things Gallery

Sterling, Lisabeth
R. Duane Reed Gallery

Stevens, Gary
del Mano Gallery

Stevens, Missy
Hibberd McGrath Gallery

Stiansen, Kari
browngrotta arts

Stone, Judy
Aaron Faber Gallery

Straker, Ross
Despard Gallery

Striffler, Dorothee
Charon Kransen Arts

Strokowsky, Cathy
Galerie Elena Lee

Stutman, Barbara
Charon Kransen Arts
Mobilia Gallery

Suh, Hye-Young
Charon Kransen Arts

Suidan, Kaiser
Gallery 500

Sullivan, Brandon
Mobilia Gallery

Superior, Mara
Ferrin Gallery

Sutton, Polly Adams
Katie Gingrass Gallery

Suzuki, Hiroshi
Clare Beck at Adrian Sassoon

Svensson, Tore
Galerie Tactus

Swirnoff, Sandy
Jean Albano Gallery

Syoryu, Honda
Tai Gallery/Textile Arts

Syvanoja, Janna
Charon Kransen Arts

T

Tagliapietra, Lino
Holsten Galleries

Takaezu, Toshiko
Perimeter Gallery, Inc.

Takahashi, Kazuya
James Singer

Takamiya, Noriko
browngrotta arts

Takayama-Ogawa, Joan
Ferrin Gallery

Takesonosai, Higashi
Tai Gallery/Textile Arts

Talcott, Lori
Hibberd McGrath Gallery

Tanaka, Chiyoko
browngrotta arts

Tanaka, Hideho
browngrotta arts

Tanigaki, Ema
Morgan Contemporary
 Glass Gallery

Tanikawa, Tsuroko
browngrotta arts

Tanner, James
Maurine Littleton Gallery

Tate, Blair
browngrotta arts

Tawney, Lenore
browngrotta arts

Taylor, David
Galerie Tactus

Taylor, Michael
Habatat Galleries
Leo Kaplan Modern

Teasdale, Ed
The Scottish Gallery

Teoli, Giancarlo
Michelson Gallery

Thakker, Salima
Charon Kransen Arts

Thayer, Susan
Ferrin Gallery

Theide, Billie Jean
Mobilia Gallery
Yaw Gallery

Thiewes, Rachelle
Mobilia Gallery

Thompford, Pamela Morris
Yaw Gallery

Thompson, Cappy
Leo Kaplan Modern

Threadgill, Linda
Mobilia Gallery

Throop, Thomas
Jeffrey Weiss Gallery

Tidäng, Erik
Galerie Tactus

Timar, Tibor
Ann Nathan Gallery

Timm-Ballard, Charles
Sherry Leedy Contemporary Art

Timofeev, Valeri
Aaron Faber Gallery

Tiozzo, Claudio
Genninger Studio

Tobin, Steve
Mostly Glass Gallery

Tokuzo, Shono
Tai Gallery/Textile Arts

Tolla
Adamar Fine Arts

Tolsma, Thea
Charon Kransen Arts

Tomasi
Charon Kransen Arts

Tomita, Jun
browngrotta arts

Toops, Cynthia
Mobilia Gallery

Torreano, John
Jean Albano Gallery

Toscano, Giuseppina
Berengo Fine Arts

Toso, Gianni
Leo Kaplan Modern

Toubes, Xavier
Dubhe Carreño Gallery

Trask, Jennifer
Mobilia Gallery

Traylor, Pamina
Snyderman-Works Galleries

Trekel, Silke
Charon Kransen Arts

Trimm, Rex
Snyderman-Works Galleries

Trova, Ernest
Walker Fine Art

Turner, Annie
Galerie Besson

Umbdenstock, Jean-Pierre
Modus Gallery

Ungvarsky, Melanie
UrbanGlass

Uravitch, Andrea
Mobilia Gallery

Urbán, Ramon
Jerald Melberg Gallery

Urbschat, Erik
Charon Kransen Arts

Urino, Kyoko
The David Collection

Urruty, Joël
Finer Things Gallery

Valdes, Carmen
Snyderman-Works Galleries

Vallee, Nad
Galerie Daniel Guidat

Vallien, Bertil
Donna Schneier Fine Arts
Heller Gallery

Valoma, Deborah
browngrotta arts

van Aswegen, Johan
Sienna Gallery

Van Cline, Mary
Leo Kaplan Modern

van der Leest, Felieke
Charon Kransen Arts

Van der Sluis, Melis
Raglan Gallery

Van Earl, Delos
Finer Things Gallery

van Kesteren, Maria
Barrett Marsden Gallery

VandenBerge, Peter
John Natsoulas Gallery

Vari, Zolan
Orley & Shabahang
 Persian Carpets

Vatrin, Gérald
Galerie Ateliers d'Art de France

Veilleux, Luci
Galerie des Métiers
 d'Art du Québec

Vermette, Claude
browngrotta arts

Verstraeten, Hubert
Charon Kransen Arts

Vesery, Jacques
del Mano Gallery

Viennet, Christine
Ferrin Gallery

Vigliaturo, Silvio
Berengo Fine Arts

Vikman, Ulla-Maija
browngrotta arts

Vízner, František
Donna Schneier Fine Arts
Galerie Pokorná
Thomas R. Riley Galleries

Vogel, Kate
Maurine Littleton Gallery

Volkov, Noi
William Zimmer Gallery

Voulkos, Peter
Donna Schneier Fine Arts
Sherry Leedy Contemporary Art

Wagle, Kate
Mobilia Gallery

Wagle, Kristen
browngrotta arts

Wagner, Andrea
Charon Kransen Arts

Wahl, Wendy
browngrotta arts

Walentynowicz, Janusz
Marx-Saunders Gallery

Walker, Audrey
The Gallery at Ruthin
 Craft Centre

Walker, Jason
Ferrin Gallery

Waller, Carole
Contemporary Applied Arts

Walling, Philip
Hawk Galleries

Walter, Barbara
Mobilia Gallery

Waltz, Silvia
The David Collection

Wang, Kiwon
Jeffrey Weiss Gallery

Warashina, Patti
Ferrin Gallery

Wargin, Tom
Gallery 500

Warner, Carol
Yaw Gallery

Wason, Jason
Joanna Bird Pottery

Webb, Roger
Despard Gallery

Webber, Delross
Thomas R. Riley Galleries

Wegman, Kathy
Snyderman-Works Galleries

Wegman, Tom
Snyderman-Works Galleries

Weinberg, Steven
Leo Kaplan Modern

Weissflog, Hans
del Mano Gallery

Weldon-Sandlin, Red
Ferrin Gallery

Werner, Howard
Snyderman-Works Galleries

Westphal, Katherine
browngrotta arts

Whiteley, Richard
Marx-Saunders Gallery

Whitney, Ginny
Aaron Faber Gallery
Mobilia Gallery

Wiken, Kaaren
Katie Gingrass Gallery

Wilensky, Laura
Mobilia Gallery

Wilkin, Neil
Clare Beck at Adrian Sassoon

Willenbrink-Johnsen, Karen
Thomas R. Riley Galleries

Williams, Beth
Morgan Contemporary
 Glass Gallery

Williamson, Dave
Mobilia Gallery
Snyderman-Works Galleries

Williamson, Roberta
Mobilia Gallery
Snyderman-Works Galleries

Willits, Laura
Hibberd McGrath Gallery

Wilson, Emily
Jerald Melberg Gallery

Wingfield, Leah
Habatat Galleries

Wise, Jeff
Aaron Faber Gallery

Wise, Scott
Finer Things Gallery

Wise, Susan
Aaron Faber Gallery

Wittrock, Grethe
Gallery deCraftig

Woffenden, Emma
Barrett Marsden Gallery

Wolfe, Andi
del Mano Gallery

Wolfe, Rusty
Finer Things Gallery
James Tigerman Gallery

Wolff, Ann
Habatat Galleries

Wolters, Lene
Galerie Metal

Woo, Jin-Soon
Charon Kransen Arts

Wood, Joe
Mobilia Gallery

Woodman, Betty
Franklin Parrasch Gallery, Inc.

Woodman, Rachael
Clare Beck at Adrian Sassoon
Snyderman-Works Galleries

Wrobel, Cindy
del Mano Gallery

Wynne, Robert
Raglan Gallery

Yamada, Mizuko
Mobilia Gallery

Yamamoto, Koichiro
Contemporary Applied Arts

Yamamoto, Yoshiko
Yaw Gallery

Yamano, Hiroshi
Marx-Saunders Gallery

Yanagihara, Mutsuo
James Singer

Yasuito, Tsuchida
Berengo Fine Arts

Yonezawa, Jiro
browngrotta arts
James Tigerman Gallery
Katie Gingrass Gallery

Yoon, Kwang-Cho
Galerie Besson

York, Susan
Dubhe Carreño Gallery

Yoshida, Masako
browngrotta arts

Youn, Soonran
Mobilia Gallery

Yovovich, Noll
Mobilia Gallery

Zanella, Annamaria
Charon Kransen Arts

Zaytceva, Irina
Ferrin Gallery

Zimmermann, Erich
Charon Kransen Arts

Zimmermann, Jorg
Mostly Glass Gallery

Zobel, Michael
Aaron Faber Gallery
Sabbia

Zoritchak, Yan
Galerie Daniel Guidat

Zuber, Czeslaw
Galerie Daniel Guidat

Zucca, Ed
Leo Kaplan Modern

Zynsky, Toots
Elliott Brown Gallery
Habatat Galleries

SOFA NEW YORK CHICAGO

The International Exposition of Sculpture Objects & Functional Art

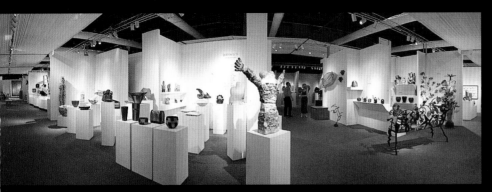
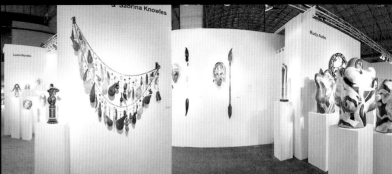

Photo: David Ba

SOFA NEW YORK 2004

June 3-6
Seventh Regiment Armory

Opening Night Gala
A benefit for the Museum of Arts
& Design, New York City

SOFA CHICAGO 2004

November 5-7
Navy Pier

Opening Night Gala
A benefit for the Arts Program of
Northwestern Memorial Hospital, Chicago

Information:
800.563.7632
info@sofaexpo.com

sofaexpo.com
For the latest news & information!